JACOB VAN
RUISDAEL

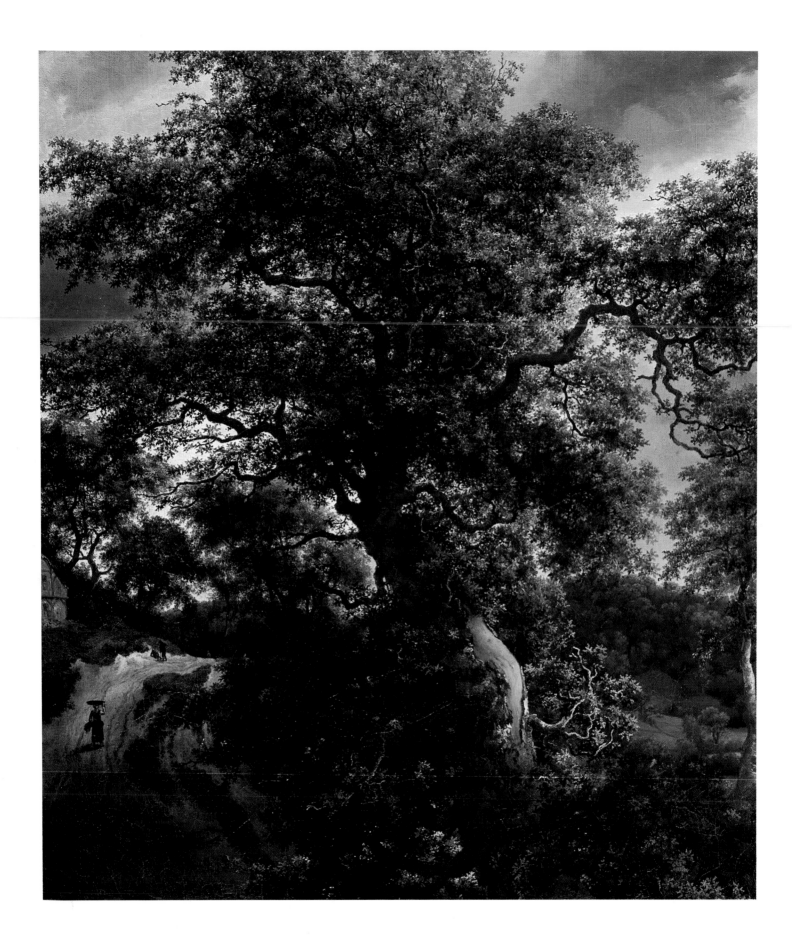

JACOB VAN
RUISDAEL

Seymour Slive
Director, Fogg Art Museum, Harvard University
Catalogue and Selection

H. R. Hoetink
Director, Mauritshuis
Selection and Organization

Mauritshuis, The Royal Cabinet of Paintings
The Hague
1 October 1981–3 January 1982

The Fogg Art Museum, Harvard University,
Cambridge, Massachusetts
18 January 1982–11 April 1982

Abbeville Press • Publishers • New York

DESIGNER: ULRICH RUCHTI
EDITOR: MARK GREENBERG

Library of Congress catalog card number: 81-65933

ISBN 0-89659-226-X (cloth)
ISBN 0-89659-237-5 (paper)

Printed and bound in Japan.

On the jacket: *The Jewish Cemetery*. See commentary on pages 68–75.

Facing the title page: *Hilly Landscape with a Great Oak and a Grain Field* (detail). See commentary on page 60.

IN MEMORY OF
JAKOB ROSENBERG
1893–1980

SELECTION COMMITTEE
H. R. HOETINK
Director, Mauritshuis
SEYMOUR SLIVE
Director, Fogg Art Museum
Gleason Professor of Fine Arts
Harvard University
F. J. DUPARC
Resarch Assistant, Mauritshuis

CATALOGUE
SEYMOUR SLIVE

ORGANIZATION
H. R. HOETINK
SEYMOUR SLIVE
F. J. DUPARC
F. J. M. JEHEE
Registrar, Mauritshuis
HILDEGARD VAN HALL
Secretary, Mauritshuis
JANINE NAUTA
Assistant, Mauritshuis
ALICE I. DAVIES
Research Assistant, Fogg Art Museum
GABRIELLA JEPPSON
Assistant Director for Curatorial
Affairs, Fogg Art Museum
JANE MONTGOMERY
Registrar, Fogg Art Museum

The exhibition in the United States was made possible by grants from United Technologies Corporation and from the National Endowment for the Arts, a federal agency, and by a federal indemnity from the Federal Council on the Arts and Humanities.

KLM Royal Dutch Airlines was responsible for major transportation for the exhibition.

Dutch edition published in 1981 by Meulenhoff/Landshoff

Works exhibited only at The Hague: Cat. nos. 3, 36, 50, 52, 63, 67, 69, 78, 88, 89, 90, 95, 107-A (Paris, Bibliothèque Nationale).

Works exhibited only at Cambridge: Cat. nos. 9, 107-A (London, British Museum).

Owing to unforeseen circumstances, Catalogue 72 cannot be included in the exhibition.

Lenders

The Jacob van Ruisdael exhibition was made possible thanks to the generous support of the following lenders.

Her Majesty Queen Elizabeth II [10, 75]

Austria
Vienna, Albertina, Graphische Sammlung [96-B, 100, 102]

Belgium
Brussels, Koninklijke Musea voor Schone Kunsten [93, 94]

France
Paris, Baroness Gabriele Bentinck [5]
Paris, Bibliothèque Nationale [107-A]
Paris, École des Beaux-Arts [82, 83, 84]
Paris, Fondation Custodia (coll. F. Lugt), Institut Néerlandais [25, 53, 96-A]
Paris, Musée du Louvre [47, 85]
Paris, Petit Palais [104]

German Democratic Republic
Dresden, Staatliche Kunstsammlungen, Gemäldegalerie and Kupferstichkabinett [21, 37, 57, 58, 59, 60, 61, 62]

German Federal Republic
Berlin, Staatliche Museen, Gemäldegalerie and Kupferstichkabinett [55, 63, 78, 95, 99]
Brunswick, Herzog Anton Ulrich-Museum [17]
Düsseldorf, Kunstmuseum [5]
Hamburg, Kunsthalle [1, 86, 92]
Kettwig (Ruhr), Herbert Girardet Collection [33]
Munich, Bayerische Staatsgemäldesammlungen [29, 41]

Great Britain
Birmingham, City Museums and Art Gallery [16]
Bowhill, The Duke of Buccleuch and Queensberry [15]
Cambridge, The Fitzwilliam Museum [56]
Edinburgh, The National Gallery of Scotland and Edinburgh University [9]

London, Trustees of the British Museum [64, 65, 81, 98, 101, 103-A, 107-A]
London, The Trustees of the National Gallery [22, 43]
Oxford, Worcester College [18]
Polesden Lacey, The National Trust [49]

Hungary
Budapest, Museum of Fine Arts [4]

Ireland
Blessington, Beit Collection [14]

Italy
Florence, Uffizi Gallery [50]

The Netherlands
Amsterdam, Amsterdams Historisch Museum [74]
Amsterdam, Rijksmuseum and Rijksprentenkabinet [39, 42, 80, 87, 91, 97, 103-B, 106-A, 108-B]
Eindhoven, The Heirs of Mr. & Mrs. Philips-de Jongh [2]
Groningen, Groninger Museum voor Stad en Lande [79]
Haarlem, Frans Hals Museum [28]
Haarlem, Teyler Museum [70, 76, 77]
The Hague, Mauritshuis [44]
The Hague, Museum Bredius [88, 89, 90]
Rotterdam, Museum Boymans-van Beuningen [30, 73, 105-B, 106-B, 107-B, 108-C]

Portugal
Lisbon, Calouste Gulbenkian Foundation [72]

Sweden
Stockholm, Nationalmuseum [11]

Switzerland
Lugano-Castagnola, Thyssen-Bornemisza Collection [6]
Zurich, Kunsthaus, Stiftung Prof. Dr. L. Ruzicka [26, 45]

U.S.S.R.
Leningrad, Hermitage [3, 36, 52, 67, 69]

The United States
Miss Yvette Baer [71]
Boston, Museum of Fine Arts [48]
Cambridge, Fogg Art Museum, Harvard University [34]
Chicago, The Art Institute of Chicago [19]
Cincinnati, Cincinnati Art Museum [51]
Detroit, The Detroit Institute of Arts [20]
Manchester, The Currier Gallery of Art [7]
New York, The Metropolitan Museum of Art [31, 108-A]

New York, The Pierpont Morgan Library [66]
Pasadena, The Norton Simon Foundation [38]
Toledo, The Toledo Museum of Art [40]
Washington, D.C., National Gallery of Art [54, 68, 105-A]
Worcester, The Worcester Art Museum [32]

In addition we are beholden to several anonymous lenders [8, 12, 13, 16, 23, 24, 27, 35, 46].

Contents

Preface

As early as the nineteenth century Jacob van Ruisdael was recognized as one of the greatest Dutch painters. Goethe, Burckhardt, Fromentin, Bode, and many others highly praised his accomplishment. Although we may emphasize different qualities from those stressed by his early admirers, Ruisdael's distinction as a landscapist remains unchallenged. Nevertheless, and strange as it may seem, there has never been an exhibition dedicated exclusively to Ruisdael. Therefore, there was good reason for the Mauritshuis to organize an exhibition of the artist's work, and all the more so since 1982 marks the 300th anniversary of his death. In view of the importance of an exhibition devoted to the artist—the first, and probably the last in our time—it is fortunate that the Fogg Art Museum was able to join in this initiative. The joint effort enables the American as well as the European public to gain an idea of the extraordinary quality and unmatched range of Ruisdael's landscapes.

Preparation for the exhibition started in 1977 when the organizers began to examine the artist's numerous paintings and drawings; about 700 of the former and more than 100 of the latter are attributable to him. From the beginning we have aimed to assemble only works of outstanding quality and in a fine state of preservation. An effort has also been made to show representative works from every phase of Ruisdael's career and from the wide diversity of his subjects.

Many lenders have generously contributed to this effort. Our thanks go first to Her Majesty Queen Elizabeth II of England. Further, we are deeply indebted to numerous private collectors and to the trustees and staffs of museums and other institutions who have generously consented to lend their works to the Mauritshuis and the Fogg Art Museum. In doing so they have deprived themselves for nearly seven months of work that they cherish.

Apart from the lenders we owe a debt to many people who significantly contributed to the realization of the exhibition and catalogue by their helpful collaboration and the information they provided. Kind assistance was received from His Excellency F. J. Th. J. van Agt, Ambassador of the Netherlands to the U.S.S.R.; His Excellency Jonkheer Mr. J. A. Beelaerts van Blokland, Ambassador of the Netherlands to Hungary; His Excellency Drs. A. J. H. van der Maade, Ambassador of the Netherlands to the German Democratic Republic; Mr. H. V. Baron Bentinck, Counsellor at the Netherlands Embassy to the German Democratic Republic.

Additional deep thanks go to the Director and staff of the Rijksbureau voor Kunsthistorische Documentatie, The Hague; Sir Geoffrey Agnew, London; Prof. Peter S. Ashton, Cambridge, Massachusetts; Mrs. Marjorie B. Cohn, Cambridge, Massachusetts; Miss L. C. J. Frerichs, Amsterdam; the late Prof. J. G. van Gelder, Utrecht; the late Prof. H. Gerson, Groningen; we thank in particular Drs. P. J. Giltay who provided us with his material on Ruisdael's drawings before his article on them was published in *Oud Holland*, 1980; Mr. J. Hoogsteder, The Hague; Dr. Y. Kusnetzov, Leningrad; The Honorable Patrick Lindsay, London; Prof. Elizabeth B. MacDougall, Washington, D.C.; Dr. Anneliese Mayer-Meintschel, Dresden; Mr. R. Noortman, London; Mr. Christopher Norris, Polesden Lacey; Mr. D. T. Piper, Oxford; the late Prof. Wolfgang Stechow, Oberlin; Dr. Peter Sutton, Philadelphia; Sir Ellis Waterhouse, Oxford; Dr. Christopher White, London.

The Mauritshuis is particularly indebted to the Ministry of Culture, Recreation, and Social Welfare for its generous collaboration which made possible the showing of the exhibition at The Hague. Thanks also go to the Executive Board of the Foundation Johan Maurits van Nassau, which once again created the opportunity for the Mauritshuis to publish a scholarly catalogue.

Exceptionally generous and welcome help was provided by KLM Royal Dutch Airlines. It enabled the Mauritshuis and the Fogg Art Museum to defray most of their transportation costs, a major part of the expense of an international exhibition. We wish to extend our thanks to this public-spirited organization's assistance.

The Fogg Art Museum owes an enormous debt to the National Endowment for the Arts for a gen-

erous grant, and to United Technologies Corporation for its munificent support of the Cambridge showing. Without their enlightened help the American public would not have had an opportunity to view the exhibition. Most of the foreign loans to Cambridge have been insured under the provisions of the Arts and Artifacts Indemnity Act passed by Congress in 1975 and implemented through the Federal Council on the Arts and Humanities. The Fogg Art Museum is most grateful for this indemnification; without it insurance costs would be prohibitive.

The author of the catalogue expresses his very special gratitude to Dr. Alice I. Davies for her effective research and many helpful suggestions. His overwhelming debt is to the late Prof. Jakob Rosenberg who was the mentor of his Ruisdael studies.

The organizers of the exhibition are also grateful to Mr. F. J. Duparc for his many valuable suggestions and his valuable help.

Finally, the organizers are gratified that part of the showing of the Ruisdael exhibition occurs during 1982, the year that marks two centuries of uninterrupted diplomatic relations between The Netherlands and the United States. A cultural event that helps further mutual knowledge and understanding is an appropriate way to help celebrate this historic event.

H. R. HOETINK
Director, Mauritshuis

SEYMOUR SLIVE
Director, Fogg Art Museum
Gleason Professor of Fine Arts
Harvard University

Introduction

Art historians have a simple index for determining the popularity of paintings that is arguably as trustworthy as the questionnaires designed by pollsters to estimate the ratings of politicians or breakfast foods. Their indicator is the modest picture postcard. Accounts of the sale of cards offer a reliable measure of the rank the public assigns to artists and their pictures.

Nobody will be surprised to learn that from the time postcards have been sold in Dutch museums the far and away best-sellers have been Rembrandt's *Night Watch* and Vermeer's *View of Delft*. The runner-up is not a masterwork by Frans Hals or Jan Steen. It is Jacob van Ruisdael's *Windmill at Wijk*.

Despite the world-wide popularity of Ruisdael's *Windmill at Wijk* and the familiarity of art lovers with his grandiose panoramic views of Haarlem, his paintings of *The Jewish Cemetery*, and a few of his other frequently reproduced pictures, not many people have an idea of his extraordinary range and the unmatched variety of his landscapes. It is easy to explain why. Not only is the literature devoted to Holland's greatest landscape painter both sparse and scarce, but also the public has never been given an opportunity to obtain an overview of Jacob's achievement in an exhibition. The current occasion is the first comprehensive show ever held of his work in all media.

To be sure, Ruisdael's landscapes have always been included in major loan exhibitions that offered a representative view of the heroic age of Dutch art. The earliest and most impressive of these gatherings was a group brought together over a century ago by the organizers of the spectacular Manchester *Art Treasures Exhibition* of 1857—an assemblage that makes the blockbuster shows of our day look miniscule. Its organizers amassed 16,000 works selected exclusively from collections in the United Kingdom. As part of the large seventeenth-century Dutch section, twenty-two paintings attributed to Ruisdael were exhibited. Dutch drawings were virtually ignored; only eight were placed on view, and not one by Ruisdael. But Dutch prints were not forgotten. Impressions of five of Jacob's etchings were shown, the largest group of them mounted for the public until the current exhibition.

It is no accident that so many of Ruisdael's works were available in British collections for the 1857 exhibition or that the largest single collection of them in our time is not in Holland but at the National Gallery in London.

Ruisdael's paintings began to appear in London sale rooms with some frequency as early as the 1740s, and even before the middle of the century youthful Gainsborough managed to make a drawing in black and white chalks after Jacob's imposing landscape, populated with conspicuous figures by Nicolaes Berchem, which now belongs to the Louvre (Figs. 1, 2). Where Gainsborough saw the Ruisdael he copied and when it left England remain mysteries, but the provenance of numerous others can be established. Scores of them crossed the Channel after the French Revolution forced the dispersal of notable continental collections of seventeenth-century Dutch paintings. The large number that found permanent homes in Britain during these years is testimony to the appeal Ruisdael's romantic feeling for landscape and astonishing truth to nature had for early nineteenth-century British collectors. Their appreciation was shared by England's preëminent landscapists: Turner paid homage to Jacob more than once, and Constable adored him from the time he began his training as a professional painter. However, admiration for Ruisdael was not universally endorsed by the England of Turner and Constable. In 1812 Benjamin Robert Haydon, who unsuccessfully dedicated his life and work to resuscitating the grand tradition of High Renaissance history painting, contemptuously characterized his colleagues who did not support his views as "idling and capricious connoisseurs with Raphael in their mouths and Ruysdael in their hearts"—hardly flattering to the Dutch artist, but good proof that his name already had become a household word in England.

British interest in showing Ruisdael's work to the public did not diminish after the Manchester exhibition of 1857. The first effort to gather Ruisdael's drawings for a loan exhibition was made by the Royal Academy in London. It was not a large attempt. Only four drawings attributed to the artist were included in the Academy's *Dutch Art Exhibition* of 1929, but not one of the subsequent loan exhibitions that have included Jacob's drawings has been more ambitious. The organizers of the 1929 exhibition did not show any of Ruisdael's

Fig. 1. Jacob van Ruisdael, Wooded Landscape with a Flooded Road. *Paris, Musée du Louvre, on extended loan to Douai, Musée de la Chartreuse.*

etchings; their selection of prints was restricted to Hercules Segers and Rembrandt. However, their selection of eight paintings by Jacob was choice.

Hitherto, the only attempt to bring together more of the artist's paintings than had been seen at Manchester was made by the organizers of the *Dutch Pictures: 1450–1750* exhibition in 1952–53, also held at the Royal Academy. The selection committee mounted twenty-six paintings attributed to Ruisdael; they were assembled almost entirely from British collections.

Among the numerous nineteenth- and twentieth-century European and American exhibitions dedicated to the golden age of Dutch art that included Jacob's works (see pp. 262-266 for a representative list), only two meet the high standard of selection set by the British. One was held in Eindhoven in 1948; the other was seen at Paris in 1950–51.

If a generation has passed since the public has been offered a chance to view even a small selection of Ruisdael's fine works in a loan exhibition, more than fifty years have elapsed since full-dress accounts have been given of his accomplishment.

Strange as it may seem, an extensive, amply illustrated study of Ruisdael's work has not been published since Jakob Rosenberg's classic mono-

14

Fig. 2. Thomas Gainsborough (after Ruisdael), Wooded Landscape. *Manchester, The Whitworth Art Gallery.*

graph and summary catalogue of the artist's paintings and drawings appeared in 1928. The distribution of Rosenberg's handsome folio volume was restricted from the very beginning. It was published in a limited edition of only 360 copies. Today it is virtually untraceable on the book market. When the volume appears it fetches almost the price of one of Ruisdael's rare etchings.

Rosenberg's painting catalogue was based on the one Hofstede de Groot produced in 1911, which, in turn, was based on John Smith's pioneer catalogues of 1835 and 1842. The list of drawings he published was the first one compiled.

Rosenberg's conclusions regarding the knotty problems of the chronology of the artist's work still stand in their essential features and his sensitive assessments of Ruisdael's achievements remain unmatched. My enormous debt to his monograph and the help I received from him during the course of our long association as colleagues and close friends is reflected in the present study in innumerable ways.

A year before Rosenberg's work appeared, Kurt Erich Simon published his dissertation on Ruisdael's artistic development; a trade edition, with a supplement and corrections, became available in

1930. Simon's study has not stood the test of time as well as Rosenberg's. Its principal limitation is the author's tendency to follow too strict a continuity of the artist's style without leaving room for cross currents and recurrences.

After the publication of Rosenberg and Simon's volumes, Ruisdael's art did not attract much attention from scholars until quite recently. The chief contribution has been made by J. Giltay who published an extensive article and catalogue of the drawings in 1980. Giltay offers valuable new information on their function, technique, and history as well as revisions to Rosenberg's primary list. His introduction of many previously unpublished sheets brings the total number of drawings to more than one hundred. I have benefited from an opportunity to study Giltay's article before it was published and gratefully acknowledge my debt to him. Two new catalogues of Ruisdael's small output as an etcher—only thirteen prints are known—have appeared in recent years: one by George S. Keyes, which is accompanied by an essay (1977); the other by Dieuwke de Hoop Scheffer (1978).

Ruisdael's production as a painter was prodigious. Today about 700 paintings can be attributed to him. Contemporary students have made close studies of a few of them as have specialists who search seventeenth-century Dutch pictures for covert meaning and hidden symbolism that are easily overlooked by modern viewers if their presence is not signaled. Most likely some of Ruisdael's own contemporaries who were prone to read all of nature as symbols of God's creation or transcendental ideas found symbolic and allegorical meanings in his landscapes, but apart from his patently moralizing paintings of *The Jewish Cemetery*, the attempts that have been made to find symbolic allusions in his works remain speculative.

A solid contribution to the understanding of Ruisdael's paintings is found in Wolfgang Stechow's *Dutch Landscape Painting of the Seventeenth Century*, which appeared in 1966. Stechow treats the vast subject by themes. He established a typology of thirteen kinds of Dutch landscape painting and traces their origin and history. His typology highlights Ruisdael's unrivaled many-sided activity. Jacob makes stellar appearances in ten of Stechow's categories: dunes and country roads, panoramas, rivers and canals, woods, winter scenes, beaches, marines, town views, imaginary scenes, and Scandinavian landscapes. Ruisdael's unpublished painting of an *Evening River Scene with an Angler* (Fig. 3), monogrammed and dated 1649, in a private collection, shows that he tried his hand at painting at least one nocturne, yet another one of Stechow's categories. To our best knowledge, the artist painted neither Italianate landscapes nor foreign scenes, apart from Scandinavian ones, the two remaining subjects of Stechow's classification.

Both Rosenberg and Simon based their brief biographies of Ruisdael on research done by a small group of dedicated Dutch scholars, especially A. Bredius. In 1932 this data was amplified and corrected in some important respects by H.F. Wijnman in a series of articles on Ruisdael and his extended family. W.F.H. Oldewelt presented his findings on the last phase of the artist's activity in 1938. Repeated searches in the archives of Holland in recent years have turned up nothing new. In fact, the meager biographical information that has been discovered after more than a century of research does little to satisfy our curiosity about Jacob's life and milieu. Not a single line written by him has survived. None of his immediate contemporaries has left us a word about him or about their reactions to his art. No portrait of the artist has ever been identified.

We can establish that Ruisdael was born between 1628 and 1629 because he declares himself to be 32 years old in a notary's deed dated 9 June 1661. Though his name is variously spelled in contemporary documents, and members of his family used various spellings of their surname, he himself always spelled it "Ruisdael." To our best knowledge all permutations of this spelling on his works are later additions by other hands.

The unusual name of Ruisdael is connected with the castle of Ruisdael or Ruisschendaal in the neighborhood of Blaricum, a village about thirty kilometers southeast of Amsterdam. Apart from its ruined cellars and unexcavated foundations, nothing remains of the castle today. In the 1590s Jacob's grandfather Jacob Jansz de Goyer (c. 1560–1616) moved from the site of the castle to the nearby town of Naarden where he worked as a carpenter and lived in comfortable circumstances. Three of his four sons changed their surnames from de

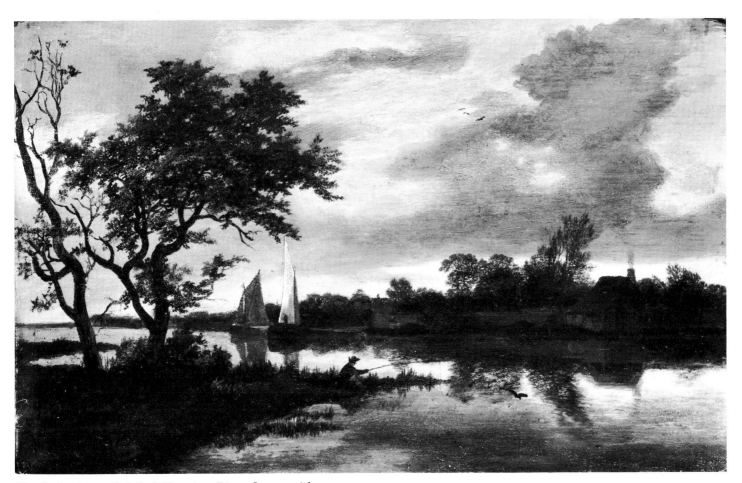

Fig. 3. Jacob van Ruisdael, Evening River Scene with an Angler, *1649. Private collection.*

Goyer to Ruisdael (or Ruysdael), most likely to fix their family's origin in the family name. Two of them concern us here: Jacob's father, Isaack van Ruisdael and his uncle, the outstanding landscape painter Salomon van Ruysdael.

Isaack was born in Naarden in 1599; Salomon was born there before 1603. Both brothers moved to Haarlem about 1616, presumably after the death of their father. A record in the Haarlem archives informs us that on 12 November 1628 Isaack, a widower from Naarden, married Maycken Cornelisdr, a maid of Haarlem. It seems reasonable to conclude that Jacob was a child of this marriage, but this is not certain since we do not know if Isaack's first wife bore a child, nor do we know when she died. Therefore, the possibility that Jacob was the child of an earlier marriage cannot be excluded. However, circumstantial evidence lends support to the supposition that Maycken was Jacob's mother.

From a series of reports of legal proceedings, we know that Isaack's financial affairs were in a mis-erable state from about the time Jacob was born until he began to work as an independent artist. The earliest record of Isaack's difficulties is dated 25 August 1628 when he was sued by his landlord who wanted him evicted for not paying his very modest annual rent: 14 guilders, 10 stuivers. The court was lenient. A week later it decreed that his debt should be lowered to 8 guilders, and he was ordered to pay it in installments of one guilder per month. The fact that Isaack married when he was living in dire poverty suggests that he took Maycken as his bride because she was with child, and that Jacob was the issue of this union.

The date of Maycken's death has not been discovered, but it must have occurred before 9 March 1642 when Isaac married Barbertgen Hoevenaels (not Hoevenaers) in Haarlem. She was the sister-in-law of the almost forgotten still life painter Cornelis Cruys. The following year Barbertgen bore a daughter: Maria van Ruisdael, Jacob's half-sister.

Besides following his principal trade of frame

making, Isaack occasionally worked as a picture dealer. Documentary evidence also establishes that he was an artist. When he was sued for his rent in 1628 he was identified as a *patroonmaker* (designer of cartoons for tapestries and wall hangings). In a document of 1634 he is listed on the rolls of the Haarlem Guild of St. Luke as an apprentice and art dealer, but not as a master. It states further that the guild fined Jan van Goyen three guilders for painting three pictures in Isaack's house. The painter's guild of Haarlem severely restricted competition by enforcing their regulation that no artist could work at his trade while he was in the town unless he was a member of the guild. Van Goyen, who was a citizen of The Hague at this time, was fined because he broke the rule.

There are also a few references to paintings by Isaack in old inventories: *Summer* and *Winter* landscapes are listed in one made in 1636; two small tondi are cited in the inventory compiled in 1668 of the estate of the genre painter Jan Miense Molenaer; an unidentified painting is listed in an inventory of 1669. In addition, Arnold Houbraken refers to him as the teacher of the little-known landscapist Isaack Koene in his *De Groote Schouburgh der Nederlantsche Konstschilders en Schilderessen* (1718–21), a three-volume work that remains the most valuable source for knowledge of seventeenth-century Dutch artists. But none of Isaack van Ruisdael's paintings have been identified. Thus it is impossible to say what he taught his son about painting or what impact his art had upon him.

The voluminous litigation in which Isaack is involved between 1628 and 1646 tells a pathetic story. He continually figures as a man exceptionally dilatory in payment or delivery. For example, a case pressed against him in 1632 reveals that he delayed six years in fulfilling his obligation to pay for a beachscape commissioned from the outstanding marine painter Jan Porcellis. Never is Isaack's honor questioned in these suits, but invariably he loses his case, and one gains the impression that the frequency of his appearance in court stems not only from continuous money troubles but also from a certain weakness of character. In the summer of 1646 he is involved in two lawsuits over large amounts owed for bread and wine, then the proceedings cease.

Since Jacob appears on the scene as a prolific painter in 1646, the year the two lawsuits end, we can assume that at the early age of seventeen or eighteen the son began providing financial help for his father, who died in 1677. Impressive evidence of Jacob's later care for his old father is given by his two wills of 1667, described more fully below, and also by his father's own will of 1668. In addition, Arnold Houbraken, who has the distinction of publishing the earliest account of Ruisdael's life and art in *De Groote Schouburgh*, informs us in his thumbnail biography of the artist that Jacob "remained single to the end of his life, men say in order the better to be able to support his old father." On the other hand, Ruisdael's feelings of affection for his step-mother appear to have been of another sort. His wills of 1667 generously provide for his father and half-sister but his stepmother is not even mentioned in them. She was buried in a pauper's grave at Haarlem in 1672, a decade before Jacob's death.

Houbraken reports that Jacob's father "had him taught Latin when he was a boy, and then put him to study medicine which he pursued so far that he performed several surgical operations in Amsterdam and gained a wide reputation." At first it seems difficult to square Houbraken's statement with Ruisdael's prodigious output, especially when one considers the large amount of work he produced in his youth, precisely at the time Houbraken tells us he was studying medicine at his father's instigation. Yet there may be some truth in the account. It is not unlikely that the impoverished father of this evidently gifted boy may have hoped for something better for him than an artist's life, which apparently brought Isaack himself small satisfaction.

Moreover, Houbraken knew something about surgeons and their activities; he married the daughter of one (Jacob Sasbout Souburg), in Dordrecht in 1685. Is it possible that Houbraken erred? Did he confuse Jacob van Ruisdael the painter with a doctor who bore the same name? This was the tentative solution offered more than a century ago by P. Scheltema (1861) when he proposed, on the basis of a clue he had discovered, that Jacob had such a cousin who was born in Alkmaar and later studied medicine in Amsterdam. Later archival research has shown that Scheltema's supposition

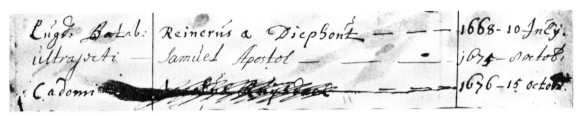

Fig. 4. Excerpt from the List of Amsterdam Doctors showing the deletion of the name of "Jacobus Ruijsdael" who received his medical degree at Caen on 15 October 1676. Municipal Archives of Amsterdam.

has no foundation. Finally, if Houbraken erred, so did the anonymous compiler of the sale catalogue of an auction held in Dordrecht in 1720. He described a lot in that sale as "a very ingenious landscape with a waterfall by Doctor Jacob Ruisdael beautifully and pleasantly painted." His reference to Ruisdael as a doctor was made a year before Houbraken's biography of the artist was published.

Houbraken's report regarding the artist's activity as a doctor seemed to gain credibility after Wijnman's discovery (1932) that the name "Jacobus Ruijsdael" [*sic*] appears in an Amsterdam list of doctors now in the city's Municipal Archives. However, the appearance of the name on the list not only fails to clinch the case: It poses additional riddles. Knowledge that Ruisdael himself never spelled his name "Ruijsdael" cannot be ignored in assessing the reliability of the entry, but too much weight should not be given to the discrepancy. Orthographic changes made by scriveners are not uncommon in seventeenth-century Holland. Another aspect of the entry is more puzzling: The name "Jacobus Ruijsdael" has been vigorously scratched out in ink that appears to be identical to the ink used to inscribe it (Fig. 4). It is the only name in the *Series Nominum Doctorum* preserved at Amsterdam that has been deleted. Why was it expunged? A satisfactory answer to this question has not been found.

The entry in the Amsterdam list of doctors also states that "Jacobus Ruijsdael" received his medical degree at the University of Caen on 15 October 1676. Is it probable that Ruisdael found time and energy to study for a doctor's degree in northern France during the final phase of his career? Recent biographers of Ruisdael who answer the question affirmatively have assumed that the artist began his study of medicine in the United Provinces and worked with a surgeon there. Then, late in life, after gaining proficiency and experience, he traveled to Caen where it was easier to get a degree than at a Dutch university. However, there is no evidence to support the assumption that medical degrees at Caen were less difficult to obtain than those earned in the Netherlands in 1676. A recent search for evidence pertinent to the issue has been fruitless, and chances of finding confirmation that he enrolled and completed his medicine studies at Caen are slim; its existing matriculation rolls postdate 1702, and there is no record there of dissertations completed before 1792.

The effort to establish Ruisdael's residence in France about 1676 by arguing that the panoramic vistas of vast mountain ranges in his *Three Great Trees* (Cat. no. 38), now in The Norton Simon Foundation's collection, and in the Louvre's *Le Coup de Soleil* (Cat. no. 47) were inspired by views he saw while traveling in northern and central France loses its force when we recall the artist's power to paint more than one hundred convincing views of northern waterfalls without ever traveling to Sandinavia. Like his waterfall paintings, the Norton Simon and Louvre pictures are imaginary views. Moreover, there is reason to believe that his *Three Great Trees* was painted in the late 1660s, before Jacob's hypothetical journey to Caen, and that *Le Coup de Soleil* owes a greater debt to Rembrandt's fantastic landscapes than to scenery he saw with his own eyes.

In brief, a review of the evidence provided by Amsterdam's list of doctors does not provide an open-and-shut case. The "Jacobus Ruijsdael" who earned a medical degree at Caen in 1676 may or may not be identical with Jacob van Ruisdael the painter. The reason the name was stricken remains unexplained.

Ruisdael's connection in 1678 with Jan Baptist van Lamsweerde, an Amsterdam doctor who won

notoriety for the part he played in a pamphlet war that centered around the manner of delivery of a still-born baby, does not throw light on the artist's putative medical activities either. As we shall see, this contact involved a substantial loan that Jacob made to van Lamsweerde, not a professional matter.

No more is known about Ruisdael's early training as an artist than about his alleged activities as a surgeon. No contemporary reference tells us where or with whom he served his apprenticeship. Ample evidence, however, testifies that he was extraordinarily precocious. He appears on the scene in Haarlem as an accomplished artist in 1646 with a number of signed and dated paintings, drawings, and etchings. From the very beginning, his powerful originality is evident.

The appearance of his signature on works done when he was seventeen or eighteen years old is an indication of early recognition of his talent since, as we have already heard, the Haarlem painter's guild ran a closed shop. It did not permit anyone who was not a member to work independently in the town. Ordinarily, the guild did not admit candidates to membership until they had reached their twentieth birthday. Exceptions were made only for those who showed extraordinary promise.

The signatures on Ruisdael's works done in 1646 and 1647 (thirteen known ones bear the former date and sixteen are signed with the latter) are difficult to reconcile with the reference found in the list compiled by the Haarlem artist Vincent Laurensz van der Vinne (1629–1702) of the names of guild members. He notes that Ruisdael joined in 1648. Perhaps van der Vinne had reason to believe that Jacob was born in 1628 and assumed the date he cited on the basis of the guild's normal rule regarding membership age.

Merely a few of Ruisdael's earliest pictures corroborate the likely suggestion that he had close contact with his uncle Salomon van Ruysdael, at that time one of Haarlem's leading landscape painters and a respected member of its guild. Salomon was *vinder* of the guild in 1647 and its deacon in the following year. To judge from what is known of Salomon's large *oeuvre*, youthful Ruisdael's passion for drawing and etching was not derived from him; not a single drawing can be ascribed firmly to Salomon, and to our best knowledge he never made a print.

More decisive for Ruisdael's early artistic development was the influence of the tender mood and refined detail of Cornelis Vroom's landscapes. It is especially evident in Jacob's works of 1648 and 1649, and lingers on for a few more years. About that time Jacob was not alone in his admiration for Vroom. The historian and poet Theodorus Schrevelius wrote in his *Harlemum, sive Urbis Harlemensis*, a history of the town published in 1647, that among living Haarlem artists "who paint our fields, woods and forests the first place and palm of honor goes to Cornelis Vroom."

Salomon van Ruysdael had a son who also was called Jacob; he, too, became a landscape painter. Despite their different patronymics (Jacob Isaackszoon van Ruisdael: Jacob Salomonszoon van Ruysdael), the similarity of the names of the cousins has caused occasional confusion regarding the attribution of their landscapes, and Wijnman (1932) has shown that the persistent myth that Holland's foremost landscapist died penniless in Haarlem's Alms House is based on a muddle that has been made concerning facts related to the last years of their lives. The circumstances that brought Jacob, the son of Salomon, not Jacob, the son of Isaack, to the Alms House are described below.

A close relationship between the two families seems to have continued when the cousins were later in Amsterdam. In 1667 Ruisdael named his uncle and cousin as executors of his will, expressly releasing them from supervision by the public authorities as a token of his special confidence. In 1673 he was witness at the second marriage of his cousin who meanwhile had fallen upon bad times. Like many Dutch artists who had no market for their works, Jacob Salomonsz sought salvation in a second job, the menial trade of selling stockings in the Kalverstraat in Amsterdam.

It is evident from his landscapes that Ruisdael traveled during his youth and early maturity but his *Wanderlust* never took him very far from his native town. In the 1640s he visited Egmond aan Zee and investigated the countryside near Naarden, his father's birthplace. During the course of the following decade he visited other towns and sites not far from home: Alkmaar, the nearby ruins of a castle and abbey church at Egmond, and the Portuguese Jewish Cemetery at Ouderkerk on the Amstel River.

His most ambitious trip was made during the

early 1650s, when he toured in the border region between the eastern provinces of the Netherlands and western Germany, as is proved by his dated and datable pictures of Bentheim in Westphalia (see Cat. no. 12) and the water mills of Singraven in the province of Overijssel (see Cat. no. 22). He made the trip to Bentheim, which is only about 175 kilometers from Haarlem, with his friend and sometime collaborator Nicolaes Berchem, whose father, the prominent still life painter Pieter Claesz, was born in nearby Burgsteinfurt. On this tour Ruisdael most likely traveled south to the province of Utrecht where he visited Rhenen; this we can deduce from drawings at Leningrad and Berlin (see Cat. no. 69), which are stylistically attributable to these years. The scenery he saw on this trip was not particularly impressive (see Fig. 24). Yet he was able to use it as a starting point for a number of landscapes that show a marked increase in their heroic quality. It is during these years that his forms became larger and more massive and his trees acquired an unprecedented abundance and fullness.

Like virtually all of his landscapes, the specific market for which they were produced remains unknown. However, a couple of inventory references indicate that his early clientele was not restricted to his native town. An inventory made in 1653 of the stock of a deceased Amsterdam dealer lists "a landscape by the young Ruysdael with a tree trunk in the foreground" and "a small landscape by the same Ruysdael in an ebony frame." In the same year an inventory compiled in Leiden lists three of his paintings.

The year 1653 is a notable one for students of the artist's chronology; Ruisdael dated many of his pictures from 1646 until 1653, then he almost ceased the practice. The number of his landscapes that bear dates after 1653 until his death in 1682 can be counted on the fingers of one hand. Consequently, determination of the range and character of Ruisdael's expression from his early maturity until his final phase must be based primarily on the style of his works. Only in a few instances does the topographical evidence offered by his cityscapes (see Cat. nos. 56, 83, 92) or knowledge of the years during which the artists who added figures to his paintings were active (see Cat. nos. 35, 43) help establish the beginning or end of the period in which one of his works must be dated.

About 1656 or 1657 Ruisdael made the short eighteen-kilometer move from Haarlem to Amsterdam where he remained for the rest of his life, except perhaps for his stay in Caen. His residence in Amsterdam is documented by 14 June 1657. A notice bearing that date in the records of the Reformed Church of the city informs us that Ruisdael, then living at the "Silvere Trompet" on the Beursstraat, near the Dam, announced his intention to be baptized into the Reformed Church. The baptism took place a week later at the village of Ankerveen, near Naarden. Jacob's religion before his baptism, as well as his father's religion, are unknown. Since his paternal grandfather, his uncle Salomon, and his cousin Jacob Salomonsz were Mennonites, it is probable that he also was a member of the sect.

On 15 June 1659 he purchased citizen's rights in Amsterdam. In the following year, young Meindert Hobbema, who was also a resident there, received a testimonial from Ruisdael. It stated that he had a good character and had "served and learned" (*gedient en geleert*) with him for several years. The master and his gifted and only documented pupil evidently remained close friends; Ruisdael served as a witness at Hobbema's marriage at Amsterdam in 1668.

Ruisdael presumably moved to Amsterdam because the richest and largest city of the new republic offered far better prospects than the town of Haarlem. Although precise statistics for Dutch cities and towns during the course of the seventeenth century are not available, some reasonable estimates can be made. A conservative one of Amsterdam's population in 1625 places it at slightly more than 100,000; by 1650 its population had exploded to about 200,000. According to a census made at Haarlem, 39,455 people lived within its walls in 1622. The population of Haarlem also grew during the century, but never at Amsterdam's rate. Other Haarlem landscapists, including Allart van Everdingen and Ruisdael's cousin Jacob Salomonsz, moved to Amsterdam too; Everdingen shortly before Ruisdael (1652) and Jacob Salomonsz rather later (1666).

Apparently Ruisdael was sensitive to the demands of Amsterdam's thriving art market. His enormous and sometimes routine production of Scandinavian waterfalls, which begins not long after he settled in the metropolis, is best explained by his desire to capitalize on the vogue that Allart

van Everdingen had established for them there. The high regard for Everdingen's waterfalls can be seen from the appraisal of one in the inventory of an Amsterdam collector in 1669; it was valued at 60 guilders, about three times the average price of the other pictures in the collection. We can tell from the same inventory that Ruisdael already had earned a reputation with his depictions of the theme and that they were more highly prized than one of his other landscapes. Ruisdael was represented by no fewer than three waterfalls valued at the respectable sums of thirty-six, forty-two, and again forty-two guilders. The collection contained yet another painting by Jacob which was described by the appraisers as *"een Haerlempje van Ruysdael"* (a view of Haarlem by Ruisdael). It was appraised at the middling sum of twenty-four guilders.

Ruisdael's earliest biographer, Houbraken, likewise placed particular value on his waterfalls, singling them out for special praise:

> He painted native and foreign landscapes, particularly those in which water was to be seen falling from one to another rock to end noisily—as his name seems to intimate—tumbling down or spraying out. He could portray water splashing or foaming as it dashed on the surrounding rocks so naturally, tenderly and transparently, that it seems to be real water.

The only other theme that Houbraken mentions in his notice are Jacob's seascapes:

> He also understood how to paint the sea when he wanted to depict stormy waters on a panel, as they pound against cliffs and dunes with the force of the surging waves, so that he was the best at this subject.

Ruisdael also did his bit to help satisfy the enormous demand for topographical views that blossomed in Amsterdam about 1660 by making six drawings (see Cat. no. 83) of sites near the city's old ramparts before its dramatic extension began in 1663–64. The prolific Amsterdam printmaker, Abraham Blooteling, produced etched copies of them, and in 1670 he engraved copies of Ruisdael's drawings of the Portuguese Jewish Cemetery at Ouderkerk (see Cat. nos. 76, 77).

Jacob acquired a sufficient reputation in Amsterdam to be called as a young expert together with three older artists in 1661 to authenticate a painting. (At this hearing he testified he was thirty-two years old, thereby providing us with the one and only source for the year of his birth.) The picture in question was a shore scene with cliffs and figures, which the plaintiff had bought as a Jan Porcellis from a dealer in Delft, and which he contested was not autograph. Barent Kleeneknecht, as first expert, declared that probably almost the whole picture was painted by Henrick van Antonissen, the brother-in-law and pupil of Porcellis. Allart van Everdingen maintained that Porcellis at most had done something to the cliffs. The eminent still life painter Willem Kalf was less optimistic. He concluded that the picture had nothing to do either in detail or in general with Porcellis' paintings. In Ruisdael's opinion Porcellis had perhaps begun it, but in its present condition it must not be sold as his work. Evidently he found the picture so heavily damaged or repainted that it could no longer qualify as an original. Hobbema signed the document as one of the witnesses.

The alleged Porcellis obviously was not on the borderline. All of the experts agreed it was not authentic. However, there was no consensus regarding an alternate attribution. To contemporary students who attempt to determine the authorship of Dutch paintings done more than three centuries ago, the case is a humbling one. What are our chances of finding definitive attributions for marginal works if four specialists who had knowledge of the art scene of their time which we can never match failed to agree upon one? But students of our day also can find a measure of comfort in the affair. It is consoling to learn that some experts of the period shared our frequent inability to give firm names to substandard works.

It is not known if the question of authenticity of works attributed to Ruisdael posed any problems for his contemporaries. However, a reference in an inventory made in 1687 of the estate of an Amsterdam art dealer to "a waterfall in the manner of Ruisdael" indicated that at least one seventeenth-century specialist was prepared to distinguish an original landscape by the artist from one done in his style. Citation of an imitation of one of his waterfalls in an inventory compiled only five years after the artist's death is yet another indication of

the popularity of his paintings of the subject.

Thanks to Houbraken, an early imitator of the master can be identified. He writes that the landscapist Jan Griffier the Elder (c. 1645–1718) was able to imitate Jacob's style so successfully that some of the paintings he did in his manner were sold as genuine works by Ruisdael. Houbraken does not state when Griffier made his imitations (before he moved from Amsterdam to London about 1667; when he was in Rotterdam about 1695–1705; or during his last years after he returned to England). It seems that imitating Ruisdael became a specialty of the Griffier family. According to J. van Gool (1751), Robert Griffier (1668–c. 1760), the son of Jan the Elder, also was able to deceive experts with the pictures he did in Ruisdael's style; like his father he was active in both Holland and England. None of the imitations done by Jan Griffier or his son Robert have been identified.

Van Gool also tells us that Robert Griffier had another tricky talent; he could populate his deceptions of Ruisdael's landscapes with figures and horses that passed as staffage painted by Philips Wouwerman. His effort to simulate Wouwerman's figures suggests that in his day a painting by Ruisdael was valued more highly if it was embellished by Haarlem's popular painter of little pictures of outdoor life that almost always include horses. Whether this was indeed the case in his or in earlier times are questions that must be left open. It is evident, however, that Ruisdael sometimes called upon Wouwerman as well as upon Nicolaes Berchem, Adriaen van de Velde, Johannes Lingelbach, and Gerard van Battem to supply staffage for his landscapes.

On one occasion Ruisdael collaborated with a portrait specialist. The large conversation piece, now at Dublin, of the powerful and extremely wealthy Amsterdam burgomaster Cornelis de Graeff, Lord of Zuidpolsbroek, and members of his family arriving at his country estate at Soestdijk (Fig. 5) is a collaborative effort by Jacob and Thomas de Keyser. Ruisdael depicted the landscape and the villa; de Keyser painted the figures, animals, and richly appointed carriage.

The painting, which is datable about 1660, could be used to illustrate the poem Joost van den Vondel, the preëminent seventeenth-century Dutch poet, included with his verse translation of Virgil's *Aeneid*, which he dedicated to Cornelis de Graeff and published in 1660. Vondel wrote that the burgomaster sought welcome relaxation in Soestdijk's bucolic setting after slaving day and night at the service of his city and country in Amsterdam's Town Hall. Vondel did not exaggerate. De Graeff's burden was a heavy one. During the last decades of his life he was the guiding political force in Amsterdam and the advisor and confidant of Johan de Witt, Holland's leading statesman. He also was one of the city's most devoted citizens and benefactors. He helped plan the program and select the architect for Amsterdam's new Town Hall, and he gave financial support for its construction. The inscription on the panel that commemorates the laying of the cornerstone of the Town Hall, the greatest building erected in the United Provinces during the seventeenth century, was composed by him.

Special note is made of Cornelis de Graeff here because he is the artist's only patron whose name can be linked firmly to one of his existing works. Admittedly, the lion's share of the de Graeff commission was certainly Thomas de Keyser's, and Jacob's contribution to it does not rank as one of his major achievements. Moreover, the painting is exceptional in Ruisdael's *oeuvre*. Apparently painting landscape backgrounds for professional portraitists did not suit his temperament. Apart from a reference in a 1742 sale catalogue to the background he painted for an untraceable portrait by Bartholomeus van der Helst, there is no indication that he did more of this kind of bread-and-butter work.

A household record of the de Graeff family is also interesting because it provides the only documented source of the intent of some of Ruisdael's landscapes. Two of them are listed in a posthumous inventory compiled in 1709 of the effects of Cornelis de Graeff's son Pieter (he is the horseman directly behind the carriage in the Dublin painting; his younger brother Jacob is the horseman following him):

a painting of Zuidpolsbroek by Jacob Ruisdael f 36.
a ditto of Soestdijk f 36.

Most probably the latter entry does not refer to the Dublin painting of de Graeff arriving with

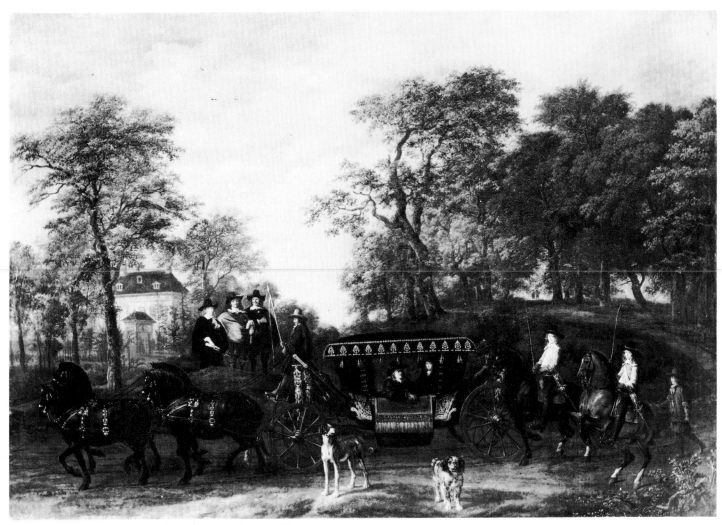

Fig. 5. Jacob van Ruisdael and Thomas de Keyser, The Arrival of Cornelis de Graeff and Members of his Family at Soestdijk, his Country Estate. *Dublin, Courtesy of the National Gallery of Ireland.*

members of his family at his estate at Soestdijk. It is hardly likely that the compiler, who identifies virtually all the subjects of the portraits listed in the 1709 inventory, would have failed to note that the painting includes a portrait of the deceased owner, his brother, and his parents, not to mention de Keyser's other models. It is also unlikely that the compiler would have failed to cite the name of the well-known artist who painted the portraits. He was surely familiar with Thomas de Keyser's name; his inventory includes a reference to "two portraits, one of Pieter de Graeff and the other of Jacob de Graeff, both done by Thomas Keyser." Since Cornelis de Graeff did not have a large house on his segniory (*Heerlijkheid*) at Zuid-

polsbroek, it is safe to conclude that the Dublin picture is not identical with the reference in the 1709 inventory to "a painting of Zuidpolsbroek by Jacob Ruisdael."

In short, the references in the 1709 inventory indicate that an owner of landed estates had one or two views of his properties that were painted by Ruisdael. These references to two of Jacob's unidentifiable or lost paintings offer a rare clue to one kind of commission the artist received. Although we can only guess at how many of Ruisdael's landscapes, or those done by other Dutch artists, were commissioned as portrayals of specific sites in the countryside, it is evident that the de Graeff family had a penchant for views of this

type. In addition to the two by Ruisdael, Pieter de Graeff's 1709 inventory lists two by Isaac de Moucheron (1667–1744):

a painting of the segniory and court of Ilpendam by young Moucheron f 20.

a ditto of the segniory of Zuidpolsbroek f 40.

The appraisal of thirty-six florins given to each of Ruisdael's landscapes in the inventory of 1709 is consistent with prices assigned to his works while the artist was still alive. Each one of them was valued higher than Frans Hals' *Nurse and Child*, which also appeared in the inventory and is most probably identical with his famous painting now at Berlin. Hals' double portrait was valued at thirty florins.

To our best knowledge, Ruisdael was never rich, but his economic situation does not seem to have been as bad as has been assumed by some of his early biographers. The appraisals that were made of his paintings, as mentioned before, were respectable and were far from being in the lowest range. One more can be cited; sixty guilders was the appraisal given to "a large landscape" by Ruisdael in an inventory made in 1664. It was the highest price cited in the list. Other valuations ranged from twelve to forty-two guilders; the inventory included works by Meindert Hobbema, Jan van der Heyden, Jan Wynants, Willem van de Velde, Claes Molenaer, and Abraham Beerstraaten.

That he was able to provide for his father is known both from his father's will (11 April 1668), in which the father left his son sole inheritor of all his possessions "in repayment of the sums which his son has lent him," and from Ruisdael's two wills of 23 and 27 May 1667. On 23 May he designated his half-sister Maria van Ruisdael as sole heiress on condition that she pay the statutory portion to her father and that he have the usufruct of the estate during his lifetime. A few days later, on 27 May, he retracted his first will and made his father direct heir. The usufruct of the capital was to be supervised by his uncle Salomon and his cousin Jacob Salomonsz whom he appointed as executors. The money was to be invested and his father to have the interest. If the interest was insufficient for his father's support, he was first to receive the entailed portion of the capital and then the regular interest on the remaining capital. He also stipulated that, if his father should be in difficulties or become ill, the executors were to lodge him in a decent place (*"op een civiele plaetsen"*) and pay his expenses until the end of his life. In this will his half-sister was not considered until after the death of their father.

Ruisdael is described in both wills as "a bachelor, living in the Kalverstraat across from the 'Hof van Holland,' sick in body, but in possession of his physical and mental faculties." His sickness probably explains why he thought it possible that his father would survive him, though he himself was scarcely forty years old. Nothing is known about the nature of his illness, but clearly it did not affect his creativity. There is no noticeable decline in his paintings of the late 1660s. On the contrary, during these years he painted some of his most heroic and personal landscapes.

For a long time it was thought that toward the end of his life Ruisdael was put in the Alms House at Haarlem and died there a pauper, circumstances that seemed to be confirmed by Houbraken's melancholy note that he "could find no hint that fortune was his friend." But Wijnman (1932) has shown that this was an error due to a confusion with his cousin Jacob Salomonsz van Ruysdael who did die there. Jacob Salomonsz went insane and was brought by his Mennonite brethren from Amsterdam to Haarlem, where he was confined to the town's Alm House on 28 October 1681. His confinement was not a long one. He died there on 13 November 1681.

From about 1670 Ruisdael lived on the south side of the Dam in Amsterdam above a shop kept by the book and art dealer Hieronymous Sweerts who published some of the artist's etchings. Jacob's flat on the great square must have suited him splendidly. It provided him with northern light as well as with a view of the airy expanse of the city's principal square as seen in his painting and drawing of the site done in the seventies (Cat. nos. 55, 93).

Ruisdael most likely died in Amsterdam on or about 10 March 1682. His body was sent to Haarlem, where a grave was opened for it on 14 March at St. Bavo, the great church that he depicted so often in his majestic panoramic views of his native town.

The artist did not die rich. His name does not appear in the register of death duties levied by the

authorities of Amsterdam upon the estate of a citizen who died without direct descendents. Its absence indicates that he possessed neither real estate nor securities at the time of his death. However, he earned his bread, and probably a bit more, during his last years. His landscapes continued to be appraised at fair prices until the end. He earned enough to be assessed the special "200th penny tax" the city levied on its citizens in 1674 to help pay for the costly war that drove Louis XIV from the gates of Amsterdam in 1672. The tax of ½% was demanded only from citizens whose effects were worth more than 1000 guilders. Jacob paid 10 guiders, an indication that his possessions were appraised at 2000 guilders. We have already noted that he was able to lend Dr. Jan Baptist van Lamsweerde 400 guilders in 1678 and that his debtor proved to be a bad risk. On 21 January 1682, less than two months before his death, Ruisdael brought suit in Amsterdam against Dr. van Lamsweerde and had him distrained of his goods because he had not paid the required interest. To his half-sister Maria, who had married meanwhile, Ruisdael bequeathed the note of the debt as a legacy in the form of a letter of credit for which she was paid 150 guilders.

Manifold aspects of the legacy Ruisdael bequeathed to us are discussed in the following pages. In making a selection from his numerous paintings and drawings, which are now scattered on five continents, an effort has been made to show the breadth of his production by representing every type of landscape he depicted. The paintings and drawings have been arranged in an approximate chronological order and range from the astonishingly precocious ones he produced from about 1646 to the works of his very last phase. Ruisdael's limited activity as an etcher was confined to the first decade of his career. Impressions of all the prints he produced during these years are discussed in the final section of the catalogue.

SEYMOUR SLIVE

Paintings

Landscape with a Cottage

1

Hamburg, Kunsthalle (no. 159)
Panel, 71.8 x 101 cm. Signed and dated
1646, lower left.

PROVENANCE: J. Amsinck, Hamburg,
who bequeathed it to the Kunsthalle,
1879.

BIBLIOGRAPHY: A. Bredius, Zeit-
schrift für bildende Kunst, N.F. 1,
1890, p. 191 (staffage by Berchem); HdG
806 (staffage by Berchem); Ros 503
(staffage by Berchem); Simon 1930, p. 15
(staffage by Berchem); Kunsthalle,
Hamburg, Catalogue, 1956, no. 159;
Schaar 1958, p. 36, note 32.

The year 1646 has a particular claim as Ruisdael's *annus mirabilis*. It is the year when the seventeen- or eighteen-year-old youth appears on the scene in Haarlem as an accomplished master with a large group of dated landscapes (thirteen have been identified), many of which are sharply distinct from those done by older artists or his contemporaries. Merely a handful of his works can be tentatively dated a bit earlier (c. 1645/46) on the basis of their style; some drawings in the "Dresden Sketch Book" (see Cat. no. 57) and Jacob's three tiny oval etchings (Cat. nos. 98–100) may belong to this category.

Among Ruisdael's precocious works of 1646, the Hamburg landscape near dunes with a modest cottage and a ruined plank outhouse takes a special place. It already has the unmitigated density of vegetation that remains characteristic of so many of his paintings; his ardor for nature is expressed repeatedly by a massive crowding of closely packed trees and thick undergrowth. To judge from the astonishingly accurate portrayal of the blasted pol- lard willow, the blooming elder bush, and the oak tree in the painting, young Jacob must have made many drawings of the structure and epidermis of individual trees and shrubs that worked toward that almost microscopic attention to detail found in Dürer's famous watercolors of grasses, ferns, and wild flowers. But if he did, none of them have survived.

The figures and animals in the picture, which have partly disappeared through cleaning, have been traditionally attributed to Nicolaes Berchem. Eckhard Schaar (*op. cit.*), who has made a close study of Berchem's work, disputes this attribution and sees no reason why they should not be ascribed to Ruisdael himself. His suggestion is not unreasonable. The staffage in a similar painting of a farmstead virtually hidden by trees and a thicket, also signed and dated 1646, is most likely by the same hand (Fig. 6; canvas, 74.3 x 106 cm; Major Simon Whitbread, Southill, Biggleswade). For landscapes with figures and animals indisputably by Berchem, see Fig. 1 and Cat. no. 16.

Fig. 6. Jacob van Ruisdael, Landscape with Cottages, Dunes, and Willows, 1646. Southill, Biggleswade, Major Simon Whitbread.

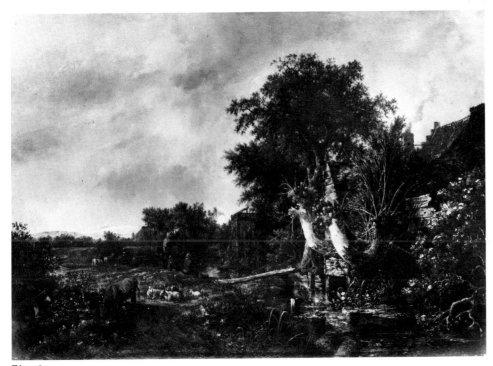

Fig. 6

View of Egmond aan Zee

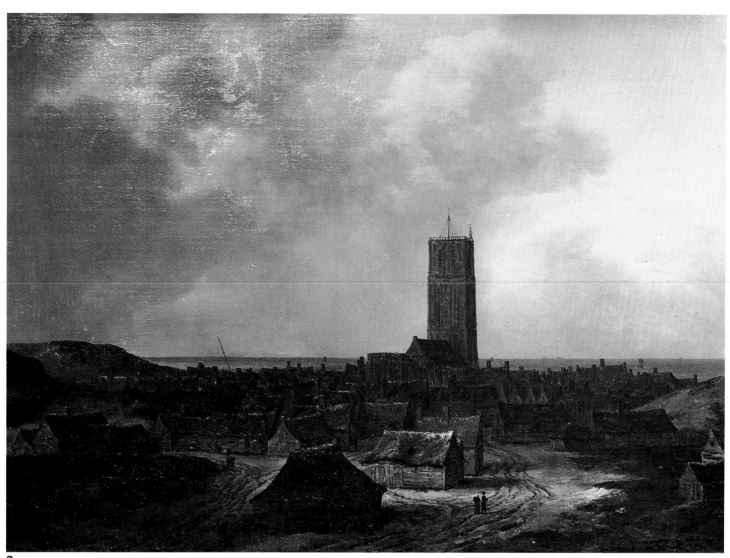

2

*Eindhoven, The Heirs of Mr. and Mrs.
Philips-de Jongh*
*Canvas, 96 x 132 cm. Signed and dated
1646, lower left.*

*PROVENANCE: Dealer J. Boehler,
Munich; A.F. Philips, Eindhoven.*

*EXHIBITIONS: Paris 1921, no. 89;
Eindhoven 1937, no. 23; Eindhoven
1948, no. 58, repr.*

*BIBLIOGRAPHY: Ros 29; Stechow
1966, p. 105; Bol 1973, p. 279f.*

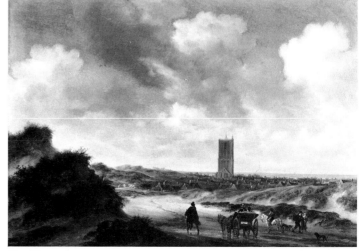

Fig. 7

Another of the outstanding works that Ruisdael signed and dated in 1646 is this *View of Edmond aan Zee*. Admittedly the theme is not an original one. The motif of a village nestled between dunes seen against a high, pale sky can be found in works by earlier Dutch landscapists, but young Jacob transformed the subject by tightening and heightening their style. The straggling village, with its crowded plank houses, is seen close up from an elevated point of view, while a new monumental effect is realized by his emphasis on the central motif, the square church tower that soars above the modest village and the dominating horizon of the sea.

Comparison of the Philips picture with Salomon van Ruysdael's painting of the same subject at the Staatsgalerie, Stuttgart (Fig. 7; no. 2714; panel, 45.5 x 65 cm) suggests that young Jacob derived this early view of Egmond aan Zee by extrapolating and then vastly enlarging the pertinent part of his uncle's picture. The date of 1640, which formerly was read on Salomon's painting, appeared to confirm this impression. However, since Wolfgang Stechow questioned the authenticity of both the date and monogram on the Stuttgart picture and noted that its style places it with Salomon's works of the early 1660s, it has been difficult to maintain that the older artist's treatment of the subject had an impact on his nephew (see Stechow 1966, p. 206, note 24 and Stechow 1975, no. 268; a recent firsthand inspection of the painting revealed that it certainly is not dated 1640; the last digit of the date has been completely obliterated; solubility tests have not yet been made on what remains of the date and monogram). In this case, there is excellent reason to conclude that the nephew influenced his uncle and that Salomon's reaction to young Jacob's remarkable achievement was a delayed one. It is noteworthy that Salomon's painting of the *Beach at Egmond aan Zee* dated 1652 (with the dealer Bottenwieser, Berlin, 1928; Stechow 1975, no. 269, photo R.K.D.) bears no connection to Jacob's work. Only when we turn to the Stuttgart picture or to Salomon's *Egmond aan Zee* (Dienst Verspreide Rijkscollecties, The Hague; Stechow 1975, no. 279, photo R.K.D.), which also is datable to the 1660s, can a relation between the treatments of the theme by the older artist and the younger be seen.

In the Philips Collection there is another large, close-up *View of Egmond* by Jacob, which shows the village from the beach (Fig. 8; canvas, 87 x 130.5 cm; possibly identical with HdG 52; Ros 58); it probably was painted about the same time as the present picture. The horizontal format he employed for these works was used again for his views of Egmond, done a few years later, which are now at Stockholm (no. NM 618; HdG 50; Ros 33) and Glasgow (no. 34; HdG 47; Ros 31; both authors state the Glasgow painting is dated 1655, but today the date is illegible). For Jacob's other views of Egmond see Cat. no. 7. The prominent tower of the village's church also appears in Ruisdael's beachscape at the National Gallery, London (Fig. 58). In Ruisdael's time the choir of the church was already a ruin. The church no longer exists; its last remains fell in 1743 (see van der Aa 1843, IV, p. 85).

Fig. 7. Salomon van Ruysdael, View of Egmond aan Zee. *Stuttgart, Staatsgalerie.*

Fig. 8. Jacob van Ruisdael, View of Egmond aan Zee. *Eindhoven, The Heirs of Mr. and Mrs. Philips-de Jongh.*

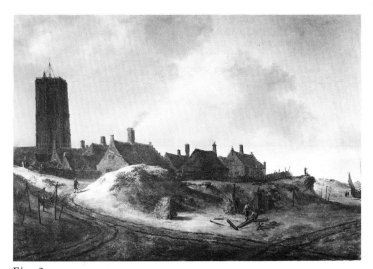

Fig. 8

Dune Landscape

The subject of the Leningrad painting does not come as a surprise. It was as natural for a young artist eager to make a mark as a landscapist in Haarlem in 1646 to paint a view of a modest cottage surrounded by a clump of trees and set near a road winding through an expanse of sand dunes as it was for one of his contemporaries who wanted to establish a reputation as a still life painter to depict a table top bearing, at least, a loaf of bread, a drinking glass, a piece of cheese, and a herring. These themes had been staple items in the repertoires of Haarlem artists for more than a generation, and, to judge from the quantity that still was produced in the 1640s, the demand for them remained strong. Young Ruisdael did his share to satisfy the call for dunescapes. His prodigious early output, from the time we first recognize his hand until he left his native town about 1650 for his *Wanderjahre* in the Dutch-German border region, includes many themes; however, dunescapes were his favorite subject during this phase.

As in Jacob's other incunabula, the Leningrad picture shows the astonishing velocity with which he gave novel effects to a traditional scheme. By 1646 both Salomon van Ruysdael and Jan van Goyen had produced numerous broad views of dunes with a house crowded by trees set on an elevation in the middle ground and distant vistas on either side of the main motif. New in the Leningrad painting is the greater solidity Ruisdael gives to the large dominating tree group and the way it stands out forcibly against the sky. The large concentration of strong light on the sandy road introduces an unusually emphatic contrast in the foremost plane, where the grainy paint and rugged touch characteristic of Jacob's works done in the forties and fifties is particularly evident. The large size of the canvas also is exceptional; it is an index of the youthful artist's ambition.

In the painting a solitary traveler is seated at the side of the road. Some viewers may conclude he is contemplating the quiet mood of the simple scene. Others may believe he is studying the changes Ruisdael has introduced to the well-known theme. But no one, apart from K.E. Simon (*op. cit.*, 1935, p. 189; *op. cit.*, B.M. 1935, p. 17) has argued that the seated figure as well as the smaller ones in the background were added to the landscape by Isaack, the artist's father. Simon's proposal is improbable.

A smaller, autograph version of the Leningrad dunescape, also signed and dated 1646, is at the Gouverneurs Huis, Paramaribo, Surinam (Fig. 9; panel, 68.8 x 87.5 cm; possibly identical with HdG 143; Ros 534; wrongly dated 1645 in R. Fritz, *Sammlung Becker, Gemälde alter Meister*, Dortmund, 1967, no. 80; the painting was given to Surinam by the Dutch government in 1975). It is salutary for our age, which finds a high correlation between the uniqueness of a work of art and its aesthetic value, to be reminded that from the very beginning of his career an artist of Ruisdael's creative power was prepared to make two versions of the same composition with only minor changes. During his early years he also painted variants with more significant alterations. For a discussion of one based on a dunescape he painted in the following year, see Cat. no. 5.

3

Fig. 9

*Leningrad, Hermitage (no. 939)
Canvas, 105.5 x 163 cm. Signed and
dated 1646, right center near the bottom.*

*PROVENANCE: Acquired for the Her-
mitage, 1859.*

*BIBLIOGRAPHY: HdG 895; Ros 552;
Simon 1935, p. 189 (staffage by Isaack
van Ruisdael); Simon B.M. 1935, p. 17
(staffage by Isaack van Ruisdael);
Hermitage, Leningrad, Catalogue, 1958,
p. 246, no. 939.*

*Fig. 9. Jacob van Ruisdael, Dune Land-
scape, 1646. Paramaribo, Surinam,
Gouverneurs Huis.*

An Oak Tree and Dense Shrubbery at the Edge of a Pond

When Felix Young, the good-natured artist in Henry James' *The Europeans*, took his sister, the Baroness Eugenia Silberstadt Schreckenstadt, for her first drive through the New England countryside, he remarked "that it was apparently a country in which the foreground was inferior to the *plans reculés*." Young Ruisdael saw the countryside around his native Haarlem through quite different eyes. For him foregrounds were almost always paramount, and in his early works such as this close view of a sharply lit, battered oak engulfed by dense undergrowth near the edge of a pond, or the unique impression at the British Museum of his small etching of a similar subject (Cat. no. 101), distant views have been eliminated completely.

Jacob's innate acuteness as a draughtsman, which invariably is seen to some extent in his paintings, is particularly evident here in his depiction of the tangled growth in the light area near the edge of the still pond. Equally remarkable is his expressive portrait of the half-barren, blasted oak. The birds were most probably done by another hand. T. Frimmel (*op. cit.*) attributed them to Dirck Wijntrack (before 1625–87), a painter who specialized in birds, particularly ducks.

Agnes Czobor (*op. cit.*) mentions that the old tree trunk and owl in the tree allude to the mortality of life. Iouryi Kouznetsov (*op. cit.*, p. 39), who is well aware of the many symbolic meanings that have been assigned to trees since ancient times, proposes that, in this case, the tree symbolizes fragility and corruptibility. Kouznetsov further writes that the owl perched on a broken limb of the tree is being attacked by two small birds. This motif,

he adds, traditionally alludes to strife and hate in the world, and it may have this meaning in Ruisdael's painting. The best-known treatments of this theme are found in Hieronymus Bosch's drawings. (For a discussion of the iconography of the motif in Bosch's time that centers on the well-known drawing of *Owls in a Tree* at the Boymans–van Beuningen Museum, see Jakob Rosenberg, "On the Meaning of a Bosch Drawing," *De Artibus Opuscula XL, Essays in Honor of Erwin Panofsky*, ed. Millard Meiss, vol. I, New York, 1961, pp. 422ff.) It is difficult to accept Kouznetsov's interpretations because it is not clear if the two little birds are indeed attacking the owl. The case for their attack is not strengthened by the presence of two other air-borne small birds, who are oblivious to it. Kouznetsov does not insist upon the point. He notes that the owl may allude to the *vanitas* theme, as Czobor suggests, or to *melancholia*. He further proposes that the owl and other birds may have been added to the painting by one of Ruisdael's contemporaries without the artist's knowledge to give the landscape added meaning.

The symbolic possibilities for battered trees and owls can be enlarged upon. Whether Ruisdael himself intended them to have one of the multitudinous meanings that has been assigned to them since the tree of life and tree of knowledge appeared in the garden of Eden and Athena appeared in Athens with her owl remains moot.

There is a copy of the painting by the Biedermeier painter Ferdinand Georg Waldmüller (1798–1865) at the Landesmuseum, Graz (no. 587; panel, 64.5 x 48 cm).

Budapest, Museum of Fine Arts (no. 263)
Panel, 66 x 48.9 cm.

PROVENANCE: *Collection Esterházy.*

BIBLIOGRAPHY: Catalog der Gemählde-Gallerie des durchlauchtigen Fürsten Esterházy von Galantha zu Laxenburg bey Wien, *1812, VIII, no. 9; T. Frimmel,* Kleine Galeriestudien, *vol. I, Bamberg, 1892, p. 173; Ros 279a; A. Pigler,* Katalog der Galerie Alter Meister, *Budapest, 1967, p. 601f., inv. no. 263; Ágnes Czobor,* Dutch Landscapes, *Budapest, 1967, no. 23; Kouznetsov 1973, pp. 35ff.*

Etched by Friedrich Loos (1797–1890).

4

Dune Landscape near Haarlem

5

Paris, Baroness Gabriele Bentinck (on loan to Kunstmuseum, Düsseldorf, no. D27/70)
Panel, 66.7 x 88.2 cm. Signed and dated 1647, lower right.

PROVENANCE: *G. Wilbraham, London, 1835; sale, George Wilbraham, Delamere House, Northwich, Cheshire, at London (Christie's), 18 July 1930, no. 32 (Goudstikker); dealer J. Goudstikker, Amsterdam, Cat. no. 39, 1930–31, no. 63; Heinrich Baron Thyssen-Bornemisza, Lugano-Castagnola; by descent to Baroness Gabriele Bentinck, Paris.*

EXHIBITIONS: *London, British Institution, 1838, no. 135; Paris 1970, no. 37, repr.; Düsseldorf 1970–71, no. 45; Bielefeld, Kunsthalle,* Landschaft aus vier Jahrhunderten aus dem Kunstmuseum Düsseldorf, *1973, no. 8.*

BIBLIOGRAPHY: *Smith 134; HdG 910; Schloss Rohoncz, Lugano-Castagnola, Catalogue, 1937, p. 134, no. 365; Kunstmuseum, Düsseldorf,* Malerei, Ausgewählte Werke, *I, 1976, no. 8, no. D27/70.*

Fig. 10

Fig. 11

Despite their novel features, the two versions of the dunescape that Ruisdael painted in 1646 (see Cat. no. 3) are still redolent of those done by an older generation of Dutch artists. The Bentinck picture, painted only one year later, is not. It is an outstanding example of young Ruisdael's tendency to enlarge a detail of nature into a central motif in a spacious setting. Here he concentrates on the scrubby, dense growth along a curved sandy road that culminates in the clump of trees dramatically thrusting across the sky. An original spatial tension is created between near and far by the juxtaposition of the closely seen brambles, bushes, and trees and the convincing impression of the distant field and view of Haarlem beyond it.

It has not been noticed in the literature that Ruisdael's celebrated dunescape at the Louvre, popularly known as *Le Buisson* (Fig. 10; no. 1819; canvas, 66 x 80 cm; HdG 890, possibly identical with HdG 901d; Ros 557), is a version of the Bentinck painting. Jakob Rosenberg, who did not know the Bentinck dunescape when he published his monograph on Ruisdael, observed that *Le Buisson* is datable to about 1647 (Rosenberg 1928, p. 17) because it belongs by analogy with a closely similar dunescape in the Bayerische Staatsgemäldesammlungen, Munich, dated 16[4]7 (no. 1022; HdG 889, possibly identical with HdG 904c; Ros 556). Reappearance of the Bentinck variant of 1647 virtually clinches the date Rosenberg assigned to *Le Buisson* on the basis of its style.

We have seen that, apart from their scale, the differences between the two versions that Ruisdael painted of his 1646 dunescape are negligible (Cat. no. 3). Apparently he had achieved the effect he desired in whichever painting was the first version and was prepared to repeat it with only minor alterations. A close look at the Bentinck and Louvre variants tells another story. In *Le Buisson* the effect of the distant view of Haarlem is greater, loose elements are suppressed, the tree that has been planted on the dune at the right now makes the curving road cut a gash through the landscape, and most important, the main motif, the group of trees that thrusts out of the landscape, is far greater in size, density, and weight.

In 1844, Thoré-Bürger, the leading nineteenth-century champion of the "*naïfs et modestes*" masters of seventeenth-century Dutch art, cited Ruisdael's *Le Buisson* as a work that may appear to be merely a transcription of a scene from nature but is, in fact, the result of the same kind of intense intellectual effort that masters of "composed landscapes" (Poussin, Gaspard Dughet, and members of their school) put into their work (T. Thoré-Bürger, *Le Salon de 1844 . . .* , Paris, 1844, pp. 49–52; for further discussion of the appraisal Thoré-Bürger and his contemporaries made of the "*petits maîtres*" of the Low Countries, see Frances Suzman Jowell, *Thoré-Bürger and the Art of the Past*, New York and London, 1977, pp. 144ff.).

If Thoré-Bürger's argument needs more support, the differences in cohesion and monumental effect between the Bentinck and Louvre pictures help provide it. The changes result from thought and analysis, not mindless replication of nature or a painting.

The staffage in both versions is by Ruisdael. The suggestion that perhaps the figures in *Le Buisson* were added by Adriaen van de Velde (Louvre, Catalogue, 1979, p. 123, no. INV. 1819) unnecessarily complicates matters. Not only are they dissimilar to his figures, but Adriaen, who was born in 1636, was about eleven years old when the work was painted.

A third version, which I know only from a photo, is now in an English private collection (Fig. 11; canvas, 48.3 x 64.7 cm; sale, Duke of Leeds, London [Sotheby], 14 June 1961, no. 28; dealer Duits, London; exhibited Barrow Art Gallery, *Old Masters from Jersey Collections* [Arts Council Exhibition], 1952, no. 41). It employs the dense clump of trees that figures in the Louvre variant, but makes it much squatter. The accents of light in this variant do not appear to be as sharp or gathered as effectively as they are in the other two versions.

A copy of *Le Buisson* is in the Aukland Art Gallery, New Zealand (62 x 74 cm).

Fig. 10. Jacob van Ruisdael, Dune Landscape near Haarlem (Le Buisson). *Paris, Musée du Louvre.*

Fig. 11. Jacob van Ruisdael, Dune Landscape near Haarlem. *England, private collection.*

View of Naarden and the Church at Muiderberg

6

Lugano-Castagnola, Switzerland,
Thyssen-Bornemisza Collection
Panel, 34.7 x 66.5 cm. Signed and dated
1647, lower left.

PROVENANCE: Duke of Westminster;
Lady Theodora Guest; dealer Matthiesen,
Berlin, 1928; acquired for the Schloss
Rohoncz Collection by 1928.

EXHIBITIONS: London 1929, no. 190;
Düsseldorf 1929, no. 57; Munich 1930,
no. 283, repr.; Rotterdam-Essen 1959–
60, no. 92, repr.; London 1961, no. 95.

BIBLIOGRAPHY: Ros 73; C. Linfert,
"Eine Landschaft des Haarlemer Vermeer
im Wallraf-Richartz-Museum zu Köln,"
Kunstchronik und Kunstliteratur,
appendix to Zeitschrift für bildende
Kunst, January 1930, pp. 113–14;
Gerson 1934, p. 79, repr.; Simon 1935,
p. 191; Gerson 1936, p. 19; Schloss
Rohoncz, Lugano, Catalogue, 1937, no.
364, repr.; ibid., 1958, no. 364; Stechow
1966, pp. 42, 45, repr.; The Thyssen-
Bornemisza Collection, Catalogue of
the Paintings, Castagnola-Ticino,
1969, p. 295, no. 296, repr.

Fig. 12

Although it is possible to recognize a presage of Ruisdael's brilliant panoramas in the *View of Egmond aan Zee* painted in 1646 (Cat. no. 2), this picture, done only one year later, takes pride of place as Jacob's earliest existing flat landscape, a theme that he later took up for some of his most original and impressive pictures. It is also his only existing dated paroramic view. (The *View of the Dunes near Haarlem* [HdG 79; Ros 66], also in the Thyssen Collection, is said to be monogrammed and dated 1660 in the 1969 catalogue of that collection [*op. cit.*, p. 269, no. 27, repr.], but a technical examination of the painting made in 1971 revealed that it is neither signed nor dated.)

The panoramic view belonged to the repertoire of Dutch landscapists since the beginning of the century. The main stages of its development are marked by Goltzius' prophetic drawings of flat landscapes, by Hercules Segers' rare prints and even rarer paintings, and by works of Jan van Goyen and Philips Koninck. In his *View of Naarden* Ruisdael shows his debt to earlier artists in the low, oblong shape he chose for his painting; this was the format favored by his predecessors for their extensive views. The mound on the left, beautifully balanced in the picture by the dramatically lit field in the middle ground and by lighted area on the horizon, was also a device often used by earlier landscapists to help frame and fix the foremost plane of their panoramas. Original to Ruisdael is the subtlety with which he suggests movement into depth through the obliquely arranged fields and the broad road winding its way to the town.

A black chalk drawing, extensively retouched with gray wash by another hand, which may have served as a preliminary study for the *View of Naarden*, is at the Rijksbureau voor Kunsthistorische Documentatie, The Hague (Fig. 12; 6.3 x 18.4 cm; Giltay 53). The close correspondence of the drawing to the painting supports its ascription to Ruisdael; however, the later touches of wash, which virtually obliterate the light chalk drawing, make it difficult to give the sheet an unqualified attribution. A bolder chalk and wash panoramic drawing of Naarden and the church at Muiderberg from a lower point of view was acquired by the Hessiches Landesmuseum, Darmstadt in 1978 (Fig. 13; no. Hz 8735; 12.1 x 18.4 cm; Giltay 35). Probably done about the same time as the painting, the drawing does not contain the lateral mound on the left. If the early Thyssen painting, which strikes an unusual note in Jacob's *oeuvre*, had been lost or remained unknown, it is doubtful if either drawing would have been attributed to the artist.

Naarden lies about twenty kilometers southeast of Amsterdam on the Zuider Zee (in 1932 the name of the sea was changed to the Ijselmeer). The sea can be seen on the extreme right of the painting. The small sunlit building in the far distance on the horizon is the ruined church of Muiderberg. Naarden and its environs must have had a particular attraction for Ruisdael; his grandfather settled there late in the sixteenth-century, and it was his father's birthplace. A year after the Thyssen picture was painted, Jacob made a finished drawing of a coastal scene that includes a view of the ruined church of Muiderberg with Naarden in the background (see Cat. no. 64). Some of his landscapes, especially those including distant views of the sea, were probably inspired by his walks in the vicinity.

Fig. 12. Jacob van Ruisdael, View of Naarden and the Church of Muiderberg. *The Hague, Rijksbureau voor Kunsthistorische Documentatie.*

Fig. 13. Jacob van Ruisdael, View of Naarden. *Darmstadt, Hessisches Landesmuseum.*

Fig. 13

A Blasted Elm with a View of Egmond aan Zee

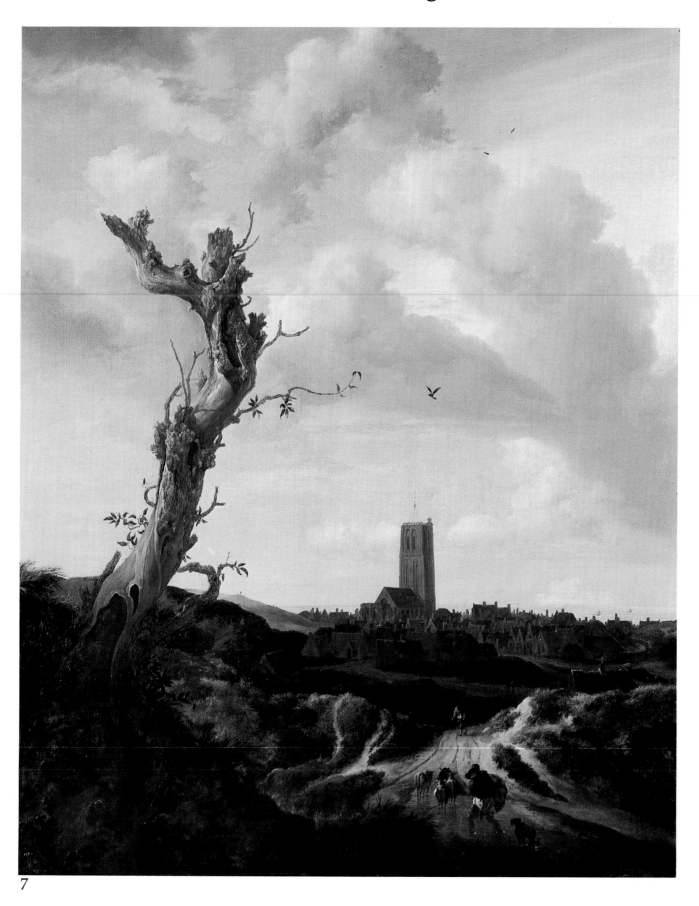

7

The identification of the extraordinary blasted tree as an elm in this *View of Egmond* was made by Peter S. Ashton, professor of dendrology and botany at Harvard University and director of the Arnold Arboretum. In his opinion, it could serve as a paradigm of the characteristic twisted trunks of elms and their simple leaves. See Cat. no. 4 for a note on the possible symbolic meaning of Ruisdael's conspicuous battered trees.

At first, it appears that Ruisdael chose an upright format for this unusual picture because it seemed most appropriate for his full-length portrait of the ancient, weather-beaten tree, but a closely related verison of the painting at the Pushkin Museum, Moscow (Fig. 14; no. 1712; panel, 45 x 37 cm; HdG 48; Ros 32), which has the same format but without the tree, indicates that the tree did not necessarily determine the shape of the picture. The Moscow variant has other differences: The figures in it have been used to set the scale of the scene rather than create a diversity of attraction, the patches of light are more effectively concentrated, and the movement into the picture over the complicated terrain is accomplished with greater ease. These alterations suggest that it probably was painted a bit later than the Manchester painting.

Jakob Rosenberg (*op. cit.*) and Erich Kurt Simon (*op. cit.*) doubted the authenticity of the Manchester picture; however, Rosenberg later informed me that he changed his opinion when a cleaning done not long before the painting was acquired by the Currier Gallery in 1950 brought out its striking qualities and revealed the unpublished signature and date. The doubts expressed by K. Malitskaya (*Great Paintings from the Pushkin Museum*, New York [n.d., 1964?], no. 53) regarding the attribution of the Moscow variant are unjustified.

An inferior copy of the Manchester painting was with the dealer L.J. Botenburg, The Hague (photo R.K.D.).

For references to Ruisdael's other paintings of Egmond aan Zee, see Cat. no. 2.

Manchester, New Hampshire, The Currier Gallery of Art
Panel, 62.5 x 49 cm. Signed and dated 1648, lower left.

PROVENANCE: Sir Frederick Cook, Doughty House, Richmond, Surrey; Sir Herbert Cook, Doughty House, Richmond; Walter Dunkels, Walhurst Manor, Cowfold; dealer E. Speelman, London, 1946; sale, London (Christie's), 12 March 1948, no. 124 (the sale catalogue erroneously states that the painting is dated 1645 [Partridge]); acquired by the gallery in 1950.

EXHIBITIONS: Worcester 1951, no. 24; New York–Toledo–Toronto 1954–55, no. 69; Amsterdam–Toronto 1977, no. 121.

BIBLIOGRAPHY: HdG 49; Kronig 1914, p. 94, no. 351 (painted about 1660; figures by Adriaen van de Velde); Ros, p. 116, note 1 (Jan van Kessel); Simon 1930, p. 81 (by a contemporary Haarlem artist); Elizabeth Smith, "An Early Landscape by Ruisdael," A.Q., XIV, 1951, p. 359f.; Stechow 1966, p. 105; Bol 1973, p. 279.

Fig. 14. Jacob van Ruisdael, View of Egmond aan Zee. *Moscow, Pushkin Museum.*

Fig. 14

Dunes by the Sea

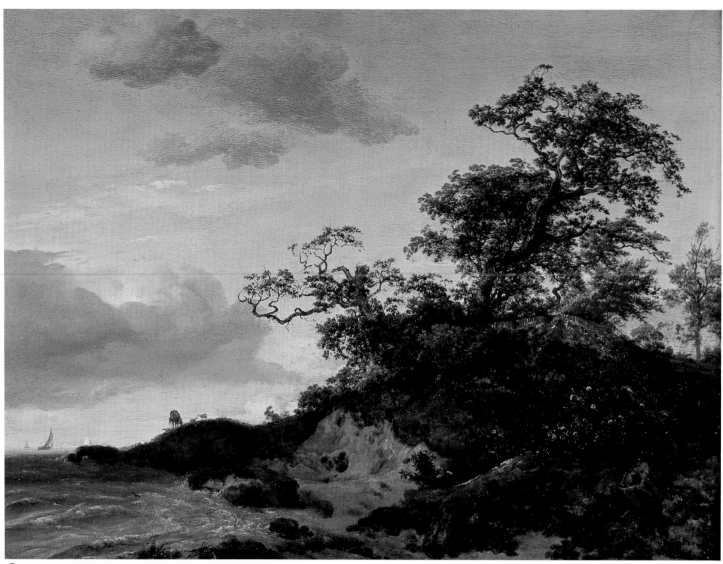

8

Private collection
Panel, 46 x 61 cm. Signed and dated
1648, right center at the bottom.

PROVENANCE: *Richter Oelrich,*
Bremen, about 1820; Bernhard Haus-
mann, Hannover, 1831; Provinzial-
museum, Hannover; sale, Duke of
Cumberland, Berlin (Lepke), 31 March
1925, no. 63, repr.; Düsseldorf art
market, 1948.

EXHIBITION: *Cologne 1954, no. 19,*
repr.

BIBLIOGRAPHY: Verzeichniss der
Hausmann'schen Gemälde-Samm-
lung in Hannover, *Brunswick, 1831,*
no. 270; Gustav Parthey, Deutscher
Bildersaal, II, *1864, p. 461, no. 135;*
Provenzialmuseum, Hannover, Cata-
logue, 1891, no. 474; HdG 925 (dimen-
sions reversed); Ros 567; Stechow 1966,
p. 29.

One of the subjects young Ruisdael tried a few times and then apparently abandoned was a view of a coast flanked by a spit of land supporting hardy trees and shrubs that have been whipped by the wind and sea. Today only two paintings of the theme are known; they are signed and dated 1647 and 1648, respectively.

The earlier one, formerly in the S.J.L. Hardie Collection, Ballathie, Perthshire (Fig. 15; panel, 45 x 63.5 cm; HdG 928; Ros 571), has the compact, falling diagonal composition ending with a vista into the distance that Ruisdael favored during his first phase. Its bright, far view of the sea gives a small foretaste of Ruisdael's marines.

His coastal scene exhibited here is clearly a variation on the Hardie painting. The changes rung on the theme indicate that it was done after Ruis-

dael had assimilated the elegant fashioning of forms that Cornelis Vroom (1591/92–1661) had introduced into Dutch landscape painting more than a decade earlier. Vroom's impact is seen in the more transparent and fine filigree treatment of the foliage and in the lighter, more tender palette of the 1648 painting. The differences between the two paintings suggest that Ruisdael was not strongly attracted to Vroom's work before 1648.

Ruisdael made a rather highly finished drawing, signed and dated 1648, of a coastal scene that includes a view of Muiderberg and the town of Naarden (see Cat. no. 64). The 1648 drawing is yet another variation on the compositional scheme he used for his two paintings and also betrays Vroom's influence in the treatment of the foliage.

Fig. 15. Jacob van Ruisdael, A Wooded Bank by the Sea, *1647. Formerly Ballathie, Perthshire, S.J.L. Hardie.*

Fig. 15

The Banks of a River

9

Edinburgh, Lent by the University of Edinburgh (Torrie Collection), from the National Gallery of Scotland (no. 75) Canvas, 134 x 193 cm. Indistinctly signed and dated 1649, lower left.

PROVENANCE: Sir James Erskine of Torrie, who bequeathed it to Edinburgh University, 1835; on loan to the National Gallery of Scotland since 1845.

BIBLIOGRAPHY: Smith Suppl. 32 (the principal figures by Wouwerman); Waagen 1854, III, pp. 273–74 (principal figures by Wouwerman); Hofstede de Groot 1893, p. 133 (an important rather early work; figures probably by Berchem, not Wouwerman); HdG 703 (figures possibly by Berchem); Ros 431; Simon 1930, pp. 20, 23; The National Gallery of Scotland, Edinburgh, Fifty-Sixth Report of the Board of Trustees, 1962 (1963), p. 5; The National Gallery of Scotland, Edinburgh, Catalogue, 1978, p. 94, no. 75 (staffage based on those of Wouwerman done during this period; see especially his Water-place, HdG, II, no. 71, with Böhler, Lucerne, 1949).

A cleaning in 1962 revealed the indistinct signature and date of 1649, confirming the date Jakob Rosenberg (1928, p. 22) assigned to the painting on the basis of its style.

As the references cited in the bibliography indicate, the staffage has been attributed with varying degrees of conviction to Nicolaes Berchem and Philips Wouwerman (1619–68); the attribution to the latter is possibly correct.

Ruisdael's *River Landscape with a High Sandy Bank*, dated 1647, in the Hage Collection, Nivaagaard, Denmark (Fig. 16; panel, 66 x 97 cm; HdG 694; Ros 449) most likely provided the initial idea for the painting, but it offers no hint that two years later he would transform it into the most imposing landscape he created before his departure from Haarlem about 1650 for his *Wanderjahre* in the Dutch-German border region. Indeed, a longing

for journeys to far-off places already is evident in the vast imaginary panorama of rolling hills and the prominent road that winds along the bank of the mirror-smooth river until it is lost in the distance. As in the *Dunes by the Sea*, painted a year earlier (Cat. no. 8), there are reminiscences of Cornelis Vroom in the majestic painting. Here they are evident in the poetic mood as well as in the refined, airy treatment of the foliage of the half-bare, split beech and in the elegant trees in the distant vista. Transcending Vroom are the tremendous scale of the landscape, the heroic treatment of the commanding group of trees on the left against the towering sky, and the grouping of a great wealth of motifs into powerful rhythms, all of which show Jacob's growing desire for monumental effect.

Fig. 16. Jacob van Ruisdael, River Landscape with a High Sandy Bank, *1647. Nivaagaard, Denmark, Hage Collection.*

Fig. 16

Evening Landscape: A Windmill by a Stream

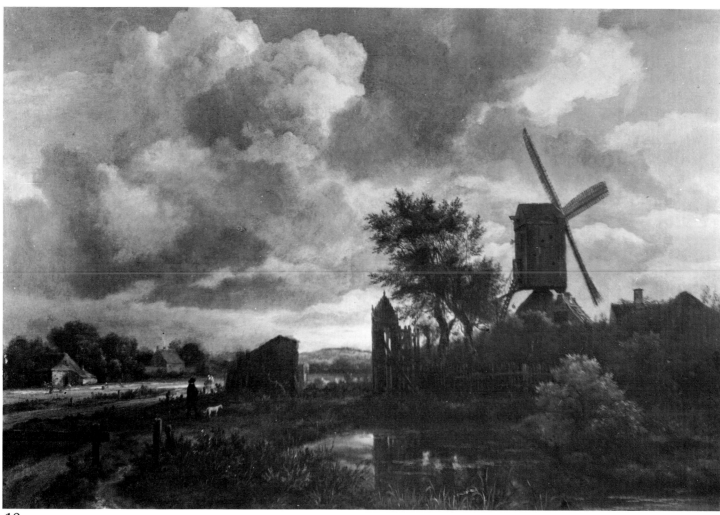

10

London, Buckingham Palace, Her Majesty Queen Elizabeth II
Canvas, 75.6 x 108 cm. Signed, lower left.

PROVENANCE: Sale, Earl of Halifax, London (Christie's), 25 June 1808, no. 100 (£192, 3s); sale, Walsh Porter, London (Christie's), 14 April 1810, no. 8 (£304, 10s, Lord Yarmouth for the Prince Regent).

EXHIBITIONS: London, Royal Academy, 1876, no. 160; London, Royal Academy, 1894, no. 76; London 1946–47, no. 371, repr.; London 1952–53, no. 297; London 1971–72, no. 19 (about 1655); London 1975–76, no. 31.

BIBLIOGRAPHY: Smith 102; Jameson 1844, p. 44, no. 102; Waagen 1854, II, p. 21: HdG 173, identical with HdG 197b; Ros 114; Simon 1930, p. 20, note 28 (repetition of HdG 180; Ros 119; painted c. 1660–65), 74; Stechow 1968, p. 252 (a few years after 1646).

Engraved by T.A. Prior in The Royal Gallery of Art, 1858.

Fig. 17. Jacob van Ruisdael, Landscape with a Windmill, 1646. Cleveland, The Cleveland Museum of Art, Mr. and Mrs. William H. Marlatt Fund.

Fig. 17

Fig. 18. Jacob van Ruisdael, Landscape with a Windmill. London, British Museum, Trustees of the British Museum.

Fig. 18

Ruisdael depicted windmills from the very beginning of his career. He chose them as the main subject for four of the precious group of eleven drawings, now at Dresden, that probably belonged to a sketchbook he used about 1645–46 for studies he made of the countryside, most likely within walking distance of his home in Haarlem (see Cat. no. 58). A windmill is also the major motif of one of his earliest paintings, *Landscape with a Windmill*, signed and dated 1646, The Cleveland Museum of Art (Fig. 17; no. 67.19; HdG 180; Ros 119). In the Cleveland picture the mother-of-pearl pink, blue, gray, and white of the streaky clouds in the evening sky distinctly recall effects achieved by Jacob's uncle Salomon van Ruysdael. The dense shrubbery and low trees that virtually hide the modest farmstead surrounding the bulky windmill are original. Comparable tightly knit forms and towering windmills are not found in Salomon's work.

The Buckingham Palace painting, datable to about 1650, is a brilliant variation on the theme of the Cleveland picture. It shows the strides young Ruisdael made during the course of a few years. The farmstead and mill are set back, masses are broken up more, the distant view—which now includes a bleaching field—is considerably expanded, and reflections of evening light fall into the lower and middle zones, creating a more ample and freer sense of space. Notable changes also are seen in the heightened sky and the introduction of emphatic thick clouds that billow above and extend over the landscape.

A small drawing that may have been used for the Buckingham Palace painting is at the British Museum (Fig. 18; black chalk, gray wash; 9.1 x 15 cm). Hind (1931, IV, p. 42, no. 11) first recognized its relationship to the picture. The sheet is not included in the corpus of Ruisdael drawings published by Jakob Rosenberg (1928) or J. Giltay (1980). Christopher White has kindly informed me that he will publish it in his forthcoming catalogue of Her Majesty The Queen's Dutch pictures as an authentic work that may have served as a preparatory study for the painting.

During the course of the 1650s Ruisdael made only a few other paintings and drawings of windmills (see Cat. no. 24). In his maturity he essentially abandoned the theme. The motif is used again in only a few of his rare late winterscapes (see Cat. no. 53), and most notably for his best-known picture, *The Mill at Wijk bij Duurstede* (Cat. no. 39).

Oliver Millar (London 1971–72, pp. 22, 70) mentions that Lord Yarmouth, who purchased the painting now at Buckingham Palace in 1810, was George IV's principal advisor on pictures and often bid for him at auctions.

About a decade after the painting entered the Royal Collection, John Constable told his friend Archdeacon Fisher that he had seen it at the Academy and wanted to copy it: "The beautiful Ruisdael of the 'Windmill and log-house' which we admired at the Gallery is left there for the use of the students—I trust I shall be able to procure a memorandum of it" (Beckett 1952, p. 79; Beckett 1968, VI, p. 74; 20 September 1821). Regarding this brief passage David Lucas, the artist's intimate friend, wrote that Constable expressed special admiration for the picture "in which he said he could all but see the ells [*sic*] in the pools. of water—that there were acres of sky expressed" (Parris *et al.* 1975, p. 57). In the same letter Constable also gave high praise to a Poussin which had been lent to the Academy, *Landscape: A Man Washing His Feet at a Fountain*, now at the National Gallery, London (no. 40). Students of Constable's works have been uncertain as to whether Lucas' comment refers to the Ruisdael or the Poussin. Since the Poussin landscape cannot be characterized as a work with acres of sky and is hardly one that conjures up images of eels in pools, it seems safe to assume that Lucas' comment refers to Constable's reaction to the Ruisdael, not the Poussin.

Whether Constable managed "to procure a memorandum" of Ruisdael's painting is not known. In any event, a copy by him of the Buckingham Palace picture has not been identified.

Hofstede de Groot (173) notes that a good copy of the Queen's picture attributed to G. Hulseboom (b. 1784, Amsterdam) was in the sale, Raedt van Oldenbarnevelt, Amsterdam, 6 November 1900, no. 187. Georges Broulhiet (no. 153) reproduces a copy of the painting, formerly in the collection of George Meagher, Toronto (44.4 x 64.6 cm; *Art News*, 4 May 1918, repr.), and proposes that it may be identical with the one that was in the Oldenbarnevelt sale. Possibly it is. There is no reason to accept Broulhiet's suggestion that the copy is by Hobbema.

A Rough Sea with Sailing Vessels

11

Stockholm, Nationalmuseum
(no. NM 4033)
Panel, 49 x 65 cm.

PROVENANCE: Perhaps sale, Rotter-
dam (van Leen-Lamme), 25 April 1817,
no. 157 (132 florins); sale, Maurice
Kann, Paris (Petit), 9 June 1911, p. 66,
no. 61, repr. (15,000 francs, Preyer);
private Dutch collection; dealer F. Muller
and Co., Amsterdam; H. Heilbuth Col-
lection, Copenhagen; Herman Rasch,
Stockholm; acquired by the museum in
1943.

EXHIBITIONS: Amsterdam, F. Muller
and Co., 1911, no. 18 (monogrammed);
Stockholm 1967, no. 135; The Hague–
London 1970–71, no. 82, repr.

BIBLIOGRAPHY: Perhaps identical
with HdG 968h; most probably identical
with HdG 962 and Ros 597 (both authors
state the work is dated 1649); H. Heilbuth
Collection, Copenhagen, Catalogue,
1920, no. 70 (monogrammed; probably
identical with HdG 968h); Ros 600;
Simon 1930, p. 76 (to judge from the
reproduction in the sales catalogue, not
by Ruisdael); Nationalmuseum, Stock-
holm, Catalogue, 1958, p. 176, no. 4033;
Bol 1973, pp. 278–79 (dated 1649).

The painting has been variously published as monogrammed and dated 1649. Today it bears neither a monogram nor a date. In fact, not a single existing seascape by Ruisdael is dated, and there has been little general agreement about their chronology. For example, Jakob Rosenberg (*op. cit.*, pp. 15, 40) dated some in the 1640s, while Wolfgang Stechow wrote "there can be little doubt that none was painted before 1660" (1966, p. 122).

The Stockholm painting suggests that Rosenberg was closer to the mark than Stechow, although I do not agree with Rosenberg's conclusion that some of the artist's early seascapes show the impact of those done by his uncle Salomon van Ruysdael (*op. cit.*, p. 15). A date in the late 1640s or early 1650s is proposed here for the Stockholm picture primarily on the basis of its close connection to Jan Porcellis' epoch-making marines and those by his follower Simon de Vlieger.

Porcellis (before 1584–1632) is the artist who changed the subject as well as the style of Dutch marine painting (for the best appraisal of his achievement, see J. Walsh, "The Dutch Marine Painters Jan and Julius Porcellis—I: Jan's early career," *B.M.*, CXVI, 1974, pp. 653–62; "—II: Jan's maturity and 'de jonge Porcellis'," *ibid.*, pp. 734–

45). Earlier specialists ordinarily made ships the principal subject of their pictures. Ships are not absent from Porcellis' paintings, but his emphasis shifted to choppy seas, overcast skies, and atmospheric effects. Strong light and dark contrasts bonded by a fine gray tonality characterize his latest works (Fig. 19). Simon de Vlieger (c. 1600–53) painted marines in the same manner. The relationship of the Stockholm painting to the Porcellis-Vlieger tradition is unmistakable. There are also significant differences: Ruisdael has given a greater unity to the large shadowed expanse of the sea in the foreground, the contrasts between light and dark areas have become much sharper, clouds have gained in volume, his touch is stronger and his paint heavier than is found in seascapes done by his predecessors.

The compositional scheme of a Ruisdael seascape now in the possession of the Dienst Verspreide Rijkscollecties, The Hague (Fig. 20; no. N.K.3274; HdG 952; Ros 587) is similar to that of the Stockholm picture. Its more scattered accents, rather formless clouds, and more pronounced monochromatic effect as well as the artist's use of lightning flashes and a rainbow to heighten the drama suggest that it was painted a bit earlier.

Fig. 19. Jan Porcellis, Seascape with Fishing Boats. *Oxford, Ashmolean Museum.*

Fig. 20. Jacob van Ruisdael, Sailing Vessels in a Stormy Sea. *The Hague, Dienst Verspreide Rijkscollecties.*

Fig. 19

Fig. 20

The Castle of Bentheim

12

The date of 1651 inscribed on the painting provides a firm *terminus ante quem* for Ruisdael's trip to Bentheim, a small German town in Westphalia near the border between the United Provinces and Germany. Support for the hypothesis that he most probably traveled there with his friend Nicolaes Berchem, whose father, the still life painter Pieter Claesz, was born in nearby Burgsteinfurt, is offered by Berchem's drawing of Bentheim dated 1650, Städelsches Kunstinstitut, Frankfurt am Main (Fig. 21) and by Ruisdael's painting of a similar but more ambitious view, formerly in Bremen (Fig. 22; no. 259 [lost in the Second World War]; Ros 12), which is datable to the same period. Additional evidence of their contact during these years is found in Jacob's *Great Oak*, dated 1652 (see Cat. no. 16), and his *Forest Entrance*, dated 1653, Amsterdam, Rijksmuseum (no. A 350; HdG 440; Ros 256); Berchem painted the figures in both landscapes.

Two of Berchem's pictures, each dated 1656, incorporate views of Bentheim: One, which combines his familiar handsome Italianate figures and animals in a rocky landscape with a distant view of the German castle, is at Dresden (Fig. 23; no. 1481; HdG, IX, p. 81, no. 109; also see Hagels 1968, p. 50f., repr.); the other, an imaginary panoramic view of a great river valley with dancing and music-making shepherds and cowherds, which includes an even more distant view of the castle on a high mountain, is in the collection of the Duke of Westminster (HdG, IX, p. 81, no. 110). The castle in both paintings is seen from the same point of view as Berchem depicted it in his 1650 drawing. There is a noticeable resemblance between the compositional scheme of the Westminster painting and Ruisdael's great *River Landscape*, dated 1649, at Edinburgh, which was painted seven years earlier (see Cat. no. 9).

At least a dozen of Ruisdael's landscapes that include views of the Castle of Bentheim are known today. Unlike those by Berchem, they range in

Fig. 21. Nicolaes Berchem, The Castle of Bentheim, 1650. Frankfurt am Main, Städelsches Kunstinstitut.

Private collection
Canvas, 97.7 x 81.3 cm. Signed and dated 1651, bottom left center.

PROVENANCE: Purchased 19 March 1859 from the Munro Collection by the dealer J. Rutley for J.S. Beckett (£300 plus £15 commission for Rutley); John Staniforth Beckett; inherited by Sir H.B. Bacon about 1890; Sir Hickman Bacon, Gainsborough.

EXHIBITIONS: London 1938, no. 273, repr. (wrong provenance); London 1952–53, no. 318, repr.; London 1976-II, no. 99, repr.

BIBLIOGRAPHY: HdG 24; Ros 15; Keith Roberts, B.M., CXIX, 1977, p. 515.

Fig. 21

date from the period of his trip to the site to the very last phase of his career. Some of them show the castle from the same angle; for example, it is seen here from the southwest and it is seen from virtually the same angle in the Beit painting of 1653 (Cat. no. 14), as well as in one that is datable to the late 1670s (Smith Suppl. 15; HdG 30). We can deduce from these paintings that Ruisdael made drawings of the castle which served as *aides-mémoire* for landscapes worked up in his studio long after his visit, but of course the possibility that he made sketches of the place during the course of a later trip to the border region cannot be excluded. The fact that not a single one of his drawings of Bentheim has survived indicates that only a portion of his total output as a draughtsman is known. We can only guess how many of his sketches have been lost.

There is no height near Bentheim comparable to the one Jacob shows on the left of the painting. This invention is an outstanding expression of his desire to enlarge solid forms during the early 1650s. The picturesque castle has been given a subordinate place beyond the heavily wooded hill in the middle distance. Primary emphasis is on the naturalistic detail of the dense trees and thick undergrowth that covers the imaginary hill and the gargantuan fallen tree trunk that dwarfs the unobtrusive horsemen.

The setting of the castle in the present picture is imaginary, as is the case in most of Ruisdael's views of it. Berchem also placed the castle in fantastic settings but Jacob never followed his friend's lead to place it in an arcadian Italianate landscape. Indeed, to our best knowledge Ruisdael never painted a sunny southern landscape. His imagination was confined to the north.

Fig. 22. Jacob van Ruisdael, Hilly Valley with a View of the Castle of Bentheim. *Formerly Bremen, Kunsthalle (lost in the Second World War).*

Fig. 23. Nicolaes Berchem, Landscape with the Castle of Bentheim, *1656. Dresden, Staatliche Kunstsammlungen.*

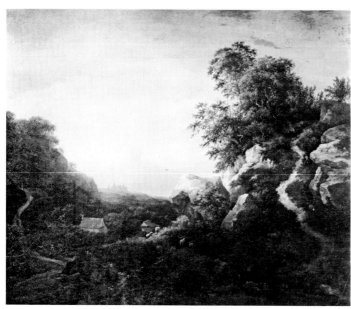

Fig. 22

Fig. 23

The Castle of Bentheim

13

This painting of the castle seen from the west northwest is one of the rare ones by Ruisdael that appears to offer a topographically accurate view of the site as it looked in the artist's day.

Sporadic destruction, renovation, and restoration during the course of the last three centuries have considerably altered the castle's fabric, and today the hillside is criss-crossed with streets and rows of neat, modern dwellings, a few of which are built in half-timber with vertical plank gables, a revival of the vernacular style of architecture of the region. The two small houses at the foot of the hill in Ruisdael's painting are built in the characteristic style of the area; a clearer picture of these half-timber houses can be seen in other works by Ruisdael: for example, Cat. nos. 22, 23, 70, 105. For the vernacular architecture of the region, see Schepers 1976.

A close variant (copy?) of the present painting, formerly in the collection M. Strauss, Vienna, appeared in the sale, Stockholm (H. Bukowski), 21–22 February 1935, no. 25, repr. (panel, 36.5 x 45 cm); see HdG 28; Ros 22. Its present whereabouts is unknown.

Private collection
Canvas, 38.1 x 47 cm. Signed, lower right.

PROVENANCE: *Purchased in 1850 for £120 from the London dealer Norton by*

John Staniforth Beckett; inherited by Sir H.B. Bacon about 1890; Sir Hickman Bacon, Gainsborough.

EXHIBITIONS: *London, The Guild Art*

Gallery, 1890, no. 76; London 1952–53, no. 298; Utrecht 1953, no. 81, repr.

BIBLIOGRAPHY: *HdG 23; Ros 14.*

The Castle of Bentheim

No support has been found for the appealing tradition, first related by John Smith (258) in 1835, that this picture of the Castle of Bentheim was expressly painted for the Count of Bentheim and that it remained in the family's possession until the French entered Germany about 1792–94. However, there is universal support for the view that it is Ruisdael's most imposing painting of the Castle.

Jakob Rosenberg demonstrated how Ruisdael heightened and enhanced the unimposing site he depicted when he juxtaposed a photograph of it (see Fig. 24; repr. from Rosenberg 1928, Fig. 46) with the painting. Comparison of photographs of the subjects depicted by artists with their works is common practice today, but to my best knowledge the comparison that Rosenberg made in 1928 between the photograph and Ruisdael's painting is the first time an art historian used a camera to clinch a point regarding a landscapist's transformation of an actual site.

As the photograph shows, the hill at Bentheim is a low one. In the mighty Beit picture Ruisdael enlarged it into a wooded mountain, which provides the castle with a commanding position. The dense mass of the mountain, obliquely stretching away into depth, and the coulisses on either side of the front edge of the painting are reminiscent of some compositions painted by the generation of his teachers, but the spatial clarity is new, as is the way he unifies the close view of a nearly overwhelming wealth of detail with the most distant parts of the landscape into a consistent whole. The impact of the broad prospect is as intense as that of the vegetation seen close-up.

A. Nöldeke (*Die Kunstdenkmäler der Provinz Hannover*, IV, no. 4, *Die Kreise Lingen und Grafschaft Bentheim*, Hannover, 1919) presents an excellent, well-illustrated survey of the history of the castle; additional material on its history is found in H. Krul ("Das Schloss zu Bentheim und die Ereignisse im Jahr 1795," *Jahrbuch des Heimatvereins der Grafschaft Bentheim*, 1956, pp. 73–81) and Götker 1964.

Fig. 24. Photograph of Bentheim.

Fig. 24

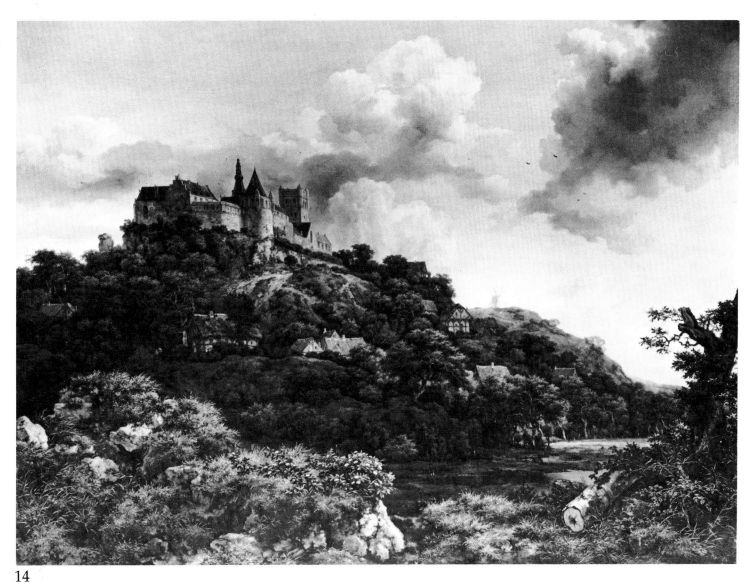

14

Blessington, Ireland, Beit Collection
Canvas, 110.5 x 144 cm. Monogrammed
and dated 1653, lower left.

PROVENANCE: Smith (258) states that
according to tradition Ruisdael painted
the picture "expressly for the Count of
Bentheim, in whose family it is said to
have remained until the entrance of the
French into Germany about which time
it was taken to Paris. . . ." He adds that
from Paris it passed into England and
became the property of William Smith,
M.P. It was consigned by William Smith
to W. Buchanan, "and afterwards passed
into the possession of a gentleman at
Bristol. It was valued at £500"
(Buchanan, II, 1824, p. 360). Thomas
Kebble of Green Trees, near Tonbridge,
Kent, by 1835; sale, a nobleman, Lon-
don, 2 June 1856, no. 54 (£1270, 10s,
Woodin for J. Walter); John Walter,
Bearwood; Sir Otto Beit, London; by
descent to the present owner.

EXHIBITIONS: London, British Institu-
tion, 1815; Manchester 1857, no. 708;
London, British Institution, 1861, no. 50
(Walter); Leeds 1868, no. 792; London
1929, no. 95; Brussels 1935, no. 764.

BIBLIOGRAPHY: W. Buchanan,
Memoirs of Painting, with a Chron-
ological History of the Importation of
Pictures by the Great Masters into
England Since the French Revolution,
vol. II, London, 1824, p. 360; Smith
258; Bürger 1865, p. 295; Michel 1910,
pp. 148ff., repr. pl. 9; HdG 25; Bode
1913, no. 50, repr.; Ros 18; Götker 1964,
pp. 96–100; Hagels 1968, p. 46.

Hilly Wooded Landscape with Cattle

This landscape is datable to the early 1650s, when Ruisdael began to use the compositional scheme of hills rising high on either side of a vista into the distance. Other examples are his *Hilly Valley with a View of Bentheim Castle*, formerly at Bremen (Fig. 22; no. 259; Ros 12), *Landscape with a Footbridge*, dated 1652, at The Frick Collection (see Fig. 94 for a detail of the painting; no. 49.1.156; HdG 525; Ros 393), and the *Mountain Landscape with Wooded Cliffs*, now at Leipzig (no. 1854; HdG 705; Ros 409). However, in none of his existing variations on the theme are the multifarious geological formations and luxuriant mass of foliage and vegetation on either side of the cleavage brought so close to the foreground. The close-up view intensifies the feeling of their density, massive solidity, and weight, while the sky that comes deep down into the landscape accents the distant prospect. As in the *Castle of Bentheim* in the Beit Collection (Cat. no. 14), the closely observed near and far views have been united into a consistent whole.

The excellently preserved painting shows the granular quality of the artist's paint during the early fifties as well as the rich variety of his ochres and browns, and the vivid green he favored for distant foliage in his youth and early maturity. A minor detail regarding the monogram on the picture is worth mentioning. Ruisdael gave it special emphasis by painting it in two colors to give it a three-dimensional effect. He used the same device for the signature he inscribed on his magnificent *Landscape with a Footbridge*, dated 1652, at the Frick Collection, and traces of it can still be seen on the monogram and date of 1653 on his *Water Mills* in a private collection (Cat. no. 23). This kind of stress upon his authorship, which also occurs on a few of his early etchings (see p. 231), suggests an understandable pride in his accomplishment.

A. Nöldeke (*Die Kunstdenkmäler der Provinz Hannover*, IV, no. 4, *Die Kreise Lingen und Grafschaft Bentheim*, Hannover, 1919) presents an excellent, well-illustrated survey of the history of the castle; additional material on its history is found in H. Krul ("Das Schloss zu Bentheim und die Ereignisse im Jahr 1795," *Jahrbuch des Heimatvereins der Grafschaft Bentheim*, 1956, pp. 73–82) and Götker 1964.

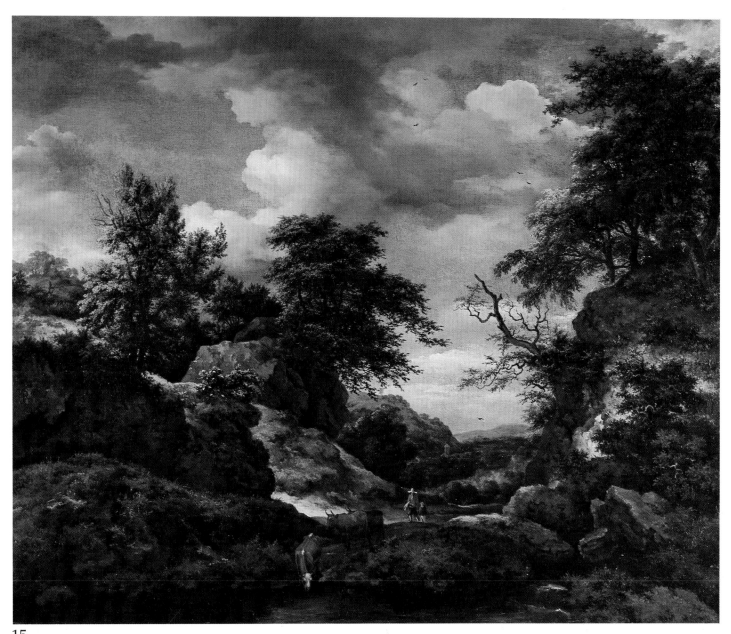

15

Selkirk, Bowhill, The Duke of Buccleuch
and Queensberry (no. D. 176)
Canvas, 101.6 x 127 cm. Monogrammed,
on the left.

PROVENANCE: According to Smith
(283), in the collection of the Duke of
Buccleuch, Dalkeith Castle, in 1835.

EXHIBITION: London 1978, no. 37,
repr.

BIBLIOGRAPHY: Smith 283; Waagen
1854, III, p. 313; Waagen 1857, p. 436;
Hofstede de Groot 1893, p. 213; Dalkeith
Castle Collection, Catalogue, 1911, no.
176; HdG 546; Ros 402.

The Great Oak

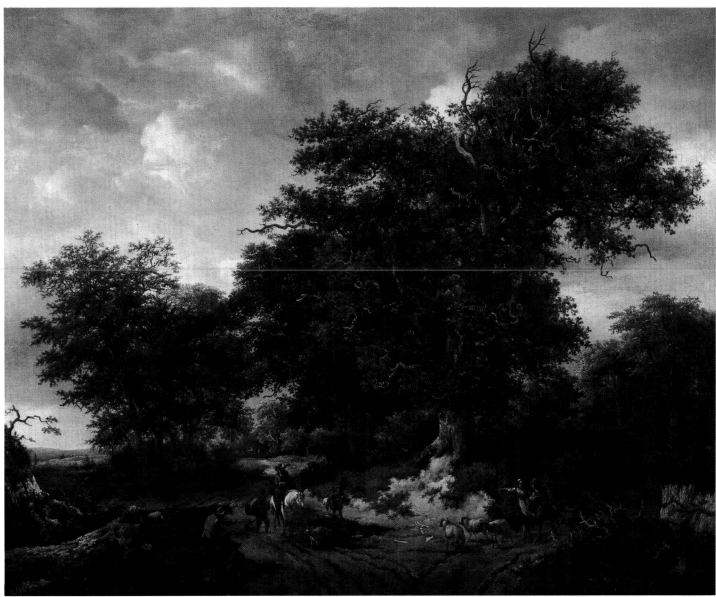

16

Birmingham, England, Anonymous Loan to the City Museums and Art Gallery

Canvas, 85.1 x 104.3 cm. Signed and dated 1652, bottom center.

PROVENANCE: Sale, Pierre de Grand-Pré, Paris (Langlier), 16 February 1809, no. 98 (7,001 francs); private sale, Duchesse de Berry, London (Christie's), 1834, no. 37 (priced at £480); sale, [Duchesse de Berry], Paris, 4–6 April 1837, no. 26 (8,000 francs); Samuel Wheeler, 1867; sale, S. Wheeler, London, 29 July 1871 (£792, 15s, King); G. Cav-endish Bentinck, 1876; sale, G.A.F. Cavendish Bentinck, London, 8–11 July 1891, no. 566 (£1470, Colnaghi); Arthur Sanderson, Edinburgh; F. Fleischmann, London, acquired from Colnaghi, 1897; F.N. [Noel] Ashcroft, London.

EXHIBITIONS: London, British Institution, 1856, no. 22; London, British Institution, 1867, no. 54 (lent by Samuel Wheeler); London, Royal Academy, Winter Exhibition, 1867, no. 67 (lent by G. Cavendish Bentinck); London, Royal Academy, 1890, no. 73; dealer Lawrie, London, Catalogue, 1903, no. 4; London, Grafton Galleries, October 1911, no. 69 (lent by Mrs. Fleischmann); London 1949, no. 142.

BIBLIOGRAPHY: Smith 103 (signed by both Ruisdael and Berchem) and Suppl. 54; Blanc 1858, II, pp. 423–24; Hofstede de Groot 1893, pp. 211–12; HdG 550 (the English translation of Hofstede de Groot notes the work is signed by both Ruisdael and Berchem); Ros 339 (signed by both Ruisdael and Berchem); Schaar 1958, p. 36 (staffage by Berchem).

Only a few of Ruisdael's works of the 1640s employ great trees as the protagonists of his landscapes. An outstanding early example is his rare etching of *Oaks and a Pond*, dated 1647, which is known through a unique impression (Cat. no. 102). During the early 1650s this motif becomes more frequent, as can be seen in his *Two Oak Trees*, dated 1651, formerly in the Von Schubert collection (HdG 702a; Ros 276; reproduced Rosenberg 1928, Fig. 38) and in this picture of a heroic oak painted a year later. The brightly lit sandy patch at the foot of the giant oak focuses attention on its sturdy trunk and on the foliage of its luxuriant crown, which dominates the landscape.

When *The Great Oak* appeared in the sale of the Duchesse de Berry's pictures at Paris in 1837, it fetched 8,000 francs. Someone wrote after the price "C'est pour rien" in the copy of the catalogue from which Blanc compiled a selected list of paintings that appeared in the sale (Blanc 1858, II, p. 424). At the same sale Terborch's famous *Signing of the Peace at Münster*, now in the National Gallery, London (no. 896), brought 45,500 francs, Potter's *Seven Cows in a Meadow*, in the Philips-de Jongh Collection, Eindhoven (HdG, IV, 45) was sold for 37,100 francs, and Isaack van Ostade's *Travelers Outside an Inn*, Mauritshuis, The Hague (no. 789; HdG, III, 22 and 56) fetched 31,000 francs. In view of these prices we can agree that *The Great Oak* went "for nothing" at the sale. Another picture that appeared in that auction would today be considered an even greater bargain than the Ruisdael: Vermeer's *Woman with a Maid Servant*, now in The Frick Collection (no. 19.1.126), was purchased for 4,015 francs.

It already has been noted that Ruisdael and Nicolaes Berchem most probably traveled together to the border region of the United Provinces and Germany in the early 1650s, and that Berchem painted the figures in some of Ruisdael's landscapes (Cat. no. 12). According to John Smith, C. Hofstede de Groot, and Jakob Rosenberg, *The Great Oak* offers documentary proof of one of their joint efforts; they note that the painting is signed by both artists. Today, only Ruisdael's signature and the date of 1652 are visible upon the painting, but there can be no doubt that the figures at either side of the great oak were painted by Berchem (Fig. 25). As Ruisdael's *Wooded Landscape with a Flooded Road* (Fig. 1; Louvre, on extended loan at the Musée de la Chartreuse, Douai; HdG 499; Ros 354) demonstrates, the artists continued to collaborate in the following decade. The prominent staffage in that painting, which is datable to the late 1660s, is also unmistakably by Berchem.

Fig. 25. The Great Oak, *detail.*

Fig. 25

Hilly Landscape with a Great Oak Tree and a Grain Field

The giant oak tree, which seems to embody the vital forces of growth in nature, is the hero of this hilly landscape. Its powerful twisted roots claw into the cliff upon which it grows, much the way the beech in his etching datable to the first half of the 1650s clings precariously to its bluff (see Cat. no. 106). The oak's massive, curved dark brown trunk is brightened by a reddish-ochre bare patch— the most vivid hue in the picture—and its great crown spreads across the middle of the large painting and reaches beyond its upper edge. Like *The Great Oak*, dated 1652, at Birmingham (Cat. no. 16), there are vistas on either side of the awe-inspiring tree, but here they are richer. Instead of a fork in a road with views of subsidiary trees, one side opens up to a silvery yellow grain field on a gently rolling slope with an unidentifiable village and castle sharply silhouetted against the gray sky beyond, the other to a steeply rising road flanked by a half-timber cottage. The more varied spatial organization of the painting and the greater amount of light that pierces and lightens the foliage suggest that it postdates the Birmingham painting by a few years.

The eight small figures in the landscape were painted by Ruisdael. One is a solitary woman on the road; on the right a man enters the scene accompanied by a dog. More unusual is the pensive woman seated in the dark shadow of the oak. The perfect accord of these unobtrusive figures with the mood of the landscape makes one wonder why Ruisdael ever felt the need to call upon other artists to furnish the staffage in his paintings.

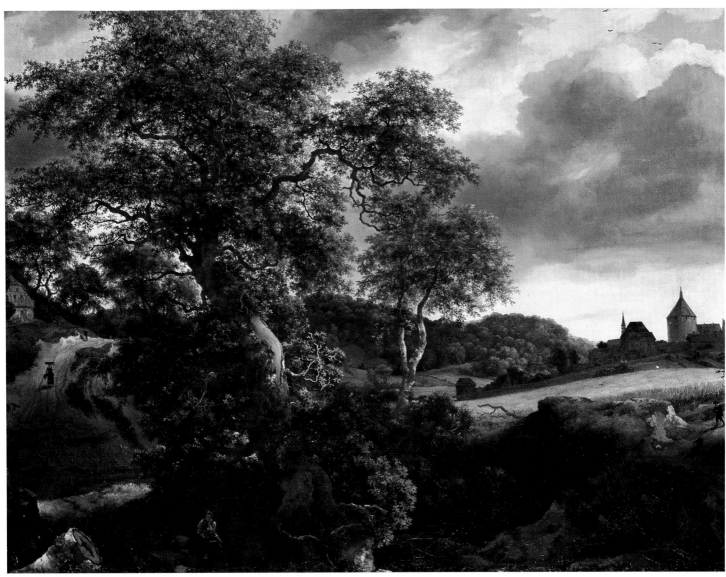

17

Brunswick, Herzog Anton Ulrich-
Museum (no. 376)
Canvas, 106 x 138 cm.

PROVENANCE: Acquired by the Duke
of Brunswick, Salzdahlum in 1738; taken
by the French and exhibited in Paris by
1810; later returned.

EXHIBITION: Krefeld 1938, no. 107,
repr.

BIBLIOGRAPHY: Filhol 1810, VII, no.
442, repr.; Ainé [n.d.], [n.p.], repr.;
Smith 299, identical with Smith 331;
HdG 107; Ros 74; Herzog Anton Ulrich-
Museum, Brunswick, Catalogue, 1976,
p. 51, no. 376.

Etched by De Saulx in Filhol (op. cit.);
engraved by De Saulx in the Musée
Français, see Ainé (op. cit.).

A Grain Field at the Edge of a Forest

Jacob's instinctive affinity for forest scenes can be seen in paintings, drawings, and etchings done as early as 1646, and he continued to make pictures of this theme during the course of his intensive youthful activity. In the following decade the subject gained in importance for him. He began about 1650 with rather opaque, overcrowded compositions. Very soon afterward he freed himself from these cramped views by pushing back the masses of trees, stressing large motifs, and introducing sharp light accents that help untangle complexly dense spatial relationships. Although strictly speaking not a forest picture, *The Great Oak*, dated 1652, at Birmingham (Cat. no. 16), shows this phase of his development. By the mid-fifties, the period that can be assigned to Worcester College's miraculously well-preserved painting, Ruisdael's forest scenes remain compact, but they attain a new order, clarity, and stateliness that express the nobility and peaceful beauty of the forest.

In *A Grain Field at the Edge of a Forest*, Jacob uses the old scheme of a diagonal arrangement of a dense grove of trees ending in a prospect to the horizon, but he achieves a new effect by the small opening in the center that sharply contrasts the near view of the dark oak trees and the very far vista of the terrain beyond them. It is an early effort to achieve the utmost contrast between near and far, large and small. Similar accents, more generously used, become a mainstay of his later, more spacious forest pictures.

How deeply and intensely Ruisdael studied nature is seen in the diversified growth supported by the broad expanse of the smooth pond and its banks. The breadth of the foreground, accented by the sandy road that turns abruptly to the right and the horizontal stretch of the light golden grain field, also sets the monumental wall of the wood sufficiently far back to allow its full contour to be viewed clearly. At the same time the oaks at the edge of the forest are seen near enough to impose a sense of their size and weight as well as afford an opportunity to scrutinize the lichen and moss growing on their great trunks. Seen from the point of view of the more open forest interiors Jacob painted about a decade later, such as *The Marsh* at Leningrad (Cat. no. 36), the almost impregnable impression of the wood here may appear crowded, but even if Ruisdael had never painted a forest landscape after the masterwork at Worcester College, his reputation as the peerless painter of forests would be safe.

18

Oxford, Worcester College
Canvas, 103.8 x 146.2 cm. Signed,
lower right.

PROVENANCE: The Reverend R.T.
Nash, who bequeathed it to Worcester
College in 1811.

EXHIBITIONS: Manchester 1857, no.
711; London, Royal Academy, Winter
Exhibition, 1902, no. 100; London 1924,
no. 12; London 1929, no. 145; Paris
1950–51, no. 72; London 1952–53, no.
300; The Hague–London 1970–71, no.
86, repr.; Oxford 1975, no. 34, repr.

BIBLIOGRAPHY: Waagen 1854, III, p.
50; Bürger 1865, pp. 294–95; HdG 121;
Ros 89; Simon 1930, p. 73 (c. 1670);
Stechow 1966, p. 74 (1650s).

Landscape with the Ruins of the Castle of Egmond

19

Chicago, The Art Institute of Chicago, Potter Palmer Collection (no. 47.475) Canvas, 98.9 x 129.9 cm. Monogrammed, lower right.

PROVENANCE: Sale, Baron de Beurnonville, Paris (Drouot), 9 May 1881, no. 451 (10,000 francs; erroneously called Ruins of the Castle of Brederode); *G. von Ráth, Budapest; Oscar Huldschinsky, Berlin, purchased from P. & D. Colnaghi, London by 1906; sale, Oscar Huldschinsky, Berlin (Cassirer), 10–11 May 1928, no. 29 (61,000 marks, Boehler, bought in); dealer J. Goudstikker, Amsterdam, Catalogue no. 36, 1928–29, no. 67; dealers Bachstitz and Agnew, London, Catalogue, 1932, no. 27; dealer K.W. Bachstitz, Berlin, 1935.*

EXHIBITION: Berlin 1906, no. 117, repr.

BIBLIOGRAPHY: HdG 51 (Egmond?); W. von Bode, Die Sammlung Oscar Huldschinsky, *Frankfurt a. M., 1909, no. 26; Ros 34 (Egmond?); A.L. Romdahl, ''Barock, Kontrabarock och Akademism,''* Tidskrift för Konstvetenskap, *XX, 1937, pp. 39–40; D.C. Rich, ''Two Great Romantic Landscapes,''* Bulletin, Art Institute of Chicago, *XLII, 1948, pp. 20–22; Renaud 1940, pp. 339–41; Paintings in the Art Institute of Chicago, 1961, pp. 408–409; Kouznetsov 1973, p. 35.*

Fig. 26. Jacob van Ruisdael, The Entrance Gate of the Castle of Brederode. *Philadelphia, Philadelphia Museum of Art, John G. Johnson Collection.*

Fig. 27. Hercules Segers, The Entrance Gate of the Castle of Brederode. *Etching. Amsterdam, Rijksmuseum, Rijksprentenkabinet.*

The painting is another example of Jacob's renewed urge in the early fifties to heighten large forms, emphasize solid masses, and create solidly constructed compositions. Apart from the huge trailing cloud formations, Ruisdael's approach to the landscape was a frontal one. The far bank of the castle moat provides a firm base for the surging power of the towering ruin of Egmond and the massiveness of the long, low hill close behind it. Colors have gained in freshness and concentration. As remarkable as his treatment of the light terracotta red of the noble ruin is his handling of white. The strongest patch of the latter is on the low wall. Smaller strokes of white and near-white have been gathered together very restrainedly to animate other portions of the ruin, while a few gentle touches appear as blossoms on the large elder bush, sheep on the bank, moss on the oak stump in the foreground, and reflections in the water. There is only a single, small point of pure color in the painting: the shepherd's red jacket.

Although the powerful impact of the large picture recalls nothing in Cornelis Vroom's *oeuvre*, reminiscences of the older artist's landscapes are still perceptible in it. The oblique slope of the hill that stretches across the middle ground recalls a compositional scheme that Vroom often favored, and the delicate lacy foliage of the small tree on the right could pass as a quotation from one of his works.

Jakob Rosenberg (1928, pp. 20–21) proposed that Ruisdael was stimulated in the early 1650s to use ruins as a principal motif by Jan Both and Jan Asselyn, who had been to Italy and returned to the Netherlands (Both in 1641, Asselyn in 1646 or 1647), where they painted many of their beautiful Italianate landscapes that include large classical ruins. Rosenberg suggests that Ruisdael was introduced to their work by his friend Nicolaes Berchem, whose landscapes from the beginning show his familiarity with Both's pictures and who began to borrow from Asselyn as early as 1652 (see Albert Blankert, *Nederlandse 17e Eeuwse Italianiserende Landschapschilders*, 2nd ed., Soest-Holland, 1978, p. 28).

Rosenberg's proposal is plausible; however, an equally if not more important source of inspiration for Jacob's interest in the subject can be cited: the well-established pictorial tradition in the Netherlands of depicting actual Dutch ruins. The tradition is well-exemplified in works by Dutch landscapists

Fig. 26

Fig. 27

who, to our best knowledge, never crossed the Alps: Willem Buytewech, Claes Jansz Visscher, Esaias van de Velde, Jan van de Velde, and Hercules Segers. There is no need, for example, to search for precedents among the Italianate painters for Ruisdael's *Entrance Gate of the Castle of Brederode*, datable c.1655, at the John G. Johnson Collection, Philadelphia (Fig. 26; HdG 766; Ros 479). The unique impression of Seger's etching of the same subject at the Rijksprentenkabinet, Amsterdam (Fig. 27)—albeit in reverse and seen from a much more dramatic point of view—provides one. E. Haverkamp Begemann, who first made this telling juxtaposition (*Hercules Segers: The Complete Etchings* , Amsterdam–The Hague, 1973, pp. 37–38, 87, no. 40), also notes that comparison of the two works confirms that the artists provided an accurate portrayal of the ruined gate.

The ruins in Ruisdael's Chicago painting readily conjure up images of transience, decay, and death (see Kouznetsov, *op. cit.*). But, as Haverkamp Begemann rightly stresses (*op. cit.*, p. 38) ruins of ancient buildings can also have other connotations. They can be interpreted as visible proof of the durability of man's work and the series of landscape prints of "Pleasant Spots" (*Plaisante Plaetsen*) made by Buytewech, Visscher, and Jan van de Velde show that leading members of an earlier generation of Dutch artists recommended the sites of ruins as fine places for enjoying sylvan pleasures. Whether Ruisdael specifically intended his painting to have any of these meanings is not clear, but it is evident that he was not concerned with giving a topographically accurate picture of the castle's site. The prominent hill he placed behind the ruins, like the one he introduced in his two versions of *The Jewish Cemetery* (Cat. nos. 20, 21), is a product of his imagination.

Firm identification of the ruins as those of the Castle of Egmond aan den Hoef was first made by J.G.N. Renaud in 1940 (*op. cit.*, p. 340, note 1) in his study of the castle's iconography; he also established the location of Ruisdael's drawings of the site (see Cat. nos. 78–80). In the Chicago painting the remains of the southeast corner tower of the main building and the adjacent wall of the south facade are seen.

The castle, situated near Alkmaar, was the seat of the counts of Egmond. Spanish troops occupied it during their invasion of Holland in 1573–74. Soon after they departed the castle was destroyed at the command of the Prince of Orange by the troops of Diederik Sonoy, governor of the northern quarter of Holland, to prevent the Spanish from again using it as an encampment. Since that time the castle has remained a ruin; only a few modest remains of it are visible today. The site, easily accessible from either Haarlem or Amsterdam, obviously intrigued Ruisdael in the early and mid-fifties when monumental forms began to play a key role in his work. Apart from the painting, at least five drawings of the ruins by Jacob, datable about the same time, have been identified; three of them are discussed here (Cat. nos. 78–80). None of the existing sketches relates to the Chicago painting, an indication that he made others which are lost.

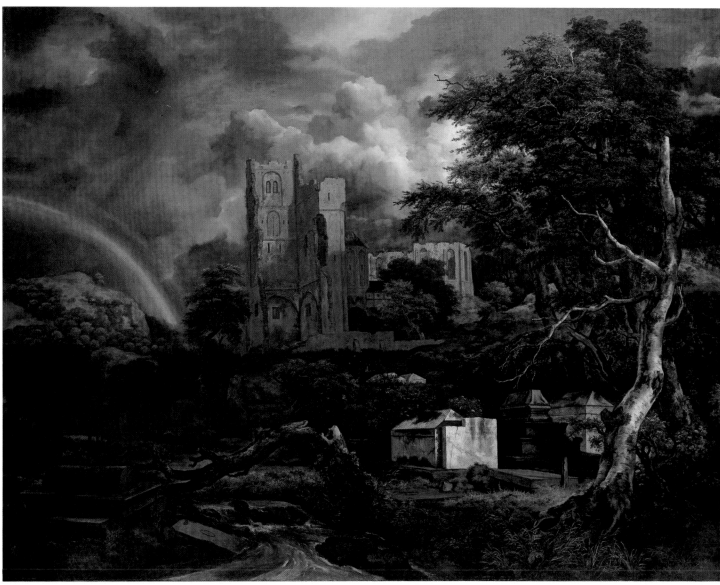

20

Detroit, The Detroit Institute of Arts, Gift of Julius H. Haass in memory of his brother Dr. Ernest W. Haass (no. 26.3) Canvas, 141 x 182.9 cm. Signed on the tomb at the lower left.

PROVENANCE: Possibly sale, Amsterdam, 16 September 1739, no. 88, "Een Joode Begraafplaats, zeer natuurlyk, door denzelven [Ruisdaal]" (11 florins, 10; see Hoet, I, p. 604). According to Smith (60) and Hofstede de Groot (219), the picture had the following early history: Probably sale, Amsterdam, 9 May 1770, no. 2; sale, P. Locquet, Amsterdam, 22 September 1783, no. 315 (40 florins, Vullens); sale, Marin, Paris (Lebrun), 22 March 1790, no. 124 (2,000

francs, Lebrun); sale, Paris, 1802 (3,203 francs); Huybens [Huygens?], who imported it into England, purchased it (20,000 francs) from a banker in Paris c. 1815, and sold it to George Gillows; purchased from Gillows' executors by Mr. Zachary. Sale, M.M. Zachary, London (Phillips), 31 May 1828, no. 51 (£913, 10s). The author of the Zachary sale catalogue notes that: "This magnificent specimen of art merits a place in the Gallery of the greatest Nation on earth—from Monsieur Bonnemaison's collection" (ibid., p. 14). The reference may be to Féréol Bonnemaison (active by 1796–1827), a Parisian artist, picture restorer, and dealer who was particularly

active selling pictures to English collectors, even during the troubled decades that followed the French Revolution (see Haskell 1976, p. 26, note 10); the work does not appear in the sale (Bonnemaison, peintre), Paris (Le Brun), 15–17 July 1802 nor in the sale, Féréol Bonnemaison, Paris, 17–21 April 1827. By 1835 the painting was in the Mackintosh Collection (Smith 60). It then disappeared and only reappeared in the 1920s, when it was acquired by the London dealer Anthony Reyre. According to Zwarts (1928, p. 243) Reyre sold it to Romford, and it appeared in his sale, London (Christie's), 30 April 1924, no. 353; dealers Leo Blumenreich and Frantz M.

Ruisdael's celebrated versions of *The Jewish Cemetery* at Detroit and Dresden (Cat. no. 21) are among the rare landscapes by the master that were painted with a deliberate allegorical intent. The combination of their conspicuous tombs, ruins, large dead beeches, and broken tree trunks alludes to the transience of all life and the ultimate futility of man's endeavors, a common theme in seventeenth-century Dutch art. On the other hand, the burst of light that breaks through the ravening clouds of each painting, their rainbows, and the luxuriant growth that contrasts with the dead trees offer a promise of hope and renewed life. Their allegorical content has been recognized by virtually every author who has discussed them since they entered the literature early in the nineteenth century, but there has been neither unanimous approbation of these overtly moralizing landscapes nor a consensus on their meaning or the mood they evoke.

The Dresden version, smaller by almost half than the Detroit painting, is the better known of the two paintings, thanks to its presence for about 200 years in one of Europe's greatest picture galleries and to Goethe's discussion of it in his famous essay on *Ruysdael als Dichter* (Ruisdael as Poet) written in 1813 and published in 1816 (reprinted in *Goethes Werke*, XII, 1973, pp. 141–42).

Goethe's essay deals with three of Ruisdael's landscapes in the Dresden Gallery: a *Waterfall* (no. 1495; HdG 214; Ros 155), *The Monastery* (no. 1494; HdG 753; Ros 467), and the *Cemetery*. Goethe wrote that the Dresden version of the *Cemetery* is "dedicated to the past" and that "even in their ruined state the tombs point to a past beyond the past; they are tombs of themselves." He did not emphasize a melancholy interpretation of the picture. On the contrary. He cited it as a paradigmatic example of the way a "pure feeling, clear-thinking artist, proving himself a poet, achieves perfect symbolism, and, through the wholesomeness of his outer and inner mind, delights, teaches, refreshes and animates us at the same time."

Goethe's refusal to acknowledge a sorrowful note in the painting was emphasized again in his conversation in 1825 with Friedrich Förster about the *Monastery in Winter* by Karl Friedrich Lessing (1808–80). Goethe criticized the symbolism in Lessing's landscape as a "negation of life." Förster, in his attempt to defend young Lessing's picture, referred to Ruisdael's *Jewish Cemetery* and asked whether it does not show that an elegiac mood has a rightful place in landscape painting. Goethe responded: "Certainly—but only when the marble slabs of the tombs by the magic of the moonlight put us in a benevolent, touching mood, and the trees with their green foliage, grass and flowers make us forget that we are on a burial ground" (see Carl von Lorck, "Goethe und Lessing's 'Klosterhof im Schnee'," *Westdeutsches Jahrbuch für Kunstgeschichte Wallraf-Richartz-Jahrbuch*, IX, 1936, p. 205; Goethe 1816, pp. 611–12).

Zatzenstein, Berlin, 1925; dealer Galerie Matthiesen, Berlin; Julius H. Haass, Detroit, who presented it to the museum in 1926.

EXHIBITIONS: Berlin 1925, no. 339; Detroit 1929, no. 59; Providence 1938, no. 42, repr.; New York 1942, no. 55; Chicago 1942, no. 35; Brooklyn 1945–46, no. 26; Philadelphia 1950–51, no. 41; New York–Toledo–Toronto 1954–55 (shown at Toledo and Toronto), no. 71; Seattle 1962, no. 29, repr.; Leningrad 1976 (shown at Moscow, Kiev, and Minsk), p. 10.

BIBLIOGRAPHY: Taillasson 1807, p. 49; Smith 60; see HdG 219; J. Rosenberg, "Jewish Cemetery by Jacob van Ruisdael," Art in America, XIV, 1926, pp. 37ff. (probably late fifties; Dresden version: the sixties); W.R. V[alentiner]., "'The Cemetery' by Jacob van Ruisdael," Bulletin of the Detroit Institute of Arts, VII, 1926, pp. 55ff., (1660s); Ros 153; Simon 1930, p. 31f. (both versions done 1653–55; Zwarts 1928, pp. 232ff. (c. 1678; Dresden version c. 1679); Detroit Institute of Arts, Catalogue, 1930, no. 196 (1660–70); Wijnman 1932, p. 179 (c. 1678; Dresden version c. 1679); Rosenberg 1933, pp. 217ff. (1650s); Gerson 1934, p. 79 (1660s); Simon 1935-I, p. 158f. (both versions done 1653–55; it is not possible to determine which version was done first); W. Martin, De Hollandsche Schilderkunst in de 17de Eeuw, vol. II, Amsterdam, 1936, pp. 300f., 516, note 512 (1665–75); Gerson 1952, p. 45 (c. 1655; Rosenau 1958, p. 241f. (both versions painted after 1674); Stechow 1966, p. 139f. (neither version can be placed far from 1660); Dubiez 1967, p. 206f. (both versions possibly done after 1674); Wiegand 1971, pp. 57–86 (no reason to date either version after 1674); Kouznetsov 1973, p. 31f.; Vega 1975, passim; Scheyer 1977, pp. 133–46 (both versions c. 1653–55).

In 1807, nine years before Goethe published his essay praising the "thinking artist" who painted the Dresden *Cemetery* as a poet of superb symbolism, the almost forgotten French artist and critic Jean Joseph Taillasson (1745/6–1809) wrote of the surpassing poetic qualities of Ruisdael's landscapes. "One cannot find," he asserted, "in the paintings of other artists of his country a poetry as moving as that which he puts into his own; he inspires a sweet melancholy; this comes, no doubt, from the sensitivity of his soul, from the choice of the objects he painted, and perhaps from the dark color of almost all his greens. Several times he painted the tombs of the Jews in Amsterdam. These silent resting places, surrounded by trees, and with a spirit of sadness, please the eye, with their unity, the simplicity of their form, and with their harmony of color" (Taillasson, *op. cit.*, p. 49; I am indebted to Haskell 1976, p. 111, for knowledge of this romantic critic's appraisal of Ruisdael).

Taillasson refers to the "sweet melancholy" inspired by Jacob's landscapes almost in the same breath that he mentions his paintings of the tombs of the Jews in Amsterdam. If he had the latter in mind when he wrote the phrase, he probably is the earliest critic to call them "melancholic" in print.

Taillasson's specific reference to several paintings by Ruisdael of the tombs of the Jews of Amsterdam also suggests that he had firsthand knowledge of the Detroit version of *The Jewish Cemetery*, which he could have seen in a Parisian private collection between 1790 (see provenance above) and 1807, the date his book was published, as well as of the Dresden *Cemetery*, perhaps through prints made by J. Georg Primavesi (1774–1855) or Philipp Veith (1768–1837). Since he explicitly states that the paintings show the "tombs of the Jews of Amsterdam," he may also have known the two prints Abraham Blooteling engraved in 1670 after Ruisdael's drawings of the site; they are inscribed "*Begraef-plaets der Joden buyten Amsterdam*" (Burial place of the Jews outside Amsterdam; see Figs. 70, 71).

Unlike Taillasson, Goethe either was unaware that Ruisdael depicted Jewish tombs in the Dresden version or did not believe it was worth mentioning their religious identity when he wrote about the sarcophagi in his essay. An earlier compiler, though, described the Dresden painting in an inventory there in 1754 (vol. II, p. 490) as "*Eine dunkele Landschaft, worauf ein Juden-Begräbnis.*" (The earliest known reference to a painting by Ruisdael of a *Jewish Burial Place* is the one listed in an anonymous auction held at Amsterdam in 1739 [see provenance above], but it is not possible to establish whether it refers to the Dresden or the Detroit picture or to one of the untraceable versions mentioned below.)

The title of the Dresden painting given in the catalogue of the gallery published in 1765 was more in accord with classical taste: 'Un Paysage orné de

Fig. 28. The Jewish Cemetery, *detail.*

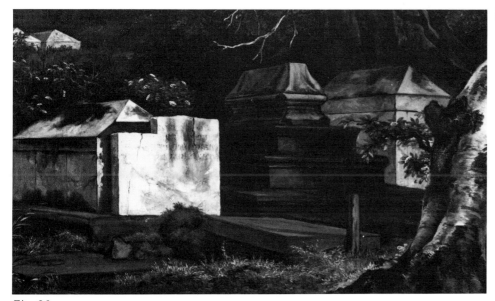

Fig. 28

69

Tombeaux à l'antique, avec une Inscription en lettres hebraïques (*Catalogue des Tableaux de la Galerie Electorale à Dresde*, Dresden, 1765, p. 108, no. 548). The same description of it is cited in *Abregé de la Vie des Peintres dont les Tableaux Composent la Galerie Electorale de Dresde . . .* , Dresden, 1782, p. 423, no. 548. Today, the tombs in neither the Dresden nor the Detroit version bear decipherable Hebrew inscriptions. A close technical examination of them may reveal that they formerly bore them and that the pseudo-Hebraic inscriptions now visible on their paint surfaces were later additions.

Goethe made no remarks about the Dresden *Cemetery* in the catalogue he annotated during the course of his visit to the Dresden Gallery in 1790; evidently the work did not impress him on this early trip. He did, however, make notes about six other Ruisdaels in the collection. The one which made the strongest impression was the artist's *Stag Hunt* (Cat. no. 37: "Vortrefflich und das beste von diesem Meister allhier;" Goethe 1790, pp. 368–87); the painting was not cited in his essay on "Ruisdael as Poet" published sixteen years later.

The changes in Goethe's taste for Ruisdael's work cannot detain us here, but it is worth mentioning that his deep admiration for the artist was

a life-long one, and he collected works by and after the artist. The compiler of the posthumous catalogue of his art collection lists six original etchings by Ruisdael (Ch. Schuchardt, *Goethe's Kunstsammlungen*, vol. I, Jena, 1848, p. 183, nos. 379–85), two prints after his paintings (*ibid.*, nos. 387–387a), and a red chalk, counterproof drawing of *Einige Grabdenkmäler* attributed by the author of the catalogue to Ruisdael (*ibid.*, p. 309, no. 882; the probability that it was a counterproof of a copy is high; to our best knowledge Ruisdael did not make red chalk drawings). Goethe also possessed impressions of Blooteling's prints after Ruisdael's drawings of tombs at the Jewish cemetery outside of Amsterdam (*ibid.*, p. 183, no. 386, the pair; see Figs. 70, 71). Inasmuch as Goethe did not refer to the obvious connection between them and the Dresden painting in his essay on "Ruisdael as Poet," perhaps he did not own the prints before the essay was published in 1816. However, the report Eckermann left of an evening spent with Goethe and some friends looking through a portfolio of Netherlandish prints at the poet's home on 17 February 1830 establishes that he had them by that date. Eckermann notes: "Ruysdael's studies for his Cemetery were then looked at, and from

Fig. 29. The Jewish Cemetery, *detail.*

Fig. 29

them one saw what pains even such a master had taken" (Johann Peter Eckermann, *Gespräche mit Goethe in den letzten Jahren seines Lebens*, ed. F. Bergemann, Wiesbaden, 1955, p. 359).

In 1835, five years after Eckermann recorded Goethe's late remarks about Ruisdael's work, John Smith published the first catalogue of the artist's painted *oeuvre*. His pioneer catalogue introduced the version of the *Cemetery* now in Detroit to the literature (Smith 60). Smith, an exceptionally well-informed London dealer and tireless cataloguer of works by Dutch, Flemish, and French artists, provides us with word that the Detroit painting was imported from Paris into England about 1815 as well as most of what is known of its early history (see provenance above). Smith also knew the Dresden picture. In the introduction to his Ruisdael catalogue (1835, p. 4) he wrote: "Two pictures also, of a highly classical character, merit particular notice: one of them is in the collection of Mr. Mackintosh; the other in the Dresden Gallery. They are styled 'The Jews' Burying Ground'; but are evidently intended as allegories of human life." Smith added in his catalogue entry (*ibid.*, no. 60) on the painting now in Detroit: "In this excellent picture, the artist has evidently intended to convey a moral lesson of human life; and in addition to this, there is a sublimity of sentiment and effect reigning throughout the composition which renders it worthy of the powers of Nicolo Poussin." Smith was more critical of the Dresden version; he called it "a duplicate . . . but differing in size, and inferior in quality, having become dark from time" (*ibid.*).

In 1835, the very year that Smith published the Detroit version of the *Cemetery*, Constable delivered his lecture on Dutch and Flemish landscape painting to the British Institution. Constable referred in his discourse to a Ruisdael painting which, he noted, was called during the artist's lifetime *An Allegory of the Life of Man*. If the Ruisdael painting that Constable had in mind is identical with the Detroit version of the *Cemetery*, which Smith characterized as evidently an allegory of human life intended to convey a moral lesson—and it is difficult to imagine it is not—the great English landscapist also knew the painting. Unlike Smith, he considered it a failure.

Constable did not give his low estimate of the picture before he extolled the outstanding qualities of a winterscape and seascape by Ruisdael. To make his points he used his own copy of the artist's winterscape now in the John G. Johnson Col-

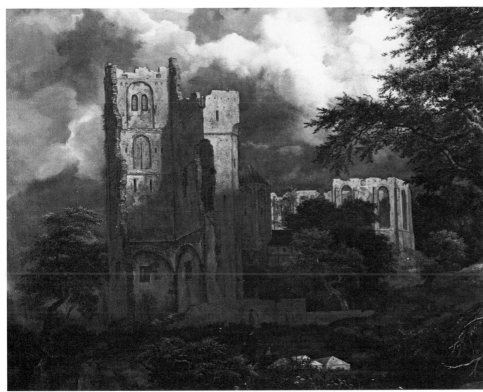

Fig. 30. The Jewish Cemetery, *detail.*

Fig. 30

lection (Fig. 60; for an additional note regarding the copy see Cat. no. 53), and an untraceable copy of an unidentified marine because they exemplified his maxim: "We see nothing till we truly understand it." Then Constable added, "In another instance he [Ruisdael] failed, because he attempted to tell that which is outside the reach of art. In a picture which was known, while he was living, to be called 'An Allegory of the Life of Man' [and it may therefore be supposed he so intended it], there are ruins to indicate old age, a stream to signify the course of life, and rocks and precipices to shadow forth its dangers. But how are we to discover all this?" (R.B. Beckett, *John Constable's Discourses*, Ipswich, 1970, p. 64).

Our knowledge of seventeenth-century Dutch documents throws no light on Constable's source for his statement that a painting by Ruisdael was known while the artist was living as "An Allegory of the Life of Man." Perhaps his statement was based on hearsay or he may have used a lecturer's license to drive home a point by employing a fact a bit recklessly. In any event there can be no doubt that Constable concluded that Ruisdael failed when the intention of important elements in one of his landscapes could not be understood without an exegesis of their signification. Jakob Rosenberg voiced a similar sentiment almost a century later when he wrote of the Dresden *Cemetery*: "Today the symbolic burden of the picture no longer appears to be such a remarkable artistic achievement. We respect Ruisdael more when he solely allows the landscape to speak" (1928, p. 30).

Since the Detroit version completely vanished from sight after Smith published it in 1835, and only reappeared in the London art market in the 1920s, during the intervening decades discussion centered naturally on the Dresden picture. In a study published in 1883, David Henrique de Castro (1883, pp. 17–18, note 34) noted that the conspicuous tombs in the picture are identical with some early seventeenth-century sarcophagi that can still be seen at Beth Haim (House of Life), the cemetery at Ouderkerk on the Amstel River, a village about eight kilometers from Amsterdam. The cemetery is the burial place of the Portuguese-Jewish congregation of Amsterdam.

Castro, who knew the prints Blooteling made in 1670 after Ruisdael's drawings of the Jewish ceme-

tery (Figs. 70, 71), observed that the tombs in the Dresden painting are unmistakably related to those in Ruisdael's two drawings now at the Teyler Museum, Haarlem; for identification of the tombs depicted in them and a discussion of the burial site see Cat. nos. 76, 77. Castro rightly added that, apart from the monuments, the Dresden painting shows nothing of the actual site of the Portuguese-Jewish cemetery at Ouderkerk (*ibid.*). When the Detroit version was rediscovered, it became patent that it also places the tombs at the site in an imaginary landscape. As Ruisdael's two drawings indicate, the cemetery is in a flat landscape, not a hilly one, and no rushing stream runs through it. In addition, the site never had monumental ruins. The largest edifice in the vicinity is St. Urban's Church, an unimposing Romanesque structure which can be seen beyond the trees in the background of the Ruisdael drawing showing the tombs from the rear (Cat. no. 77); it is the Oude Kerk (Old Church) from which the village of Ouderkerk received its name.

Few scholars were better qualified than Castro to identify the tombs Ruisdael depicted and to discuss their setting. He was a member of the Portuguese-Jewish community that had established Beth Haim cemetery in the early seventeenth century, and was responsible for its nineteenth-century restoration. Castro spent more than two decades at the burial site identifying and restoring its monuments; the study he published in 1883 records his findings.

Ruisdael's drawing at Haarlem which depicts the tombs as they can be seen today from the east (Cat. no. 76) or one very similar to it must have served as a preparatory study for the tombs in the Detroit and Dresden paintings. The group of three imposing tombs is seen virtually the way they appear in both paintings. The tomb surmounted by a half-column in the right foreground of the drawing has been transposed in the paintings to the left, and, for pictorial reasons, shown from different points of view.

The ruins in the background of the Dresden version (Fig. 31) evidently were inspired by or based on drawings Ruisdael made of the remains of the Castle of Egmond near Alkmaar (Renaud 1940, p. 340, note 1). One of them, which has elements that may have been incorporated into the paint-

ing, is at Berlin (Cat. no. 78). A copy at Stuttgart (no. C 64/1329) after a lost drawing by Ruisdael shows the ruins from a point of view that bears an even closer resemblance to those in the Dresden picture (Fig. 32).

No preliminary drawings have been identified for the more elaborate ruins in the Detroit painting (Fig. 30), but they were most likely inspired by studies Ruisdael made of the noble remains of the Romanesque Abbey Church of Egmond and the Gothic Buurkerk at Egmond-Binnen, about three kilometers west of Alkmaar. Ruisdael included a more topographical view of the large ruin in the background of his small oil sketch of a windmill, now in the collection of the Earl of Northbrook (HdG 176; Ros 117). For other representations of the site, see the painting by Salomon van Ruysdael, dated 1662, formerly O. Hirschmann, Amsterdam (Stechow 1975, no. 206, Fig. 65) and the print by A. Rademaker (*Kabinet van Nederlandsche Outheden en Gezichten*, Amsterdam, 1725, no. XLV).

On the basis of the ruins seen in the backgrounds of both versions of *The Jewish Cemetery*, J. Zwarts (*op. cit.*) made an unconvincing attempt to establish that both paintings must have been done after 1674. His case rests on the fact that the spire of St. Urban's Church at Ouderkerk (it will be recalled that it can be seen in one of Ruisdael's drawings of the cemetery, Cat. no. 77) was destroyed on 1 August 1674 and on his erroneous assumption that Ruisdael must have seen the damaged spire before he could have painted the Detroit and Dresden pictures. Zwarts went further. On the basis of an inconclusive identification of some of the less conspicuous monuments represented in the paintings and his estimate of the rate at which stone monuments withstand the ravages of time, he concluded that the Detroit picture was painted about 1678 and the Dresden version about 1679. Zwarts does not discuss the problem his very late dates pose when a critical attempt is made to relate the style of the Detroit and Dresden paintings to the idyllic mood of the thinly painted and minutely executed works that are datable to Ruisdael's last years.

Zwarts' *terminus post quem* of 1674 for both pictures was endorsed by H.F. Wijnman (*op. cit.*), revived by Helen Rosenau (*op. cit.*), and was not ruled out by F.J. Dubiez (*op. cit.*). It was rejected with good reason by Jakob Rosenberg (*op. cit.*, 1933), K.E. Simon (*op. cit.*, 1935-I), Wolfgang Stechow (*op. cit.*, 1966), and Ernst Scheyer (*op. cit.*). It is ingenuous to maintain that Ruisdael had to see the tower of the church at Ouderkerk without its spire before he could incorporate a ruin in his paintings. His views of the Castle of Bentheim (Cat. nos. 12, 14) show how readily he combined the real with the imaginary and his numerous Scandinavian waterfalls repeatedly reveal his gift for making convincing paintings of sites he had never seen. Moreover, it should be stressed that if he visited Ouderkerk after St. Urban's Church had been damaged in 1674, he did not see it as a ruin. To be sure, it lost its spire in that year, but according to our only available source, the masonry of the tower remained intact and there is no reference to additional damage to the church. Furthermore, the church was later given a new, smaller spire—hardly the kind of restoration given to a ruin (van der Aa 1846, VIII, p. 678: ". . . de toren [of the church] was vierkant en pronkte, tot in het jaar 1674, met eene hooge spitse kap, die, den 1 Augustus van dat jaar, tot op het muurwerk des gebouws nedergeslaagen werd; de spits werd naderhand weder opgebouwd, echter niet zoo hoog . . ."). Finally, the same ruin is not represented in the Detroit and Dresden paintings, and neither of them resembles the church at Ouderkerk as seen in Ruisdael's own drawing of it (Cat. no. 77), in J. Beerstraten's painting of 1659 (Rosenau, *op. cit.*, p. 241, Fig. 2), or A. Rademaker's engraving (*ibid.*, Fig 3).

The powerful cohesion between the broad expanse of the foregrounds of the Detroit and Dresden paintings and the wall-like impression of the bushes, trees, and ruins beyond them as well as the firm brushwork of their richly detailed forms relate both pictures to Ruisdael's forest scenes and hilly landscapes datable to the mid-fifties. The much larger, brighter Detroit version shows the tombs closer and more to the side. Nature's luxuriant growth, ruins, clouds, and rainbow are more strongly stressed in it than in the Dresden version. The greater compactness and concentration on the motif of the tombs, and the bareness of the beech tree suggest the Dresden picture postdates the Detroit version; however, a long interval of time can hardly separate the two works.

rate the two works.

As the provenance of both paintings makes clear, nothing is known about their early ownership or whether Ruisdael was commissioned to paint them. W. Martin (*op. cit.*, p. 304) suggests that the latter was most likely the case. He writes they were probably commissioned specifically as portraits of the tombs and that their symbolic references were simply added for good measure. Martin finds it difficult to imagine that Ruisdael would have made a variant of the composition without a specific order for it. Scheyer (*op. cit.*, p. 138) also notes that Ruisdael may have received commissions to paint the pictures and proposes that one of them may have been ordered by the family of Eliahu Montalto, the famous doctor (see Cat. no. 76) whose white marble tomb is the most prominent one in both paintings, and that two other versions were probably comissioned afterwards by other members of the Portuguese-Jewish community. Scheyer's proposal is not an impossible one, but it should be noted that the status of the third version to which he refers remains uncertain; it is known only from a reference in Hofstede de Groot (p. 74, no. 219, English edition). This small untraceable version, which may be a copy of the Detroit or Dresden painting, appeared in the sale, R. Pott *et al.*, Rotterdam, 11 October 1855, no. 85, panel, 47 x 62 cm; Zwarts (*op. cit.*, p. 246) notes that it was probably from the collection of the artist and dealer A. Lamme. A fourth version (or a copy of the Detroit or Dresden painting?; support unknown, 72 x 91 cm) passed from the collection of Arthur Kay through the following sales: H. Lane, London, 6 July 1917, no. 119; Miss Seymour and others, London, 23 January 1920, no. 37; W. van Druten and others, London, no. 55; most probably London, 5 June 1925, no. 70. This version may be identical with a copy of the Dresden painting now at the Fine Arts Gallery, Florida State University, Tallahassee (canvas, 76 x 94 cm), where it is attributed to Patrick Nasmyth. I have neither seen the Florida picture nor been able to learn the source of its attribution to Nasmyth, a Scottish artist who worked in Ruisdael's style and that of other Dutch landscapists of his generation.

The suggestion that the paintings were done for Jewish patrons raises the question, mentioned earlier, of the authenticity of the pseudo-Hebraic inscriptions now visible on the tombs in the known versions. If a technical examination establishes that they are indeed part of the original paint layers of the pictures, the possiblity that they were done for members of the Jewish community becomes highly unlikely. It is improbable that one of them would have comissioned or accepted works that had pseudo-inscriptions instead of faithful transcriptions of the original Hebrew texts on the tombs.

Concern for literal transcriptions of Hebrew inscriptions by Jewish patrons is found in the drawing Romeijn de Hooghe (1645–1708) made in 1668 of a group portrait of a Jewish family in a richly appointed interior of a circumcision scene (see William H. Wilson, " 'The Circumcision,' A Drawing by Romeyn de Hooghe," *Master Drawings*, XIII, 1975, pp. 250ff., repr. Pls. 22, 23). De Hooghe's transcription of a Hebrew inscription over the doorway in the interior is clearly legible; his drawings of the two Biblical paintings mounted in the room are also clear enough for identification of their subjects (*ibid.*, pp. 255–56), good proof that some members of the Jewish community decorated their homes with paintings.

According to Wilfried Wiegand's analysis of the paintings (*op. cit.*, pp. 57ff.), they could not conceivably have been commissioned by Jewish patrons. After interpreting virtually every element in the paintings as a symbol of *vanitas* (not only their "pompous" tombs, ruins, broken trees, rainbows, rushing streams, but also their clouds, birds, the suggestion of wind and air—even the three tiny figures in the background of the Detroit painting), Wiegand concludes that the message of the pictures is: "Do not trust formalities, ceremonies, and the ostentatious—as the godless and especially the Jews do—for all these things are as nothing in view of transience's universality" (*ibid.*, p. 82).

There can be little doubt that Ruisdael intended the Detroit and Dresden paintings as moralizing allegories on transience. However, there is no evidence that he thought Jewish customs and tombs examples *par excellence* of man's vanity. Knowledge that Ruisdael probably was a Mennonite, a sect particularly sympathetic to the Jews in seventeenth-century Holland, before he became a member of the Reformed Church in Amsterdam in 1657 when he was about thirty years old, throws no light on the question. Simply nothing is known about

Jacob's thoughts or attitude toward the Jews before or after his conversion. Moreover, when seventeenth-century Christian moralists in the Netherlands cited passages from the Bible to spur their contemporaries to think on the vanity of all worldly things ("vanity of vanities; all is vanity" Eccles. I,2), the frailty of humankind, the brevity of human life, and the certainty of death ("Man that is born of woman is of few days. . . . He cometh forth like a flower, and is cut down" Job XIV, 1–2), they were not merely reminding their listeners of the godless and especially the Jews. Their message was much more general.

The value of tombs for generating thoughts about transience is stated explicitly by Dirck van Bleyswijck in his *Beschryvinge der Stadt Delft*, published at Delft in 1667, about a decade after Ruisdael painted his versions of *The Jewish Cemetery*. Van Bleyswijck's work is an exhaustive two-volume history *cum* Baedeker of the town. At the conclusion of his lengthy account of the monument of Willem the Silent in Delft's New Church (Nieuwe Kerk), then and now the most famous seventeenth-century tomb in the United Provinces, he exhorts his readers to visit tombs every day to consider where one's own corpse will lie, the vanity of ambition, avarice, pride, and other vices, and the fragility of life (*ibid.*, p. 271). If the fortunate possessors of Ruisdael's versions of *The Jewish Cemetery* were inclined to follow his dismal admonition, they were able to comply without making a daily pilgrimage to tombs. They also had the added advantage of repeatedly seeing allusions in their pictures to the promise of hope and new life as well as enjoying landscapes that rank with the most imposing done during Holland's great age of painting.

The Jewish Cemetery

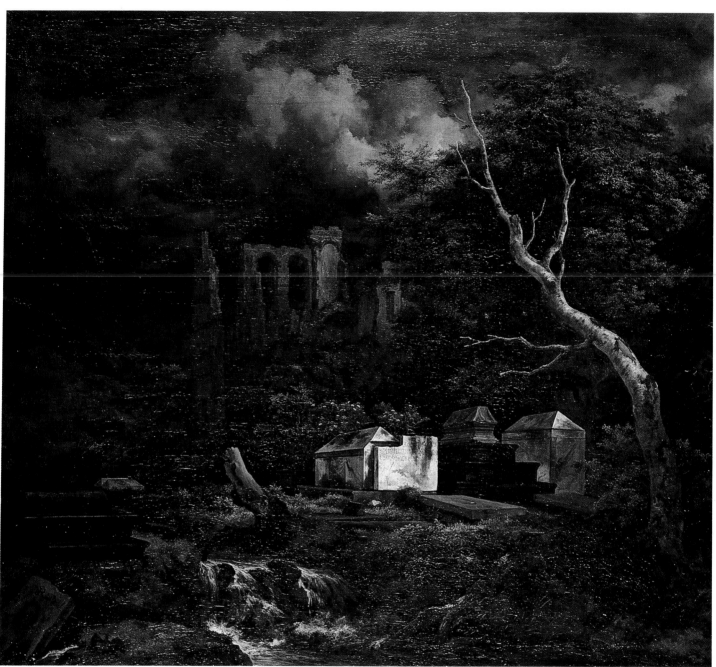

21

Dresden, Staatliche Kunstsammlungen (no. 1502)
Canvas, 84 x 95 cm. Signed on the tomb in the lower left.

PROVENANCE: Possibly sale, Amsterdam, 16 September 1739, no. 88 "Een Joode Begraafplaats, zeer natuurlyk, door denzelven [Ruisdaal]" (11 florins, 10; see Hoet, I, p. 604). In the Dresden inventory of 1754, II, p. 490 ("Eine dunkele Landschaft, worauf ein Juden-Begräbnis").

EXHIBITIONS: Berlin 1955–56, p. 102; Zurich 1971, no. 41; Washington–New York–San Francisco 1978–79, no. 561, repr. (c. 1660).

BIBLIOGRAPHY: Goethe 1816, pp. 141–42, 611–13; Smith 60 (describes the Dresden painting as "a duplicate, differing in size and inferior in quality, having become dark by time" of the version

now in Detroit (Cat. no. 20); Castro 1883, pp. 17–18, note 34; HdG 219; Ros 154; Renaud 1940, p. 340, note 1 (motifs taken from the Castle of Egmond are recognizable); Carus [1955], pp. 83–84; Gemäldegalerie, Dresden, Catalogue, Alte Meister, 1979, p. 289, no. 1502.

Engraved by J. Georg Primavesi (1774–1855), Philipp Veith (1768–1837), and Ludwig Friedrich (1827–1916).

For additional bibliographical references and discussion of the painting and its relation to the larger version at Detroit, see Cat. no. 20.

The famous painting has been copied numerous times, particularly during the first half of the nineteenth century. Ferdinand Georg Waldmüller (1798–1865) copied it when he visited Dresden in 1827. A copy attributed to the Scottish artist Patrick Nasmyth (1787–1831), who worked in Ruisdael's as well as Hobbema's and Wynants' manner, is at the Fine Arts Gallery, Florida State University, Tallahassee (canvas, 76 x 94 cm); for its possible provenance, see Cat. no. 20. An older, partial copy by an anonymous artist is at Budapest: *Waldansicht mit Ruine* (canvas, 67.5 x 55.5 cm; Budapest Catalogue, 1967, p. 603, no. 53.410); formerly collection Count Edmund Zichy, Vienna. It is based on the right part of the picture and includes the beech tree and part of the ruined church but eliminates the tombs.

Fig. 31

Fig. 32

Fig. 31. The Jewish Cemetery, *detail.*

Fig. 32. After Ruisdael, The Ruins of the Castle of Egmond. *Stuttgart, Staatsgalerie.*

Two Water Mills and an Open Sluice

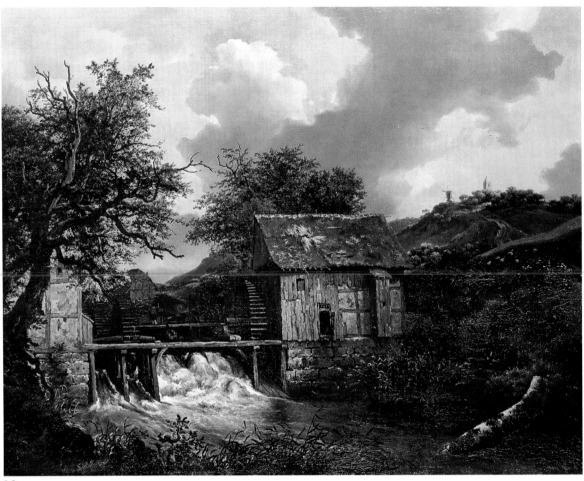

22

London, The National Gallery, The Trustees of the National Gallery (no. 986) Canvas, 87.3 x 111.5 cm. Signed lower left.

PROVENANCE: Probably sale, Thomas Emmerson, London, 15–16 June 1832, no. 151 (£504); probably in the collection of Wynn Ellis, London, by 1854; he bequeathed it to The National Gallery in 1876.

EXHIBITIONS: London, British Institution, 1860, no. 94; London, Royal Academy, 1871, no. 56.

BIBLIOGRAPHY: Smith 17; Waagen 1854, II, p. 297; HdG 148; Ros 100; MacLaren 1960, pp. 359–60, no. 986 (c. 1650–52).

Fig. 33. Jacob van Ruisdael, Two Water Mills and an Open Sluice. Formerly Chippenham, Wilts., Grittleton House, Sir Audley Neeld.

Fig. 34. J.J. de Boissieu (after Ruisdael), The Great Mill. Etching.

Fig. 35. Jacob van Ruisdael, Two Water Mills and an Open Sluice. Winchcombe, Cheltenham, Gloucestershire, Dent Brocklehurst Collection.

Fig. 33

Fig. 34

Fig. 35

Among the themes Ruisdael discovered during the course of his trip to Bentheim was the water mill. The research of K. Döhmann and W.H. Dingeldein (*Singraven, De Geschiedenis van een Twentsche Havezate*, III, 1934, pp. 144–45) has made it possible to identify a water mill he visited in its vicinity during the early fifties. Almost certainly it served as the point of departure for the National Gallery's imposing picture as well as for a group of closely related paintings.

Döhmann and Dingeldein's contribution concerns Hobbema, not Ruisdael. They established that two of Hobbema's well-known landscapes with water mills (Louvre, Paris, no. M.I. 270; HdG, Hobbema 89; Broulheit 441, and The National Gallery, London, no. 832; HdG, Hobbema 76; Broulheit 220) represent the water mills that belonged to the manor house of Singraven near Denekamp, a village in the eastern part of the province of Overijssel. But thanks to their identification, Ruisdael's *Two Water Mills*, formerly in the E. Habich Collection, Cassel (HdG 170; Ros 97; photo R.K.D.; a smaller version last appeared in the sale, Ant. W.M. Mensing, Amsterdam [Muller], 15 November 1938, no. 88, photo R.K.D.) can be pinpointed as a view of the same site. The two water mills in the Habich painting are virtually identical with those that can still be seen at Singraven. Neil MacLaren (*op. cit.*, p. 360) suggests a date of 1649 for the Habich picture, but close analogies between it and Ruisdael's pictures dominated by large trees done during his *Wanderjahre* indicate it was painted a few years later. The artist most probably visited the picturesque site during his trip to the border region between the United Provinces and Germany; Denekamp is merely thirteen kilometers from Bentheim. A chalk and wash drawing related to the aforementioned paintings is at the Rijksprentenkabinet, Rijksmuseum, Amsterdam, where it is attributed to Ruisdael (no. A 1390; Giltay 4); it is, however, a work done in Jacob's manner by a later seventeenth-century hand (Dalens?).

The Habich picture shows an upstream view of the two undershot water mills. The National Gallery painting, and variants of it, depict them from the downstream side. As in his paintings of the Castle of Bentheim, Ruisdael changed the landscape settings in the variants (there are no hills near Singraven); he also made changes in the mills.

A variant that places the large oak behind the left water mill instead of in front of it and shows the right mill partially demolished was formerly in the collection of Sir Audley Neeld, Chippenham, Wiltshire (Fig. 33; panel, 51 x 66.5 cm; HdG 147; Ros 99). Another painting, known from an engraving (Fig. 34) by J.-J. de Boissieu, dated 1782, done when it was in the collection of François Tronchin, Geneva (sale, Paris [Constantin], 23–24 March 1801, no. 163; panel, 47.5 x 62.5 cm; HdG 196), is very similar to the Neeld water mills, but it extends further to the right; it shows two men sketching and it omits the sheep. There is a reduced version of the Neeld picture at Strasbourg (panel, 35 x 44 cm; HdG 157; Ros 108). A weak variant by another hand (or a copy after a lost Ruisdael) related to the Neeld and Strasbourg paintings appeared in the sale, Lucerne (Fischer), 16 June 1959, no. 2434 (panel, 52 x 68 cm); Lillian Berkman, New York, The Berkman painting was exhibited in *Cinco siglos de obras maestras de la pintura en colecciones norteamericanas cedidas en préstamo a Costa Rica*, Museo de Jade, San José, 6 May–30 June 1978, no. 21, repr. (wrong dimensions).

A fine variant that shows the righthand mill in a further state of deterioration is in the Dent Brocklehurst Collection, Sudley Castle, Winchcombe (Fig. 35; canvas, 86.5 x 90 cm; HdG 150 [wrong dimensions]; Ros 103 [wrong dimensions]).

Since there is no reason to believe that Ruisdael made topographically accurate representations of the site in his downstream paintings of the two mills, it is not possible to rely on the state of preservation of the righthand water mill as a reference point for the relative chronology of the paintings cited above. However, the more complex spatial arrangement and greater openness in Jacob's painting, dated 1653, of a downstream view of the two water mills seen from the opposite bank (see Cat. no. 23) suggest that all of them probably pre-date it.

The rushing cascades falling from the broad open sluices in these pictures show that, by the early fifties, Jacob was a master at portraying powerful torrents and seething foam—an ability that stood him in good stead toward the end of the decade when he began to paint motifs he had never seen: Scandinavian waterfalls (see Cat. no. 34).

Two Water Mills and an Open Sluice

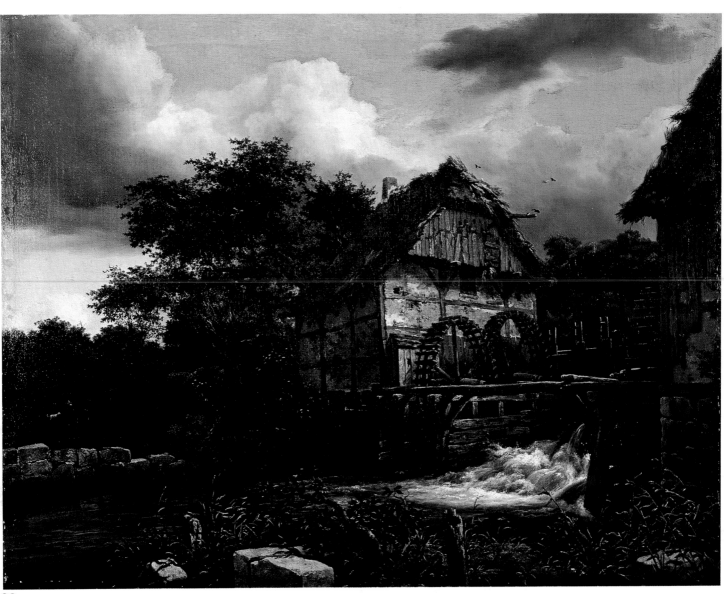

23

Private Collection
Canvas, 66 x 84.5 cm. Monogrammed and dated 1653 on the stone embankment on the left.

PROVENANCE: Sale, Jhr. J. Goll van Franckenstein, Amsterdam, 1 July 1833, no. 70 (1,980 florins, Clarke for C.J. Nieuwenhuis); sale, Casimir Périer, London, 5 May 1848, no. 13 (£367, 10s, Gardner); sale, J.D. Gardner of Bottisham Hall, Cambridgeshire, London, 25 March 1854, no. 71 (£451, 10s, Brown; a manuscript note in the R.K.D. annotated copy of the catalogue states that the painting is dated 1653); sold by Brown to Edmund Foster, Clewer Manor, near Windsor; sale, Richard Foster of Clewer Manor, London, 3 June 1876, no. 13 (£1,837, 10s, Durlacher); Alfred de Rothschild, 1876; Baroness Mathilde von Rothschild, Frankfurt a.M.; art market, Berlin, 1923–25; dealer Kleykamp, The Hague, Catalogue, 1927, no. 34, repr.; H.M. Clark, London, c. 1930; private collection, Switzerland, 1945; sale, Laren N.H. (Christie's), 20 October 1980, no. 252, repr.

EXHIBITION: Basel 1945, no. 79.

BIBLIOGRAPHY: Smith 250, also see Smith 111; Waagen 1857, IV, p. 287 (wrong dimensions and support); HdG 169d; Ros 102 (wrong dimensions; wrongly said to be identical with HdG 171); Simon 1930, p. 81.

The present work of 1653 is the only surviving painting by Jacob of a water mill theme that bears a date in the 1650s. See Cat. no. 22 for a discussion of a group of others that may slightly pre-date it, and for evidence supporting the supposition that all of them were inspired by the undershot water mills Ruisdael saw at the estate of Singraven near Denekamp during the course of his travels to the Dutch-German border region.

Earlier references to the 1653 painting give diverse descriptions of its size and support, and partially confuse its provenance with a painting of two water mills datable about the same time that was formerly in the collection of Lord Swaythling, London (Fig. 36; HdG 152, identical with HdG 163 and HdG 171; Ros 107). The schemes of the two paintings are similar, but there are notable differences in the treatment of the landscape, the angle from which the mills are seen, the design of the principal mill, and the state of preservation of the mill on the right.

Ruisdael's *Water Mill in a Wooded Landscape*, dated 166(1?) at the Rijksmuseum, Amsterdam, is his only other painting of the theme that bears a date (no. C 213; HdG 145 [dated 1661], possibly identical with HdG 158i; Ros 93 [dated 1661]). Today, the last digit of the date on the Amsterdam picture is virtually illegible, but since Hobbema, Ruisdael's pupil, based a series of water mills on it, some of them dated 1662, there is little reason to doubt the date of 1661 read on it by earlier students. Ruisdael did not paint the theme often in the following years. The subject, however, soon became one of Hobbema's specialities, and today, when we think of the theme, his paintings not Ruisdael's come to mind. A fresh look at the powerful group of water mills Ruisdael painted before Hobbema held a brush in his hand indicates that they have been unduly neglected.

Fig. 36. Jacob van Ruisdael, Two Water Mills and an Open Sluice. *Formerly London, Lord Swaythling.*

A Windmill on a River Bank

24

Private collection
Canvas, 49.5 x 66.5 cm. Monogrammed,
lower right.

PROVENANCE: *A handwritten label*
pasted to the stretcher reads: Frederick
Wright Esq./Lenton Hall/Nr Notting-
ham; dealers P. & D. Colnaghi, London;
G. Martius, Kiel; dealer W. Bernt,
Munich, 1933; dealer O. Hirschmann,
Amsterdam, 1934; dealer Cassirer,
Amsterdam, 1936; dealer Feilchenfeldt,
Zurich; dealer C. Duits, London; Mr.
and Mrs. David Birnbaum, New York;
dealers Lock and Baer, New York, 1944;
J. T. Cremer, New York; sale, J.T. Cre-
mer, Amsterdam (Sotheby Mak vanWaay),
17 November 1980, no. 16; dealer Robert
Noortman, London.

EXHIBITIONS: *According to a printed*
label on the stretcher it was exhibited
at the Midland Counties Art Museum,
Nottingham Castle (Mr. Wright);
Montreal, Art Association of Montreal,
Five Centuries of Dutch Art, *9 March–*
9 April 1944, no. 73 (Lent by Mr. and
Mrs. D. Birnbaum).

BIBILIOGRAPHY: *HdG 172; Ros 112;*
Eduard Plietzsch, "Randbermerkungen
zur Ausstellung holländischer Gemälde
im Museum Dahlem," Berliner
Museen, Berichte aus den ehem.
Preussischen Kunstsammlungen,
Neue Folge, I, nos. 3–4, 1951, p. 42.

This poetic landscape is one of the rare ones by the artist that makes a windmill its principal motif. It is closely related to a black chalk drawing which shows the mill from the same point of view but minimizes the height of the river bank (Fig. 37; formerly Kunsthalle, Bremen, no. L 295; lost in the Second World War; 9.4 x 15.1 cm.; Giltay 28). The drawing belongs to a group of black chalk sketches datable to the late forties and first half of the fifties (see Cat. nos. 67, 68). To judge from the

painting's clear silvery air, its relatively vivid colors, and the heavy viscosity of its paint it was done about 1655. Comparison of the two works gives a glimpse of the way Ruisdael transformed an initial light sketch, most probably done from nature, into a vigorous painting with large solid forms seen against an airy sky and strong contrasts of light against dark.

The Bremen black chalk drawing had a companion piece that was identical in size, medium and style (Giltay 29) which depicted a different windmill on the bank of a river; it was another Bremen casualty of the Second World War. The lost pendant is related to Ruisdael's little painting of a *Windmill and a Cottage on a River Bank*, now at The Detroit Institute of Arts (no. 1953.352; panel, 31.8 x 35 cm; Smith 135; HdG 181, possibly identical with HdG 190; Ros 110; Stechow 1966, p. 59, repr.; another drawing of a mill and cottage likewise similar to those in the Detroit picture is at the Hermitage, Leningrad, no. 300 [Ros Z 36; Giltay 66]).

Giltay (28) suggests that the pair of lost Bremen drawings is probably identical with two sheets that appeared as a lot in the sale, S. Feitama, Amsterdam (de Bosch), 16 October 1758, no. G.30, and again as a lot in the sale, H. Busserus, Amsterdam (van der Schley), 21 October 1782, no. 378. In both sales the drawings were identified as "The Windmill at the Horse Pond outside the Haarlemmerpoort and the other near the Zaagmolenpoort." Although Giltay's suggestion may very well be correct, the question of determining whether one or the other drawing represents the former or latter windmill remains unresolved.

A much smaller and better known version of the present painting, with minor changes in the composition, is at the Staatliche Museen, Berlin (Fig. 38; no. 885J; panel, 23.5 x 34.5 cm; monogrammed, lower left). It was singled out as "un Tableau très piquant" as early as 1760 by J.D. Descamps (*La Vie des peintres flamandes, allemandes et hollandais*, vol. III, Paris, p. 12) when it was in the collection of Comte de Vence, Paris, and it has been accepted as an original by Smith (21), Hofstede de Groot (179), Rosenberg (109) and Eduard Plietzsch (*op. cit.*). Jan Kelch, the author of the entry on the picture in the *Katalog, Gemäldegalerie, Staatliche Museen, Berlin*, 1975, (p. 380) expresses doubts about the attribution, and sees a connection between it and works done by Ruisdael's late seventeenth- and early eighteenth-century followers. I see no reason to reject the traditional attribution of the little oil sketch to the artist. It was most probably done before Ruisdael achieved the intense light-dark contrasts, concentrated accents, clarification of the spatial arrangement, and heightening of the towering effect of the modest windmill that distinguish the larger variant.

A third version was in the Cremer collection (no. 470; panel, 31 x 41.5 cm.; Broulhiet 155, repr. [wrongly attributed to Hobbema]). Old photos of the untraceable work suggest it is a copy of the Berlin picture.

Fig. 37. Jacob van Ruisdael, Windmill near a River Bank. *Formerly Bremen, Kunsthalle (lost in the Second World War).*

Fig. 38. Jacob van Ruisdael, A Windmill on a River Bank. *Berlin, Staatliche Museen, Gemäldegalerie.*

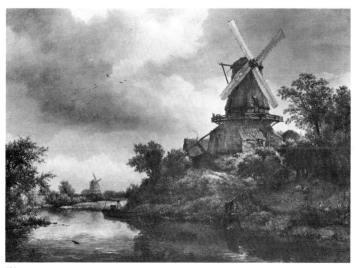

Fig. 38

Dune Landscape, with a Herdsman, Sheep, and Goats

25

Paris, Fondation Custodia (collection F. Lugt), Institut Néerlandais (no. 6484) Panel, 19.5 x 26 cm. Monogrammed, lower right.

PROVENANCE: Possibly sale, [Ségur (le Mal de)], [Clesle (de)], [Beaudoin], e.a., Paris (Paillet), 9 April 1793, no. 45 (231 francs, Petit); sale, J.B.P. Lebrun, Paris, 23 May 1814, no. 132; Matthew Anderson, Jesmond Cottage, near Newcastle-on-Tyne, by 1857; E. Warneck, Paris; sale, E. Warneck, Paris, 27–28 May 1926, no. 74 (staffage probably by A. van de Velde); E. Veltman, Bloemendaal; dealer O. Wertheimer, Paris, 1952; F. Lugt, Paris.

EXHIBITION: Leeds 1868, no. 856 (Matthew Anderson).

BIBLIOGRAPHY: Waagen 1857, IV, p. 483 (staffage by Berchem); Michel 1910, repr. p. 153 (in the collection of E. Warneck); HdG 914d; Ros 537 (staffage by A. van de Velde).

The dunescape, which Gustav Friedrich Waagen (*op. cit.*) aptly characterized as "a picture of the rarest delicacy," belongs to the precious group of little paintings that Ruisdael began to produce as a young artist in Haarlem and continue to make until his last years. Like every great master of the heroic age of Dutch painting, Ruisdael was as much at home working on a small scale as a large one.

The present painting, one of the smallest pictures of the group, is datable to the mid-fifties. Two others that are datable to more or less the same time are shown here (Cat. nos. 26,28). In one case there is a correlation between the size of his pictures and his subject; he had a penchant for doing diminutive winter landscapes (see Cat. no. 41).

Since hardly any of Jacob's small pictures can be related to the works he did on a grander scale, it seems that most of them were done not as preparatory oil sketches for more ambitious paintings but were intended as independent works of art. This must have been the case here: The Fondation Custodia dunescape would look curiously empty without the help of Ruisdael's collaborator —most likely Adriaen van de Velde (1636–72)— who "finished" the picture by contributing the Italianate herdsman with his flock in the foreground.

Although not a word is known about the reaction of Ruisdael's clientele to his work, the existence of this series of intimate landscapes on various themes indicates that a group of his patrons must have been as charmed by their freshness and directness as we are.

View from the Dunes to the Sea

This little painting of a stretch of stormy sea and a high ominous sky seen from the dunes that are the natural dike between Holland and the sea is datable to the mid-fifties. Its compositional scheme of strata of dunes with a marine view beyond is reminiscent of beachscapes Jan van Goyen and Simon de Vlieger painted in the previous decade. Ruisdael, however, has introduced more emphatic contrasts into his painting, which increase the effect of solidity. Most striking is the luminous area of the sandy dune in the center seen against the dark gray sky. His paint is heavier than theirs, his touch more varied and vibrant. Few pictures capture greater freshness of sea air in a high wind.

During the course of the following decades Ruisdael produced some beachscapes proper (see Cat. no. 49), but we know only one other painting of a beach scene seen from the dunes (Fig. 39; canvas, 62.8 x 87.5 cm; private collection); it is datable to the 1670s. In it the vantage point is higher and more distant, and the view of the sea is far more extensive. A drawing by Guillam Du Bois (1623/25–80), at the Fondation Custodia, Paris (Fig. 40; no. 3852; black chalk, heightened with white, on brown paper; 22.3 x 42.9 cm), is closely related to it. Du Bois' drawing has been dated to about 1647–50 (Brussels-Rotterdam-Paris-Berne 1968–69, p. 47, no. 42, Pl. 129, c. 1647; J. Giltay, "Guillam du Bois als tekenaar," *O.H.*, XCI, 1977, pp. 155–56, Fig. 15, c. 1650). Since little in Du Bois' *oeuvre* indicates that he was capable of anticipating Ruisdael's achievement by about two decades, the date that has been assigned to his drawing is most likely too early. The link between the drawings Du Bois did in the late 1640s and those done by Ruisdael about the same time has been rightly stressed by Giltay (*ibid., passim*). Du Bois' drawing at the Fondation Custodia suggests that he continued to be influenced by Ruisdael's work during the final phase of his career.

Fig. 39. Jacob van Ruisdael, View of the Sea from the Dunes. *Private collection.*

Fig. 40. Guillam Du Bois, Beach Scene. *Paris, Institut Néerlandais, Fondation Custodia (Coll. F. Lugt).*

Fig. 39

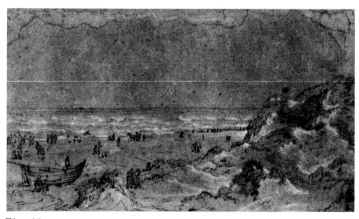

Fig. 40

26

*Zurich, Kunsthaus, Stiftung Prof. Dr.
L. Ruzicka (no. R. 31)*
*Canvas, 26 x 35.2 cm. Signed, lower
right.*

*PROVENANCE: Possibly sale, [A.
Paillet], Paris (Paillet), 15 sqq. Decem-
ber 1777, no. 236; possibly sale, Paris
(Paillet), 22 sqq. February 1779, no.
132; Andrew Fountaine, Narford Hall,
1850; sale, Andrew Fountaine, London
(Christie's), 7 July 1894, no. 33; sale,
Hope Edwardes and others, London
(Christie's), 27 April 1901, no. 57 (300
guineas, Wallis); Maurice Kann, Paris;
dealer F. Kleinberger, Paris; A. de
Ridder, Cronberg, near Frankfurt a.M.;
sale, F. Kleinberger, New York, Novem-
ber–December 1913, no. 57 (an extract*

*of Bode's 1913 catalogue of the de Ridder
Collection); sale, de Ridder, Paris, 2 June
1924, no. 63; dealer K.W. Bachstitz,
The Hague; dealer Paul Cassirer, Am-
sterdam, 1957.*

*EXHIBITIONS: Zurich 1949–50, no.
31, repr.; Rome 1954, no. 126; Milan
1954, no. 129, repr.; Cologne 1954,
no. 22.*

*BIBLIOGRAPHY: Waagen 1854, III,
p. 430; W. Bode,* Die Gemälde-
Galerie des herrn. A. de Ridder,
*Berlin, 1910, no. 81; HdG 922, identical
with HdG 937; W. Bode,* Collection . . .
de Ridder, *Berlin, 1913, no. 57, repr.;
Ros 573; Simon 1930, p. 76; Stechow
1966, p. 105, repr.*

A Rough Sea

27

Private Collection
Canvas, 98.5 x 131 cm. Signed, bottom
right of center.

PROVENANCE: *The history of this*
picture was muddled by earlier cata-
loguers; it was clarified by Bille (see
Bibliography below). She notes that
Smith (2), Waagen (1854, III, pp. 158–
59), and Hofstede de Groot (945) erred
in stating that it was in the Anthony
Sydervelt sale, Amsterdam, 23 April
1766, no. 49. Lot 49 in that auction was
purchased by Locquet and was in his
sale, 22 September 1783, no. 314 (1,410
florins); it is now in the Louvre (no.

1818; The Tempest; *HdG 961; Ros*
596). She also notes that Smith (2),
Waagen (op. cit.), and Hofstede de
Groot (945) wrongly state that it was in
the Paillet sale, Paris, 19 July 1802.
There was a Ruisdael in the Paillet sale,
Paris, 18 April 1803, no. 203, but it
was much smaller: 44 x 55 cm. To our
best knowledge the present picture's
correct provenance is: Sale, Hoogeveen,
Amsterdam, 5 June 1765, no. 36 (214
florins, Fouquet for Braamkamp; see Ter-
westen, p. 465); Gerard Braamkamp ap-
parently tried to sell the painting 4 June
1766, no. 6, as a work by Dubbels; that

sale catalogue gives the same description
and the same dimensions given to lot no.
198 in Braamkamp's 1771 sale (see below;
moreover, a pencil note in a contemporary
hand in an edition of the 1766 sale cata-
logue states that the painting is by Ruis-
dael; see Bille, op. cit., pp. 82, 117);
sale, Gerard Braamkamp, Amsterdam,
31 July 1771, no. 198 (264 florins, P.
Fouquet); bought privately by John Smith
from the family of the Marquis Marialva,
1824 (for 9000 francs); from Smith to the
Earl of Liverpool (£500); sale, Earl of
Liverpool, London, 25 March 1829, no.
76 (£535, Lord Lansdowne); Marquis of

The pronounced contrast in this impressive marine between the broad dark foreground and the band of wind-whipped waves beyond it that has been illuminated by a brilliant burst of sunlight is still redolent of the seascapes Ruisdael painted in the Porcellis-Vlieger tradition. It has been proposed here that an early marine of this group is at Stockholm (Cat. no. 11). The much finer gradations in both the light and dark areas of the painting, which heighten the spatial effect, suggest that it postdates the Stockholm marine by a few years.

Jacob employed an unusually restricted palette for the work: black, white, blue, and some warm brown earth colors (probably ochre, burnt sienna, and/or umber). A few slightly rubbed passages (for example, in the foreground of the breakwater that supports the tall beacon) indicate that in this case the artist used a warm brown ground for a painting that has a predominantly cool tonality.

A copy of the painting by another hand, which misses the extraordinary range of grays of the original, is at The National Gallery of Ireland, Dublin (no. 916), where it is wrongly attributed to Ruisdael: canvas, 90 x 124 cm.; it is also erroneously ascribed to the artist by Hofstede de Groot (960) and Rosenberg (595).

There is a story about Turner connected with the Dublin copy. When it appeared in the sale, James Ross, London, 8 July 1927, no. 24, it was claimed that Turner had copied the picture when it was in the collection of his patron H.A.J. Munro, and that he called his copy *Port Ruysdael* (exhibited in 1827, now at the Yale Center for British Art, New Haven; see M. Butlin and E. Joll, *The Paintings of J.M.W. Turner*, vol. I, New Haven and London, 1977, pp. 131–32, no. 237, repr., with wrong provenance for the Ruisdael that was in Munro's collection). This account is apocryphal. Although the Dublin picture was in Munro's collection, he only acquired it in 1856, twenty-nine years after Turner painted *Port Ruysdael* and five years after Turner's death.

Even if it could be established that Turner saw either or both versions of Ruisdael's seascape before he painted *Port Ruysdael*, it would be wrong to claim there is more than a general resemblance between them. Turner conjured up another, more personal vision of the port of homage in his *Fishing Boats Bringing a Disabled Ship into Port Ruysdael* (exhibited in 1844; now in The Tate Gallery, no. 536; *ibid.*, p. 232, no. 408, repr.). The year after Turner died, Peter Cunningham rightly noted that Turner's "'Port Ruysdael' was a fancy name after the great painter" ("The Memoir," pp. 29–30, in John Burnet, *Turner and His Works*, London, 1852).

For Turner's comments on Ruisdael's *Coup de Soleil* and the sketch he made of it when he saw it at the Louvre in 1802, see Cat. no. 47 and Fig. 57.

Lansdowne, Bowood, Calne, Wilts.; dealer Th. Agnew, London, c. 1950; Lady Nairne, London; dealer Th. Agnew, London, c. 1976.

EXHIBITION: London, Royal Academy, 1884, no. 191.

BIBLIOGRAPHY: Smith 2; Jameson 1844, pp. 318–19, no. 86; Waagen 1854, III, pp. 158–59; HdG 945, identical with HdG 966; Ros 579; C. Bille, De Tempel der Kunst of het Kabinet van den Heer Braamkamp, vol. II, Amsterdam, 1961, pp. 48, 48a, 82, 116, 117.

Dune Landscape with a Rabbit Hunt

28

We have already had a foretaste of the celebrated panoramic views that Ruisdael painted in his maturity in his precocious *View of Naarden*, dated 1647 (Cat. no. 6). The fresh colors and grainy paint place this delectable little flat landscape in the early or mid-fifties. Like so many of his small oil sketches done during the decade, it permits us to share his keen enjoyment of the observation of natural phenomena. It also helps dispel the conventional notion that Ruisdael painted only dark, gloomy landscapes. K.E. Simon's doubts about the authenticity of this dunescape (*op. cit.*, 1930 and 1935) were rightly rejected by Wolfgang Stechow (*op. cit.*). Its style is compatible with that of other little pictures Jacob painted during this phase of his career; the format, the rich alteration of lights and darks in the fields, and the palpable clouds in the high sky anticipate his later panoramas.

Haarlem, Frans Hals Museum (no. I-299) Panel, 33 x 38 cm. Monogrammed, lower left.

PROVENANCE: *Sale, Plessis-Bellière, Paris, 10 May 1897, no. 129; dealer E. Warneck, Paris; bought in Paris in 1900 for the museum by the Society for the Extension of the Art Collection and Antiquities in the Frans Hals Museum.*

EXHIBITIONS: *Brussels 1935, no. 765; Eindhoven 1948, no. 56; Paris 1950–51, no. 70; London 1952–53, no. 309; New York–Toledo–Toronto 1954–55, no. 70.*

BIBLIOGRAPHY: *Château de Moreuil, Catalogue, 1884, no. 195; HdG 885; Ros 545; Simon 1930, p. 76 (not by Ruisdael; probably painted at a later date); Simon 1935, p. 192 (Kessel); Stechow 1968, pp. 45, 48, 195, note 41 (Simon doubted it without sufficient reason); Frans Hals Museum, Haarlem, Catalogue, 1969, p. 58, no. 257; Burke 1974, p. 7.*

Extensive Landscape with a View of the Town of Ootmarsum

29

Munich, Alte Pinakothek, Bayerische Staatsgemäldesammlungen (no. 10818) Canvas, 59.1 x 73.2 cm. Falsely signed, lower right.

PROVENANCE: Acquired in 1942 from the collection Prince Ernst von Sachsen-Meiningen by the Bayerische Staatsgemäldesammlungen, Munich.

EXHIBITION: Enschede, Rijksmuseum Twenthe, Oost-Nederland Model: Landschappen, Stads-en Dorpsgezichten, 3 April–25 May 1980, p. 68, no. 18 (the painting was catalogued but not exhibited).

BIBLIOGRAPHY: HdG 37; Ros 27; Stechow 1966, p. 48 and Fig. 82; Alte Pinakothek, Munich, Catalogue, 1967, p. 76, inv. no. 10818; Dietrich Maschmeyer, "Jacob Isaackzoon van Ruisdael und Meindert Hobbema malen Motive aus der Grafschaft Bentheim und ihres Umgebung," Jahrbuch des Heimatvereins der Grafschaft Bentheim, 1978, p. 61; Z. Kolks, "Een tot nu toe niet bekend gezicht op Ootmarsum in München," Jaarboek Twenthe, XVII, 1978, pp. 89ff. (c. 1650); Z. Kolks, "Ruisdael's gezicht op Ootmarsum," 't Inschrein, XI, no. 2, 1979, pp. 21–24 (painted in the sixties or later).

The painting was identified as a veiw of Beverwijck (HdG 37; Ros 27; Stechow, *op. cit.*) until Dietrich Maschmeyer (*op. cit.*) convincingly established that it is a view of Ootmarsum, a small town in eastern Overijsel near the German border; the town is about twenty kilometers from Bentheim. Ootmarsum's medieval church of Saints Simon and Jude with its distinctive pseudo-double transept is seen slightly to the right of the center towering above the red tile roofs of the town's small houses with their characteristic planked gables. The church still stands, but its tower was demolished before the middle of the nineteenth century because of its ruined condition; it was replaced by a smaller one. The windmill on the extreme left has been identified as the *"molen van Bökkers"*; the little spire on the building on the far right belonged to the Huis Ootmarsum, a castle that originally served as the commandery of a German order. An almost microscopic view of Bentheim castle can be seen on the horizon on the right. Maschmyer (*ibid.*) thinks it noteworthy that Ruisdael did not depict the town's powerful fortifications; Z. Kolks (*op. cit.*, 1979, p. 22) explains why: The fortifications at Ootmarsum, as well as those of a number of other towns in Overijsel, were dismantled by order of Bishop Philip of Burgundy in 1518.

Kuiperberg (Cooper Mountain) on the outskirts of the town offers a height from which this panorma of Ootmarsum and the surrounding countryside can be seen. The vista from the summit of Kuiperberg (people familiar with mountain ranges would call it a hill) remains a tourist attraction in Overijsel. The view from it shows that here, as in many of his other paintings of identifiable sites, Ruisdael took liberties with the topography. He vastly enhanced the size of the church to make its proud tower and sharp spire dominate the horizon, and he considerably shifted the position of Bentheim Castle to fit it into the picture.

On the assumption that Ruisdael painted the picture during the course of his journey to the Dutch-German border region, Kolks (*op. cit.*, 1978) dated the work about 1650, but later he rightly assigned it to a more mature phase of the artist's activity (*op. cit.*, 1979). The picture was most likely done in the first half of the 1660s, before panoramas like the majestic landscape at The National Galley, London (Cat. no. 43) and the classic views of Haarlem (Cat. nos. 44, 45) were painted. It anticipates, but does not achieve, the refined transitions between the foreground and the vast plain beyond and the richer light-dark effects of Ruisdael's later extensive landscapes.

Drawings Jacob made while on his travels in the early fifties to Bentheim and its environs probably served as the point of departure for the panorama, but not enough is known about the artist's activities to exclude the possibility that he based his painting on sketches done during a later trip to the eastern provinces.

Ruisdael's painting of *A Sluice*, which may have been located at Singraven, a manor not far from Ootmarsum, is at The Toledo Museum of Art; it is datable to the late 1660s (see Cat. no. 40).

A Sunlit Grain Field on the Bank of a Coast

From the very start of his career Ruisdael made pictures of the Dutch countryside that place special emphasis on sunlit grain fields. The Rotterdam painting belongs to a group most likely done in the early 1660s, when he seems to have been especially captivated by the beauty of the light, fresh atmosphere and space of his native land. Here the golden grain field, illuminated by a shaft of silvery light from the sea-reflecting sky, follows the rolling terrain. The informal treatment of the rich brown and olive-green foreground gives the impression that the painting was done directly from nature, but there is no reason to believe that Ruisdael ever painted out-of-doors.

A close view of the well-preserved picture shows three small figures, painted by Ruisdael, at the edge of the grain field (Fig. 41); two rest upon the ground, while the third one stands. These inconspicuous figures strike an unusual note in Jacob's paintings of grain fields. In most, solitary strollers or pairs of travelers walk past them (e.g., Cat. nos. 17, 18, 31). He seldom shows people resting near them, and on the rare occasions when he paints reaped fields with sheaves of grain, he hardly ever depicts farmers at work. This detail is interesting because for some of his countrymen the image of farmers working or resting by a grain field contained more than one level of meaning. The pictorial tradition of workers both at rest and at labor in fields to signify either the season of summer or the months of July and August (haying in July, reaping in August) was still strong in the sixteenth century and it lingered on into the following century. Ruisdael's colleague Allart van Everdingen was especially familiar with it. Alice I. Davies ("Allart van Everdingen's Drawings of the Twelve Months," *The Register of the Museum of Art*, The University of Kansas, Lawrence, IV, 9, 1972, n.p.) has shown that Everdingen made at least six complete sets of Twelve-Month drawings and that some of his other drawings can be related to other seasonal series. Ruisdael's reluctance to emphasize—or even include—figures in his paintings of grain fields that could be given traditional allegorical connotations indicates that his intent in these works was secular, not allegorical. The fact that not a single painting can be linked with this group to form part of a series of months or seasons (for example, one of his winterscapes) bolsters the view

that Ruisdael, like most seventeenth-century Dutch landscapists of his generation, did not share Everdingen's interest in allegorical sets of landscapes.

Hofstede de Groot (124) wrote that the sea beyond the banks of the fields is probably the Zuider Zee. H. Gerson (*op. cit.*) was more specific: He states that the landscape shows a scene in the vicinity of Naarden near the Zuider Zee. R.H. Fuchs (*op. cit.*, pp. 287–88) suggests the landscape may depict a view of the south or east coast of the Zuider Zee, the Veluwe, or the southwest hook of the Frisan coast, and rightly adds that, in this particular case, firm determination of the precise site would tell us little.

About a decade later, Ruisdael incorporated the principal motif of the Rotterdam painting into the right side of his most spacious and imposing picture of grain fields (Fig. 42; canvas, 100 x 130.2 cm; HdG 119; Ros 86a), a justly famous landscape that can be seen only in The Metropolitan Museum's galleries. It is part of the bequest Benjamin Altman made to the museum, by whose terms none of the works in it can be lent.

Fuchs (*op. cit.*) uses the Rotterdam *Grain Field* as a point of departure for his essay on seventeenth-century Dutch landscape paintings as documents of the feeling and thought of the period. Borrowing a term from semiology, he argues that artists of the time painted representative landscapes that satisfy a typical "code" of the period, rather than what they saw at a glance. The code, he adds, indicates that nature was scrupulously studied and suggests that it was also seen in allegorical ways. Although a survey of landscapes of the period shows that some artists studied nature more scrupulously than others and, as noted above, nature was not always allegorized, no one can quarrel with Fuchs' observations. However, his opinion that seventeenth-century Dutch landscapes merely express in a roundabout way the general feeling for nature of the epoch (*viz.*, a feeling for the typical aspects of nature closely observed), and virtually nothing of the artist's own feeling for it is disputable. The personal feeling before nature that Ruisdael, Hobbema, Aelbert Cuyp, Adriaen van de Velde, or Potter express through the code (or style) of their period is what helps distinguish them from each other and their small army of good and less good followers.

30

Rotterdam, Boymans–van Beuningen
Museum (no. 1742)
Canvas, 61 x 71 cm. Signed, lower left.

PROVENANCE: Sale, F.J.O. Boymans,
Utrecht (van Ommeren and van Groot-
veld), 31 August 1811, no. 82; bequest
of F.J.O. Boymans, 1847.

BIBLIOGRAPHY: HdG 124; Ros 92;
Simon 1930, p. 54 (c. 1670); Boymans–
van Beuningen Museum, Rotterdam,
Catalogue, 1962, p. 122; H. Gerson,
''Jacob van Ruisdael: 'Het Korenveld,'''
Openbaar Kunstbezit, VIII, 1964, no.
21; Boymans–van Beuningen Mu-
seum, Illustrations, Rotterdam, 1972,
pp. 74, 221; Fuchs 1973, pp. 281–92
(erroneously states the painting is not
signed).

Fig. 41. A Sunlit Grain Field on the
Bank of a Coast, detail.

Fig. 42. Jacob van Ruisdael, Grain
Fields. New York, The Metropolitan
Museum of Art, Bequest of Benjamin
Altman, 1913.

Fig. 41

Fig. 42

The Grain Field

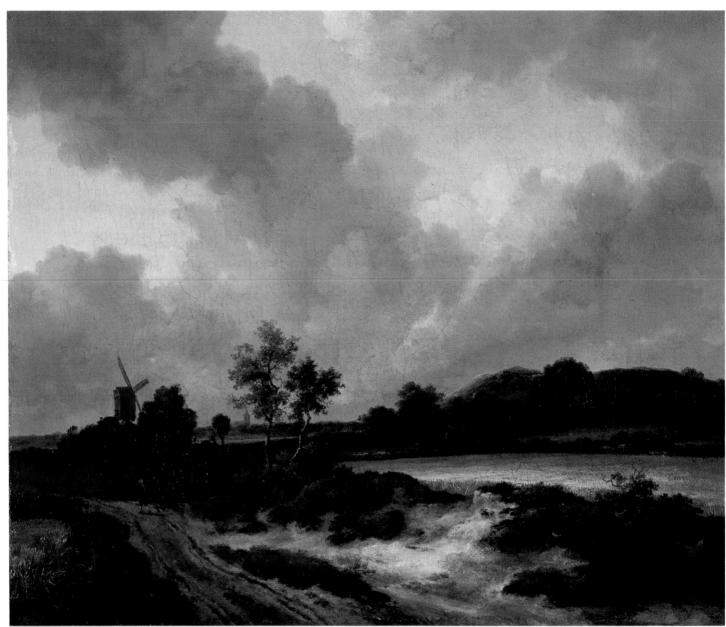

31

New York, Lent by The Metropolitan
Museum of Art, Bequest of Michael
Friedsam, The Friedsam Collection (no.
32.100.14)
Canvas, 47 x 57.2 cm. Signed, lower
right.

PROVENANCE: Collection Louis
Viardot, sold privately before his public
sale, about 1863; sale, G. Rothan, Paris
(Petit), 29 May 1890, no. 95 (24,000
francs, A. Lehmann); Albert Lehmann,
Paris; sale, A. Lehmann, Paris (Petit),
12–13 June 1925, no. 282; Michael
Friedsam, who bequeathed it to the
museum, 1931.

EXHIBITIONS: Paris 1921, no. 90 (lent
by Albert Lehmann); New York 1940,
no. 90, repr.

BIBLIOGRAPHY: C. Blanc, Chronique
des Arts, Paris, 1863, p. 130; HdG
141; Ros 87; The Metropolitan Museum
of Art, Catalogue, 1954, p. 87; Stechow
1966, p. 29, Fig. 37.

Engraved by Maxime Lalanne (1827–86).

An autograph variant datable to the early 1660s of the present landscape, which includes a vista of the sea instead of a field and town in the far distance, is at Basel, Öffentliche Kunstsammlungen (Fig. 43; canvas, 46 x 56.5 cm; no. 924; HdG 144, HdG Zus. 144; Ros 72). The richer structure, greater spaciousness, and mild, airy atmosphere that permeate the Metropolitan Museum's serene painting suggest that it postdates the Basel picture by a few years. In the Metropolitan's landscape sharp contrasts have been minimized in the clouded sky and on the ground. The inconspicuous windmill, light trees, and low hill in the middle ground soften the transition to the distance rather than interrupt the view, while the pale yellow grain field flanked by a sandy road and low dunes that virtually fill the breadth of the foreground emphasize the openness of the extensive plain.

Fig. 43. Jacob van Ruisdael, A Grain Field. *Basel, Öffentliche Kunstsammlungen.*

Fig. 43

View of Het IJ on a Stormy Day

32

Worcester, Massachusetts, The
Worcester Art Museum (no. 1940.52)
Canvas, 65.8 x 82.7 cm. Signed by
another hand, lower right: JvRuysdael.

PROVENANCE: Possibly sale, P.
Calkoen, Amsterdam, 10 September
1781, no. 116 (450 florins, Wubbels);
Earl of Beverly, London, 1842; sold with
his collection en bloc, 7 June 1851;
purchased in 1851 by Thomas Baring,
who bequeathed it to the Earl of North-
brook, London; dealer R. Langton
Douglas, London, who sold it to T.T.
Lewis, Worcester, in 1927; bequeathed to
The Worcester Art Museum by Mary G.

Ellis in 1940 as part of the Theodore
T. and Mary G. Ellis Collection.

EXHIBITIONS: London, Royal
Academy, Winter Exhibition, 1871, no.
224; London, Guildhall Art Gallery,
1890, no. 52; London, Burlington Fine
Arts Club, 1900, no. 29; Hartford 1950–
51, no. 14; Caracas 1967, no. 17, repr.

BIBLIOGRAPHY: Smith Suppl. 2;
Waagen 1854, II, p. 187, no. 1; L.
Viradot, Les Musées d'Angleterre,
de Belgique, de Hollande et de Russie
. . . , 3rd ed., Paris, 1860, p. 155;

Lord Ronald Gower, The Northbrook
Gallery, London, 1885, p. 33; W.H.J.
Weale, A Descriptive Catalogue of
the Collection of Pictures Belonging
to the Earl of Northbrook, London,
1889, p. 67, no. 94; Michel 1910, pp.
145–46, repr. Pl. 10; HdG 959, possibly
identical with HdG 968; Ros 594; L.
Preston, Sea and River Painters of the
Netherlands, London, New York,
Toronto, 1937, p. 47 (incorrectly states
that the picture is still with R. Langton
Douglas and that a similar painting is
still in the collection of the Earl of

Strengthening of the signature at a later date accounts for its wiry character and the unusual spelling of the artist's name on the painting; to our best knowledge he always signed his works "Ruisdael," never "Ruysdael." A technical examination of the signature made in June 1966 confirmed that it was reinforced. The lower part of the "y" is readily soluble in methyl alcohol. The lower part of the "l" is partly soluble in the same solvent, leaving remnants of old paint that were part of the original signature.

Restoration of the picture at The Worcester Art Museum in 1981 revealed that its paint surface is evenly and generally abraded, but it has not suffered any significant losses. Restoration also revealed that its exquisite gray harmonies had been heavily veiled by old, badly yellowed varnish. Now it is evident that apart from the diminutive Dutch flag mounted on the mast of the foremost boat, scattered patches of delicate blue in the sky, and the discrete touches of light terra cotta on a few sails and a sailor's jacket, the painting is a study in grays and white.

The marine employs the compositional scheme Ruisdael used most frequently for his seascapes: a high sky filled with clouds that tower over a relatively narrow expanse of the sea affected by winds ranging from fresh to gale force; in the foreground waves either play or pound against a breakwater or wharf that projects from one side of the painting; the sailing vessels are seldom overly prominent and are confined to the middle and far distance. Here, the silvery gray, airy tonality and restrained accentuation of the spatial structure of the seascape suggest that it is datable to the early 1660s. Only in the deep shadow of the cloud that cuts across the feathery whitecaps of the choppy, shallow sea is there still a recollection of the Porcellis-Vlieger tradition. The skyline of Amsterdam can be seen toward the left on the horizon; the long roof of the East India Company's large warehouse (called the Buitenhuis) is clearly distinguishable.

So far no one has recognized that a drawing attributed variously to Ludolf Backhuysen and Abraham van Beyeren is a copy after the Worcester painting; the drawing is now in the collection Herbert Girardet, Kettwig (see Cologne-Rotterdam 1970, no. 76, repr.; K.J. Müllenmeister, *Meer und Land im Licht des 17. Jahrhunderts*, vol. I, Bremen, 1973, no. 123, repr.).

No authentic drawings by Ruisdael of the sea or of ships are known.

Northbrook; as noted in the provenance above, these are one and the same picture; erroneously identified as The Meer at Haarlem; Worcester Art Museum Annual, *IV (1941), p. 22f., repr.; Gerson 1952, p. 57, repr.; Stechow 1966, p. 122, repr. (c. 1665);* European Paintings in the Collection of The Worcester Art Museum, *"Dutch School" by Seymour Slive, 1974, pp. 131–33, no. 1940.52.*

Etched by P.J. Arendzen in C. Hofstede de Groot, Hollandsche Kunst in Engelsche Verzamelingen.

Winter Landscape with a View of the Amstel River and Amsterdam

33

Kettwig (Ruhr), Herbert Girardet Collection
Canvas, 44.5 x 55 cm. Signed, lower left.

PROVENANCE: Sale, John Smith, London, 2–3 May 1828, no. 56 (£71, 8s, Stanley); H.J. Munro by 1835; bought by Smith and sold to a Paris collector (according to a ms. note by Smith in his own copy of his catalogue); sale, Prince Paul Demidoff, Paris, 3 February 1868, no. 36; Max Kann, Paris; Mrs.
Brooks, London; sale, B[rooks], Paris, 16–18 April 1877, no. 68, repr.; sale, Auguste Courtin, Paris (Drouot), 29 March 1886, no. 18 (14,700 francs); sold by the dealer C. Sedelmeyer, Paris, to Franz von Mendelsohn, Berlin, by 1898; Herbert Girardet, Kettwig; by descent to his heirs.

EXHIBITIONS: Berlin 1906, no. 119, repr.; Cologne-Rotterdam 1970, no. 45,
repr.; Brussels 1971, no. 89 (1660s or later).

BIBLIOGRAPHY: Smith 223; Sedelmeyer 1898, p. 204, no. 183 (now in the collection of F. von Mendelsohn, Berlin); HdG 987; Ros 605; Simon 1930, p. 59 (painted during the last decade).

Prints after the painting were made by Louvy, Louis Lucas, and Alfred Brunet-Debaines (1845–?).

Only about twenty-five of Ruisdael's winter landscapes have been identified, and to judge from the relatively few references to them in old inventories and sale catalogues, he did not paint many more. To our best knowledge none of them was part of a Seasons or Twelve-Month series (see Cat. no. 30). Not one of them bears a date. Jakob Rosenberg (1928, p. 40) proposed that Ruisdael began painting them soon after 1655 when he moved to Amsterdam and broadened his choice of traditional landscape subjects. His suggestion that the artist's unusual *Winter Landscape with a View of a Town and a Wooden Bridge*, formerly in the J.C.H. Heldring Collection, Oosterbeek (Ros 614; reproduced in Stechow 1966, Fig. 189) belongs to this early group gains support from Wolfgang Stechow's observation (*ibid.*, pp. 96, 204, note 51) that Jan Beerstraten's *Castle of Muiden in Winter*, dated 1658 (The National Gallery, London, no. 1311), is painted in a similar manner.

Like the Heldring painting, the Girardet winterscape is without a particular accent in the composition and shares its fine airy, gray atmosphere. However, the more spacious effect of the Girardet painting suggests it was done later, probably in the first half of the sixties. In the far distance, dark snow clouds veil a view of Amsterdam (first mentioned by the compiler of the Demidoff sale catalogue, 1868, *op. cit.*). H. Vey, author of the Cologne-Rotterdam 1970 exhibition catalogue (no. 45), notes that a similar view of Amsterdam is seen in Abraham Blooteling's etching after Ruisdael's lost drawing of a view of the Hooge Sluis seen from a bank of the Amstel River (Fig. 79). The Girardet painting offers a more distant and extensive view of Amsterdam's skyline than is offered in the print after Jacob's drawing, but the artist employed the same general compositional scheme for both works. Since the lost drawing can be dated about 1663 (see Cat. no. 83), these resemblances also bolster a date in the first half of the 1660s for the winterscape.

No evidence has been formed to support the claim made in the earlier literature (Sedelmeyer 1898, p. 204, no. 183; HdG 987; Cologne-Rotterdam 1970, no. 45) that the painting belonged to Sir Robert Peel. For a discussion of the *Winter Landscape* by Ruisdael that was in Peel's collection, see Cat. no. 53.

Waterfall with a Castle and a Cottage

34

Paintings of northern landscapes with rugged mountains, giant firs, and powerful waterfalls cascading over huge boulders and dead trees form the largest category of Ruisdael's work, and he convinces us, more than any other artist, that these pictures are based upon his own intense, first-hand study of their elements. Strange as it may seem, Ruisdael did not know such scenes from his own direct observation. His vision of them is based on art, not nature. They are derived from works by the Alkmaar artist Allart van Everdingen (1621–75), who introduced and popularized northern landscapes in the Netherlands.

Everdingen traveled in Norway and Sweden in 1644 and returned to Holland with a number of northern motifs. He settled in Haarlem in 1645 and was active there until 1652 when he moved to Amsterdam (Davies 1978, pp. 35–37). During these years Everdingen evolved the Scandinavian landscapes that served as the point of departure for Ruisdael's numerous paintings of the theme. Thus, Ruisdael may have had an opportunity to see them while he was a young artist active in his native city. If he did, he apparently felt no compulsion to add northern landscapes to his repertoire during the early phases of his career.

It has been noted (Rosenberg 1928, p. 43) that a small northern-style *Waterfall in a Mountain Landscape*, monogrammed and dated 1659, is Ruisdael's earliest dated Everdingen-like landscape (HdG 280; Ros 180, repr.). The tiny panel (28 x 21.5 cm) was formerly in the P. von Semenov Collection, St. Petersburg, then entered the Hermitage. In 1930 it was sent from the Hermitage to a museum in the Kuban area of the north Caucasus. Its present location is unknown (kind communication from Yuri Kuznetsov), but old photographs of the untraceable picture raise doubts about the traditional attribution to Ruisdael; they are not dispelled by the facsimile of the uncharacteristic monogram and date on the painting published in the catalogue for the Semenov Collection (1906, p. 180, no. 463). Regardless of the attribution of the lost Semenov painting, it can be established on stylistic grounds that Ruisdael began to use Everdingen's waterfalls as the central motif of a large group of paintings datable to the early 1660s, about four or five years after he, like Everdingen, moved to Amsterdam. Most likely the vogue for them in the leading city of the United Provinces, sparked by Everdingen, induced him to devote part of his energy to painting Scandinavian waterfalls.

Cambridge, Massachusetts, Fogg Art Museum, Harvard University, Gift of Miss Helen Clay Frick (no. 1953.2) Canvas, 99.7 x 86.3 cm. Signed on a rock, lower right.

PROVENANCE: Edward R. Bacon, New York; Miss Helen Clay Frick, New York, who presented it to the museum, 1953.

EXHIBITIONS: Chapel Hill 1958, no. 53, repr.; Baltimore 1968, no. 16, pp. 32–33, repr.

BIBLIOGRAPHY: Jakob Rosenberg, "A Waterfall by Jacob van Ruisdael," Fogg Art Museum, Annual Report, 1952–53, p. 11, repr.; Stechow 1966, p. 145, Fig. 288.

At first Ruisdael closely followed Everdingen's example by employing rather thin fir trees, an overabundance of rocky clefts and fallen trees, and the older artist's rather sweet color harmonies of pinky reds and pale greens. Vague reminiscences of motifs Jacob discovered during his *Wanderjahre* in the Dutch-German border region are also occasionally evident. By the mid-sixties he began to paint a series of waterfalls that outstrips even Everdingen's finest Nordic scenes. The Fogg Art Museum's *Waterfall* is an outstanding example of this group. The wide torrent wildly rushing over large boulders is seen close and fills more than the lower third of the painting. The space behind it is built high, on one side with towering firs and on the other with a dense mass of rocky wooded hill, a cottage, and a precipitous mountainous cliff sur-

Fig. 44

Fig. 44. Jacob van Ruisdael, Waterfall with a Castle on a Mountain. *Brunswick, Herzog Anton Ulrich-Museum.*

Fig. 46. Jacob van Ruisdael, Mountainous Landscape with a Waterfall. *Amsterdam, Rijksmuseum.*

Fig. 46

104

Fig. 45

mounted by a castle. Although the format is vertical (his favorite one for Nordic scenes in this period), the height of the landscape and the expanse of the waterfall are in perfect equilibrium. Ruisdael used the same general scheme for other splendid waterfalls painted about the same time; four of them are reproduced here (Figs. 44–47; Brunswick, nos. 377 and 378; HdG 206, 207; Ros 142, 143; Amsterdam, no. A 348; HdG 199; Ros 121; and Herbert Girardet Collection, Kettwig, respectively). They impress through the variations he achieved by differing the height of the drop of the falls, the direction of the rushing water, the character of the boiling foam, the formation of the rocks and terrain, the variation of color, and the organization of the powerful contrasts of light and dark areas.

Fig. 45. Jacob van Ruisdael, Waterfall in Two Cascades. *Brunswick, Herzog Anton Ulrich-Museum.*

Fig. 47. Jacob van Ruisdael, Landscape with a Waterfall, *Kettwig (Ruhr), Herbert Girardet Collection.*

Fig. 47

Waterfall with a Steep Hill and Cottages

35

Private collection
Canvas, 106.7 x 150.5 cm. Signed on
the large rock left of center.

PROVENANCE: Bought from a collec-
tion at Alkmaar, about 1810, by Walker
(who valued it at £840); J. Campbell,
London, 1831; bought by John Smith
(£276, 3s) and sold to Héris of Brussels;
Baron J.G. Verstolk van Soelen, The
Hague, 1835, no. 45; acquired with his
collection in 1846 by Thomas Baring,
H. Mildmay, and S. Jones Lloyd (after-
ward Lord Overstone); Lord Overstone,
London; Lady Wantage, London.

EXHIBITIONS: London, British Institu-
tion, 1847, no. 23; ibid., 1848, no. 45;
Manchester 1857, no. 702; London,
Royal Academy, Winter Exhibitions of
1871; 1888, no. 67; 1907, no. 107;
London 1952–53, no. 302.

BIBLIOGRAPHY: Smith 129 (a "super-
lative production"); Waagen 1857, IV,
p. 141 ("This picture is in every respect
one of the finest known to me of the
master"); Bürger 1865, p. 296;
Wantage Catalogue, 1902, no. 200;
HdG 252; Ros 194.

In the discussion of the Fogg Museum's *Waterfall* (Cat. no. 34) it is noted that during the mid-sixties Jacob's favorite format for paintings of this theme was a vertical one. Later in the decade and in the early 1670s, when he turned to more open spatial effects and began to concentrate on panoramic views, he painted a group of waterfalls in a large horizontal format. The present picture exemplifies this new development. Although there are giant boulders in the foreground, towering height no longer prevails over breadth. The countryside has become flatter and the long, open vista on the right, which creates an effect of great distance, stands in contrast to the hill on the left. Despite the relatively low terrain, the waterfall retains its force and power, but it has been set back; the rushing movement and froth of the torrent below it decisively broaden the view.

Other outstanding waterfalls in a horizontal format that are datable about the same time are at the Rijksmuseum, Amsterdam (Fig. 48; no. C 210; canvas, 142 x 195 cm; HdG 198; Ros 120), the Wallace Collection, London (Fig. 49; no. P56; canvas, 104 x 144 cm; HdG 251; Ros 189), and the Hermitage, Leningrad (Fig. 50; no. 942; canvas, 108 x 142.5 cm; HdG 276; Ros 178). The figures and animals in the Hermitage *Waterfall* are by Adriaen van de Velde; his death in 1672 provides a *terminus ante quem* for the Leningrad painting. While in all these pictures there is still the proliferation of gigantic boulders that is found in Ruisdael's heroic Scandinavian waterfalls, none of them includes stately firs. The scene has been shifted to a more temperate zone, and their wooded passages, particularly those in the great Amsterdam picture (Fig. 48), herald the idyllic mood that becomes more frequent in Jacob's final phase.

Fig. 48. Jacob van Ruisdael, Waterfall. *Amsterdam, Rijksmuseum.*

Fig. 49. Jacob van Ruisdael, Waterfall. *London, Wallace Collection.*

Fig. 50. Jacob van Ruisdael, A Waterfall in a Hilly Landscape. *Leningrad, Hermitage.*

Fig. 48

Fig. 49

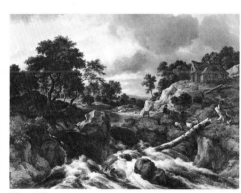

Fig. 50

A Marsh in a Forest

Worcester College's great forest picture (Cat. no. 18) demonstrates that by the mid-fifties Ruisdael produced heroic wooded scenes in which the mass of the forest is treated like a compact wall. During the following years he continued to paint landscapes of thick woods that keep their monumental character but the later works, like most of his more mature pictures, acquire greater spaciousness. Clearings and open vistas are now combined in varying degrees with large-scale forms, and massive trees no longer virtually seal off middle ground and distant vistas. The majestic Leningrad *Marsh* is one of the high points of this new trend.

Only one of Ruisdael's forest scenes of the Leningrad type is dated, and its date is only partially visible. It is the Clowes' *Wooded Landscape with a Pond*, which is inscribed: 166[?] (Fig. 51; sale, H.A. Clowes, London [Christie's], 17 February 1950, no. 49 [3,200 guineas, Clowes]; Smith 169 [date not cited]; HdG 548 [date not cited]; Stechow 1966, p. 200, note 41). The Clowes picture supports the date in the 1660s customarily given to Jacob's forest paintings which join powerful forms seen close-up with open spaces. While mindful that experimentation and unexpected cross-currents must be taken into account when considering an artist of Ruisdael's creative power, and equally mindful of the admonition, partially derived from Lewis Carroll and partially from Erwin Panofsky to "beware the boa constrictor," it is nevertheless reasonable to propose that Ruisdael's forest scenes with more open compositions were probably painted later in the decade than those that stress the massiveness of the forest. This is the rationale that provides a date of about 1665 for the present picture.

More than one student of Ruisdael's works has noted (Roh, *op. cit.*; Rosenberg 1928, p. 48f.) that the Leningrad *Marsh* was inspired by a composition of Roelant Savery's (1576–1639) engraved by Egidius Sadeler (Fig. 52). Juxtaposition of the two works does not diminish Jacob's accomplishment. The complex interweaving of Savery's wildly contorting trees and growth illustrates the fantastic-decorative trend of late mannerist landscapists. Savery's marshy woods could serve as a wondrous setting for a fairy tale as easily as it does for a hunting scene. Ruisdael's marsh in a forest could not. He has used Savery's composition to evoke the splendor and sublimity of the forest. "An architectonic genius," in Jakob Rosenberg's words, "has blown over Savery's fantastic structure and has transformed it into a grown space of architectural order and solidity. Playful ornamentalness has been transformed into the mighty reality of the three-dimensional existence of things. The usual rich abundance of forms, their load of expression and their pressure of movement, has been pacified by the rhythm of the composition and by a sure feeling of what is possible in nature. It is the peace of controlled power, not the passive peace of the observed mood of the countryside to which we are accustomed in Dutch landscape painting" (*ibid.*, p. 49). The close connection between Savery's *Marsh* and the Clowes landscape (Fig. 51) is also striking.

Fig. 51. Jacob van Ruisdael, Wooded Landscape with a Pond, *166[?]. Norbury, Ashbourne, Derbyshire, H.A. Clowes.*

Fig. 52. Egidius Sadeler (after Roelant Savery), Stag Hunt in a Marsh. *Engraving.*

Leningrad, Hermitage (no. 934) Canvas, 72.5 x 99 cm. Signed, lower left.

PROVENANCE: *Acquired for the collection, 1763–74.*

EXHIBITION: *Washington et al. 1975–76, no. 23.*

BIBLIOGRAPHY: *Smith 306; Michel 1910, pp. 150ff, repr. p. 162; HdG 508; Franz Roh, Holländische Malerei, Jena, 1921, p. 331, note to Fig. 158; Ros 313; Hermitage, Leningrad, Catalogue, 1958, p. 250, no. 934; Kouznetsov 1973, p. 33.*

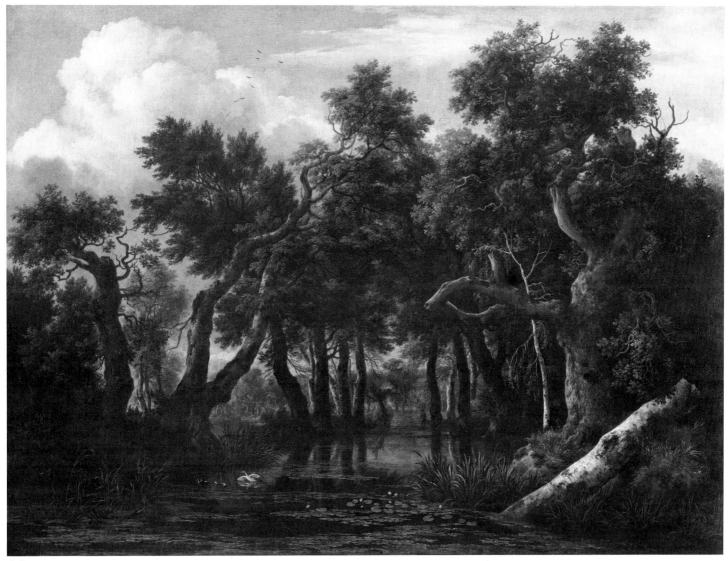

36

Fig. 51

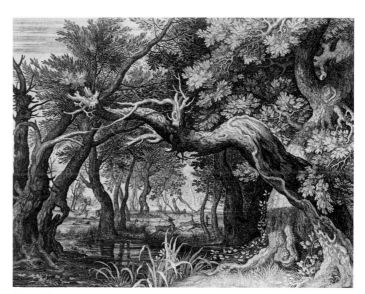

Fig. 52

A Stag Hunt in a Wood with a Marsh

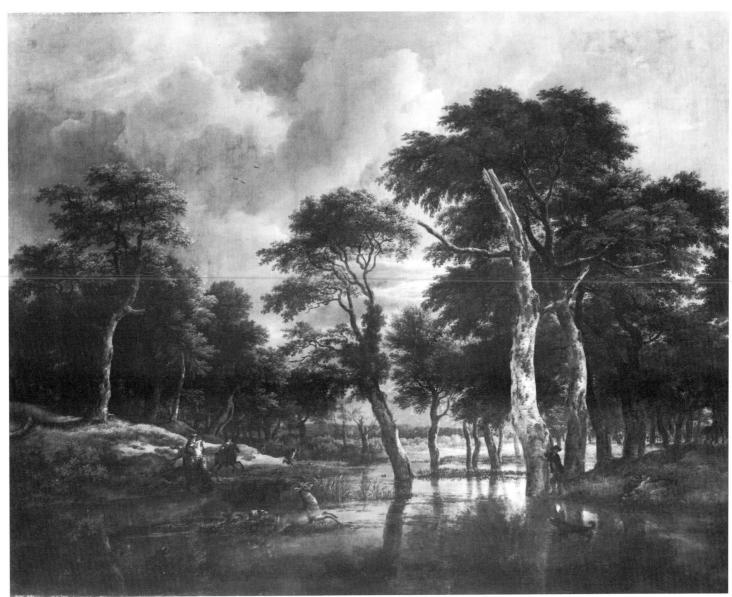

37

Dresden, Staatliche Kunstsammlungen
(no. 1492)
Canvas, 107.5 x 147 cm.

PROVENANCE: In the Dresden inventory of 1754, II, no. 205.

EXHIBITIONS: Berlin 1955–56, p. 103;
Tokyo-Kyoto 1974–75, no. 60.

BIBLIOGRAPHY: Goethe 1790, p. 375,
no. 196; Smith 230 (staffage by Berchem);
Michel [1890], repr. p. 57; HdG 454
(staffage by Adriaen van de Velde); Ros
285 (staffage by Adriaen van de Velde);
Carus [1955], p. 76; Gemäldegalerie,
Dresden, Catalogue, Alte Meister,
1979, p. 288, no. 1492, repr.

Engraved in reverse by Adrian Zingg
(1734–1816).

Ruisdael creates a vast expanse of space in this magnificent landscape by filling the entire front plane with a smooth, broad marsh virtually devoid of luxuriant growth, lifting the powerful beeches out of the context of the forest, and, not least, placing massive middle-ground forms against tangible distant views. In contrast to his earlier wooded landscapes we now see further into the picture, higher up, and more around the volume of individual trees. The differentiation between light and shadow also is heightened and richer, particularly in the touches of sparkling, silvery white on the giant dead beech seen against the bronze-brown and deep green background of the trees and in the strong pulse of light in the distant vistas and on the marsh and low hill.

The figures and animals in the landscape are by Adriaen van de Velde. Like those van de Velde most probably added to the tiny dunescape at the Fondation Custodia (Cat. no. 25), the staffage in the Dresden painting can hardly be an afterthought. The spacious scene would have looked empty if it had not been enlivened by the stag hunt.

Efforts to discover whether this painting was commissioned by a patron with a passion for hunting or if the work was made for stock have been as fruitless as the attempts which have been made to learn how Ruisdael and van de Velde planned their joint efforts. Adriaen's hand establishes that the noble landscape must have been painted before 1672, the year of his death. Van de Velde also provided the staffage for Jacob's great panoramic view at The National Gallery, London (Cat. no. 43) and a *Waterfall* at Leningrad (Fig. 50). Both paintings are datable to the second half of the sixties; the Dresden *Stag Hunt* probably was done during the same period.

For reference to Goethe's admiration of the *Stag Hunt*, see Cat. no. 20.

Three Great Trees in a Mountainous Landscape with a River

38

Pasadena, California, The Norton Simon Foundation (no. F.71.2.P)
Canvas, 138 x 173 cm. Signed on a rock, lower right.

PROVENANCE: Collection Lady Cooper, London, 1842; Edward Dawkins of Guisborough Grange, January 1895, when it was submitted to Christie's for auction (Christie's no. 944K is on a stretcher bar); for reasons not specified in Christie's records the picture was not offered and was returned to Dawkins (information kindly supplied by Darryl E. Isley); dealer C. Sedelmeyer, Paris, Catalogue, 1895, no. 36, repr.; Maurice Kann, Paris; sale, Maurice Kann, Paris (Petit), 9 June 1911, no. 59, repr.; dealer C. Sedelmeyer, Paris, 1925; sale, Baron Marczell von Nemes of Munich, Amsterdam, 13 November 1928, no. 62 and Munich, 16 June 1931, no. 60; sale, Gustav Oberlaender of Reading, Pennsylvania, New York (Parke-Bernet), 25–26 May 1939, no. 256; John Bass, New York, 1940; sale, John Bass, New York (Parke-Bernet), 25 January 1945, no. 22 ($5,000); dealer F. and P. Nathan, Zurich.

EXHIBITION: San Francisco 1940, no. 199.

BIBLIOGRAPHY: Smith Suppl. 8; HdG 673, identical with HdG 708 and HdG 725; Ros 416; Simon 1930, p. 75; Simon B.M. 1935, p. 135 (painted during the artist's latest years; inspired by his travels to northern and central France).

The youthful Ruisdael used three powerful trees as the motif for an etching as early as 1649 (Cat. no. 104), and in the following years he made variations on the theme. The large Norton Simon picture is his last known and most imposing treatment of the subject. It is another splendid example of his tendency in the late sixties to combine powerful, closely seen forms with great effects of distance. Ruisdael's even larger *Wooded Landscape with a Flooded Road* (Fig. 1; Louvre, on extended loan to Musée de la Chartreuse, Douai; canvas, 171 x 194 cm; HdG 499; Ros 354), which has been embellished with beautiful figures and animals by Nicolaes Berchem, is yet another outstanding landscape that can be assigned to this phase but its distant prospect is less extensive.

The massiveness of the three trees in the Norton Simon painting is accented by their position in the foremost plane, and their towering height is stressed by the clarity of their luxuriant foliage. Virtually every leaf on the edges of the feathery boughs of the sharply lit, silvery beech's single live branch as well as those on the full crowns of the two oaks is seen silhouetted against the light sky. The dramatic contrast in scale between the giant trees and the vast expanse of the bird's-eye view of the village, high mountains, and broad river flowing to the sea also underscores the colossal size of the three trees. The imaginary distant view, which is redolent of the *Weltlandschaften* painted in the previous century by Patenir and Bruegel, strikes an unusual but not unique note in seventeenth-century Dutch landscape painting at this time. Similar archaistic "world panoramic" vistas can be found in landscapes painted by Herman Saftleven (1609–85) and by Jan Griffier (1645–1718). However, nothing in the works of these artists resembles the exaltation of creative power and heroic mood evoked by the Norton Simon painting.

The Windmill at Wijk bij Duurstede

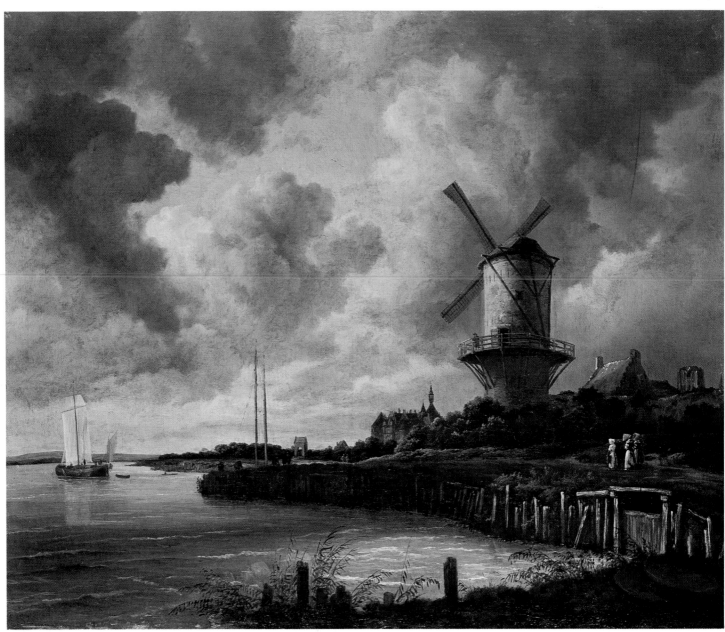

39

Amsterdam, Rijksmuseum (no. C 211; on loan from the city of Amsterdam) Canvas, 83 x 101 cm. Signed, lower right.

PROVENANCE: Probably sale, J. Juriaans, Amsterdam, 28 August 1817, no. 55 (1,200 florins, van Heijningen); purchased in the London art market, 1833, by A. van der Hoop, Amsterdam, who bequeathed it to the city of Amsterdam, 1854; deposited on loan at the Rijksmuseum, 1885.

EXHIBITIONS: Paris 1921, no. 91, repr.; London 1929, no. 207; Rotterdam, Museum Boymans, Winter Exhibition, 1945–46, no. 39; Brussels-Antwerp 1946, no. 91, repr.; Paris 1950–51, no. 75.

BIBLIOGRAPHY: HdG 105, probably identical with HdG 183; Ros 70; H. Hijmans, Wijk bij Duurstede, Rotterdam–The Hague, 1951, pp. 51–57; Rijksmuseum, Amsterdam, Catalogue, 1960, p. 270, no. 2074; Stechow 1966, pp. 59–60, Fig. 115; M. Imdahl, Jacob

van Ruisdael: Die Mühle von Wijk, Stuttgart, 1968; Rijksmuseum, Catalogue, 1976, p. 487, no. 211; H. Kauffmann, ''Jacob van Ruisdael: 'Die Mühle von Wijk bei Duurstede,''' Festschrift für Otto von Simson zum 65. Geburtstag, ed., L. Grisebach and K. Renger, Frankfurt a. M., 1977, pp. 379–97.

Engraved by C.L. van Kesteren (1832–97), W. Steelink, Sr. (1826–1913), and J.M. Graadt van Roggen (b. 1867).

It is appropriate that a windmill, the best-known symbol of the Dutch landscape, should be the subject of Ruisdael's most famous picture. But to judge from the small number of times the artist made a windmill the major accent in his paintings, he was not particularly partial to the motif. Only about fifteen are known today, and except for a few, they are datable to the first ten or twelve years of his activity as a painter (see Cat. nos. 10, 24). The most remarkable exception is the *Mill at Wijk bij Duurstede*, which was painted about 1670. It is his classic pronouncement on the subject.

The essence of the pictorial beauty of this magnificent painting is the firm cohesion of forms that harmonizes the dominant vertical mass of the mill's cylindrical body towering over the village with the high clouded sky, the breadth of the landscape, and the broad expanse of the river. The bond between the upper and lower parts of the landscape is strengthened by the counterplay between the cloud masses and countryside. Not only does the direction of the arms of the huge mill relate to the direction of the thick clouds, but also almost every point on the ground and in the water is subtly connected to a corresponding spot in the vault of the heavy gray sky. Rhythmic tension is created between near and far by the strong emphasis on both the close and distant views, and by the contrasts between light and shadow which work together with the intensified concentration on mass and space.

It has long been recognized that the painting is a view of Wijk bij Duurstede, a small town situated about twenty kilometers from Utrecht where the Lower Rhine divides into the Lek and the Kromme (Crooked) Rhine. Until H. Hijmans published his history of the town in 1951 (*op. cit.*), it was assumed that the mill Ruisdael painted is the one that still exists there. Hijmans' research demonstrates that this supposition is incorrect. The existing windmill is a gate mill with a square base and lies north of the town. The one Ruisdael painted had a round base and was situated south of the town; today only some remnants of its foundation remain. An anonymous dated drawing of it at the Rijksprentenkabinet (Fig. 53; no. AP 2.i.), which depicts the mill from the opposite side, shows that it was still intact in 1750. It is possible to identify two of the buildings Ruisdael saw from the bank of the Lek: To the left of the mill the late medieval castle of Wijk is clearly distinguishable; on the extreme right the squat tower of the Church of St. John the Baptist can be seen. In 1668 the town fathers ordered the installation of clock faces on the four sides of the church tower. Since Ruisdael painted the tower with the clock faces in place, the order for their installation provides a probable *terminus post quem* for the picture (Imdahl, *op. cit.*, p. 3). The town's Vrouwen Poort (Women's Gate), which is not included in Ruisdael's painting, was a short distance down the road on the right; it is clearly seen in the anonymous eighteenth-century drawing of the mill (Fig. 53). M. Imdahl suggests that the three women on the road are an allusion to it (*ibid.*, p. 5).

On one level it is evident that the *Mill at Wijk* is accessible to everyone as a characteristic scene of the Dutch countryside. H. Kauffmann's sensitive essay on the painting (*op. cit.*) reminds modern viewers that it may have had another level of meaning for some of the artist's contemporaries.

In Ruisdael's time, when people were more

keenly aware of mankind's dependence upon the forces of nature that run windmills, water mills, and sailing vessels than we are today—and when moralists were prone to read all of nature as symbolic of transcendental ideas—it was not uncommon for analogies to be made between the natural forces that power what man has made and the divine spirit that gives him life. A good example of this moralizing tradition is offered by an emblem published in Zacharias Heyns' *Emblemata, emblemes christienes, et morales. Sinne-Beelden streckende tot Christelicke Bedenkinghe ende Leere der Zedicheyt,* Rotterdam, 1625 (Fig. 54; Kauffmann, *op. cit.,* pp. 382, 388). The emblem's motto "The letter killeth, but the spirit giveth life" (2 Cor. 3,6) and the explanation (*Wtlegginghe*) that accompanies it, which

elaborates on the similarity of the miller's dependence on the wind to grind his grain to man's dependence on the spirit of the Lord for life, is complemented by Jan Geeritsz Swelincks' engraving of a prominent windmill on a high bastion. Other epigrams and mottos were employed by moralists to express similar ideas: "Unless it breathes it is unmoved" (*Ni spiret immota*); "they are moved by the spirit" (*Aguntur Spiritu; ibid.,* p. 392). In view of this visual and literary tradition, it is not hard to imagine that some of Ruisdael's contemporaries found a symbolic meaning in *The Windmill at Wijk bij Duurstede.* The extent to which the artist wanted his masterwork to convey this level of meaning has not yet been measured.

Fig. 53. Artist unknown, The Mill at Wijk bij Duurstede, *1750. Amsterdam, Rijksmuseum, Rijksprentenkabinet.*

Fig. 54. Jan G. Swelincks, Windmill on a High Bastion. *Engraving from Zacharias Heyns,* Emblemata, *1625.*

Fig. 54

116

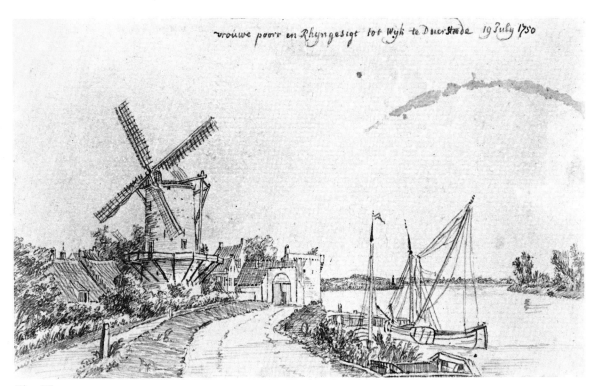

Fig. 53

Wooded Landscape with a Sluice at a River Bank

The support of the painting is still its original canvas, a rarity for a picture that is more than 300 years old. The fact that the work has never been relined helps account for the fine state of preservation of its paint surface.

The landscape is datable to about 1665–70, when Ruisdael combined powerful forms in the near and middle distance, in this case the cavernous sluice and a noble silvery beech, with fully developed receding spaces. Although he made a notable series of water-mill paintings (see Cat. nos. 22, 23), a sluice rarely figures as the principal motif in his paintings. Only three others are known. There are two early ones that most likely portray the superstructure of the same sluice, which also served as a bridge. One of these is at Rijksmuseum Twenthe, Enschede, dated 1647 (no. 433; HdG 659; Ros 444); the other, probably painted a year or two later, was formerly in the collection of Mrs. John W. Simpson, New York (HdG 663; Ros 448). The third, datable to the early 1650s, was formerly in the collection of J. Reiner, Amsterdam (HdG 674; Ros 447). For his drawings of sluices see Cat. nos. 74, 75.

It has been suggested (Brussels 1971, no. 87) that the sluice in the Toledo painting is most likely identical with one at the manor house of Singraven near Denekamp, a village in the eastern part of the province of Overijsel. It is still used to regulate the level of the water of the Dinkel River, which serves the estate's water mills. Although the similarity is striking, the sluice cannot be identified with certainty; this type of sluice is not uncommon in the area.

We have already noted that Jacob most likely visited Singraven in the early fifties while traveling in the Dutch-German border region and that the paintings of water mills done during this phase were probably based upon those he saw there (see Cat. no. 22). If the sluice of the Toledo painting is in fact the one at Singraven, it also may have been based on drawings made on his early trip. On the other hand, not enough is known about Ruisdael's movements to exclude the possibility that he made a later trip to the same region and produced sketches that served as *aides-mémoire* for the Toledo *Sluice* and other paintings done in the sixties and seventies which employ motifs found in the vicinity. Among them are his *Extensive View of Ootmarsum*, a town that is only five kilometers from Singraven (see Cat. no. 29), and his late views of the Castle of Bentheim, situated about ten kilometers from the estate.

In the Toledo painting Ruisdael shows an inoperative sluice. The level of the river is very low. It is a time that enables one of the workmen to lay bundles of branches in the river bed to protect it from the tremendous force of rushing water when the sluice functions. The other worker, who is silhouetted against the bright reflection in the water, is driving in a stake that will help support the branches. The arduous jobs some country people do when nature affords them a favorable opportunity are seldom seen in Ruisdael's pictures. More familiar figures are the hunter and his dogs and the inconspicuous solitary traveler in this landscape.

Toledo, Ohio, The Toledo Museum of Art, Gift of Edward Drummond Libbey (no. 78.68)
Canvas, 104.2 x 88 cm. Signed, lower right.

PROVENANCE: Collection Koucheleff Besborodko, St. Petersburg, by 1835; sale, Count Koucheleff Besborodko, Paris (Drouot), 5 June 1869, no. 30 (26,500 francs); Edmond de Rothschild, Paris; Maurice de Rothschild, Geneva; dealer Th. Agnew, London; dealer Rosenberg and Stiebel, New York, c. 1954; Sidney J. van den Bergh, Wassenaer; sale, anon., *London (Sotheby), 10 December 1975, no. 73 (bought in); dealer G. Cramer, The Hague, 1976; dealer H. Schickman, New York, 1977; purchased by the museum, 1978.*

EXHIBITIONS: Leiden 1965, no. 37, repr.; Tokyo-Kyoto 1968–69, no. 56, repr.; The Hague–London 1970–71, no. 84, repr.; Brussels 1971, no. 87.

BIBLIOGRAPHY: Smith 311; HdG 675; A.B. de Vries, "Old Masters in the Collection of Mr. and Mrs. Sidney van den *Bergh," Apollo, LXXX, 1964, p. 357, Fig. 7; Verzameling Sidney J. van den Bergh, Wassenaar, 1968, no. 88, repr. (the anonymous author of the catalogue entry notes that on the back of the canvas there is a seal probably bearing the coat of arms of the Koucheleff Besborodko family [it bears a strong resemblance to one reproduced in J.B. Rietstap, Armorial Général, vol. I, Paris, n.d., Pl. CC, seventh seal in the top row], and an old Th. Agnew label, with the no. 124163).*

40

A Village in Winter

41

Probably painted in the mid–1660s. Ruisdael had a special predilection for the small size and upright format of the Munich painting for his winterscapes. More than one-third of them, datable from the early sixties to his last phase, have similar dimensions and the same shape. None of these intimate paintings better succeeds in capturing the brooding mood of a winter day darkened by threatening storm clouds.

Munich, Alte Pinakothek, Bayerische Staatsgemäldesammlungen (no. 117)
Canvas, 36 x 31 cm. Signed, lower right.

PROVENANCE: *Zweibrücken Gallery.*

BIBLIOGRAPHY: *Smith 338; Ältere Pinakothek, Munich, Catalogue, 1904, no. 549; Michel 1910, repr. p. 163; HdG 999; Ros 618; Stechow 1966, p. 97, repr. (early sixties).*

Winter Landscape

42

Amsterdam, Rijksmuseum (no. A 349)
Canvas, 42 x 49 cm. Signed, lower right.

PROVENANCE: *Sale, [F.J. Noord-*
wijck], Rotterdam, 3 August 1811, no.
38 (350 florins, Gleym for J. Rombouts,
Dordrecht); with Rombouts in 1842 and
1850; L. Dupper Wzn, who bequeathed
it in 1870 to the Rijksmuseum.

EXHIBITION: *Rome 1956–57, no. 263.*

BIBLIOGRAPHY: *Smith Suppl. 82;*
HdG 985; Ros 602; Simon 1930, p. 58
(somewhat later than 1660); Wolfgang
Stechow, "The Winter Landscape in the
History of Art," Criticism, *II, 1960,*
p. 183; Stechow 1966, pp. 96–97 (early
sixties); Rijksmuseum, Catalogue, 1976,
pp. 487–88, no. A 349; Evert van
Straaten, Koud tot op het Bot: De
verbeelding van de Winter in de
zestiende en zeventiende eeuw in de
Nederlanden, *The Hague, 1977, p.*
120, repr.

In this famous winter scene Ruisdael's emphasis on the massive tower-like building and the large houses that flank it, and on the vigorous contrasts of light and shade, closely relate the picture to the landscapes he painted in the second half of the sixties that stress heroic motifs invigorated by strong chiaroscuro effects. The gigantic, sinister black cloud, which extends obliquely from high on the left toward the massive houses, imparts a forbidding atmosphere that is relieved by the brilliance of the snow and the blue and yellow streaks in the threatening sky.

In his informative essay on "The Winter Landscape in the History of Art," which includes literary and musical parallels to depictions of winter scenes from late medieval to modern times, Wolfgang Stechow wrote of the Amsterdam painting (*op. cit.* 1960, p. 183):

> . . . there is no trace here of the traditional gaiety of Avercamp's or even van Goyen's and van der Neer's scenes nor of the lyrical elegance of van de Cappelle's; it would be altogether absurd to think of skaters before this picture; the real topic is the forlorn, tragic mood of a winter day, with winter interpreted as the corollary of sadness and even death. There is a touch of pathos here which makes us realize that paintings such as these belong to . . . the 1660s and in some cases even later—and that we are therefore not so very far removed from the time when Alexander Pope saw "Pale suns, unfelt, at distance roll away" ("The Temple of Fame"), and when James Thomson was to write . . . [of the season in which] "the sun scarce spreads through ether the dejected day. . . ." A side glance at music would here have to encompass some late seventeenth century examples from Lully (*Isis*, 1677) and Purcell, particularly the latter's wonderful "shivering" aria of Frost from *King Arthur* (1691) . . .

An Extensive Landscape with a Ruined Castle and a Village Church

43

London, The National Gallery, The Trustees of The National Gallery (no. 990)

Canvas, 109 x 146 cm. Signed in the water, lower right.

PROVENANCE: Sale, Jan Gildemeester, Amsterdam, 11 sqq. June 1800, no. 190, "Vue en Gooiland" (315 florins, Thys); Marquis de Marialva, Paris, who died in 1823; bought privately by John Smith, apparently in 1825; sale, John Smith, London, 2–3 May 1828, no. 78 (£472, 10s, Richard Abraham); sale, Richard Abraham, London (Phillips), 28 June 1831, no. 69 (275 guineas); Richard Sanderson, London, by 1835; sale, R. Sanderson, London, 17 June 1848, no. 23 (480 guineas, Brown); Wynn Ellis, London by 1851; Wynn Ellis Bequest, 1876.

EXHIBITIONS: New York 1830, no. 2; London 1947–48, no. 75; London 1976-II, no. 98, repr.

BIBLIOGRAPHY: Smith 214; Waagen 1854, II, pp. 288–89, 296–97. Mac- Laren (1960, pp. 364–65) notes that Waagen confused the provenance of the painting when he described it twice. He listed it in the Wynn Ellis Collection (op. cit., pp. 296–97), and again in the Richard Sanderson Collection (ibid., pp. 288–89). Waagen's latter entry is incorrect. He rightly described the painting as in the Sanderson Collection in Works of Art and Artists in England, 1838, II, pp. 399–400, and repeated this description in his 1854 volume in the erroneous belief that the painting was

In this grandiose panorama with a ruined castle in the foreground and a village church in the middle distance, the large forward-surging cloud formations, which broaden and expand the view, appear as palpable as the landscape's firm tracts of land. Its heroic mood and strong chiaroscuro effect suggest it was painted about 1665–70. The two shepherds and the animals in the left foreground were painted by Adriaen van de Velde, whose death in January 1672 provides a *terminus ante quem* for the picture.

Several of Ruisdael's paintings show the same vast plain, or part of it, from an elevated height. In the earlier literature they are described variously as views of Haarlem, or as views of Beverwijk, a small village which lies about twelve kilometers north of Haarlem. Only one of them depicts the unmistakable silhouette of Haarlem in the background (private collection, England; HdG 775, identical with HdG 812; Ros 63a, identical with Ros 512). The prominent church, which provides an important accent for the structure of the National Gallery picture and which figures in other paintings by or attributed to Ruisdael, is not compatible with the seventeenth-century appearance of St. Bavo at Haarlem or St. Agatha at Beverwijk. Thus, these paintings can be called neither views of Haarlem nor Beverwijk. (For the topography of Beverwijk, see H.J.J. Scholten, "Salomon van Ruysdael in de contreien van Holland's landengte," *O.H.*, LXXVII, 1962, pp. 1ff.).

When A.P.A. Vorenkamp ("Four Acquisitions of 1943–44," *Smith College Museum of Art Bulletin*, June 1947, pp. 9–10, repr.) published Ruisdael's flat landscape now at the Smith College Museum, Northampton, Massachusetts (HdG Zus. 35b, identical with HdG 128; Ros 23), which includes a church similar to the one in the National Gallery's painting and some of Jacob's other works, he suggested that the style of these church towers resembles that of the architecture found in the vicinity of Blaricum in Gooiland, the cradle of the Ruisdael family. Vorenkamp sensibly added that Ruisdael often made free use of motives; therefore, exact identification is difficult. However, Vorenkamp's suggestion may be close to the mark. As noted in the provenance, when the National Gallery landscape appeared in the Gildemeester sale in 1800, it was identified as a *Vue en Gooiland*. There may be a grain of truth in the traditional title, for Ruisdael may have derived the motif from the neighborhood of his forebears.

Three small variants of the composition are known: The National Gallery, London (no. 256; HdG 36, identical with HdG Zus. 66a, HdG 90, and possibly HdG 779d; Ros 25, identical with Ros 26); private collection, New York (HdG 750; Ros 463); Dutuit Collection, Petit Palais, Paris (HdG 74; Ros 61). Perhaps the little version in the National Gallery served as a preliminary study for the large painting; the status of the other two variants is uncertain. An untraceable version was with

still there. The confusion was compounded by an erroneous entry in the provisional catalogue of the 1857 Manchester exhibition, which states that the picture was in the exhibition, lent by Sanderson. MacLaren has shown that it was not. Bürger 1865, p. 296 (Bürger's reference is erroneous; see MacLaren 1960, pp. 364–65, note 20); HdG 136, identical with HdG 758 and HdG 844d; Ros 24; Simon 1930, p. 73; MacLaren 1960, pp. 361–65, no. 990.

the dealer Knoedler, New York, 1926 (53.4 x 61 cm). (Provenance: Mrs. Josephs, London; J.H. Dunn; Exhibitions: London, Royal Academy, 1891, no. 77; New York, dealer Knoedler, *Loan Exhibition of Dutch Masters*, 16–28 November 1925, no. 20.) Two of the paintings cited above, one in a private English collection and the other at the Smith College Museum, are not variants of the large National Gallery landscape; however, they share recognizable elements with it.

Richard Abraham (also called Abrams) exhibited the great panoramic view, along with a mixed lot of more than fifty old master originals and copies, at New York's American Academy of Fine Arts in March 1830. A catalogue was published to accompany the exhibition. To be sure, there are a few earlier references to Ruisdael's paintings in America. For example, three are listed in a catalogue of pictures exhibited at Boston in 1827, and others were shown there in 1828 and 1829 (see *The Boston Athenaeum Art Exhibition Index: 1827–1874*, ed., Robert F. Perkins and William J. Gavin III, Boston, 1980, p. 123). But these paintings are untraceable and the reliability of the attributions that were given to them is uncertain. Until an earlier reference to an identifiable work by Ruisdael is discovered, Richard Abraham can be credited with bringing the first work by the artist to the United States.

According to William Dunlap (*History of the Rise and Progress of the Arts and Design in the United States*, New York, 1834, vol. I, p. 362), chronicler of early nineteenth-century events on the American art scene, the collection Abraham exhibited in New York was the best one of old masters the country had seen. The little that is known about Abraham suggests that he did not win a reputation for many other laudable deeds. Dunlap wrote:

This man [Abrams] (as I was informed by an intelligent English gentleman, an amateur painter) was a picture dealer and cleaner in London; and having, in conjunction with another dealer, of the name of Wilmot, collected a number of good pictures, under various

pretences, they concerted the scheme of flying with them to New York. Here they were stopped, and Abrams imprisoned. Wilmot, under the name of Ward, escaped the catchpoles, and embarked for Liverpool in the same vessel with my informant; and contrived, by cards and betting with the passengers, to gain upwards of three hundred guineas. On his arrival he was recognized before he could reach the great hiding place, London, and seized by those he had defrauded. Abrams made some compromise, by which he was permitted to exhibit the pictures for the benefit of the proprietors; and he did it adroitly, with an impudence worthy of a picture dealer" (*ibid.*).

By 28 June 1831 Ruisdael's landscape along with other works in Abraham's collection had been returned to London and auctioned. We can only conjecture what effect the noble picture would have had on American landscape painters if it had remained in the United States. However, we do know that when the American portraitist Thomas Sully (1783–1872) made brief notes on the color and technique of several paintings in Abraham's collection in May 1830; he did not find Ruisdael's landscape worthy of notice (*ibid.*, vol. II, p.280). In Sully's view the best picture in the collection was a Murillo (no. 9; perhaps identical with the *Family Group*, Erik Bergmann, Monroe, Michigan; repr. in G. Kubler and Martin Soria, *Art and Architecture in Spain and Portugal*, Harmondsworth, 1959, Figs. 145A, 148A). The only other paintings Sully cites are "a fine copy of Correggio's Magdelene" (no Correggio was exhibited; there was however a *Magdelene* attributed to Titian [no. 18]), a portrait by Velázquez which he called doubtful (no. 4), a Hobbema (there were two, nos. 10 and 13; the former is *The Water Mill*, now at Brussels; HdG, Hobbema 155; Broulhiet 12; the latter was catalogued as a copy), and finally, a landscape which Sully wrote is "said to be by Claude" (no. 48; it is Claude's *Landscape with a Piping Shepherd* now in The Nelson Gallery of Art, Kansas City, no. 31–57).

View of Haarlem with Bleaching Grounds

44

The Hague, Mauritshuis (no. 155)
Canvas, 55.5 x 62 cm. Signed, lower
right.

PROVENANCE: Sale, Samuel Beyer-
man, Gouda (Boon), 21 April 1778, no.
3 (Lokhorst); sale, Gerrit Muller, Am-
sterdam (de Vries and Roos), 2 April
1827, no. 59 (6,700 florins, J. de Vries);
purchased in 1827.

EXHIBITIONS: London 1929, no. 176;
Brussels-Antwerp 1946, no. 92, repr.;
Eindhoven 1948, no. 58a; San Francisco–
Toledo–Boston 1966–67, no. 57, repr.;
Tokyo-Kyoto 1968–69, no. 54, repr.

BIBLIOGRAPHY: Smith 220; Bürger
1858, I, pp. 270–71; HdG 65; Ros 48;
Simon 1930, pp. 49–52; Stechow 1966,
p. 47; Wiegand 1971, pp. 99–106; Fuchs
1973, pp. 284–85; Burke 1974, pp. 3–11;
Mauritshuis, The Hague, Catalogue,
1977, p. 210, no. 155 (after c. 1670);
Mauritshuis, Hollandse Schilder-
kunst, Landschappen 17de Eeuw,
The Hague, 1980, pp. 90–92 (c. 1670–
75).

Although Ruisdael painted a spacious flat landscape as early as 1647 (Cat. no. 6), and occasionally used the subject for works done in the following decade (Cat. no. 28), only in his maturity did he begin to concentrate on panoramic views. The Mauritshuis' beautiful painting shows Ruisdael's favorite motif for these pictures. The prospect is seen from the dunes near Haarlem with an extensive vista of bleaching fields, woods, houses, and, on the horizon, a view of the town dominated by its great church St. Bavo. From left to right Haarlem's Bakenesse Church, St. John Church, Klockhuis, Town Hall, and New Church also can be distinguished.

None of Jacob's variations on the theme is dated, but today there is a consensus that the Mauritshuis picture and the one at the Ruzicka Stiftung, Zurich (Cat. no. 45), as well as many others of his outstanding views of his native town, were painted about 1670–75. Reference to "een Haerlempje van Ruysdael" in an estate assessed at Amsterdam in 1669 (Bredius 1916, vol. II, p. 425) establishes that he had painted one by that year. A *Haarlempje*

soon became the popular name given to the panoramic views Ruisdael and his followers (especially Jan van Kessel [1641/2–80] and Jan Vermeer van Haarlem [1628–91]) painted of the town. Wolfgang Stechow observed that the "brand-name" casualness with which *Haarlempje* is used by the compilers of the 1669 inventory bespeaks the familiarity of its user with paintings of this type (1968, p. 45). To our best knowledge the rather primitive *Haarlempje* by the little-known artist Reijer Claesz Suijcker (before 1594–1653/55), monogrammed and dated 1624, is the earliest existing painted one (Fig. 55; panel, 20.5 x 35.5 cm; Frans Hals Museum, Haarlem, no. 496).

James D. Burke (*op. cit.*) has published a systematic account of the point of view from which the principal buildings on the skyline of Ruisdael's panoramic views of Haarlem are seen. The orientation of the city can be established best by noting the position of St. Bavo. In the Mauritshuis painting and in the one at Zurich (Cat. no. 45) it is seen from the northwest, more or less as it would have been viewed from the Kopje at the village of

Fig. 55

Bloemendaal. Both pictures have been called views from the dunes at Overveen, as have some of his other panoramas which show St. Bavo from the northwest (*e.g.*, Amsterdam, Rijksmuseum, no. A 351; HdG 55; Ros 38; Berlin, Staatliche Museen, no. 885C; HdG 56; Ros 39). These titles are incorrect. When the church is viewed from the village of Overveen, which lies about two and a half kilometers due west of Haarlem, its west façade is seen. For Jacob's drawings of the lofty church from this direction and other points of view, see Cat. nos. 88–91.

Burke's study also establishes that Ruisdael's *Haarlempjes* are never exact representations of specific total prospects and that the viewing place is rarely an actual spot on the landscape. The Mauritshuis and Ruzicka paintings are cases in point; there is neither a high dune nor a height northwest of Haarlem that would present the views Ruisdael showed in them.

The bleaching fields in both paintings and those that figure in others by Jacob were familiar sights in the vicinity of Haarlem in his day. Bleaching linen manufactured in Holland as well as unbleached cloth imported from England, Germany, and the Baltic countries was one of the town's major industries. The bleacheries used the clear spring waters that emerged at the foot of the young dunes near Haarlem; long strips of treated cloth were spread to bleach in the fields. Wilfried Wiegand (*op. cit.*) notes that bleaching fields also had an emblematic meaning in the seventeenth century; they could refer to the purity of the soul and God's gift. In his view the Mauritshuis *Haarlempje* has an emblematic meaning since the bleaching field receives greater emphasis than the view of Haarlem. R.H. Fuchs (*op. cit.*) rightly rejects this far-fetched notion.

A copy of the painting was in the Frederick Cook Collection, Doughty House, Richmond (canvas, 33 x 40.5 cm; Kronig 1914, p. 92, no. 347, repr.); Hofstede de Groot (70) erroneously notes that the Cook painting is a copy of the *View of Haarlem* now at Edgehill, Upton House, National Trust (HdG 70; Ros 55). Three other copies are known: sale, Berlin (Lepke), 7 February 1911, no. 30, repr. (canvas, 25 x 31 cm); sale, Cologne (Lempertz), 15 April 1930, no. 168 (canvas, 59.5 x 66 cm), the same painting was sold, Lucerne, 21 August 1930, no. 264; Paris, private collection (panel, 47 x 63 cm).

Fig. 55. Reijer Claesz Suijcker, View of Haarlem, *1624. Haarlem, Frans Hals Museum.*

View of Haarlem with Bleaching Grounds

45

In our time Ruisdael's panoramic views of Haarlem often are preferred to his waterfalls. An indication that this may not have been the case in his day is given by the valuation given to one of his *Haarlempjes* in an inventory made of an Amsterdam collection in 1669; the appraisers valued it at 24 guilders (Bredius 1916, vol. II, p. 425; also see Cat. no. 44). In the same collection there were three waterfalls by Ruisdael; they were appraised at the respectable sums of 36, 42, and again 42 guilders (*ibid.*, pp. 423, 425).

Ruisdael's *Haarlempjes* appeal to us because they offer what is now accepted as the most characteristic view of the Dutch countryside while achieving an unparalleled degree of openness and height. The one at Zurich, a summit of Jacob's achievement, is an exemplar of the type. Its sky, as the skies in most of them, takes up more than two thirds of the canvas, but the impression of height is increased here by the vertical format, and still more by the dominant part the towering, strongly modeled clouds play in the awe-inspiring aerial zone. The prospect of the plain is shown from an exceptionally distant and elevated point of view. As a result there is a reduction both in scale and in overlappings of the watery dunes, woods, and tracts of land. The firm cohesion of the great cloudy sky gains in mass and significance from its relation to the diminutive forms. The eye can explore here—more than in most other *Haarlempjes*—the vast expanse of this land richly differentiated by the gradations of alternating bands of light and shadow into the distance toward a horizon stretched taut as sinew.

Zurich, Kunsthaus, Stiftung Prof. Dr. L. Ruzicka (no. R.32)
Canvas, 62.2 x 55.2 cm. Signed, lower left.

PROVENANCE: *Sale, Count Sierstorpff, Berlin (Lepke), 19 April 1887, no. 67 (Vieweg); collection Vieweg, Brunswick; sale, Vieweg, Berlin, 18 March 1930, no. 13, repr. (122,000 marks, Cassirer); acquired for the Ruzicka Collection in the Zurich art market, 1949.*

EXHIBITIONS: *Düsseldorf, 1886, no. 288; Zurich 1949–50, no. 32, repr.; Rome 1954, no. 131; Milan 1954, no. 134; Cologne 1954, no. 23, repr.; Oslo 1959, no. 63.*

BIBLIOGRAPHY: *HdG 59, identical with HdG 92; Ros 44; Simon 1930, p. 73; W.R. Valentiner, Das unbekannte meisterwerk in öffentlichen und privaten Sammlungen, New York, 1930, no. 58; Stechow 1966, p. 45f., repr.*

Panorama of Amsterdam, Its Harbor, and the IJ

46

A chalk and wash preparatory study for this exceptional view of Amsterdam is at the Rijksprentenkabinet (see Cat. no. 87). The drawing most probably was made from the scaffolding used to erect the tower of the city's magnificent New Town Hall on the Dam; the tower was begun in 1664 and finished in the following year. It seems, however, that Ruisdael did not use his drawing as a study for the painting straightaway. The picture is more closely related to his extensive views of Haarlem datable to the first years of the seventies than it is to those done about 1665. This is seen in the format of the painting, the rather thin clouds of the towering sky, the minute attention to detail (the picture is exceptionally well-preserved—even the forest of masts and rigging of the docked ships in the far distance remain intact), and the strong contrasts of light and dark formed in the middle ground by the long shaft of modulated sunlight that pierces the heavy shadow blanketing the wide expanse of the city and in the distance by the river IJ separating Amsterdam from the fertile polders beyond it. The scaffolding, which plays an important role in the foreground of the preparatory drawing, has been suppressed in the painting, where a projecting cornice and some building material, presumably for the upper part of the New Town Hall, can be discerned in half-shadow in the foremost part of the picture.

To judge from Ruisdael's existing views of Amsterdam, he did not share the interest that Dutch specialists in townscapes such as Jan van der Heyden and Gerrit Berckheyde showed in the New Town Hall. They often portrayed the most impressive building erected in the United Provinces during the seventeenth century. Ruisdael did not. None of his known views of Amsterdam makes a major accent of the building his contemporaries called the eighth wonder of the world.

On the right the straight row of houses that flank the Damrak can be distinguished, beyond them is the tower of the high Oude Kerk, and behind it is the Montelbaanstoren; the tower on the extreme left is the Haringpakkerstoren on the corner of the Singel Canal. Other buildings also can be identified, but as important to Jacob as topographical detail was the general impression of countless dwellings and warehouses, standing cheek by jowl, in which the inhabitants of northern Europe's leading port and most powerful trade center lived and worked. During the course of the seventeenth century Amsterdam became one of the most populous cities on the continent. An estimate of its population in 1625 places it at slightly more than 100,000 inhabitants; by the time Ruisdael settled there shortly after the middle of the century it had doubled. Not the least exceptional aspect of this extraordinary panoramic view of the mighty metropolis is that not a single soul has been included in it.

Private collection
Canvas, 41.5 x 40.7 cm. Signed on a beam of the scaffolding, lower left.

PROVENANCE: *The Marquess of Lansdowne, Bowood, Wiltshire, by 1854.*

EXHIBITIONS: *London, Royal Academy, Winter Exhibition, 1884, p. 31, no. 145; Bristol 1937, no. 3.*

BIBLIOGRAPHY: *Waagen 1854, III, p. 160; Academy Notes, January 1884, p. 34; HdG 9 (seen from the scaffolding of the New Town Hall); Ros 2; Roggeveen 1948, p. 92; Stechow 1966, p. 128 (hardly painted before the late upright Haarlempjes).*

Le Coup de Soleil

47

Paris, Musée du Louvre (no. INV. 1820)
Canvas, 83 x 99 cm. Monogrammed,
lower left.

PROVENANCE: Sale, Comte de Vau-
dreuil, Paris, 24 November 1784, no. 61
(4,360 francs, Bertels for Louis XVI);
collection Louis XVI.

EXHIBITIONS: Rome 1928, no. 104,
repr.; Paris 1945, no. 60; Paris 1950–
51, no. 76; Paris 1970–71, p. 198f., no.
191 (with a comprehensive bibliography);
Amsterdam 1971, p. 142, no. 58.

BIBLIOGRAPHY: Filhol 1804, I, no.
70, repr.; Taillasson 1807, p. 48; Ainé
[n.d.], [n.p.], repr.; Smith 11, identical
with Smith 39; Louvre, Catalogue, 1852,
no. 473; Blanc 1858, II, p. 100; Michel
[1890], p. 81; F. Engerand, Inventaire
des tableaux commandés et achetés
par la direction des bâtiments du Roi
(1709–1792), Paris, 1901, p. 557; G.
Riat, Ruysdael (Les Grands Artistes),
Paris [1905?], pp. 37, 69, 93–95, repr.
p. 89; HdG 664, identical with HdG 701;

Louvre, Catalogue, 1922, no. 2560; Ros
413; Simon 1930, pp. 53, 75; Simon
B.M. 1935, p. 135; Stechow 1966, p.
138; Louvre, Catalogue, I, Écoles fla-
mande et hollandaise, 1979, p. 123,
no. INV. 1820.

Etched by De Saulx in Filhol (op. cit.);
engraved by Pierre Laurent (1739–1809)
in the Musée Français, see Ainé (op.
cit.); etched by Daubigny.

This celebrated landscape has been called *Le Coup de Soleil* at least since it was given that title when it was published in 1804 in Filhol's *Musée Napoleon* (*op. cit.*). The attempts that have been made to identify the site of the picture as a place in the province of Gelderland (Michel, cited in Paris 1970–71, p. 199), the Rhine Valley (Riat, *op. cit.*, pp. 93–94), or a view derived from scenery Jacob saw in France when he presumably was studying medicine at Caen late in life (Simon *B.M.* 1935, p. 135) are as futile as the efforts that have been made to pinpoint the precise geographical locations of the mountainous landscapes painted by Hercules Segers and Rembrandt. Like those painted by the greatest Dutch masters of fantastic landscapes, Ruisdael's *Le Coup de Soleil* is an imaginary scene.

Reference to Rembrandt is of more than passing interest here. Landscapes by Ruisdael that show the influence of Rembrandt's art are exceedingly rare (see p. 235). It is arguable that *Le Coup de Soleil* qualifies as one of them. Its vast river valley and enormous range of mountains were possibly inspired by Rembrandt's paintings of fantastic landscapes (his numerous landscape drawings and etchings hardly ever show such scenes). Comparison of *Le Coup de Soleil* with Rembrandt's imagi-

Fig. 56. Rembrandt van Rijn, River Landscape with Ruins. *Cassel, Hessisches Landesmuseum.*

Fig. 56

nary *River Landscape with Ruins* at Cassel (Fig. 56; Bredius 454) supports this view. It is manifest that the paintings have similar compositional schemes and numerous elements in common. Their differences, however, are equally striking. Ruisdael achieves greater simplification and breadth and more convincing depth in his landscape. The unexpected strong contrasts of light and deep shadow are more concentrated, the less brilliantly lit areas are modulated more consistently, and, not least, the gigantic clouds that fill the immense height of the blue sky introduce an atmospheric life that does not play an important part in Rembrandt's painting. Jacob's imaginary landscape remains linked to nature; Rembrandt's is bound to the visionary.

The landscape is best dated to the 1670s, when Ruisdael painted panoramic views of the Dutch countryside, beachscapes, and marines that also appear to achieve the ultimate degree of openness and height. Particularly remarkable is the major accent in the painting, the huge burst of sunlight that dramatically breaks through the clouds, from which the picture gets its popular name. It heightens the drama while stressing the horizontal character of the river valley and furthering the spatial effect.

Nicolaes Berchem, Philips Wouwerman, and Ruisdael himself have been variously called the author of the staffage in this landscape. None of these attributions is fully convincing.

Many copies have been made of *Le Coup de Soleil*. The whereabouts of the one Hubert Robert painted is unknown (sale, Robert, Paris, 18 August 1821, no. 325). Turner made a quick pencil sketch of it when he visited the Louvre in 1802 (Fig. 57; see A.J. Finberg, *A Complete Inventory of the Drawings of the Turner Bequest*, vol. I, London, 1909, p. 193, no. LXXII, p. 81). Turner wrote in his sketchbook (*ibid.*, p. 182, no. LXXII, p. 22a) that he admired the landscape, but not without reservation:

A fine coloured grey picture, full of truth and finely treated as to light which falls on the middle ground. All beyond is of a true deep ton'd greyish green. The sky rather heavy, but well managed, but usurps too much of the picture and the light. The Objects near to the light are poor and ill jud[g]ed particularly

Fig. 57. J.M.W. Turner (after Ruisdael), "Le Coup de Soleil," Louvre Sketch Book. *London, British Museum, Turner Bequest.*

Fig. 57

about the Windmill inclin'd to be chalky. The foreground dark, violently so near the bright light that gives a crudeness inconsistent with the purity of the distance. The base of the picture particularly happy as a grey tone that easies the eye and gently glides into the shadow (somewhat the color of this paper). The figures are by Bergem but they do not accord with the general tone of the picture. Fortunately they are placed on the defective part of the piece and therefore create some kind of interest.

Turner's interest in Ruisdael did not flag; for his *Port Ruysdael* (exhibited 1827) and *Fishing Boats Bringing a Disabled Ship into Port Ruysdael* (exhibited 1844), see Cat. no. 27.

Le Coup de Soleil also captured the fancy of the American landscape painter Thomas Doughty (1793–1856) on his second European trip. His copy, now in The Brooklyn Museum (no. 41.5) is distinctly signed: "After Ruysdael/By T. Doughty/Paris/1846" (see *Thomas Doughty* . . . , exhibition catalogue by Frank H. Goodyear, Jr., Pennsylvania Academy of Fine Arts, Philadelphia, 1973, p. 29, no. 43, repr.).

Other copyists chose to remain anonymous. A copy by one of them was formerly in the Cremer Collection, Dortmund (canvas, 80 x 105 cm); it was erroneously sold as a Philips Koninck at the end of the nineteenth century (see Gerson 1936, p. 133, no. XXXII). According to the Paris exhibition catalogue 1970–71 (no. 191), other anonymous copies are in the Museum at Vienne, France; the H. Haedrich Collection, Brussels; the Gabz Collection, Nice; the Schloss Collection, Paris. A copy was in the collection Landsmann, Prague, January, 1928 (photo R.K.D.), and one was in the sale, anon., Amsterdam (Muller), 8–11 June 1948, no. 543 (canvas, 47 x 57 cm). It has not been possible to establish whether any of the copies cited above is identical.

The famous painting also was used as a motif on Sèvres porcelain about 1836 (see H. van der Tuin, "Reproduction et imitation de vieux tableaux flamands ou hollandais sur procelain de Sèvres (1756–1847)," *O.H.*, L, 1950, p. 58).

Rough Sea

48

Boston, Museum of Fine Arts, William Francis Warden Fund (no. 57.4) Canvas, 107 x 124.5 cm. Signed, lower left.

PROVENANCE: Said by Waagen (1854) to have been discovered in Holstein by the Hamburg dealer Harzen; Edmund Forster; Richard Forster, of Clewer Manor, Clewer Park; sale, Richard Forster, London (Christie's), 13 July 1895, no. 70 (£4,410, Colnaghi); Sir Alfred Beit, London; dealer Rudolf Heinemann, New York; acquired by the museum in 1957.

EXHIBITIONS: Manchester 1857, no. 958; London, Royal Academy, Winter Exhibition, 1908, no. 57; London 1929, no. 100, repr.; San Francisco–Toledo–Boston 1966–67, no. 76, repr.

BIBLIOGRAPHY: Waagen 1854, II, p. 452; Bürger 1865, p. 296; HdG 957 (about 1660); Bode 1913, no. 51, repr.; Ros 591; J. Rosenberg, "A Seascape by Jacob van Ruisdael," Bulletin, Museum of Fine Arts, Boston, LVI (1958), p.145f.

The major accent in this marine is the dark hull of the foremost boat and its white, sunlit sail seen against gray clouds, but equally impressive is the treatment of the foaming, feathery waves lapping against the ancient pilings and the atmospheric drama of the mighty sky. The great wealth of contrasts and the richly articulated differentiation of space in this seascape suggest that it was painted about 1670. As in his panoramic views of the extensive plains near Haarlem datable about the same time, Ruisdael provides the eye with subtle points of reference leading from the foreground to the middle and far distance.

Hofstede de Groot (957) wrote that the seascape was painted from the same place as the *View of Het IJ*, now at Worcester (Cat. no. 32), but "the view is shifted more to the right; thus the town of Amsterdam is not visible." However, without the view of Amsterdam it is not possible to accept the suggestion that both seascapes were done from the same spot. Moreover, there is no reason to assume that Ruisdael painted any of his pictures out-of-doors, and the least likely candidates for this distinction are those devoted to the moods of the sky and sea.

The Zuider Zee Coast near Muiden

49

Polesden Lacey, Dorking, Surrey, The National Trust
Canvas, 53.3 x 66 cm. Signed, lower left.

PROVENANCE: Sale, Duc de Choiseul, Paris, 6 sqq. April 1772, no. 68 (1,701 francs [with the companion, no. 67], Boileau); sale, Prince de Conti, Paris (Remy), 8 sqq. April 1777, no. 400 (2,401 francs [with the companion]), Langlier); sale, [Dulac and Lachaise], Paris, 30 sqq. November 1778, no. 355 (2,299 francs [with the companion]); collection Marquis de Marigny (later Marquis de Ménars; died 1781); sale, Marquis de Ménars, Paris, 18 March–6 April 1782, no. 102 (1,851 francs [with the companion], Hamon); sale, B———— [of Caen], Paris (Pérignon), 3 December 1827, no. 10 (2,000 francs, Delahante); collection Baron J.G. Verstolk van Soelen, The Hague, by 1835, whose collection was sold en bloc to Humphrey St. John Mildmay and others in 1846. This painting and its companion went to Mildmay; sale, Henry Bingham Mildmay, London, 24 June 1893, no. 65 (£1,785); bought by the Rt. Hon. E. McEwan and bequeathed by his daughter, the Hon. Mrs. Ronald Greville, London, to The National Trust in 1942.

EXHIBITIONS: London, Royal Academy, 1876, no. 164; London, The National Gallery, 1943; London 1945, no. 30, repr.; Paris 1950–51, no. 78; London 1952–53, no. 299; New York–Toledo–Toronto 1954–55, no. 72.

BIBLIOGRAPHY: Smith 20; Waagen 1857, IV, pp. 154–55; HdG 102 (described in reverse); Ros 572a; Polesden Lacey, Catalogue, 1955, p. 26f., no. 53; Stechow 1966, p. 106.

Engraved in reverse by an anonymous hand in Pierre François Basan, Recueil d'estampes gravées d'après le Cabinet de Monseigneur le Duc de Choiseul, Paris, 1771, no. 118.

Fig. 58. Jacob van Ruisdael, The Shore at Egmond aan Zee. London, National Gallery.

We have seen that Ruisdael painted a couple of coastal scenes in the 1640s (Cat. no. 8), and in the following decade he painted a view of the sea seen from the dunes that gives a hint of a shore line (Cat. no. 26). However, beach scenes proper only occur in the late 1660s and 1670s when sky and open distance gain a greater importance in his landscapes. They form a small category of his work; apart from the Polesden Lacey painting only about six are known today. The layout of most of them is similar: On one side high dunes run obliquely into the distance; on the other there is an extensive stretch of sea and beach seen at low tide; the horizon is low and grandiose cloud formations fill the vault above the scene. In those datable to the 1670s the dunes are pushed more to the side, and there is a tendency toward greater spaciousness and flatness, and the sea penetrates further into the distance. The Polesden Lacey beachscape is one of the loveliest of this group.

The provenance of the painting is particularly distinguished. It belonged to the Duc de Choiseul (1719–85), who amassed one of the finest collections of Dutch pictures ever assembled. At the time of his sale in 1772 he held not only the Polesden Lacey painting and three others by Ruisdael in his possession, but also a number of outstanding works by Rembrandt, Terborch, Steen, Metsu, Dou, Nicolaes Berchem, Frans van Mieris, and Adriaen van der Werff. More than half of his Dutch pictures are now prized possessions of leading European and American museums and collections.

Among Choiseul's pictures by Ruisdael was another beach scene, *The Shore at Egmond aan Zee*, now at The National Gallery, London (Fig. 58; no. 1390; canvas, 53.7 x 66.2 cm; HdG 927; Ros

Fig. 58

570). From the time it and *The Zuider Zee Coast near Muiden* were in his collection until the two paintings were separated in 1893 they have the same history. They frequently have been called companion pictures. Although both are datable to the 1670s and have virtually identical dimensions, there is no compelling reason to believe Ruisdael intended them to be viewed as pendants. Their compositions do not complement each other, and the sharpness of execution of the Polesden Lacey picture and the breaking up of its sky into numerous scudding clouds suggest that it was painted slightly later than the National Gallery picture. Moreover, the groups of figures in the paintings are not only different in scale, but they are also by different artists. The fashionably dressed figures in the National Gallery painting are similar to those which have been attributed to Gerard van Battem (see Cat. no. 55). The staffage in the Polesden Lacey picture is by another hand.

The National Gallery beachscape was engraved in reverse by Jacques Philippe Le Bas (1707–83). Neil MacLaren (1960, p. 366, note 6) has established that his print was made between 1743 and 1771. Le Bas' print is erroneously called *Vue de Skervin* (View of Scheveningen); as noted above, the painting is a view of the shore at Egmond aan Zee. His print also bears a six-line poem that gives us a glimpse of the thoughts that a late beachscape by Ruisdael could inspire in an eighteenth-century viewer when it was used as a referential object:

Le flux et le reflux qui couvrent cette plage,
Des effets de l'Amour sont la parfaite image;
Et tandis qu'en ce lieu je vois que de concert
Ces trois sages amants et ces trois jeunes Dames
Se tiennent separez, pour mieux cacher leurs
 flammes,
Leur coeur est plus ému que les flots de la Mer.

(The ebb and flow of the tide upon this shore,
Is the perfect image of the effects of Love;
And while I see here that, by mutual agreement,
These three prudent lovers and three young
 Ladies
Hold apart from each other, to better hide their
 flame,
Their hearts are more agitated than the waves of
 the Sea.)

A Waterfall with a Low Wooded Hill

Most art lovers who visit Florence understandably devote their energy to the city's peerless collections of Italian Renaissance art. Only tourists traveling at a very leisurely pace or people with a passion for the painting produced in the Netherlands during its heroic age find time for the small but choice group of seventeenth-century Dutch pictures in Florence's great galleries. One of the finest of them is this late *Waterfall* by Ruisdael, which is relatively unknown, although it was on view at the Pitti Palace for almost a century and has been exhibited at the Uffizi since 1922. None of Jacob's existing waterfalls better exemplifies how the shift from the heroic to the more intimate and idyllic mood that characterizes a considerable number of his works of the seventies affected his treatment of a subject that hardly seems to lend itself to the new tendency.

In this work the waterfall has not become insignificant, but it has been subdued, not least by the gentle beginning of its drop from a broad, quiet pool. Beyond it there is not a trace of the crushing height of his earlier waterfalls. The line of the hills has been leveled almost to a horizontal, which imbues the view with a soothing sense of breadth, while the delicate treatment of the trees seen against the evening sky emphasizes the height of the aerial zone taking up more than half of the painting and adding to the effect of peace and quiet.

A copy of the painting appeared in the sale, Henneberg of Zurich, Munich (Helbing), 29 October 1903 (canvas, 52 x 63 cm). Another copy, said to be monogrammed and dated 1647, was in the sale, Amsterdam (Brandt), 24–25 June 1959, no. 22 (panel, 52 x 64 cm). It is probably identical with the version that appeared in the sale, London (Christie's), 25 November 1966, no. 71, repr. (panel, 49.5 x 63.5 cm), which is listed as monogrammed and dated 1645. The dates of 1645 and 1647 are impossible ones for this composition.

50

Florence, Uffizi Gallery (no. 8436)
Canvas, 52.3 x 61.7 cm. Signed on the
large boulder at the lower left.

PROVENANCE: Dealer Arteria, Mann-
heim; purchased for the Pitti Gallery
about 1830 from Arteria by the Grand
Duke Leopold II (1824–59) for 1,200
francs; Pitti Palace, Florence; transferred
to the Uffizi in 1922 (details regarding
the provenance kindly provided by Marco
Chiarini).

BIBLIOGRAPHY: Pitti Palace, Cata-
logue, 1894, no. 429; HdG 221; Ros
160; Uffizi, Catalogue, 1952, p. 188,
inv. no. 8436; Gli Uffizi, Catalogo
Generale, Florence, 1979, p. 576, no.
P1836 (c. 1670?).

A River Landscape with a Castle on a High Cliff

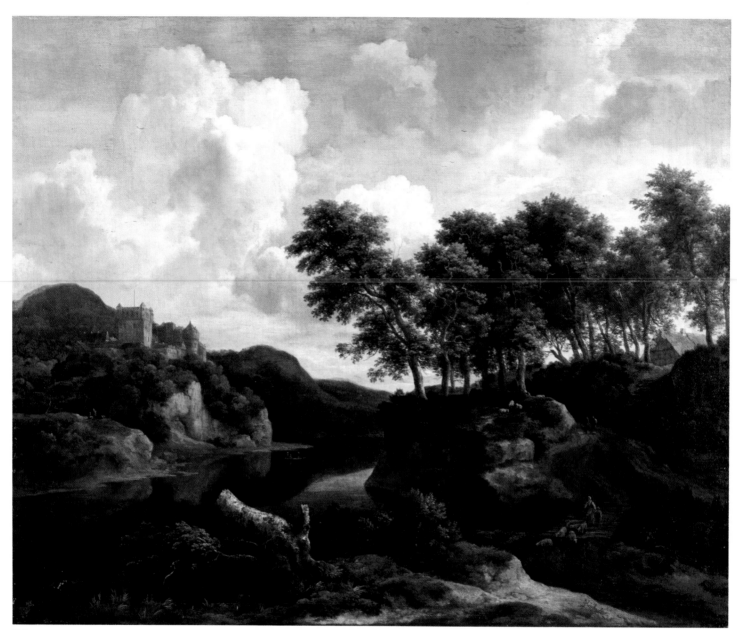

51

Cincinnati, Cincinnati Art Museum
(no. 1946.98)

Canvas, 102.2 x 126 cm. Signed, bottom
right.

PROVENANCE: Richard Hall, London,
1835; Colonel R. Spencer Hall, Malmes-
bury, Sussex; sale, Colonel R. Spencer
Hall, London, 20 June 1913, no. 34
(Bentheim; £4,200, Th. Agnew); dealers
Scott and Fowles, New York; gift of

Mary Hanna to the Cincinnati Art
Museum.

EXHIBITION: Portland 1967–68, no.
16.

BIBLIOGRAPHY: Smith 284; HdG 772;
Ros 439a; Stechow 1966, pp. 138–39,
repr.; Cincinnati Art Museum, Hand-
book, 1975, p. 121 (Scene in West-
phalia).

The range of mountains, the high cliffs, the mirror-smooth, broad river, and even the flock of sheep on the gently winding road in this painting recall the setting of the imaginary landscape in the collection of The Norton Simon Foundation (Cat. no. 38). However, a significant alteration has been made in the Cincinnati picture. Only the huge, battered beech stump in its foreground is reminiscent of the commanding presence of the closely seen colossal trees in the Simon painting. The absence of a comparable motif has discharged it of the Simon landscape's superabundant strength and exuberance. They have been replaced by a poetic peace. The accents of light are now less concentrated and the contrast between lit areas and those in shadow has been softened, but there is no loss in the strong cohesion of the compendium of earlier themes used for the imaginary scene. The walled castle high on a precipitous cliff, with its massive square tower on one side and large turret on the other, resembles the one at Bentheim (see Cat. nos. 12–14), but it is not a precise depiction of it. W. Bode, who dated the picture about twenty years too early (about the time Jacob left Haarlem to settle in Amsterdam), wrote that the landscape is based on scenery the artist studied in Germany on the Rhine and in Westphalia (letter dated 22 July 1913, Archives, Cincinnati Art Museum). Since his time it has been called a scene in Westphalia. Wolfgang Stechow (*op. cit.*) rightly notes that if it was inspired by such a view, it was romanticized beyond recognition.

A Mountainous and Wooded Landscape with a River

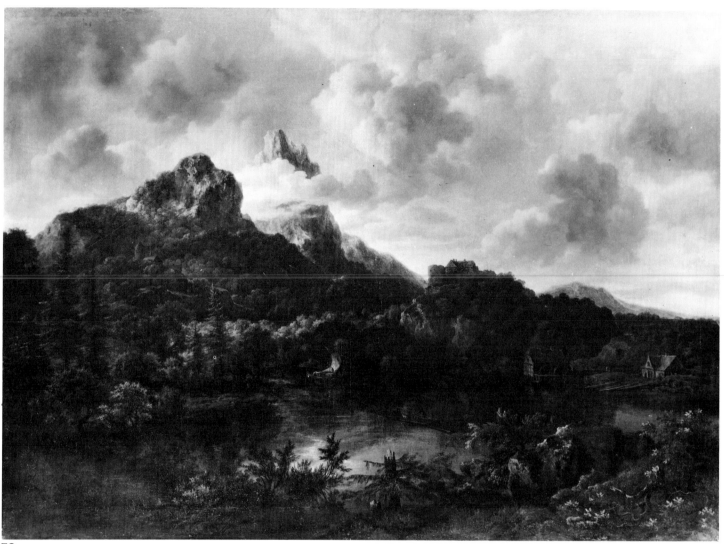

52

Leningrad, Hermitage (no. 932)
Canvas, 99.5 x 137 cm.

PROVENANCE: Collection Count
Brühl, by 1754; acquired from Brühl in
1769.

BIBLIOGRAPHY: Smith 307; HdG 155;
Ros 408; Hermitage, Catalogue, 1958,
vol. II, p. 250, no. 932.

Engraved in reverse by P.E. Moitte
(1722–80) in Recueil d'estampes
gravées d'après les tableaux de la
galerie. . . de Brühl, *Dresden, 1754, no. 5.*

Although mountains began to appear as elements in Jacob's imaginary landscapes from the time of his *Wanderjahre* and soon afterward became a staple in his Scandinavian waterfalls, the late Leningrad painting dedicated to the rugged grandeur of a range of mountains as high as the Alps, with its tallest peak shrouded by clouds, comes as a surprise. The impulse that generated its creation was a new one for Ruisdael. Mountains in his earlier pictures, grand as they may be, are part of the *mise en scène*. Only during his last years, and then only in a few paintings, did he employ them as the chief means of expressing the vastness and dominant power of nature.

Only two other paintings of this type are known today. One, very similar in character to the Leningrad picture, is in the Max Michaelis Collection, The Old Town House, Cape Town (Fig. 59; canvas, 86.3 x 104.1 cm; possibly HdG 762; Ros 401, possibly Ros 478). The other, less grandiose in conception, is in a private collection, New York (canvas, 101.5 x 134.5 cm; HdG 34 [erroneously identifies a castle on one of the mountain peaks as Bentheim], identical with HdG 763; Ros 410). The dark areas of the New York picture are abraded and have been repainted; its three prominent figures, added by a later hand, inspired someone with a fertile imagination to title it *The Oath of the Rütli* (see HdG 763). Jakob Rosenberg (399; canvas, 87 x 122 cm) attributed another view of high mountains with a river to Ruisdael. The picture, now in an American private collection, is by an anonymous follower who incorporated elements of the so-called *Oath of the Rütli* in it.

The awesome Leningrad and Cape Town mountainscapes are as unusual in seventeenth-century Dutch landscape painting in general as they are in Ruisdael's *oeuvre*. One must turn to Poussin's almost equally rare mature landscapes and those done by a few of his gifted followers to find mountain scenes that evoke comparable moods. Possibly Jacob derived inspiration for his mountainous landscapes from pictures he saw by Poussin or members of his circle in Holland; there are references to a few in seventeenth-century Dutch inventories. Less probable is the possibility that he made contact with them during the course of his hypothetical journey through northern France about 1676 to study for a medical degree at the University of Caen.

Fig. 59. Jacob van Ruisdael, A Mountainous Landscape with a River. *Capetown*, The Old Town House, Max Michaelis Collection.

Fig. 59

Winter Landscape with a Windmill

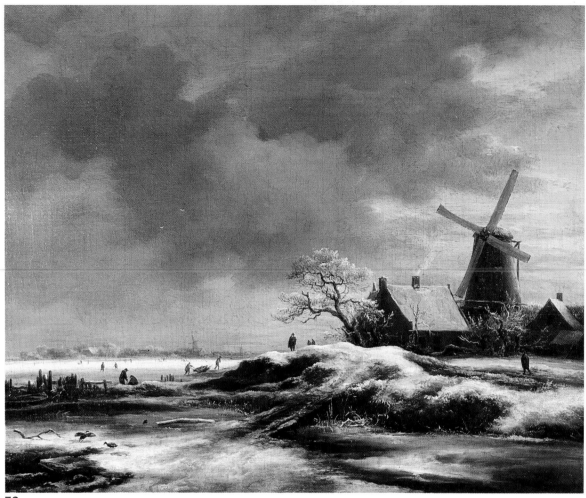

53

Paris, Fondation Custodia (coll. F. Lugt), Institut Néerlandais (no. 6104) Canvas, 37.2 x 45.8 cm. Signed, lower right.

PROVENANCE: According to Smith (164), in the G. van der Pott Collection, Rotterdam, and then in the J.J. van Allen Collection, Edinburgh; collection Alex-ander Dennistoun, Golfhill; sale, A. Dennistoun, London (Christie's), 9 June 1894, no. 87 (385 guineas); dealer Agnew, London; dealer C. Sedelmeyer, Paris, Catalogue, 1895, no. 37, repr.; Adolphe Schloss, Paris, 1895; sale, Schloss, Paris (Charpentier), 25 May 1949, no. 53 (3,200,000 francs); F. Lugt, Paris, 1949.

EXHIBITIONS: Paris 1950–51, no. 73; The Hague–London 1970–71, no. 83, repr.

BIBLIOGRAPHY: Smith 164; HdG 1002; Ros 622; Stechow 1966, p. 97 (second half of the sixties).

Fig. 60

Fig. 61

Fig. 62

The Fondation Custodia's fine painting belongs to a series of winterscapes, datable to the late sixties and to the following decade, which show vast spaces with the principal motif of unpretentious houses clustered around a windmill set in the middle distance. The present picture typifies with exquisite subtlety the almost monotonous gray atmosphere of a winter day. Here the wintry mood is tender rather than ominous.

A winter scene that belongs with this group is in the John G. Johnson Collection, Philadelphia (Fig. 60; no. 569; HdG 1005; Ros 625). The greater expansiveness of the Fondation Custodia picture, which is enhanced by the absence of emphatic accents in the broad frozen foreground extending on the left as a sheet of ice to the distant town on the wide, misty horizon, suggests that it postdates the Johnson winter scene. The rather thinly painted and less elaborate sky also supports a later date for the work, probably the early seventies. A *reprise* of the theme is on loan from a private collection at Birmingham, City Museums and Art Gallery (Fig. 61; HdG 998, identical with HdG 1030; Ros 617), and yet another is (was?) in the collection of Sir Herbert Cook, Richmond (Fig. 62; HdG 1006, identical with HdG 1025; Ros 626); both are probably datable to the late 1670s. The sunset effect in the Cook winter landscape is unusual but not unique in Ruisdael's *oeuvre*; his late *Sunset in a Wood* in the Wallace Collection (no. P247; HdG 1033; Ros 326) includes an even more prominent one.

The author of the entry on the Fondation Custodia painting in The Hague–London 1970–71 exhibition catalogue (no. 83) erroneously states that Constable copied the winterscape when it was in Sir Robert Peel's collection and that he used his copy to illustrate one of the discourses he delivered on landscape painting for the British Institution. The present painting, however, was never in Peel's collection. The Ruisdael winterscape that Peel owned, which Constable copied and discussed in the lecture he gave 22 June 1835 on Dutch and Flemish landscape painting, is the one that is now in the Johnson Collection (Fig. 60). Constable's copy was painted in 1832 and was still in his possession at the time of his death in 1837; it now belongs to the Trustees of the Will of H.G. Howe (*Constable: Paintings, Watercolours and Drawings*, The Tate Gallery, London, 1976, p. 169, no. 292, repr.). Apart from the addition of a little dog, Constable's replica of the painting is a faithful one; like the copy he made of Ruisdael's etching of a *Grain Field* in 1818 (see Cat. no. 103), it even includes the signature inscribed on the work. According to a note written by David Lucas in his annotated volume of Leslie's *Memoirs of the Life of Constable*, 1843 (now in the Huntington Library, San Marino, California), the addition of the dog was not Constable's whim but was introduced to fill a demand made by Peel:

> The loan of this picture was accompanied by a condition that some addition or omission should be made in order that the composition might be some what different he complied by introducing a dog behind the princepal [*sic*] figure in all other respects the imitation was so perfect that looking on the surface only few could detect any difference. (Cited in Parris *et al.*, 1975, pp. 61–62; London 1976–I, p. 169, no. 292.)

Lucas' note provides one of the rare accounts in the history of art of the conditions that compelled a copyist to deviate from his model.

The Ruisdael winterscape now in the Girardet Collection (Cat. no. 33) is also said to have been in Peel's outstanding collection of Dutch and Flemish paintings (seventy-seven of his pictures were acquired in 1871 by The National Gallery in London, including Rubens' *Chapeau de Paille* and Hobbema's *Avenue at Middelharnis*); no support for this claim has been found.

Fig. 60. Jacob van Ruisdael, Winter Landscape. *Philadelphia, Philadelphia Museum of Art, John G. Johnson Collection.*

Fig. 61. Jacob van Ruisdael, Winter Landscape with a Windmill. *Birmingham, City Museums and Art Gallery (on loan from a private collection).*

Fig. 62. Jacob van Ruisdael, Winter Landscape with Two Windmills. *Formerly (?) Richmond, Cook Collection.*

A Park with Fountains and a Country House

54

Washington, D.C., National Gallery of Art, Gift of Rupert L. Joseph, 1960 (no. 1551)

Canvas, 76.3 x 97.5 cm. Signed, lower left.

PROVENANCE: Collection Lord Saville, Rufford Abbey, Nottinghamshire; sale, Lord Saville, London (Christie's), 18 November 1938, no. 123, repr. (Joseph); Rupert L. Joseph, who gave it to the National Gallery of Art in 1960.

BIBLIOGRAPHY: HdG 819; Ros 520; Fr. Gorissen, Conspectus Cliviae, die Klevische Residenz in der Kunst des 17. Jahrhunderts, Kleve, 1964, p. 102 and no. 62; National Gallery of Art, Catalogue, 1965–68, no. 1551, repr.; H. Dattenberg, Niederrheinansichten holländischer Kunstler des 17. Jahrhunderts, Düsseldorf, 1967, no. 312.

During the course of the seventeenth century, glimpses of country houses, parks, and fountains are not uncommon in the backgrounds of fashionable Dutch genre paintings and portraits (for Ruisdael's view of Cornelis de Graeff's country house on his estate at Soestdijk which serves as part of the setting of a conversation piece he painted as a joint effort with Thomas de Keyser, see Fig. 5). Villas and parks are also seen in the backgrounds of still lifes done by artists who specialized in depicting hunting paraphernalia and trophies displayed out-of-doors. However, pictures that make these motifs their principal theme are not common. The National Gallery's painting, datable to the late 1670s, belongs to this small group.

Unusual in the park are its giant Norway spruces, a tree indigenous to Scandinavia. It is not inconceivable that a tree fancier or someone with close Scandinavian connections imported such trees into the Netherlands during Ruisdael's time. A member of the fabulously wealthy de Geer family of Amsterdam could qualify as a person with more than a passing interest in Scandinavia, for they had landed estates and munition factories in Sweden, but it is equally conceivable that Ruisdael's park is an imaginary one. The spruces could be direct descendants of those Everdingen transplanted to Holland after his return from Scandinavia by 1645, which began to appear in Jacob's paintings of waterfalls about 1660 (see Cat. no. 34).

Equally unusual is the park's informal character —one can almost speak of its disarray. Huge fallen trees do not normally appear in pictures of seventeenth-century Dutch parks and gardens. A viewer with allegorizing tendencies may have seen the dead spruce and the architectural fragment (a broken cornice?) as allusions to the transience of all natural and man-made things, but whether this was Ruisdael's intent is moot. The absence of neatly clipped hedges and trees, elaborate parterres, and plaited walks places the park closer to the picturesque ones designed by eighteenth-century English landscape architects than to the formal ones planned by Jacob's contemporaries in the Netherlands.

Two fountains embellish the park. The forceful jets of the more conspicuous one have been designed to keep a ball suspended in an animated state; the other is surmounted by a figure (a cupid, mannekin pis, or both?). A close look at the couple near the center of the picture shows them to be victims of the popular joke of hidden waterspouts which were placed in the pavement around the fountain (or in benches and walls) and turned on after visitors had been enticed to the spot (kind communication from Professor Elizabeth B. MacDougall, director of studies in landscape architecture, Dumbarton Oaks). They are dashing because they do not want to be drenched. It looks as if they could escape more easily to a rococo *fête galante* than to Ruisdael's earlier wooded scenes, where man's conceits are dwarfed by nature's grandeur.

A feeble painting in a vertical format, which was most likely painted in Jacob's very last years, shows a similar scene of elegantly dressed but awkwardly painted people disporting in a park with almost identical fountains, Norway spruces, and a country house. It is at Berlin (no. 885A; canvas, 65 x 51 cm; HdG 789; Ros 485, repr.). W. Bürger's attribution (1869, p. 186) of the crude figures in it to Gerard van Battem is improbable. Fr. Gorissen (*op. cit.*) and later H. Dattenberg (*op. cit.*) note that the park as well as the one in the Washington picture resembles those found in the vicinity of Kleve, a German town near Nijmegen not far from the Dutch border. Both authors suggest that the villa in the Berlin picture may be Haus Freudenberg, a country house that was destroyed by fire in 1669, on the outskirts of Kleve, but neither author offers reasons to support his supposition.

Ruisdael's only other painting of this subject is a rather badly abraded one at the University of Southern California, Los Angeles (canvas, 47 x 54.5 cm; *The Armand Hammer Collection, University of Southern California*, 1965, p. 50, repr.). The author of the catalogue entry on the painting rightly notes it was probably painted about the same time as the Washington picture and suggests that it may represent the same house from the back. The rustic grounds of the house include a grove of very tall Norway spruces and are embellished with a pond and swans instead of fountains. Huge boulders in the foreground and the view of mountains in the distance indicate that the scene is not intended to represent a Dutch park.

The Dam with the Weigh House at Amsterdam

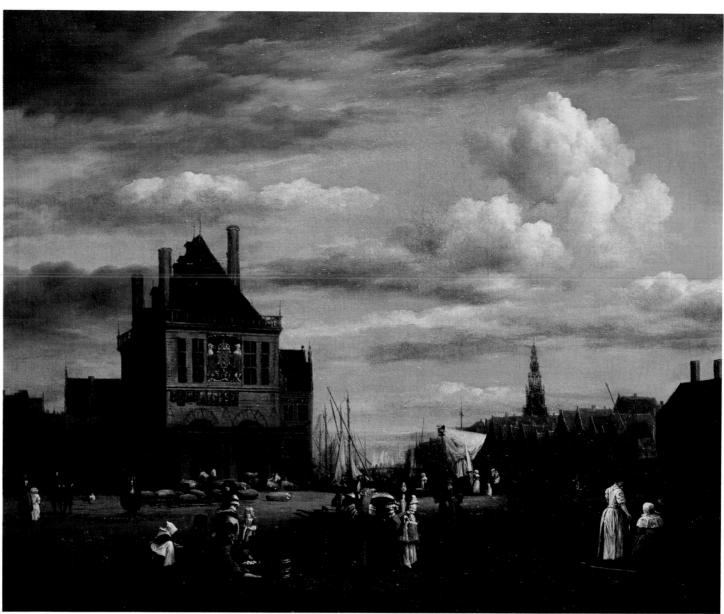

55

Berlin, Staatliche Museen, Gemälde-
galerie (no. 885D)
Canvas, 52 x 65 cm. Signed, lower left.

PROVENANCE: Possibly sale, V [. . .],
Amsterdam, 19 May 1779, no. 134 (69
florins, Nijman); possibly sale, Helsleuter,
Paris (Paillet, Delaroche), 25 January
1802, no. 146 (figures by G. Terburg
[sic] 500 francs, Paillet); sale, Engel-
berts and Tersteeg, Amsterdam (van der
Schley), 13 June 1808, no. 128 (260

florins, with presumed pendant, to Nieu-
wenhuys); collection Pastor, Burtscheid,
1820; collection B. Suermondt, Aachen,
from which it was acquired by the
museum with the Suermondt Collection
in 1874.

EXHIBITIONS: Brussels, Musée Royal
des Beaux-Arts, 1873, no. 150 (figures
by Eglon van der Neer); Amsterdam
1925, no. 436.

BIBLIOGRAPHY: Bürger 1869, pp.

184–86 (staffage by van Battem); Wurz-
bach 1906, I, p. 64 (staffage probably by
van Battem); HdG 8 (staffage by Ruis-
dael); Ros 1 (staffage by Gerard van
Battem); W.F.H. Oldewelt, "Ruisdael
en zijn Dam-gezichten," Algemeen
Handelsblad, 23 April 1938; Roggeveen
1948, p. 92; Staatliche Museen
Preussischer Kulturbesitz, Berlin,
Catalogue, 1975, pp. 378–79, no. 885D
(c. 1670).

Fig. 63. Reconstruction of Jacob van
Ruisdael's drawing of the Dam (see Cat.
nos. 93, 94).

A drawing at Brussels, which has been cut into two sheets (Cat. nos. 93, 94), served as a preliminary study for this view of Amsterdam's principal square, looking toward the former Weigh House, the inner harbor (Damrak), and the tower of the Oude Kerk rising on the right above the city. Figure 63 is a reconstruction showing the Brussels drawings joined.

The painting has been dated traditionally about 1670. Although it is hazardous to try to draw a hard and fast line between works Jacob did early in the 1670s and those done later, the cool grayish tone of the high sky and rather thin brushwork in the vista of houses and ships seen along the inner harbor recall some of his beach scenes and panoramic views of Haarlem that are datable toward the end of the decade. The style of the preliminary drawing also tends to support the later date (see Cat. no. 93).

The view of the Dam seen in these works was one that Ruisdael knew well. In 1657, after he moved from Haarlem to Amsterdam, he lived in "De Silvere Trompet" on the Beursstraat, and in 1667 he lived in the Kalverstraat across from the "Hof van Holland"; both places were close to the great square. From about 1670 until his death in 1682, Ruisdael lived on the south side of the Dam itself, above the shop of the book and art dealer Hieronymus Sweerts, who published an edition of the six prints Abraham Blooteling etched after Ruisdael's views of Amsterdam (see Cat. nos. 83, 84). Jacob's flat, which was in the second house from the corner of the Rokin (Oldewelt, *op. cit.*), most likely provided the artist with a view similar

to the one seen in the drawing and painting. (The row of houses between the Rokin and Kalverstraat is now occupied by the clothing store Peek and Cloppenburg).

Three other views of the Damrak as seen from the square, but without the prominent Weigh House, are known: The Frick Collection (no. 10.1.110; HdG 12; Ros 7); the Mauritshuis (no. 803; HdG 18); Rotterdam (no. 1744; HdG 13; Ros 8). All of them are datable to the 1670s. The Rotterdam painting has been called the companion piece of the present picture. Although they presumably appeared together in an 1808 sale, their very different points of view and the different scale of the figures indicate that the artist did not intend them as pendants.

The figures in the Berlin view of the expansive square play a more prominent role than those in most of Ruisdael's existing paintings; the Weigh House and view of the Damrak appear to have been pushed back to make room for them. The small figures in the middle ground are most likely by Ruisdael. Hofstede de Groot (8) argues that the larger, more carefully executed ones in the foreground are also by the artist. Other cataloguers have offered different opinions. If the Berlin painting is identical with the one that appeared in the 1802 auction cited in the provenance above, the compiler of the sale catalogue improbably ascribed them to Terborch. In 1873 they were attributed to Eglon van der Neer (see exhibitions above).

Following the suggestion Lamme made in his 1867 catalogue entry on Ruisdael's *View of the Damrak* at Rotterdam that the figures in it are by

Fig. 63

"Jan van Battum" [sic], W. Bürger (op. cit., pp. 185–86) concluded that the figures are by a certain "van Battem." Bürger only knew a gouache of a winter scene with many figures signed "Battem" at Rotterdam and on the basis of it wrote that the figures in the Rotterdam and Berlin paintings were undoubtedly by the same hand. He considered the paintings pendants and added that two other views of Amsterdam by Ruisdael with staffage by van Battem were also companion pieces to the pair, one in England, the other sold at Bamberg; neither has been identified.

Today we know that the van Battem first mentioned by Bürger is the Rotterdam painter Gerard van Battem (c. 1636–84). Bürger's conclusion that he was the artist who often furnished the carefully executed figures in Ruisdael's late paintings has been generally accepted. The one notable exception is Bürger's ascription (ibid., p. 186) of the figures in Ruisdael's very late *A Park with Fountains and a Country House* at Berlin (no. 885A; see Cat. no. 54) to van Battem. This has been rightly rejected by later students of Jacob's work. How these two artists managed to carry on their joint ventures remains a mystery. Van Battem, to our best knowledge, never left Rotterdam, and, as far as we know, Ruisdael never visited van Battem's native town.

Panoramic View of the Amstel Looking Toward Amsterdam

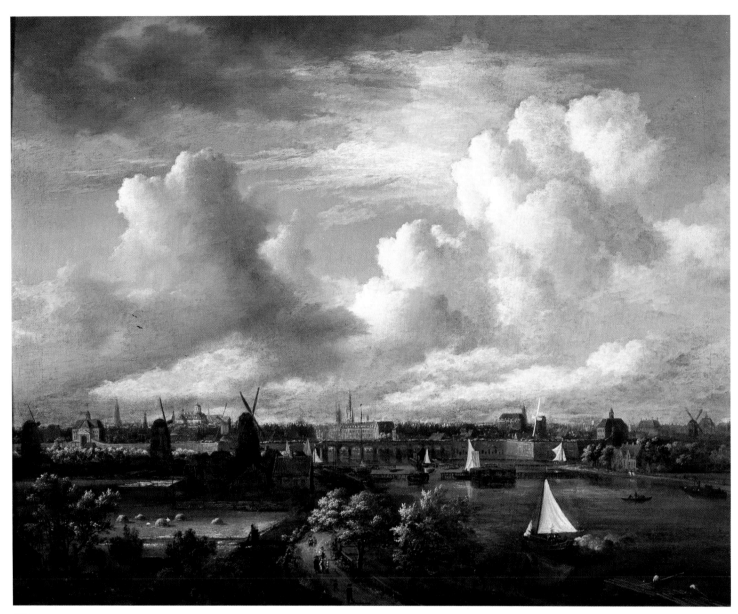

56

Cambridge, Fitzwilliam Museum (no. 74)

Canvas, 52.1 x 66.1 cm. Signed, lower left.

PROVENANCE: *Collection Edward King; bequeathed to his widow, Susanna King, 1807; bequeathed to her late husband's niece, Anne Windsor, later Countess of Plymouth, 1820; bequeathed in 1860 to her great-nephew A.A. van Sittart, who gave it to the museum in 1864.*

EXHIBITION: *Amsterdam–Toronto 1977, no. 122 (exhibited in Amsterdam only).*

BIBLIOGRAPHY: *Smith 269 (in the collection Henry Windsor, 1835); E.W. Moes in* Bulletin van den Nederlandschen Oudheidkundigen Bond *(1902/3), IV, pp. 164–65; HdG 10; Ros 4; Simon 1930, pp. 66 (original), 79–80 (old copy based on the Philips version); Simon 1935, p. 192 (not by Ruisdael; a copy); Simon 1939–40, p. 24 (hardly by Ruisdael); Roggeveen 1948, p. 94, note 13; van Regteren Altena [n.d.], p. 321, note 16 (appears to be a copy after the Philips painting); d'Ailly 1953, pp. 68–69, no. 138; Fitzwilliam Museum, Cambridge,* Catalogue of Paintings, *1960, p. 111f., no. 74 (1675–80); Stechow 1966, p. 128 (after 1675); Slive 1973, pp. 275–76.*

H. Gerson, author of the Fitzwilliam catalogue (*op. cit.*, 1960), rightly states that the quality of this painting is excellent; neither K.E. Simon (*op. cit.*) nor J.Q. van Regteren Altena (*op. cit.*) gives cogent reasons for the doubts he expresses about its authenticity. A slightly less well-preserved variant of the composition is in the Philips-de Jongh Collection, Eindhoven (canvas, 53 x 66.5 cm; Ros 5). The drawing that most probably served as a preliminary study for both paintings is at Leipzig (Fig. 64; no. 413; black chalk, gray wash; 8.4 x 31 cm [the support is two joined sheets of paper]; Ros Z33 [preparatory study for the Cambridge and Philips paintings]; Simon 1935, p. 192 [copy by another hand after a painting]; d'Ailly 1953, pp. 68–69, no. 138 [c. 1681]; Slive 1973, pp. 275–76, repr.; Giltay 65).

These extensive bird's-eye views of Amsterdam seen from the south, after the completion of the city wall, may have been possible from the tower of the Pauwentuin, a favorite seventeeth-century excursion site down the Amstel River. The Fitzwilliam picture and the Philips version show more of the vast expanse of Amsterdam than the drawing. Both paintings extend the view considerably more to the right and include the Weesper Poort, which was set in the city wall. The Utrechtse Poort can be seen in the wall on the left. The large arched bridge linking the walls is the Amstelbrug; beyond it the high spires of the Zuiderkerk and the more distant Oude Kerk are recognizable. The large building with a domed tower left of the center on the horizon is the monumental New Town Hall.

Of special interest is the rectangular building with a low pitched roof a little to the right of the center beyond a windmill (it appears on the far right of the drawing). It can be identified as the Portuguese Synagogue. Its cornerstone was laid on 17 April 1671, and it was consecrated on 2 August 1675 (see J. D'Ancona, "De Portugese Gemeente 'Talmoed Tora' te Amsterdam tot 1795," *Geschiedenis der Joden in Nederland*, ed., H. Brugmans and A. Frank, Amsterdam, 1940, pp. 287–89). The year of the synagogue's consecration is of more than antiquarian interest. It provides a probable *terminus post quem* for these three panoramic views of Amsterdam.

A.E. d'Ailly (*op. cit.*) writes that in the Leipzig drawing he can recognize the Reformed Church's Het Besjehuis (Home for Old Women) above the Amstelbrug and to the right of the tower of the Zuiderkerk. If he is correct, the *terminus post quem* for the drawing is pushed to about 1681, since construction of the home began in that year and was completed in 1683, a year after Ruisdael's death. However, the case for d'Ailly's date of about 1681 for the sheet is not iron clad. Although it is possible to distinguish a building that may be iden-

Fig. 64

tical with the old women's home in both of the painted versions of the view (see below), it is exceedingly difficult, if not impossible, to spot it here. In any event, the Leipzig drawing can serve as a safe touchstone for Ruisdael's latest drawing style. There is no reason to believe that his work as a draughtsman radically changed from about 1675 until 1681.

When we turn to the Fitzwilliam and Philips paintings, a building that may be the Het Besjehuis can be seen in both of them; it is probably the long rectangular building behind the arched bridge in the center. If it is that structure, Ruisdael provided it with many more dormers and chimneys than it actually had (for J. Smith's print of Het Besjehuis, done c. 1700, see D.C. Meijer, "Groei en Bloei der Stad," *Amsterdam in de Zeventiende Eeuw*, vol. I, The Hague, 1897, p. 187; an anonymous eighteenth-century print of it is reproduced in Kruizinga 1973, fig. 303). The pavilion at the south end of the building in the Fitzwilliam version also appears to be Ruisdael's invention.

These minor architectural details are worth consideration here because, as we have noted, construction of the Het Besjehuis began in 1681 and the large building (its façade was more than 100 meters in length) was completed in November 1683 (Meijer, *op. cit.*, p. 186; H.C. Rogge, "Het Kerkelyk en Godsdienstig Leven," *Amsterdam in de Zeventi-*

ende Eeuw, vol. II, The Hague, 1901–04, p. 106). Firm identification of the structure in Ruisdael's paintings as Het Besjehuis would pinpoint 1681 as the *terminus post quem* for both versions. Since Ruisdael died in March 1682, it would also establish them as the artist's latest existing documentable works.

We probably shall never know when Ruisdael laid down his brushes for the last time. If this event occurred before the shell of the structure was completed, it could explain why parts of the building in his paintings do not correspond with the old women's home that was actually built. Rather than show the building under construction in his pictures, perhaps Ruisdael decided to give his idea of the way it would look when finished in a panoramic view of Amsterdam. It would not have been the first time he allowed his fancy to play a role in his topographical paintings.

Two other works by Ruisdael of views along the Amstel River can be identified: one, known from Abraham Blooteling's etching after Ruisdael's lost drawing of a view of the Hooge Sluis seen from the Amstel's bank is datable to about 1663 (Fig. 79); the other, probably done about the same time, is the more extensive distant panoramic view of Amsterdam seen from a bank of the river in the *Winter Landscape* in the Herbert Girardet Collection (Cat. no. 33).

Fig. 64. Jacob van Ruisdael, Panoramic View of the Amstel River Looking Toward Amsterdam. Leipzig, Museum der bildenden Künste.

Drawings

Landscape with a Toppled Willow

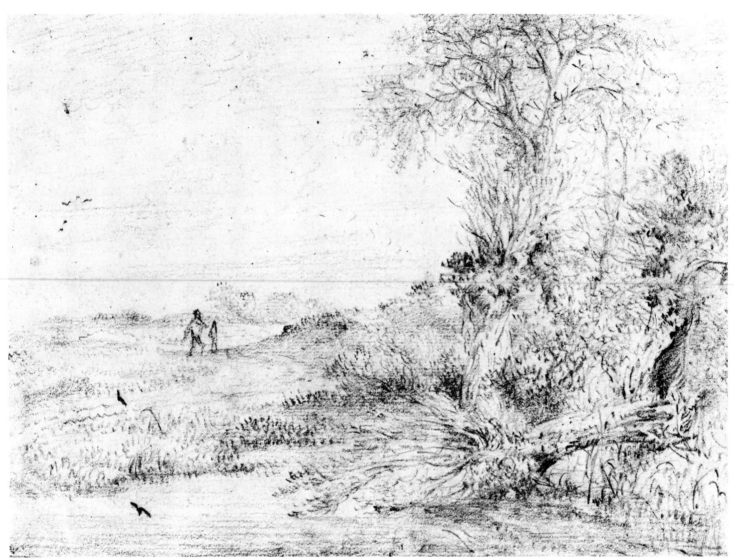

57

Dresden, Staatliche Kunstsammlungen,
Kupferstichkabinett (no. C 1285)
Black chalk, 14.4 x 19.5 cm.

PROVENANCE: Most likely acquired
along with ten other similar black chalk
drawings by Ruisdael for the Dresden
Kupferstichkabinett 1720–46 (kind com-
munication from Christian Dittrich,
curator, Dresden Kupferstichkabinett).

BIBLIOGRAPHY: Woermann 1896, IX,
Pl. 16, bottom; Ros Z18a; Simon 1930,
pp. 67, 83; Giltay 37.

This little black chalk sketch and five others shown here (Cat. nos. 58–62) are closely related to five other black chalk drawings also at Dresden (Ros Z18d, f, h, k, l; Giltay 40, 42, 44, 46, 47). Their close similarity of size, style, and medium indicate that they were done about the same time and most likely belonged to the same sketchbook. A drawing of a *House Amidst Trees and a Footbridge* now at The Metropolitan Museum of Art (bequest of Harry G. Sperling, 1975; no. 1975.131.163; black chalk, 13.6 x 18.2 cm; Giltay 82) and one of *Two Windmills* at the Albertina also may have been part of the group (see Cat. no. 58).

The very close connection of the present sketch to Ruisdael's drawing of a pollard willow and a thicket near a pond, dated 1646, formerly in the Liechtenstein Collection (see Cat. no. 63 and Fig. 66) provides a reasonable date for it. Ruisdael added touches of pen and wash to the Liechtenstein sheet, but the black chalk drawing underlying these additions is strikingly similar in its suggestive touch to that he used for the Dresden sketch.

There is a consensus that the other drawings that belong to this group were also done about 1646. (K.E. Simon [*op. cit.*, pp. 66–67] dated them in the early 1650s, but then [*ibid.*, p. 83] correctly placed them in the artist's early phase.) Naturally, the possibility that some were done slightly earlier or later cannot be ruled out. Today, they are treasured as a part of Jacob's incunabula that introduce motifs to which he returned in the decades to come: trees and shrubs near water, windmills in a flat landscape, a simple farmstead, bridges, and ruins. Their state of preservation may indicate that they were not always considered precious. Most of them are rubbed and soiled, and the supports of more than a few have scattered losses of various dimensions and shapes that have been repaired.

A Windmill at the Edge of a Village, with a Man and a Dog

58

Dresden, Staatliche Kunstsammlungen,
Kupferstichkabinett (no. C 1286)
Black chalk, 15 x 20 cm.

PROVENANCE: Identical with Cat. no.
57.

BIBLIOGRAPHY: Woermann 1896, IX,
Pl. 15, upper left; Ros Z18c; Simon
1930, pp. 67, 83; Giltay 39.

In addition to this chalk sketch, which makes a windmill its chief motif, there are three other drawings of mills in the Dresden group. Two of them are shown here (Cat. nos. 59, 60). The third one, depicting two windmills (no. C 1278; Woermann 1896, IX, Pl. 15, upper right), is accepted by Jakob Rosenberg (Ros Z18f); K.E. Simon (1930, p. 67) calls it a later forgery; although J. Giltay (42) includes it in his catalogue of Ruisdael's drawings, he notes that it may be by another hand. In my view it is authentic.

Another black chalk drawing of two windmills at the Albertina, virtually identical in size with the Dresden sketches, probably belonged to the same series; it has been disfigured by gray washes that were added by an unknown hand (no. 10109; 14.5 x 19 cm; Ros Z69; Simon 1935, p. 192 [not original]; O. Benesch, *Meisterzeichnungen der Albertina*, Salzburg, 1964, no. 196, repr.; Giltay 100).

There is a significant difference between the way windmills are shown in a landscape in these early sketches and the way Ruisdael used a mill as the principal subject in his painting dated 1646 now at Cleveland (see Cat. no. 10; Fig. 17). Jacob accented the windmill in his early picture by making it the apex of a sharply silhouetted farmstead crowded by dark, closely knit trees and shrubbery; as in most of his early paintings, the massiveness and solidity of the closely seen forms are stressed. The case is different in the drawings, especially the two sketches that show windmills in flat landscapes (Cat. nos. 59, 60), where the spaciousness, luminosity, and airy atmosphere of the countryside are emphasized as much as the main motif. The effect of solidity is hardly admitted, and differences between buildings, land, and sky are slurred over. These qualities link the sketches more closely to works done by artists of Jan van Goyen's generation than to Ruisdael's early paintings.

Landscape with a Windmill and a Cottage on the Left

59
Dresden, Staatliche Kunstsammlungen,
Kupferstichkabinett (no. C 1279)
Black chalk, 14.5 x 19.5 cm.

PROVENANCE: Identical with Cat. no.
57.

BIBLIOGRAPHY: Woermann 1896, IX,
Pl. 15, bottom; Ros Z18e; Simon 1930,
pp. 67, 83; Giltay 41.

See Cat. no. 58.

Landscape with a Windmill on the Right

60

Dresden, Staatliche Kunstsammlungen,
Kupferstichkabinett (no. C 1280)
Black chalk, 14.5 x 19.5 cm.

PROVENANCE: Identical with Cat. no.
57.

BIBLIOGRAPHY: Ros Z18g; Simon
1930, pp. 67, 83; Giltay 43.

See Cat. no. 58. The drawing was restored by Dresden's paper conservator in 1980.

A High Stone Footbridge

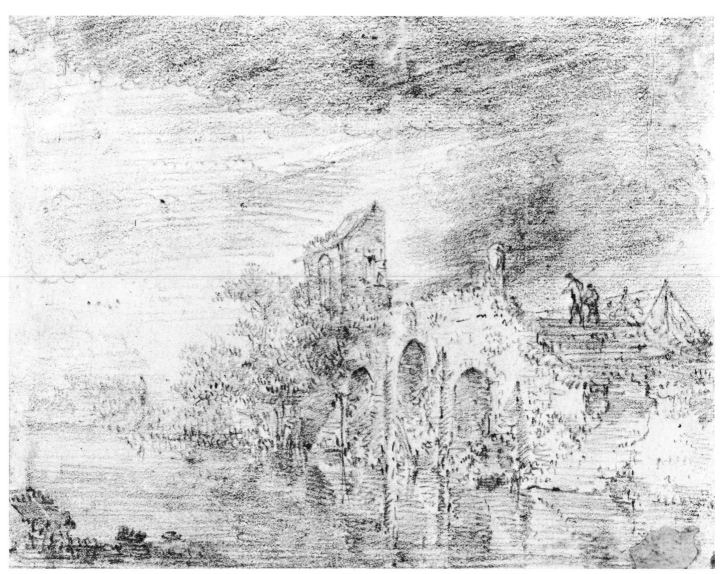

61
Dresden, Staatliche Kunstsammlungen,
Kupferstichkabinett (no. C 1284)
Black chalk, 14.3 x 19.8 cm.

PROVENANCE: Identical with Cat. no.
57.

BIBLIOGRAPHY: Ros Z18b; Simon
1930, pp. 67–68, 83; Giltay 38.

K.E. Simon (*op. cit.*, pp. 67–68) noted a connection between the footbridge in the drawing and the one in Ruisdael's painting of a *Stone Bridge* in the John G. Johnson Collection, Philadelphia (no. 570; HdG 675b; Ros 421). Apart from the stone steps that swing down to the water's edge in both works, the chance of a direct relationship is remote. In fact, none of the Dresden sketches can be identified as preparatory studies for any of Jacob's existing paintings or etchings. They probably were made as *pensées*. In a few rare cases he experimented with obtaining effects he achieved with gradations of black chalk in these early sketches in another medium. For example, in his print of a *Landscape with a Hut and Shed* (Cat. no. 97), dated 1646, he made a unique effort to translate the kind of tonal effects found in the aerial zone of this drawing into etched lines. The greater all-over airiness and more vibrant atmospheric effect of the sky in the sketch help explain why he never repeated the experiment in his prints.

The drawing was restored at Dresden in 1980.

A Farmstead with Two Dogs in the Foreground

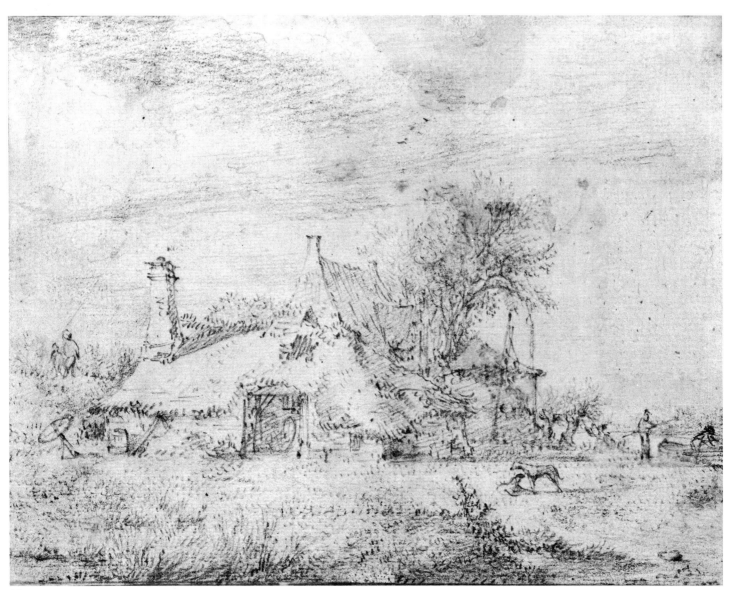

62

*Dresden, Staatliche Kunstsammlungen,
Kupferstichkabinett (no. C 1281)
Black chalk, 14.5 x 19.5 cm.*

*PROVENANCE: Identical with Cat. no.
57.*

*BIBLIOGRAPHY: Ros Z18i; Simon
1930, pp. 67, 83; Giltay 45.*

The drawing was restored at Dresden in 1980. It is one of Ruisdael's rare existing studies of a farmstead. Most likely he made others that have not survived because their modest themes did not appeal to many early collectors.

A Hunter with Three Dogs Entering a Wood

W. Schultz, the author of the 1974 Berlin exhibition catalogue (*op. cit.*), has called this sheet dated 1646 Ruisdael's earliest drawing. There are, in fact, two other drawings by the artist that also are dated 1646 (Fig. 65; black chalk and pen with gray wash, 14 x 20 cm; formerly H. Oppenheimer, London; Ros Z52; Giltay 105; and Fig. 66; black chalk and pen with gray wash, 15.2 x 15.4 cm; formerly Johann Prince Liechtenstein, Felsberg; Ros Z70; Giltay 108). The current state of our knowledge of Ruisdael's juvenilia does not permit us to say whether they were done before or after the Berlin drawing.

It is evident that Jacob began the appealing Berlin drawing of a wooded landscape, the largest and most ambitious of the three done in 1646, by first making a black chalk sketch, which he rubbed in some passages. Then he reworked it with very fine, energetic pen lines and touches of wash. If he had continued to work on the drawing, it would have been the kind that collectors in his day and ours classify as independent works, not studies. Why did he stop? Perhaps he felt, as we do, that in its present state the drawing does not need another stroke. If Ruisdael himself drew the hunter and his three elegant dogs making their way into the woods (there is little reason to believe he did not), he was far better at depicting figures and animals in a landscape than is generally believed.

Ruisdael's other drawings dated 1646 also emphasize trees. The one formerly in the Oppenheimer Collection (Fig. 65) includes a great pollard willow flanking a road that leads through dunes to a distant farmhouse. It is also a chalk drawing that has been reinforced with pen and wash. The general lay of the land in its falling diagonal scheme does not differ much from the way other artists active in the 1640s organized similar scenes. More unusual is the drawing formerly in the Liechtenstein Collection (Fig. 66), which employs the same technique, but here the delicate chalk drawing of a willow, other trees, and shrubs gives the landscape an exceptional transparent airiness. The sensitively placed darker accents of pen and wash, which add to the spatial clarity and accentuate the structure of the forms, are equally impressive.

Only three other of Ruisdael's known drawings are dated: one is inscribed 1648; two bear the date of 1649 (see Cat. nos. 64, 65, respectively)—not a large number if we recall that more than 100 drawings can be attributed to him.

Fig. 65. Jacob van Ruisdael, Dune Landscape with a Bent Willow, *1646. Formerly London, H. Oppenheimer.*

Fig. 66. Jacob van Ruisdael, A Willow and Other Trees near a Pond, *1646. Formerly Felsberg, Johann Prince Liechtenstein.*

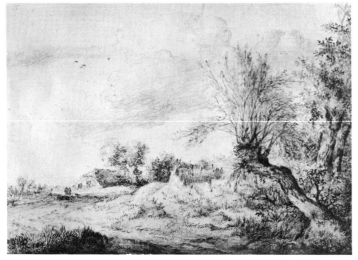

Fig. 65

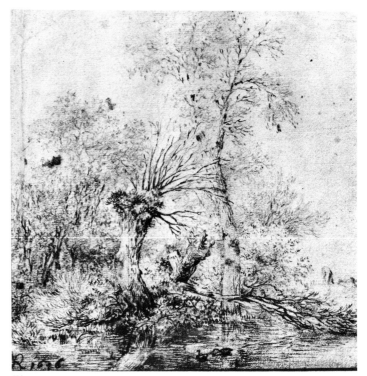

Fig. 66

63

*Berlin, Staatliche Museen, Kupferstich-
kabinett (no. 2618)*
*Black chalk and pen with gray wash,
28.4 x 38.5 cm. Monogrammed and
dated 1646, lower left.*

*PROVENANCE: Sale, Earl Spencer,
London (Philipe), 10–17 June 1811, no.
701; collection A. Donnadieu; collection
B. Suermondt, Aachen; acquired by the
museum in 1874.*

*EXHIBITION: Berlin 1974, p. 73, no.
158, repr.*

*BIBLIOGRAPHY: Ros Z6; Simon 1930,
pp. 67, 83; Bock-Rosenberg 1930, I, p.
256, no. 2618; Giltay 16.*

The Shore of the Zuider Zee with Three Anglers and a View of the Ruined Church at Muiderberg and Naarden

64

London, British Museum, Trustees of the British Museum (no. 1895.9.15.1299) Black chalk and pen with gray wash and touches of red, green, and yellow watercolor, 17.7 x 29.5 cm. Monogrammed and dated 1648, bottom, left of center (the "8" of the date is a horizontal one, the kind American cattlemen call a "lazy eight").

PROVENANCE: *B. West; sale, E. Galichon, Paris (Drouot), 10–14 May 1875, no. 141 (1,000 francs); sale, B. Suermondt, Frankfurt (Prestel), 5 May 1879, no. 124; collection J. Malcolm; purchased by the museum in 1895.*

BIBLIOGRAPHY: *Ros Z45; Simon 1930, p. 84; Hind 1931, IV, p. 40, no. 1; Giltay 74.*

In the distance of this grand drawing of 1648 there is a view of the ruined church at Muiderberg and beyond it, on the left, the tower of the church of Naarden can be seen. For Ruisdael's painting of a panoramic view of Naarden, dated a year earlier, see Cat. no. 6. We have already noted that the town and its vicinity must have had a special attraction for him; his paternal grandfather settled in Naarden in the 1590s and his father was born there. The coast and countryside of the region also appealed to other Dutch artists. Anthonie Waterloo (c. 1610–90) and Roeland Roghman (1620–86) made landscapes that include the neighborhood's landmarks, and one of Rembrandt's most imposing architectural drawings shows the ruined interior of Muiderberg's church (collection V. de Steurs, The Hague; Benesch 823).

As in other drawings done in the late forties (see Cat. nos. 65, 66), Ruisdael uses the time-honored diagonal compositional pattern for the expansive landscape. In his hands the scheme never becomes trite. Extraordinary is his use of light to isolate the trunk of the huge, back-bending tree while unifying the forms of its hoary, twisted crown with the richly foliated grove beyond it. The tall pole on the left makes a new structural accent.

The high finish of the drawing is found in a few others Ruisdael made in the late forties (see Cat. nos. 65, 66 and Figs. 92, 93). All of them were most likely intended as independent works; the fact that two of the group (Figs. 92, 93) are on parchment bolsters this supposition. Jacob usually began them by first sketching the general outlines of the landscape with very light touches of chalk. He then worked them up with pen and more extensively with crisp strokes of the point of a brush (see Cat. no. 66 for one worked up almost solely in brush). Their washes, like those in all of Ruisdael's wash drawings, are gray, ranging in value from deep darks to the most delicate, transparent tints.

A few touches of red, yellow, and green watercolor are seen in the present drawing. Most likely they are the last remnants of more extensive passages of watercolor that have disappeared because the beautiful sheet, at some time during the course of its more than three-century history, has been overexposed to the destructive effects of light. As did other artists who used the medium before the invention of relatively light-fast materials in more modern times, Ruisdael worked with watercolors that were organic in origin and highly susceptible to light. They fade at different rates, depending on their chemical makeup and density. On the other hand, the gray washes Ruisdael used were made of carbon blacks (*e.g.*, lamp black, bone black); these, when unmixed with organic substances, are relatively stable. (I am beholden to Marjorie B. Cohn, associate conservator of the Fogg Art Museum for information on the materials Ruisdael used for his works on paper; for a discussion of the permanence of watercolors see her *Wash and Gouache: A Study of the Development of the Materials of Watercolor*, Cambridge, Massachusetts, 1977, pp. 61–64.)

The slight traces of watercolor in Ruisdael's *Landscape with a Ruined Church* (Cat. no. 65), dated 1649, suggest that it also had larger areas of fugitive color that vanished because it was overexposed to light. Today the only other traceable drawing by Jacob that shows generous areas of watercolor is his *Two Oaks* at Chantilly (Fig. 93), which is also datable to 1649. According to old catalogue references another Ruisdael landscape drawing, dated 1649, of *Oaks on a Hillock* is worked up with watercolor; the whereabouts of this sheet, formerly in the A. Beurdeley Collection, is unknown (Fig. 92; see Cat. no. 104).

Landscape with a Ruined Church and a Grain Field

65

London, British Museum, Trustees of the British Museum (no. 0o 11-248) Black chalk and pen with gray wash and touches of yellow and green watercolor, 18.2 x 29.8 cm. Monogrammed and dated 1649, lower left.

PROVENANCE: Sale, Earl Spencer, London (Philipe), 10–17 June 1811, no. 702; collection R. Payne Knight, who bequeathed it to the museum in 1834.

BIBLIOGRAPHY: Kleinmann [n.d.], II, p. 17, repr.; Ros Z46; Simon 1930, pp. 67, 84; Hind 1931, IV, p. 40, no. 2; Giltay 75.

Jakob Rosenberg (*op. cit.*) and Arthur M. Hind (*op. cit.*) expressed doubts about the reading of the last digit of the 1649 date on the drawing. K.E. Simon (*op. cit.*) and J. Giltay (*op. cit.*) have correctly read it as a "9." Even if the landscape were not dated, its strikingly close similarity to the conception, style, and technique of the *Shore of the Zuider Zee* (Cat. no. 64), dated 1648, would place it in the late forties. For a comment regarding the faint touches of yellow and green watercolor on the drawing, see Cat. no. 64.

Although Ruisdael continued to make drawings during the course of the following three decades of his career (see Cat. no. 95 for one of his last ones), the present landscape and his untraceable *Oaks on a Hillock*, which also is inscribed 1649 (Fig. 92; sale, A. Beurdeley, Paris (Petit), 8 June 1920, no. 293, repr.; pen, gray wash, and watercolor on parchment; Ros Z67b; Giltay 106), are the last known dated ones.

G. Hos has suggested (note at the R.K.D.) that the ruined church in the drawing may be the one at Soest, a town about thirty-five kilometers southeast of vicinity of Naarden, the town Jacob included in the sheet he did in the preceding year (Cat. no. 64). Hos' identification is based on its similarity to a print in *Het verheerlykt Nederland of Kabinet van hedendaagsche gezigten*, vol. VII, Amsterdam, 1745–1774, no. 210.

Sun-Dappled Trees at the Edge of a Stream

Apart from very light traces of black chalk used to sketch the general outlines of this wooded landscape, with a prominent elm in the foreground and a sturdy one in the middle distance, the drawing is done with the point of a brush and wash. Felice Stampfle, author of the 1979–80 exhibition catalogue (*op. cit.*), rightly dates it to the late forties and notes that its style and handling are close to those of the artist's *Shore of the Zuider Zee* (Cat. no. 64), dated 1648.

Stampfle also mentions that its vertical format is similar to that of Jacob's even earlier paintings of wooded landscapes at Copenhagen (Ros 311, repr.) and Vienna (Ros 386, repr.), each dated 1646, and at Budapest (Cat. no. 4), datable to about the same time. In addition, she cites *Willow Trees*, a small vertical landscape published by Wolfgang Stechow as dated 1645 (1966, p. 71, Fig. 135; panel, 25.4 x 18.4 cm; HdG 644c [monogrammed]); Stechow knew the painting only from a photograph. The alleged date of 1645 is of particular interest because if it is in fact inscribed on the painting it qualifies as the earliest known dated work by Ruis-

dael. However, when it was exhibited at Lund, Skånska Konstmuseum, *Gamla holländare I Skånska Hem*, 15 November–6 December 1953, p. 29, no. 47, Pl. 9 (collection G.A. Hagemann, Bjersjöholm), no mention was made in the exhibition catalogue of either a signature or a date. The painting was not listed as signed and dated when it appeared in the sale, anon., London (Sotheby), 6 July 1966, no. 37 (£1,600, J. Maxwell). After Stechow learned that the compiler of the 1966 sale catalogue did not mention an inscription, he wrote (Stechow 1968, p. 260, note 3) that he omitted the date of 1645 in the revised edition of his *Dutch Landscape Painting of the Seventeenth Century*, London, 1968, "but I am still convinced that it is a genuine Ruisdael from that year (or 1646 at the latest)." The painting appeared again in the sale, anon., London (Christie's), 7 March 1980, no. 118, repr. (£3,000, Tim), without reference to a signature or date. To judge from a photograph, Stechow's conclusions that it is by Ruisdael and was painted about 1645 or 1646 are correct.

New York, The Pierpont Morgan Library (no. 1957.2)
Black chalk with black and gray wash, 26.4 x 19.6 cm. Monogrammed, lower right (by a later hand?).

PROVENANCE: *Possibly sale, D. Muilman, Amsterdam (de Bosch), 29 March 1773, no. P.1122; possibly Engelbert Michaël Engelberts; John, Earl of Northwick; by descent to Capt. E. Spencer Churchill, Northwick Park; his sale, London (Sotheby), 1–4 November 1920, no.201 (£26, Sabin); Martin B. Asscher, London; gift of the Fellows of the Pierpont Morgan Library with the special assistance of Mr. and Mrs. Nelson Slater, 1957.*

EXHIBITIONS: *Oberlin 1963, no. 14; New York 1974, no. 42; Poughkeepsie 1976, no. 39; Paris–Antwerp–London–New York 1979–80, no. 117.*

BIBLIOGRAPHY: *F.B. Adams, Jr., ed.,* Eighth Annual Report to the Fellows of the Pierpont Morgan Library, *New York, 1958, pp. 72–73, repr.; Felice Stampfle, "An Early Drawing by Jacob van Ruisdael," A.Q., XXII, 1959, p. 161f., repr.; F.B. Adams, Jr.,* An Introduction to the Pierpont Morgan Library, *New York, 1964, p. 31; Morgan Library,* Review of Acquisitions 1949–1968, *1969, p. 166; Giltay 80.*

66

Landscape with a Stone Bridge

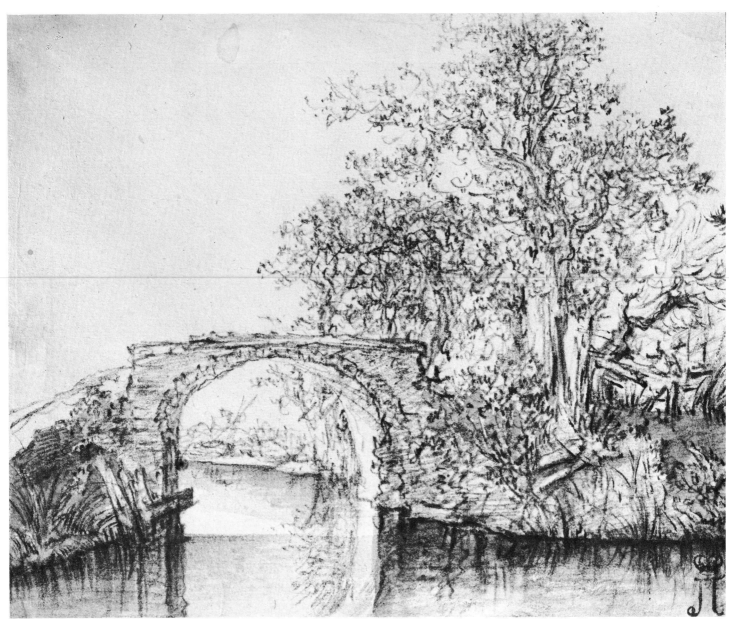

67

Leningrad, Hermitage (no. 5535)
Black chalk, gray wash, 16.5 x 20.5 cm.

PROVENANCE: *Acquired for the Hermitage before 1797.*

EXHIBITIONS: *Leningrad 1926, no. 153; Leningrad 1959, p. 28 (Russian text); Stockholm 1963, no. 75; Brussels–Rotterdam–Paris 1972–73, no. 90.*

BIBLIOGRAPHY: *Ros Z39; Simon 1935, p. 192 (by an unknown hand);* *Agafonova 1935, no. 3, p. 180; A.A. Sidorov,* Rysunki Starykh Masterov, *[n.d.], no. 111, repr.; Dobroklonsky 1961, no. 71; J.G. van Gelder,* Great Drawings of All Time, *New York, 1962, II, no. 611 (shortly before 1650); C.T. Eisler,* Drawings of the Masters, Flemish and Dutch . . . , *New York, 1963, Pl. 91; Giltay (not accepted as authentic).*

The doubts expressed by K.E. Simon (*op. cit.*) and J. Giltay (*op. cit.*) regarding the authenticity of this vigorous drawing are unjustified. The drawing is related to a group of more than fifteen quick black chalk sketches by Ruisdael. Most of them are similar in size (c. 15 x 20 cm). To some of them, as in the present one, the artist added touches of gray wash. A few have been worked up by later hands; perhaps they appeared too summary to collectors or dealers who preferred drawings with a higher finish. Evidence that early nineteenth-century collectors valued Ruisdael's sketches with wash is offered by C. Josi (1821, II, [n.p.] under "Jacob Ruisdael"), who writes that while Jacob's black chalk drawings fetch ten to fifteen louis, those with wash added realize two to three times the price.

The sketches in the group range in date from the late forties to the mid-fifties. The Leningrad sheet is one of the earliest. This view is supported by the diagonal massing of forms, by the way the trees and underbrush on the river bank are entangled and seen close (not uncommon characteristics of Jacob's early landscapes), and by the unusually impetuous touch of his chalk, which suggests that the artist had just discovered that the medium permitted bold, rapid strokes as well as carefully wrought ones. Not the least of its qualities is its fine effect of full daylight. For a discussion of a later chalk sketch that belongs to the group, see Cat. no. 68.

Trees at the Edge of a River, with Two Men in a Rowboat

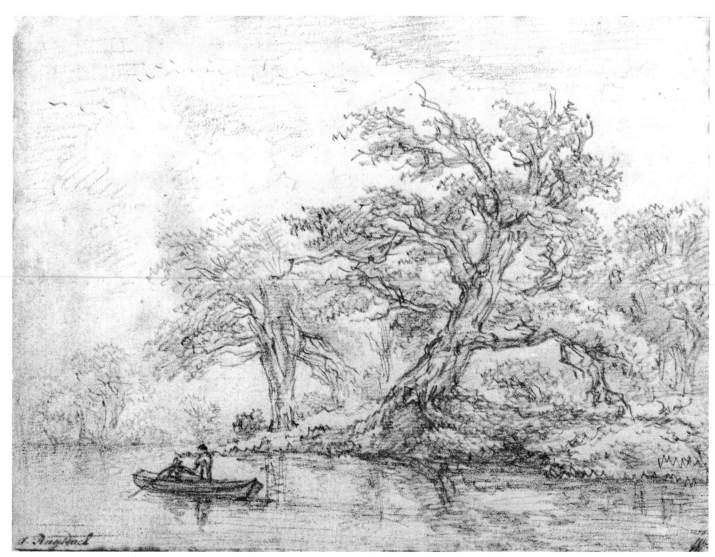

68

*Washington, D.C., National Gallery of Art, Gift of the Ruth and Vernon Taylor Foundation, 1980 (no. B-31, 427)
Black chalk, 14.5 x 19.1 cm. Signed by a later hand, lower left: J. Ruijsdael.*

PROVENANCE: William Esdaile, London; sale, William Esdaile, London (Christie's), 18–25 June 1840, no. 1091 (£1, 1s); dealer Anne Wertheimer, Paris; acquired by the gallery in 1980.

BIBLIOGRAPHY: Giltay,
Postscriptum.

This remarkably fresh sketch belongs to the group of black chalk drawings mentioned in Cat. no. 67. Its concentration on the motif of a large tree, emphasis on structural accents, great spatial clarity, and suggestive strokes that sum up large areas of the landscape with a few economic touches place it about 1655. Sketches related to it are at the Fondation Custodia, Paris (no. 2337; black chalk, 15.2 x 20.2 cm; Brussels–Rotterdam–Paris–Berne 1968–69, p. 130, no. 128, repr.; Giltay 93) and Windsor Castle (no. 6606; black chalk and gray wash, 15.2 x 20 cm; Puyvelde 1944, p. 61, no. 668, repr.; Giltay 103); however, neither of them is as bold or summary in treatment.

The inscription "J. Ruijsdael" on the lower left of the Washington sketch is found also on the Windsor sheet, on a black chalk drawing formerly at Bremen (Fig. 37), and on more than a half-dozen other drawings by Jacob. They were most probably written by a late seventeenth- or early eighteenth-century collector or dealer who had the drawings in his possession. The author of these inscriptions has not been identified.

An anonymous etched copy, in reverse (14.5 x 19.5 cm), of the Washington drawing inscribed "Ruysdael. de." appears in *A Collection of Original Etchings* . . . , London, Printed by J. M'Creery, Black Horse Court, Fleet Street, 1816; a copy of M'Creery's volume is at the British Museum.

View of Rhenen from the East

There may be an ever-so-slight underdrawing in pencil or black chalk beneath the gray wash of this panoramic view of Rhenen. Whether it is there or not, in this instance, is of little consequence. The effect of the drawing is not only of one solely done in brush and wash, but the sheet is a model of the range of tonal richness, luminous transparency, and suggestiveness Ruisdael achieved with the medium.

Less unusual is the subject of the drawing. The beautiful late Gothic tower of St. Cunera, which soars above the town of Rhenen and dominates the surrounding plain, was made the focal point of landscapes done by many Dutch artists including Hercules Segers, Rembrandt, Jan van Goyen, Salomon van Ruysdael, and Aelbert Cuyp. The town was easily accessible, lying on the Rhine, about thirty-five kilometers southeast of Utrecht. Ruisdael himself made another drawing that shows Rhenen's skyline seen from the west, which is now at Berlin (Fig. 67; no. 14712; black chalk, gray wash, 11.4 x 18.8 cm; Ros Z35; Simon 1935, p. 192 [probably done in the 1660s]; Giltay 21; Exhibition: Berlin 1974, no. 160 [1660s; wrongly called Ruisdael's only view of Rhenen]).

Although wash has been used more sparingly in the Leningrad sheet than in the Berlin drawing, close analogies in the handling of the medium in both works indicate that they were done about the same time, most likely in the early fifties, a date supported by similarities between their style and Ruisdael's slightly more finished dated drawings of the late 1640s (see Cat. nos. 64, 65).

The Berlin sheet was first assigned to the early 1650s when Jakob Rosenberg published it (1928, p. 22; Jakob Rosenberg, "Neuerworbene Zeichnungen des Kupferstichkabinetts," *Berliner Museen*, LII, 1931, p. 111). Rosenberg reasonably proposed that Ruisdael probably made it during the course of a visit to Rhenen when he was on his travels to or from the Dutch–German border region. Most likely the Leningrad sheet was made on the same trip. The drawings add a bit to our meager knowledge of Ruisdael's movements; they indicate that he traveled in the southern as well as the eastern provinces of the Netherlands during his *Wanderjahre*.

Ruisdael's two views of Rhenen appeared in the sale, D. Muilman, Amsterdam (de Bosch), 29 March 1773 (nos. K.741, 742), and both were acquired for the Hermitage before 1797 along with a number of other Ruisdael drawings that were in Muilman's collection. They were separated when the drawing now at Berlin was sold by the Soviet Union at Leipzig (Boerner), 29 April 1931 (no. 210).

An inscription by a later hand on the old mount of the Berlin drawing correctly identified the site and artist: Rhaenen door J[b] Ruysdael. However, the present sheet was erroneously catalogued as a *Vue de Flessingue, à l'embouchere de l'Escaut* when it was exhibited in St. Petersburg in 1867 (no. 297); it bore its wrong title until J.W. Niemeijer (*op. cit.*) recognized, almost a century later, that it is not a view of Flushing at the mouth of Schelde, but a panorama of Rhenen.

Fig. 67. Jacob van Ruisdael, View of Rhenen from the West. *Berlin, Staatliche Museen, Kupferstichkabinett.*

Fig. 67

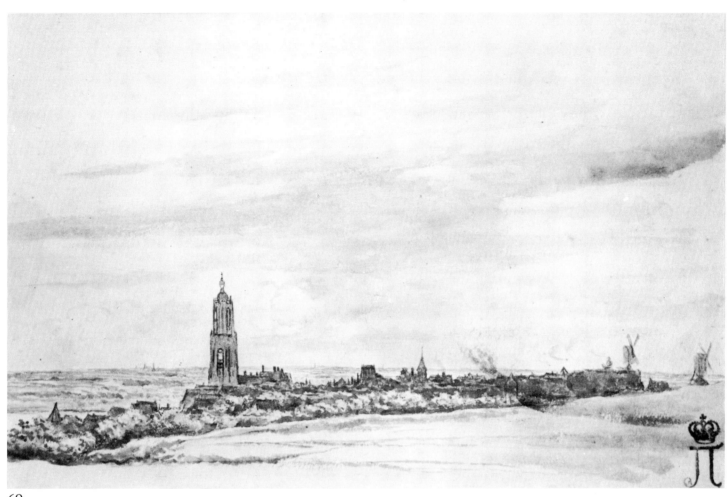

69

Leningrad, Hermitage (no. 5531)
Black chalk, gray wash, 12.5 x 19.4 cm.

PROVENANCE: Sale, D. Muilman,
Amsterdam (de Bosch), 29 March 1773,
no. K.741; Paul I; acquired for the
Hermitage before 1797.

EXHIBITION: St. Petersburg 1867, p.
67, no. 297.

BIBLIOGRAPHY: J.W. Niemeijer,
"Varia Topographica: I. Ruisdael in
Noord Brabant?," O.H., LXXVII,
1962, p. 61; Giltay 72.

Three Half-Timbered Houses Alongside a Road

70

Haarlem, Teyler Museum (no. Q*51)
Black chalk, gray wash, 14.8 x 20 cm.

PROVENANCE: Sale, J. van der Marck,
Amsterdam (de Winter), 29 November
1773, no. 466; sale, J. Gildemeester,
Amsterdam (van der Schley), 24 Novem-
ber 1800, no. N.13.

EXHIBITIONS: Washington et al.
1958–59, no. 100; London 1970, no. 41.

BIBLIOGRAPHY: Scholten 1904, p. 230,
inv. no. Q*51; Kleinmann [n.d.], II, p.
15, repr.; Ros Z29; Simon 1935, p. 192
(not by Ruisdael); Giltay 57.

The half-timbered houses with their tie-beam construction and distinctive plank gables are characteristic of those found in the area that extends roughly from the Twente in the Dutch province of Overijsel to the western part of the German state of Nordrhein-Westfalen, a stretch of land that includes Bentheim and the surrounding neighborhood (for a comprehensive historical study of the vernacular architecture of the area, see Schepers 1976). Naturally Ruisdael saw buildings of this type during the course of his visit in the early fifties to Bentheim and its vicinity. However, the attempt by some cataloguers (Washington *et al.* 1958–59, *op. cit.*; London 1970, *op. cit.*) to pinpoint the site of the present drawing as Bentheim is not acceptable; without a view of the castle it is impossible to give the place a firm identification.

From the early fifties until the last phase of his career Jacob included large and small half-timbered buildings of this type seen from various points in scores of paintings, and one of them is the principal motif of a fine etching (Cat. no. 105). His accurate rendering of their construction and the large variety he portrayed suggest that during his *Wanderjahre* he made numerous drawings of them on the spot, which later served as *aides-mémoire*. Only a few are known today—a clue to the wealth of Ruisdael drawings that have been lost.

J.Q. van Regteren Altena (London 1970, *op. cit.*) proposes that the present drawing may not have been made during the early fifties, but is a later reminiscence of his trip to Bentheim or a light sketch worked up later. The latter suggestion is supported by the massiveness of the picturesque houses, which is in accord with Jacob's inventions of the early fifties, and by a certain looseness in the handling of the wash occasionally found in some of the artist's later drawings. J. Giltay (*op. cit.*), on the other hand, classifies the drawing with the group that he assigns to Ruisdael but which were later worked up by Dirk Dalens, not Jacob himself. For another drawing Giltay places in the same category, see Cat. no. 95.

A Ruined Cottage

As the present drawing shows, Ruisdael's special fascination with ruins during the early and mid-fifties was not confined to the remains of massive walls and arches of grand castles. The deterioration of a modest cottage also attracted his attention. His depiction of the decayed house also appealed to more than one of his followers. At least four paintings by different artists, which incorporate changes in the staffage but in other respects are close to this drawing, have been identified. These copies may have been based on his drawing, but it seems more likely that Ruisdael himself used it as a preparatory study for a painting that is now untraceable. The existing variants were probably based on his lost picture.

The copy by Emanuel Murant (1622–c. 1700) is the most intriguing one (Fig. 68; Rijksmuseum, Amsterdam, no. A281; canvas, 31 x 41 cm). In Murant's version the subject has hardly changed, but the style has shifted. Murant has translated the work into his own idiom, which is reminiscent of Jan van der Heyden's; he gives almost microscopic attention to every single brick, plank, and weed. Examples in seventeenth-century Dutch painting of a slavish imitation of a composition done in a completely different style, such as Murant's work, are rare. Normally copies are straightforward attempts to replicate both the subject and manner of execution of a work; these are usually done by pupils or followers. Those done by artists who use a work done by a predecessor or contemporary as the point of departure for their own personal creations usually introduce significant compositional as well as stylistic changes.

Other painted versions:

1. Boston, Museum of Fine Arts (no. 89.502; canvas mounted on panel, 41.5 x 51.5 cm). It is ascribed to Ruisdael by: Smith 77; Bürger 1865, p. 297; HdG 796, identical with HdG 771 and HdG 1040f; Ros 492. The attribution was rightly rejected in the museum's *Summary Catalogue of European Paintings*, 1955, p. 48, no. 89.502, but the suggestion that it may have been done by Murant is unacceptable.
2. Nîmes, Musée des Beaux Arts, Catalogue, 1940, no. 374.
3. Dealer Douwes, Amsterdam, 1926 (panel, 22 x 31.5 cm); perhaps identical with a version that was with dealer Vitale Bloch, The Hague, 1964 and dealer Julius Böhler, Munich, 1969.

Giltay (note 30) mentions a version formerly in the Elkins Collection, Philadelphia (Ros 65). This painting, now in The Philadelphia Museum of Art, is not a variant of the painting but a poorly preserved panoramic view of the bleaching fields near Haarlem.

Fig. 68. Emanuel Murant (after Ruisdael), A Ruined Cottage. *Amsterdam, Rijksmuseum.*

Fig. 68

71

Miss Yvette Baer
Black chalk, gray wash, 20 x 27.5 cm.
Monogrammed, lower right corner.

PROVENANCE: *Sale, S. Feitama, Am-*
sterdam (de Bosch), 16 October 1758,
no. L.44; sale, G. Hoet, Amsterdam,
25 August 1760, no. 801; sale, J. Goll
van Franckenstein, Amsterdam (de
Vries), 1 July 1833, no. S.9; sale, H.
van Cranenburgh, Amsterdam (Roos), 26
October 1858, no. B.30 (61 florins); sale,
E. Galichon, Paris (Drouot), 10 May
1875, no. 143 (415 francs); J.P. Hesel-
tine; sale, H.S. Reitlinger, London

(Sotheby), 22–23 June 1954, no. 699;
Curtis O. Baer, New Rochelle, New
York; by descent to the present owner.

EXHIBITIONS: *Cambridge 1958, no.*
33; Poughkeepsie 1976, no. 41.

BIBLIOGRAPHY: *Josi 1821, II, [n.p.]*
under "Jacob Ruisdael"; De Vries 1915,
p. 39, no. 126; Huffel 1921, p. 63, no.
144; Giltay 15.

A drawing after the Baer sheet by C.
Ploos van Amstel was engraved by
Cornelis Brouwer; it is published in
C. Josi (op. cit.).

A Ford in a Wooded Landscape

72

Lisbon, Portugal, Calouste Gulbenkian Foundation
Black chalk, black and gray wash, 16 x 26 cm. Monogrammed, bottom left of center.

PROVENANCE: Sale, Neyman of Amsterdam, Paris (Basan), 8–11 July 1776, no. 768 (292.1 francs); C. Josi; sold to Ch. Philipe, London in 1802 (20 louis, see Josi, op. cit.); sale, Lansdowne, London (Sotheby), 25 March 1920, no. 67, repr. (£85, Colnaghi).

BIBLIOGRAPHY: Josi 1821, II, [n.p.] under "Jacob Ruisdael"; Ros Z53; Simon 1930, pp. 84–85 (early 1650s); Giltay 73.

The sheet, which is datable to the first half of the fifties, combines a woodland scene with a glimpse of an extensive landscape, a subject that occurs frequently in his later works but with less sharp contrasts between prominent foreground forms and the distant view. Characteristic of Ruisdael is the minor role that the cart drawn by a team of horses crossing the ford plays in the landscape. Unlike Isaack van Ostade and Philips Wouwerman, his contemporaries in Haarlem, this kind of rustic activity held little attraction for him.

A Tree Growing over a Stream in a Mountainous Landscape

73

Rotterdam, Boymans–van Beuningen
Museum (no. 7)
Black chalk, gray wash, heightened with
white, 15.6 x 23.6 cm. Signed, lower
left (by a later hand?).

PROVENANCE: Sale, Ch. Josi, London
(Christie's), 18 March 1829, no. 132;
sale, J.G. Verstolk van Soelen, Amster-
dam (de Vries), 22 March 1847, no. 81;
sale, G. Leembruggen, Amsterdam
(Roos), 5–8 March 1866, no. 540 (330
florins, Lamme for Museum Boymans).

EXHIBITIONS: Brussels 1937–38, no.
133, repr.; Dijon 1950, no. 92; Van-
couver 1958, no. 67; Brussels–Hamburg
1961, no. 122, repr.; Prague 1966, no.
116; Paris 1974, no. 106, repr. (c. 1660).

BIBLIOGRAPHY: Beschrijving der
teekeningen in het Museum te Rot-
terdam, gesticht door Mr. F.J.O.
Boymans, 1869, no. 714; Ros Z68;
Simon 1930, pp. 68 (end of the 1650s),
84 (c. 1660); Slive 1973, pp. 274–75,
repr. (c. 1650–53); Giltay 96 (early
fifties).

This landscape is not the only one by Ruisdael that indicates he gave more than a passing glance to those done earlier in the century by Dutch mannerists and Roelant Savery which include ancient trees with contorted roots creating fantastic designs (see Cat. no. 36). But here Jacob's sharp observation of the gnarled trunk of this wondrous tree, whose massive roots form a rustic bridge over a rushing stream, suggests that it was based on a direct study from nature, not work done by his predecessors. On the other hand, we know that Ruisdael never laid eyes on the mountains and spruce trees included in the distant view. This is not unusual. Even the most cursory review of his *oeuvre* reveals that his achievement owes as much to the strength of his imagination as to his power of observation.

I have noted elsewhere (*op. cit.*) that a tree similar to the remarkable one in the Rotterdam drawing appears in a Ruisdael painting that has been untraceable for more than fifty years (Fig. 69; canvas, 40.5 x 44.5 cm; HdG 503; Ros 297, identical with Ros 362). To judge from an old photo of the painting it was probably done in the early fifties, after Jacob had seen the hills and forests in the Dutch–German border region near Bentheim and begun to concentrate more consistently on single forms in nature. The powerful drawing is most likely datable to about the same time. For the opinion that it should be dated about 1660 because the distant view shows Ruisdael's debt to Everdingen's Scandinavian landscapes, a debt the artist did not incur until then, see the Paris 1974 exhibition catalogue cited above.

Fig. 69. Jacob van Ruisdael, Wooded Landscape with an Oak Growing Over a Stream. *Location unknown.*

Fig. 69

A Ruined Stone Footbridge over a Sluice

74

Amsterdam, Amsterdams Historisch Museum (no. A 10305)
Black chalk, gray wash, 20.1 x 25.7 cm. Monogrammed, lower left in pen by a later hand, over the original monogram. Inscribed on the verso by a later hand in pencil: bij Alkmaar JvRuisdael.

PROVENANCE: *Sale, S. Feitama, Amsterdam (de Bosch), 16 October 1758, no. H.15 (van Dijk); sale, C. Ploos van Amstel, Amsterdam (van der Schley), 3 March 1800, no. T.6 (191 florins, Josi [with no. T.7]); C. Josi; sale, B. de Bosch,* Amsterdam, 10 March 1817, no. B.5 (310 florins, de Vries for Molkenboer); sale, J.H. Molkenboer, Amsterdam (de Vries), 17 October 1825, no. H.4 (440 florins); sale, H. van Cranenburgh, Amsterdam (Roos), 26 sqq. October 1858, no. G.148 (300 florins, Lamme for Fodor); collection C.J. Fodor; bequeathed to Amsterdam in 1860.

EXHIBITIONS: *London 1929, no. 698; Amsterdam 1932-II, no. 63; Paris 1950–51, no. 156; Cologne 1955, no. 75; Haifa 1959, no. 48; Tel-Aviv 1959, no.99;* Jerusalem-Belgrade 1960, no. 77; Brussels–Hamburg 1961, no. 125; Amsterdam 1963, no. 35, repr.

BIBLIOGRAPHY: *Josi 1821, II, [n.p.] under ''Jacob Ruisdael''; Beschrijving der schilderijen, teekeningen etc., in het Museum Fodor . . . , Amsterdam, 1863, no. 189; Kleinmann [n.d.], III, p. 23, repr.; Honderd teekeningen naar oud hollandsche meesters, Bloemendaal, 1924, Pl. 80; Ros Z4; Simon 1930, pp. 68 (mid-fifties), 83; Giltay 9 (1655–60).*

Especially notable in this drawing, datable to about 1655, is the aggrandizement of the simple motif and the strong daylight effect. This peaceful view is undisturbed by the anglers and other figures that Jacob's contemporaries so often added to their pictures of such scenes. Ruisdael himself added staffage to his drawing of the same high bridge over a sluice seen from the opposite bank which is now at Windsor Castle (Cat. no. 75).

The inscription by another hand on the verso states the bridge is near Alkmaar. J. Giltay (*op. cit.*) mentions a copy after the drawing by Gerrit Lamberts (1776–1850) at the Boymans–van Beuningen Museum (no. MvS 187; black chalk, gray wash, 19.2 x 27.3 cm) which is inscribed "de hoge voetbrug by Amersfoort" (the high footbridge near Amersfoort). His effort to locate traces of a bridge near either town which resembles the one in Jacob's drawing has not been successful. He also notes that the compiler of the 1758 sale catalogue stated the drawing was reworked by Dirk Dalens (c. 1600–1676) and rightly adds that it is difficult to see the hand of another artist in the drawing.

A Windmill and Cottages near a High Footbridge over a Sluice

75

When K.T. Parker (*op. cit.*) published the drawing, he mentioned that a note on the mount states that the site is the same one seen from a different point of view in the *Ruined Stone Footbridge over a Sluice* now at the Amsterdams Historisch Museum (Cat. no. 74). The anonymous author of the note is correct. Here the bridge is seen from the opposite side of the river. For Parker, writing in 1928 (*ibid.*), "the point is of no great importance," but he correctly predicted "it is likely that increasing general interest will be taken in the places represented in Dutch landscapes of a quite general (as opposed to topographic) character, since Jakob Rosenberg's instructive comparison between motives occurring in Hobbema and Ruisdael (*Jahrbuch der Pr. Kunstsammlg.*, 1927, pp. 139ff.)."

There are more significant differences than the shift in point of view between the Amsterdam and Windsor drawings. In the former the emphasis is on the massive and weighty effect of the bridge. In the present work equal attention is given to the view of the bank, the dike, the windmill, and bridge. The effect is less concentrated, but there is a gain in airiness and light, qualities that relate the Windsor drawing to works datable about 1655–60.

Windsor Castle, Her Majesty Queen Elizabeth II (no. RL 6607)
Black chalk, gray wash, 19.5 x 29 cm.
Monogrammed, lower right.

EXHIBITION: *The Hague–London 1970–71, no. 88.*

BIBLIOGRAPHY: *K.T. Parker, Old Master Drawings, III, 1928–29, p. 10, Pl. 14; Ros Z71; Simon 1930, p. 85 (not by Ruisdael; by one of his contemporaries); Puyvelde 1944, p. 61f., no. 669; Trautscholdt 1954–55, p. 38, no. 32; Bernt 1958, II, no. 506; Giltay 101.*

The Portuguese–Jewish Cemetery at Ouderkerk on the Amstel

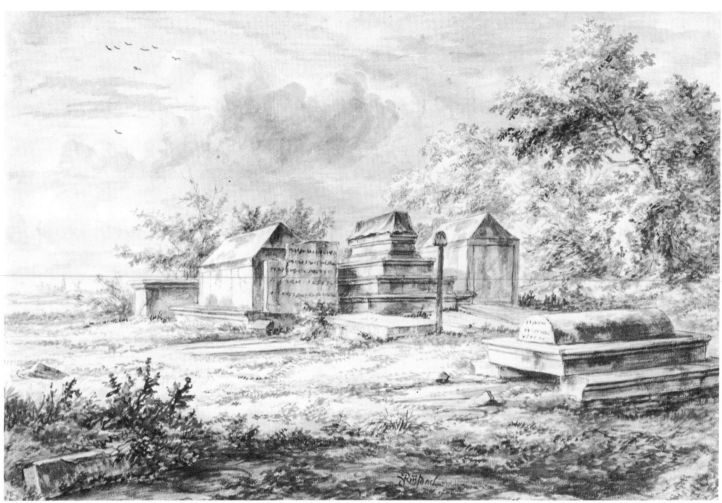

76

*Haarlem, Teyler Museum (no. Q*48) Black chalk and pen with gray wash, 19 x 28.3 cm. Signed, bottom, right of center. Indented and rubbed with red chalk on the verso for transfer.*

PROVENANCE: *Valerius Röver, 1739, Port. 46, nos. 13, 14 (with its companion); sale, G. van Berckel, Amsterdam, 24 March 1761, nos. 6, 7 (with its companion); sale, D. Muilman, Amsterdam (de Bosch), 29 March 1773, nos. P.1120, 1121 (69 florins, de Vos [with its companion]); Jacob de Vos, Sr. (not in his sale); sale, A. Saportas, Amsterdam (de Vries), 14 May 1832, no. A.3 (410 florins [or 465 florins], Hulswit*

[with its companion]); sale, H. van Cranenburgh, Amsterdam (Roos), 26 sqq. October 1858, no. F.123 (905 florins, Buffa for the Teyler Foundation [with its companion]).

EXHIBITIONS: *London 1929, no. 699; Brussels 1937–38, no. 132, repr.; Paris 1950–51, no. 159; London 1970, no. 43, repr.*

BIBLIOGRAPHY: *Josi 1821, II, [n.p.] under "Jacob Ruisdael"; Castro 1883, pp. 17–18, note 34; Scholten 1904, p. 230, inv. no. Q*48; Ros Z27; Simon 1930, pp. 31, 68 (mid–fifties), 84; Zwarts 1928,*

pp. 232ff. (c. 1664; the companion c. 1667); Wijnman 1932, p. 179 (after 1657); Rosenberg 1933, p. 217f.; Simon 1935–I, p. 158f. (mid–1650s); H. Friedenwald, "Montalto," Bulletin of the Institute of the History of Medicine, The Johns Hopkins University, February, 1935, p. 145; J.Q. van Regteren Altena, Dutch Master Drawings of the Seventeenth Century, London, 1949, p. xxvi, no. 48; Rosenau 1958, p. 241f. (shortly before 1670); Dubiez 1967, p. 208 (shortly before 1670); Vega 1975, passim; Scheyer 1977, p. 133f.; Giltay 55.

J. Giltay (55, 56) recently has established that the famous drawing and its companion, Cat. no. 77, were listed in the 1739 inventory (not sale) of Valerius Röver's outstanding collection. These are the earliest known references to drawings that can be securely identified with Ruisdael's existing work as a draughtsman. The manuscript of Röver's inventory is at the Amsterdam University Library, H.S. 1446 II A18 (for more on this Delft amateur's activities as a collector, see F. Lugt, *Les Marques de collections de dessins et d'estampes*, Supplement, The Hague, 1956, no. 2984 a–c, and Seymour Slive, *Rembrandt and His Critics: 1630–1730*, The Hague, 1953, pp. 172–76).

The principal lines of the drawing and of its pendant have been sensitively traced over with a stylus for transfer, almost certainly by Abraham Blooteling, who made prints after both works in 1670 (Figs. 70, 71; Hollstein, II, p. 216, nos. 115, 116, repr.). Some pen lines may have been added by Blooteling to facilitate transfer.

The large monuments in the central part of the present sheet are incorporated in Ruisdael's paintings of the *Jewish Cemetery* at Detroit and Dresden (Cat. nos. 20, 21); the tomb in the right foreground appears, seen from other points of view, on the left in both paintings.

The most conspicuous monuments in the draw-

ing and in its companion, which shows the opposite view of the tombs with St. Urban's Church at Ouderkerk rising in the distance, are still *in situ* at Beth Haim (House of Life), the Portuguese–Jewish cemetery at Ouderkerk on the Amstel, a village about eight kilometers from Amsterdam.

Pioneer work on the history and restoration of the cemetery was done by David Henriques de Castro; his *Keur van Grafsteenen op de Nederl.– Portug.–Israël. Begraafplaats te Ouderkerk aan den Amstel*, Leiden, 1883 (Dutch and German text), remains indispensable for the study of the iconography of the cemetery. Castro was the first scholar to recognize that the tombs in Ruisdael's drawings and Dresden painting are related to those at the cemetery (*ibid.*, pp. 17–18; in his day the Detroit picture was unknown). An excellent, succinct survey of the cemetery's history is provided by L. Alvares Vega, *Het Beth Haim van Ouderkerk*, Assen–Amsterdam, 1975 (Dutch and English text).

Land for the cemetery was purchased by the Sephardic communities Beth Jacob and Neweh Shalom of Amsterdam in 1614. In the same year the first burial took place there; the cemetery was put into official use in 1616. Additional parcels of land adjacent to the original land were acquired later in the seventeenth century and still more was bought subsequently. By 1923 all the land availa-

Fig. 70. Abraham Blooteling (after Ruisdael), Jewish Cemetery. *Engraving.*

Fig. 71. Abraham Blooteling (after Ruisdael), Jewish Cemetery. *Engraving.*

Fig. 70

Fig. 71

ble for burial was used. Since members of the Amsterdam Portuguese-Jewish community found it impossible to conceive of being buried elsewhere, an eighteenth-century part of the cemetery was raised, with rabbinical approval, with three meters of sand. It was projected that this action would enable the congregation to acquire enough new ground for forty years of burials. Thus it was anticipated that about 1960–65 the community would face the same problem it confronted in 1923. This did not happen. The Nazi death camps of the Second World War changed the situation completely. Now there is room enough for some time to come (Vega, *op. cit.*, p. 16).

Historians of the burial ground have established that the sarcophagi that can be identified in Ruisdael's drawings are among the oldest there. In the present sheet the large white marble tomb with a prismatic cover and a broken slab in front of it, belongs to Dr. Eliahu Montalto (d. 1616), who was born in Portugal of a Marrano family. (Marrano was the name given in medieval Spain and Portugal to a Jew who converted to Christianity, often under the pressure of persecution or threats of death. Many secretly clung to their old faith. Later persecution led to successive waves of their emmigration from the Peninsula to other parts of Europe and to Muslim countries.)

After Montalto left Portugal he reverted to Judaism and settled in Leghorn. His career was a distinguished one; he became physician to the Duke of Tuscany and later to Marie de Medici. Montalto died at Tours and at his own request was buried at Ouderkerk. Vega (*ibid.*, p. 27) notes the tomb poses a problem: Although Hebrew and Portuguese inscriptions on the tomb clearly state Dr. Eliahu Montalto is buried in it, one of the long sides on top of the tomb bears an inscription stating that it is the grave of Esther Montalta (d. 1692), widow of Hakam (Chief Rabbi) Moses Montalto, who was a son of Dr. Eliahu Montalto. Double burials in a single grave are forbidden by Jewish law.

The bierlike tomb behind and to the left of Montalto's monument, which is difficult to discern in reproductions of the Detroit and Dresden pictures, but clearly visible in the originals, belongs to Dr. David Farras (d. 1624).

The dark gray marble tomb with a stepped platform, over the sarcophagus of which a cloth is carved in red marble, holds the remains of Hakam Issak Uziel (d. 1622), born in Fez in Barbary. He

Fig. 72. Romeijn de Hooghe, Jewish Cemetery. *Etching.*

Fig. 73. Romeijn de Hooghe, Jewish Cemetery. *Etching.*

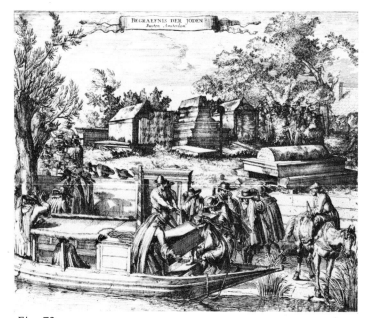

Fig. 72

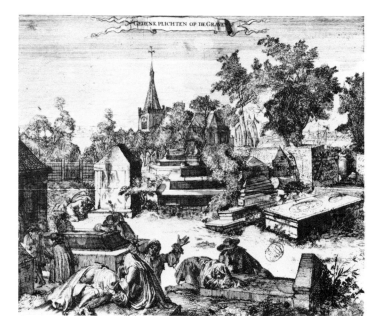

Fig. 73

immigrated to Amsterdam in 1615 and was the Hakam of the Neweh Shalom congregation from 1617 until his death in 1622. To the right of Uziel's monument is the white marble tomb of Israel Abraham Mendez (d. 1627). The tomb surmounted by a half-column in the right foreground has been identified as the monument that marks the plot where Melchior Franco Mendes (d. 1614; also called Abraham Franco O. Velho [velho = the old one]) and members of his family were buried.

It has been suggested that the drawings were commissioned as finished works to commemorate the distinguished members of Amsterdam's Jewish community whose tombs are represented (Brussels–Hamburg 1961, no. 124), a supposition that does not exclude the use of this drawing as a source for the monuments in the Detroit and Dresden pictures. It has also been proposed that the two paintings were commissioned works; for a discussion of this hypothesis, see Cat. no. 20.

The broad touch employed in both drawings suggests they were done in the mid–fifties; however, the pronounced diagonal composition of this sheet and the compactness and emphatic *repoussoir* of its companion indicate that they may have been done earlier in the decade. H.F. Wijnman's

conclusion (*op. cit..*) that they could hardly have been made before Ruisdael moved from Haarlem and is known to have resided at Amsterdam in 1657 is inconsistent with our knowledge of the artist's mobility during the early fifties. Then as now, a trip from Haarlem to Ouderkerk was much easier to make than a journey from Haarlem to the German–Dutch border region. J. Zwarts' attempt (*op. cit.*) to date them around 1664 and 1667 on the basis of his identification of some of the tombs and their rate of deterioration is inconclusive (see Simon 1935–I).

The style of the drawings rules out the possibility that they were done shortly before Abraham Blooteling engraved them in 1670 (Figs. 70, 71). Blooteling, who also made prints after Ruisdael's six views of Amsterdam (see Cat. no. 83) probably made them to help satisfy the great demand for topographical prints that arose in the Netherlands in the 1660s, and which continued until the end of the century (see B. Bakker in Amsterdam–Toronto 1977, p. 73f.). Since Blooteling's engravings are inscribed: Begraef–plaets der Joden buyten Amsteldam (Burial place of the Jews outside Amsterdam) and include no specific reference to the name of the cemetery and the congregation it served,

Fig. 74. Dirk Dalens (after Ruisdael), Jewish Cemetery. *Jerusalem, The Israel Museum.*

Fig. 75. Dirk Dalens (after Ruisdael), Jewish Cemetery. *Jerusalem, The Israel Museum.*

Fig. 74

Fig. 75

the prints were probably not commissioned by members of Amsterdam's Portuguese-Jewish community. More likely they were designed for the general public.

Evidence that there was enough interest in the cemetery to attract tourists even before the middle of the century in found in an entry in John Evelyn's *Diary* for 21 August 1641 (*The Diary of John Evelyn*, ed. E.S. de Beer, vol. II, *Kalendarium, 1620–1649*, Oxford, 1955, pp. 42–43). On that day, the first of four crowded days he spent in Amsterdam, Evelyn squeezed in visits to Amsterdam's Spin-house ("a kind of Bridewell, where incorrigible and Lewd Women are Kept in Discipline and Labour; but in truth all is so sweete and neate, as there seemes nothing lesse agreable than the persons and the place"), a privately endowed Gasthuis for the poor, another maintained by the city, the old Town House, and the Kloveniersdoelen, the headquarters of one of Amsterdam's civic guard companies, where he made note of a group portrait of militia men by Sandrart (if he had visited the Doelen a year later he would have seen Rembrandt's recently finished *Night Watch* mounted in the building). Evelyn records that he began his busy day with a visit "to a Synagogue of the Jewes (it being then Saturday)" and witnessed much that "afforded matter for my wonder and enquiry From hence I went to a place (without the Towne) called Over-kirk [Ouderkerk], where they had a spacious field assign'd them for their dead, which was full of Sepulchers, and Hebrew Inscriptions, some of them very stately, of cost."

During his brief stay in Amsterdam Evelyn notes that he bought some maps at Hendrik Hondius' shop (*ibid.*, p. 49); if prints of the Jewish cemetery had been available he probably would have bought them too.

Ruisdael's two views of the Portuguese-Jewish cemetery serve as the middle and backgrounds of the pair of fanciful scenes Romeijn de Hooghe etched of the burying ground at Ouderkerk (Figs. 72, 73; Hollstein, IX, nos. 260–261; J. Landwehr,

Romeyn de Hooghe the Etcher, Leiden–Dobbs Ferry, New York, 1973, pp. 299–300). Since de Hooghe's views do not reverse the originals he most likely copied them from Blooteling's engravings. They may have been made c. 1675 when de Hooghe produced a series of prints to commemorate the inauguration of the New Portuguese Synagogue at Amsterdam (see Landwehr, *op. cit.*, pp. 287–94).

The row of three monuments in the present drawing also appears in the background of a print designed by Bernard Picart which shows a Jewish burial scene in *The Ceremonies and Religious Customs of the Various Nations of the Known World . . .*, vol. I, London, 1733, facing p. 242 (the French edition of this work, published in Amsterdam, 1723ff., has not been examined).

Alfred Rubens ("Three Jewish Morality Pictures," *The Connoisseur*, CXXXIV, August 1954, p. 31f.) overstates the case when he writes that the background of a late seventeenth-century Dutch *memento mori* picture at the Jewish Museum, London (*ibid.*, p. 32, repr.) was taken from the drawing. The only thing in the primitive painting that recalls Ruisdael's view of the Jewish cemetery is the tomb surmounted by a half-column.

A variant of each drawing (black chalk and gray wash) is in The Israel Museum, Jerusalem, gift of Mrs. Lola Kramarsky, New York: no. 49.70 (19.8 x 28.8 cm) and no. 48.70 (19.6 x 28.7 cm). The author of the 1961 Brussels–Hamburg exhibition catalogue (no. 132) erroneously calls them identical versions of the Haarlem drawings; comparison of them with the originals shows significant differences (see Figs. 74, 75). There is an old tradition that they were done by Ruisdael and Dirk Dalens (sale, C. Ploos van Amstel, Amsterdam, 3 March 1800, no. T.11), but an even older tradition ascribes them solely to Dalens (sale, S. Feitama, Amsterdam, 16 October 1758, nos. G.37, G.38; cited by Giltay, notes 19, 20). To judge from photographs the earlier attribution to Dalens is correct; this also is J. Giltay's opinion (*ibid.*).

The Portuguese–Jewish Cemetery at Ouderkerk on the Amstel

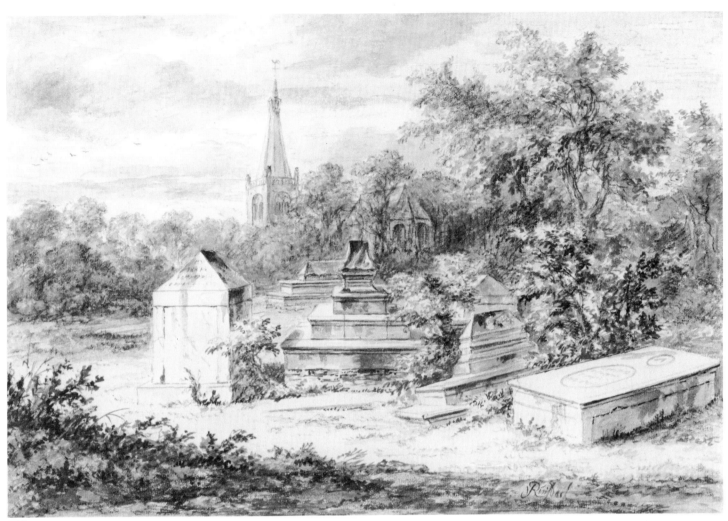

77
*Haarlem, Teyler Museum (no. Q*49)*
Black chalk and pen with gray wash,
19.2 x 28.3 cm. Signed, lower right.
Indented for transfer.

PROVENANCE: *See Cat. no. 76.*

EXHIBITION: *Brussels–Hamburg 1961,*
no. 124.

BIBLIOGRAPHY: *Josi 1821, II, [n.p.]*
under "Jacob Ruisdael"; Scholten 1904,
*p. 230, inv. no. Q*49; Ros Z28; Kus-*
nezow 1975, p. 92, Fig. 34; Giltay 56.

The drawing shows another view of the tombs depicted in Cat. no. 76; St. Urban's Church at Ouderkerk is seen beyond the trees in the distance. See Cat. no. 76 for additional bibliographical references and a discussion of the drawing, its companion, and copies made after both works.

The Ruins of the Castle of Egmond

78
Berlin, Staatliche Museen, Kupferstich-kabinett (no. 14726)
Black chalk and gray wash, 20 x 28.5 cm. Monogrammed, lower right.

PROVENANCE: Oscar Huldschinsky, Berlin; sale, Huldschinsky, Berlin (Graupe), 3 November 1931, no. 76, repr.; acquired by the Berlin Museums in 1931.

EXHIBITION: Berlin 1974, p. 74, no. 161.

BIBLIOGRAPHY: Ros Z13 (an old copy is in the Berlin Kupferstichkabinett); Simon 1930, p. 85; Renaud 1940, pp. 339–40; Rosenau 1958, p. 242; Giltay 20.

J.G.N. Renaud established (*op. cit.*, p. 339, note 1) that the drawing represents the east side of the ruins of the inner court of the ruined Castle of Egmond aan den Hoef; for a note on the history of the castle see Cat. no. 19. A copy of the sheet that is almost identical in size (19.5 x 30.8 cm) is at the Kupferstichkabinett, Berlin (Bock–Rosenberg 1930, I, p. 259, no. 5777).

Elements of the drawing are clearly recognizable in the ruins in the background of the version of *The Jewish Cemetery* at Dresden (Cat. no. 21). A copy of a lost Ruisdael drawing now at Stuttgart (no. C64/1329; Fig. 32) shows the same ruins but from a point of view more to the right, almost the way they are seen in the painting. The original that served as a model for the Stuttgart copy probably served as a preparatory study for the painting; for the view that the Stuttgart sheet is authentic, see Giltay (98).

The relationship of the Berlin drawing to the Dresden *Cemetery* has led to some flights of fancy: for example, Helen Rosenau's suggestion (*op. cit.*) that it shows St. Urban's Church at Ouderkerk after it was damaged in 1674. The drawing's style, which places it about the early or mid–1650s as well as the fact that the church was not a ruin in 1674 rules out the proposal. On 1 August 1674 the church at Ouderkerk lost only its spire, which was later rebuilt (see van der Aa 1846, VIII, p. 678).

Apart from the Berlin drawing of Egmond four others, datable about the same time, have been identified. Two of them are discussed here (Cat. nos. 79, 80). Another is at Amsterdam (no. A4561; Ros Z3; Giltay 2); the fourth, formerly at Bremen, was a casualty of the Second World War (Ros Z15; Giltay 27). In addition, the ruined castle is the principal motif of Ruisdael's great painting of the early fifties at The Art Institute of Chicago (Cat. no. 19).

The remains of the castle also may have served as the point of departure for two of Ruisdael's drawings of ruins at Leningrad (no. 5520; Ros Z37; Agafonova 1935, p. 180, repr.; Renaud 1940, p. 339, note 1; Giltay 67 [retouched by Dirk Dalens]; and no. 5533; Agafonova 1935, p. 181, repr.; Giltay 68 [retouched by Dalens]), and for one at Windsor Castle (no. 6605; Ros Z72; Giltay 102).

The Ruins of the Castle of Egmond

79

*Groningen, Groninger Museum voor
Stad en Lande (no. 1931–217)
Black chalk, gray wash, 20.1 x 28.5 cm.
Monogrammed, lower right corner.
Inscribed by a later hand, upper left in
black chalk: Egmont op d hoef.*

*PROVENANCE: S. Woodburn; J.C.
Robinson; J.P. Heseltine; sale, Heseltine,
Amsterdam (Muller), 27–28 May 1913,
no. 189, repr.; collection C. Hofstede de
Groot, inv. no. 527; presented to the
museum in 1914, no. 54.*

*EXHIBITIONS: Leiden 1916, no. 83;
The Hague 1930, no. 114; Groningen
1931, no. 118; Groningen 1952, no. 80;
Vancouver 1958, no. 66; Brussels–
Hamburg 1961, no. 123; The Hague–
London 1970–71, no. 89.*

*BIBLIOGRAPHY: O. Hirschmann,
"Die Handzeichnungen Sammlungen
Dr. Hofstede de Groot im Haag, III,"
Cicerone, IX, 1917, p. 210; F. Becker,
Handzeichnungen holländischer
Meister aus der Sammlungen Hof-
stede de Groot, Leipzig, 1923, no. 44;
Ros Z25; Simon 1930, p. 85 (by a con-
temporary of Ruisdael); Simon 1935, p.
192 (perhaps by Dirk Dalens II); Renaud
1940, p. 339, note 1; Frerichs 1963, p.
52, see no. 66; J. Bolten, Dutch Draw-
ings from the Collection of Dr. C.
Hofstede de Groot, Groninger Museum
voor Stad en Lande, Utrecht, 1967, p.
115, no. 89, repr. (wrong provenance);
Giltay 54.*

Unjustifiable doubts have been expressed about both the identification of the site (Brussels–Hamburg 1961, p. 93) and the authenticity of the drawing (according to Bolten, *op. cit.*, Hofstede de Groot attributed it to Dirk Dalens; Simon, *op. cit.*, also was inclined to ascribe it to Dalens). However, J.G.N. Renaud (*op. cit.*, p. 339, note 1) convincingly establishes that the drawing shows the ruined tower at the southeast corner of the partially destroyed castle at Egmond. L.D.J. Frerichs, J. Bolten, and J. Giltay (see bibliography above) have rightly defended the attribution to Ruisdael. The drawing is closely related in style to the artist's other drawings of the ruined castle (see Cat. no. 78), as well as to his study of a *Ruined Cottage* (Cat. no. 71), and like them is datable to the early or mid–fifties.

The Ruins of the Castle of Egmond

80

Amsterdam, Rijksmuseum, Rijksprenten-
kabinet (no. A 4560)
Black chalk, gray wash, 19.6 x 29.8 cm.
Monogrammed, lower right; inscribed,
lower right by a later hand: Egmond op
d hoef.

PROVENANCE: Sale, S. Feitama, Am-
sterdam (de Bosch), 16 October 1758,
no. H.44; sale, G. Hoet, Amsterdam, 25
August 1760, no. 272; sale, J. Tak,
Haarlem, 10 October 1780, no. 56; sale,
J. Goll van Franckenstein, Amsterdam
(de Vries), 1 July 1833, no. U.7; S.
Woodburn; W. Esdaile; probably sale,

W. Esdaile, London (Christie's), 18–25
June 1840, no. 1092 (£2, 12s, 6p, with
its companion); sale, W.N. Lantsherr,
Amsterdam, 3 June 1884, no. 284 (with
its companion); sale, M. Baron de
B[eurnonville], Paris (Drouot), 16
February 1885, no. 217 (with its com-
panion); sale, W. Pitcairn Knowles,
Amsterdam (Muller), 25–26 June 1895,
no. 563 (with its companion); acquired
by the Rijkspretenkabinet in 1902 (with
its companion).

EXHIBITIONS: Amsterdam 1935, no.

130; Vienna 1936, no. 67; Brussels
1937–38, no. 31; Paris 1950–51, no. 158.

BIBLIOGRAPHY: Josi 1821, II, [n.p.]
under ''Jacob Ruisdael''; de Vries 1915,
p. 38, no. 125; Huffel 1921, p. 63, no.
143; Ros Z2; Simon 1930, p. 85 (not
authentic); Simon 1935, p. 192 (probably
by Dirk Dalens II); Renaud 1940, p.
339, note 1, repr.; Frerichs 1963, p.
52, no. 66, repr.; Giltay 1.

Engraved by Cornelis Ploos van Amstel
(1726–98) in Josi (op. cit.).

The large ruin on the left shows the interior of the southwestern corner of the principal building of the castle; beyond it is the ruin of the southwestern corner tower of its outer structure (Renaud, *op. cit.*, p. 340). The latter ruin is the main motif of another drawing by Ruisdael at the Rijksprentenkabinet (no. 4561; Ros 3; Giltay 2). Both drawings appeared together in all of the collections and sales cited in the provenance.

Renaud, who published an account of the iconography of the castle of Egmond, emphasizes the importance of Ruisdael's drawings for our knowledge of the interior organization of the structure; he notes they are the oldest and virtually the only seventeenth-century source on the subject. There is, however, another drawing by Jan Weenix (1640–1719) at the Albertina (no. 10199; reproduced in Bernt 1958, II, no. 678) that is worth mentioning in this connection. Although it is clearly inscribed (by a later hand?): Huis te Cleef, the site of a well-known ruin near Haarlem, it appears to show the ruins at Egmond that Ruisdael depicted in this drawing in a further state of decay.

For Ruisdael's other drawings of the ruins of the castle, see Cat. no. 78. A painting of them is at The Art Institute of Chicago (Cat. no. 19).

The Gasthuisstraat Behind the Groote Kerk (Sint Laurenskerk)

81

London, British Museum, Trustees of the British Museum (no. 1895.9.15.1926) Black chalk, gray wash, 20 x 31 cm. Signed by a later hand at the lower right: Ruisdaal. Inscribed on the verso in a later hand: "Te Alkmaar agter de Groote Kerk."

PROVENANCE: Sale, S. Feitama, Amsterdam (de Bosch), 16 October 1758, no. H.11; sale, H. van Eyl Sluyter, Amsterdam (van der Schley), 26 September 1814, no. F.10; sale, J.G. Verstolk van Soelen, Amsterdam (de Vries), 22 March 1847, no. 217; sale, G. Leembruggen, Amsterdam (Roos), 5–8 March 1866, no. 543 (160 florins, Robbenson); collection J. Malcolm; purchased 1895.

EXHIBITION: Amsterdam–Toronto 1977, no. 78.

BIBLIOGRAPHY: Josi 1821, II, [n.p.] under "Jacob Ruisdael"; Ros Z47; Simon 1930, p. 84 (c. 1655); Hind 1931, IV, p. 40, no. 5; Giltay 76 (c. 1655).

Emphasis on the massiveness of the closely packed buildings places the townscape in the mid-fifties. Particularly beautiful are the delicate gradations of gray wash which capture the quality of strong sunlight permeating the shadows and almost dissolving the forms of the town's Groote Kerk seen at the end of the street. The rectangular group of buildings is the Middelbegijnhof. The bridge in the foreground spanned the Geestwater (now called the Geest). The cropped signature indicates that the lower edge of the sheet has been cut off; it may also have been cut slightly along the left side.

The Interior of the Oude Kerk [Old Church] at Amsterdam

82

This exceptionally large drawing is made up of three pieces of paper: Two have been pasted together about seventeen centimeters from the top, and a strip about four centimeters wide has been added at the right. The drawing is exceptional in other ways. Apart from the many drawings of church interiors done by Pieter Saenredam, who made a speciality of the subject, seventeenth-century Dutch drawings of the subject are rare. One by Ruisdael is unexpected. Frits Lugt, who first published the sheet (*op. cit.*), observed that it was not done by an artist who was an experienced architectural draughtsman. The initial drawing was made with black chalk, Jacob's customary way of working, but evidently he found this medium too broad. He then used lead pencil, an unusual choice for him, to lay in the architectural details.

The only other drawing of a church interior that has been attributed to Ruisdael is one of the Nieuwe Kerk (New Church) at Amsterdam, which is at the Kupferstichkabinett, Berlin (Fig. 76; no. 2619; black chalk and pen with gray wash, 30.9 x 24 cm; the top edge of the sheet is arched; signed by a later hand: Ruijsdael). Jakob Rosenberg rightly noted that "the attribution is very doubtful" (Bock-Rosenberg 1930, I, p. 258, no. 2619). Comparison of the Berlin drawing with the present sheet shows that its lines are stiffer and more mechanical than Ruisdael's and the gradations of gray wash lack his luminosity and the spirited treatment of his sensitively placed accents. The Berlin drawing probably served as a preparatory study for a painting of the *Nieuwe Kerk*, now in the collection of the

Marquess of Bute, which has been traditionally attributed to Ruisdael, with staffage by Philips Wouwerman (HdG 11; Ros 6 [not seen by Rosenberg]). When the Bute painting was exhibited in London 1952–53 (no. 322), the author of the exhibition catalogue expressed understandable reservations about the traditional ascription; little in it is suggestive of Jacob's authentic works. For a defense of the attribution of the Nieuwe Kerk drawing and painting to Ruisdael see: Frits Lugt, *Jahrbuch der preussischen Kunstsammlungen*, LII, 1931, p. 66; Lugt 1950, I, no. 519; Trautscholdt 1954–55, p. 38, no. 10; Kusnezow 1975, p. 86; Giltay 22. J.G. van Gelder (*op. cit.*) also endorsed the ascription of the Berlin drawing to Jacob in 1958, but in a later, private communication he suggested that it is probably by Beerstraaten.

Although Lugt's conclusion that Ruisdael made both drawings of the interiors of Amsterdam's two principal churches is disputable, his suggestion that there may be a connection between the artist's unusual drawing of one of them and the fact that Jacob, who was baptized into the Reformed Church in 1657 about the time he settled in Amsterdam, is intriguing (Lugt, *op. cit.*). The delicate handling of the wash, which fuses with the lines that define the forms of the structure of the Oude Kerk, while giving spaciousness and airiness to its vast interior is not inconsistent with Ruisdael's other drawings datable to the mid- or late fifties; however, the absence of comparable studies by Jacob makes this suggested date more provisional than many of those offered here.

Paris, École des Beaux-Arts (no. M1.962)
Black chalk, lead pencil, gray wash, 48.2 x 41.5 cm. Inscribed at the lower left in faded ink: d'oude kerk; over this inscription, in a darker ink, a later hand has written: J. Ruisdael.

PROVENANCE: *J. Masson (as Pieter Saenredam), who presented it to the École des Beaux-Arts.*

BIBLIOGRAPHY: *Lugt 1950, I, p. 65, no. 519; J.G. van Gelder,* Prenten en tekeningen, *Amsterdam, 1958, p. 96, no. 107, repr.; Kusnezow 1975, Pl. 34, p. 85; Giltay 91.*

The Blauwbrug [Blue Bridge] over the Amstel River at Amsterdam

83

Paris, École des Beaux-Arts (no. M 1.945)
Black chalk, gray wash, 15 x 21.2 cm. Indented; rubbed with red chalk on the verso for transfer.

PROVENANCE: *Sale, S. Feitama, Amsterdam (de Bosch), 16 October 1758, no. G.28; J. Goll van Franckenstein, Amsterdam; possibly his sale, Amsterdam (de Vries), 1 July 1833, no. S.10 or no. HH.10; sale, L. Dupper, Dordrecht (Roos), 28–29 June 1870, no. 290;* A.J. Eyndhoven; sale, J. Werneck, Amsterdam (Muller), 23–25 June 1885, no. 254 (110 florins, Wurfbain); sale, Prof. C.L. Wurfbain, Amsterdam (Muller), 20–22 November 1899, no. 3 (220 florins, Fr. Muller and Co. [sold with five other drawings presumably from the series]); collection J. Masson, who presented it to the École des Beaux-Arts.

BIBLIOGRAPHY: *Josi 1821, II, [n.p.] under "Jacob Ruisdael"; Lugt 1950, I, p. 65, no. 517, repr.; Giltay 89.*

Abraham Blooteling (1640–90), the prolific graphic artist who made prints after Ruisdael's two drawings of the Portuguese–Jewish cemetery at Ouderkerk (see Cat. nos. 76, 77), also produced a series of six topographical etchings after Jacob's drawings of views of Amsterdam done in the vicinity of the Amstel River near the city's old ramparts about the time the dramatic expansion of the metropolis began in 1663–64 (Figs. 77–82; see Hollstein, II, nos. 109–114). The first print of the series bears the inscription: Amstel-Gesichjes door Jacobus van Ruisdael (Fig. 79; *ibid.*, no. 109). Upon the basis of topographical evidence in the prints, Erich Kurt Simon (1930, p. 65, note 67a) established that Ruisdael's drawings for the prints were most likely done about 1663.

The six drawings appeared together in 1758 in the Feitama sale (nos. G.24–29), C. Josi (*op. cit.*) noted their presence in Goll van Franckenstein's collection in 1821, and according to the compiler of the Wurfbain auction catalogue of 1899 (no. 3) they were also grouped as a lot in that sale. Today two of them are known: the present drawing of the *Blauwbrug* and the view of the *Yacht Harbor* with a vista of the same bridge, which is also at the École des Beaux-Arts (Cat. no. 84). A marginal drawing and two sheets wrongly called part of the series are discussed below.

Blooteling's prints after the École des Beaux-Arts drawings do not reverse them (Figs. 77, 78), presumably for topographical accuracy. Most likely the etchings done after the untraceable drawings that belong to the set also were done in the same direction as Jacob's preparatory studies.

Fig. 77. Abraham Blooteling (after Ruisdael), The Blue Bridge. *Etching.*

Fig. 78. Abraham Blooteling (after Ruisdael), The Yacht Harbor. *Etching.*

Fig. 77

Fig. 78

The name of the Blauwbrug was derived from its color. It was also known as the Leeuwenbrug (Bridge of the Lions), an appellation that refers to the four statues of lions on its balustrade. As might be expected in cityscapes designed to be translated into prints for a clientele with a special interest in topography, a close look at the drawings of the *Blauwbrug* and the *Yacht Harbor* shows the four statues on the well-known structure, and in general they exhibit a more scrupulous attention to detail than is normally found in the artist's drawings. In light of their intent, it is notable that there is a difference in the large building seen on the right in both drawings and in the etchings made after them (the difference was first mentioned by Lugt, *op. cit.*). In the scene of the *Blauwbrug* the long façade of the building is almost a third longer than it is in the *Yacht Harbor*. Either Ruisdael took liberties with the building in one of his drawings of it, or the drawings show the building before and after it had been extended.

A problematic drawing of the *View of St. Anthoniespoort at Amsterdam* is at the Kunsthalle, Bremen (no. 56/282; black chalk, gray wash, 14.9 x 21.1 cm). Although it has been indented with a stylus and rubbed on the verso with red chalk, procedures that suggest it was transferred to a plate, it falls below the level of the École des Beaux-Arts drawings. It may be a much reworked original or a copy after Blooteling's etching of the same subject with its outlines traced and its verso rubbed to make it look like part of the series (Fig. 81; Hollstein, II, no. 109). The sheet is accepted by J. Giltay (31) as authentic.

Fig. 79. Abraham Blooteling (after Ruisdael), View of the Hooge Sluis Seen from a Bank of the Amstel River. *Etching.*

Fig. 80. Abraham Blooteling (after Ruisdael), The Windmill near the Blue Bridge *Etching.*

Fig. 79

Fig. 80

Two drawings that are certainly copies after one of Ruisdael's studies for the set or a print by Abraham Blooteling have been identified:

1. Budapest, Museum of Fine Arts. *Rear View of Mr. Huydecoeper's House* (no. 1914-149). Black chalk, gray wash, 16 x 23.5 cm; signed. The drawing appeared in the sale, A.O. Meyer, Leipzig, 19 March 1914, no. 410, repr., as an original. It was accepted by Erich Kurt Simon (1930, p. 68), but in the corrigenda to his study (*ibid*., p. 85) he endorses the view expressed by Arthur M. Hind and Frits Lugt that it is a drawing done after Blooteling's print (Fig. 82; Hollstein, II, no. 110). F.W.H. Hollstein (*ibid*.) incorrectly lists the Budapest drawing as an original.

2. Frankfurt, Städelsches Kunstinstitut. *Rear View of Mr. Huydecoeper's House* (no. 3038). Black chalk, gray wash, 15.8 x 23.4 cm; signed. A copy in reverse of the view seen in the print (Fig. 82; Hollstein, II, no. 110). Hind (1931, IV, p. xiii) mentions that Lugt called his attention to various forgeries of seventeenth-century Dutch works by a still unidentified hand that exist in various public collections. Hind attributed both the Frankfurt and Budapest drawings to the same hand. (For other forgeries he assigns to the same anonymous artist, see *ibid*.)

Fig. 81. *Abraham Blooteling (after Ruisdael),* View of St. Anthoniespoort. *Etching.*

Fig. 82. *Abraham Blooteling (after Ruisdael),* Rear View of Mr. Huydecoeper's House. *Etching.*

Fig. 81

Fig. 82

The Yacht Harbor at the Amstel River near the Blue Bridge

84

Paris, École des Beaux-Arts (no. M1.946)
Black chalk, gray wash, 14.8 x 21 cm. Indented; rubbed with red chalk on the verso for transfer.

PROVENANCE: Sale, S. Feitama, Amsterdam (de Bosch), 16 October 1758, no. G.24; J. Goll van Franckenstein, Amsterdam; possibly his sale, Amsterdam (de Vries), 1 July 1833, no. S.10 or no. HH.10; sale, Prof. C.L. Wurfbain, Amsterdam (Muller), 20 November 1899, no. 3, with five other drawings presumably from the series (220 florins, Fr. Muller and Co.); collection J. Masson, who presented it to the École des Beaux-Arts.

BIBLIOGRAPHY: Josi 1821, II, [n.p.] under "Jacob Ruisdael"; Lugt 1950, I, p. 65, no. 518, repr.; Giltay 90.

A preparatory drawing made about 1663 for one of a series of six prints Abraham Blooteling etched after Ruisdael's views of Amsterdam near the Amstel; Blooteling's etching of the drawing does not reverse it (Fig. 78; Hollstein, II, no. 112). For additional comments regarding Ruisdael's *Amstel-Gesichjes*, see Cat. no. 83.

212

A Canal Flanked by Trees with a View of a Large House and a Bridge

85

Paris, Musée du Louvre (no. RF. 707)
Black chalk, gray wash, 14.6 x 20 cm.
Monogrammed, lower left.

PROVENANCE: Sale, N. Revil, Paris,
29 sqq. March 1842, no. 240; given
in 1878 to the Louvre by His de la Salle.

BIBLIOGRAPHY: L. Both de Tauzia,
Dessins His de la Salle, Paris, 1881,
p. 131, no. 217; C. Ephrussi, "Les
Dessins de la collection His de la Salle,"
Gazette des Beaux-Arts, XXV, 1882,
p. 304; Ros Z58; F. Lugt, Musée du
Louvre, Inventaire général des
dessins des écoles du Nord, École
hollandaise, vol. II, Paris, 1931, p. 24,
no. 675, repr.; Simon 1935, p. 192 (not
by Ruisdael); Bernt 1958, II, no. 508;
Giltay 84.

The present drawing, like those Jacob did of the *Blauwbrug* and *The Yacht Harbor* at Amsterdam (Cat. nos. 83, 84), is datable to the 1660s, and is almost as highly finished as they are. The detailed execution of the topographical views of Amsterdam was dictated by their intent; it was done to provide Abraham Blooteling with the data he needed to translate the drawings into prints. The careful handling of the Louvre sheet suggests that it was intended as a finished work, which was probably sold to a visitor to Ruisdael's studio or through a dealer.

View of the Dunes near Wijk aan Zee

86

Hamburg, Kunsthalle (no. 1917/106)
Black chalk, gray wash, touched with
pencil, 20.2 x 31.6 cm. Signed by a later
hand, bottom, right of center.

PROVENANCE: Possibly sale, Baronesse
A.H.E. van Pallandt van Klarenbeek,
née Verstolk van Soelen, Amsterdam
(Roos), 4–7 November 1867, no. 33;
dealer C.G. Boerner, Leipzig, 1907, no.
192; acquired by the Kunsthalle in 1917.

EXHIBITION: London 1929, no. 700.

BIBLIOGRAPHY: G. Pauli, Prestel
Gesellschaft, *VIII, 1924 (Nieder-*
länder I), no. 31; Ros Z31; Simon
1930, pp. 68 (mid-1650s), 84; Giltay 61.

This unusual extensive panorama of the barren high dunes near the village of Wijk aan Zee that serve as part of the natural dike between Holland and the North Sea was an *unicum* in Ruisdael's *oeuvre* until another drawing of the same site done from a slightly different point of view reappeared about a decade ago. The second sheet was acquired by Fondation Custodia (no. 1971-T.4) and published by Carlos van Hasselt (black chalk, gray wash, 20.1 x 31.8 cm; Paris, Institut Néerlandais, *Acquisitions Récentes de Toutes Epoques, Fondation Custodia, Collection Frits Lugt*, 10 January–24 February 1974, p. 27, no. 68, Pl. 18; Giltay 95). The drawings are congruent in style and virtually identical in size. Both are probably datable to the 1660s, when panoramic views became one of the artist's specialties.

Ruisdael's drawings of dunes that include more extensive views of the beach and sea are as rare as the dunescapes at Hamburg and Paris. The only one that has been securely attributed to him is at Berlin; it is one of his most beautiful studies from nature (Fig. 83; no. 2593; black chalk, black and gray wash, white body color on prepared gray-brown paper, 23 x 37.8 cm; Ros Z8; Giltay 17). A possible additional candidate in this category, known to me only in a photo, is the large drawing that appeared in the sale, Frau Ehlers of Göttingen, Leipzig (Boerner), 9–10 May 1930, no. 365, Pl. XXXVII (black chalk and pencil with gray wash; 26.2 x 43 cm; provenance: Heinrich Campe, Leipzig; Hasse, Hannover), and which is now in a private German collection. In style it seems to be related to the Hamburg and Fondation Custodia views of Wijk aan Zee, but the long, high pier that extends from a high dune to the sea in the drawing is anomalous among seventeenth-century Dutch views of beaches.

Fig. 83

Fig. 83. Jacob van Ruisdael, A View of the Seashore and Boats from a Dune. *Berlin, Staatliche Museen, Kupferstichkabinett.*

Panoramic View of the Northern Part of Amsterdam and the IJ

87

Amsterdam, Rijksmuseum, Rijksprenten-
kabinet (no. 1960:116)
Black chalk, gray wash, 8.6 x 15.2 cm.
Inscribed on the verso in pencil in a
seventeenth-century (?) hand: geteekend
van t dack der Verbrandt Nieuwe Kerk
tot Amsterdam (naer 't Y).

PROVENANCE: Sale, Amsterdam, 12
February 1770, no. 283; sale, H.
Busserus, Amsterdam, 21 October 1782,
no. 2192; Friedrich August II of Saxony,
Dresden; W.J.R. Dreesmann, Amster-
dam; sale, Dreesman, Amsterdam
(Mensing), 22 sqq. March 1960, no.
24, repr. (Rijksmuseum).

EXHIBITIONS: Amsterdam 1932-I, no.
35; Washington et al. 1958–59, no. 101a
(c. 1664–65); Amsterdam–Toronto
1977, no. 77 (c. 1650).

BIBLIOGRAPHY: H.W. Singer, Zeich-
nungen aus der Sammlungen Fried-
rich August II in Dresden, Munich,
1921, no. 615; Ros Z20 (c. 1665); Simon
1930, pp. 68, 83 (by Ruisdael, c. 1665);
Simon 1940, p. 210 (not by Ruisdael; a
copy by another hand, after The Marquess
of Lansdowne's painting); Regteren Altena
[n.d.], p. 306 f., repr.; Stechow 1966,
p. 128 (c. 1665); Slive 1973, p. 275;
Giltay 3.

Jakob Rosenberg (Z20) first noted that the drawing is a study for Ruisdael's *View of Amsterdam*, now in a private collection (Cat. no. 46). There is general agreement that the painting was done during Ruisdael's maturity, but there are considerable differences regarding the date of the drawing.

The case for an early date for the sketch was made by J.Q. van Regteren Altena (*op. cit.*), who called attention to the old inscription on the verso, which states that the panorama was drawn from the burned roof of the Nieuwe Kerk at Amsterdam looking toward the IJ. The fire that damaged the church occurred in January 1645. In view of the inscription, van Regteren Altena proposed that if the drawing was indeed made from the roof of the Nieuwe Kerk, it must have been done about 1647 from the scaffolding that had been erected to repair the damage done to it. B. Bakker, the author of the Amsterdam–Toronto 1977 exhibition catalogue (*op. cit.*), argues that there is no reason to doubt the veracity of the inscription and dates the drawing about 1650. J. Giltay (*op. cit.*) also places the drawing slightly later than 1647.

Despite the inscription, a date of about 1647–50 for the study is hard to square with any of the drawings Ruisdael made during the first years of his activity in Haarlem. The summary touch, the brilliant atmospheric effect, and the close connection of the drawing to Ruisdael's panoramic landscapes showing distant views of the horizon indicate that it should be assigned a later date. The observation made by Jakob Rosenberg (Ros 2; Ros Z20) that the scaffolding in the foreground of the sketch belongs to the construction of Amsterdam's New Town Hall, and L.C.J. Frerichs' conclusion (Washington *et al.* 1958–59, no. 101a) that the drawing is datable to about 1665 since the tower of the Town Hall was begun in 1664 and finished in 1665 is consistent with the style and conception of the little drawing. It is also noteworthy that it is virtually the size size and on the same paper as Ruisdael's drawing of a distant view of Haarlem at Amsterdam, Cat. no. 91 (kind communication from L.C.J. Frerichs), which is datable to the early seventies; perhaps both sheets came from the same sketchbook.

For identification of the principal topographical features of the drawing, see Cat. no. 46. An additional point regarding its topography should be noted here. As every school child of Amsterdam knows, the New Town Hall was built on the Dam adjacent to the New Church. A view of the city from either height would have presented Ruisdael with very similar extensive views of the city—with one exception observed by van Regteren Altena (*op. cit.*): a bird's-eye view of the city and its harbor from the top of the Town Hall should include the New Church in the foreground. Van Regteren Altena noted that if the drawing was indeed made from the Town Hall, it is unclear why the church does not appear. The explanation may be that Ruisdael chose to concentrate on the vast panorama of Amsterdam, not on the architecture of the neighboring church.

Extensive Landscape with a View of Haarlem

88

The Hague, Museum Bredius (no. T 95-1946)
Black chalk, gray wash, with figures in pencil, 9.9 x 16.1 cm.

PROVENANCE: *Sale, Diderick, Baron van Leyden, Amsterdam (van der Schley), 13 May 1811, no. E.47 (sold as a lot with Cat. nos. 89, 90); A. Bredius, The Hague.*

BIBLIOGRAPHY: *Ros Z23a; Simon 1930, pp. 68, 84 (rather later than 1663; the figures by another hand); Simon 1940, p. 210 (not by Ruisdael; a copy); Blankert 1978, p. 164, T 18 (with wrong Rosenberg reference); Giltay 49.*

The drawing belongs to the precious small group of panoramic sketches Ruisdael made in the late sixties or early seventies of the plain near Haarlem with the skyline of the town in the distance. Two others of the series are also at the Museum Bredius (Cat. nos. 89, 90), and another, closely related to them, is at the Rijksprentenkabinet, Rijksmuseum, Amsterdam (Cat. no. 91). Perhaps all four sheets were part of the same sketchbook. The correspondences (some closer than others) that can be established between them and his *Haarlempjes* indicate that they were used as *aides-mémoire* for paintings that were worked up in the studio. In none of them is the proportion of sky to earth as great as it is in the paintings and only in the Amsterdam sheet is there a suggestion of the magnificent skies of the finished pictures.

J. Giltay (*op. cit.*) notes a connection between this sketch and the painting of a *View of Haarlem* at The Metropolitan Museum of Art, on loan from Ernest G. Rathenau and Ellen Rathenau Ettlinger (HdG 88; Ros 42; I do not share his doubts regarding the attribution of the painting to Ruisdael).

K.E. Simon's rejection (*op. cit.*, 1940) of the three Bredius sketches as copies is unjustified.

Extensive Landscape with a View of Haarlem

89

The Hague, Museum Bredius (no. T94-1946)
Black chalk, gray wash, with figures added in pencil, 9.2 x 15 cm.

PROVENANCE: *See Cat. no. 88.*

BIBLIOGRAPHY: *Ros Z23b; Simon 1930, pp. 68, 84 (rather later than 1663; the figures by another hand); Simon 1940, p. 210 (not by Ruisdael; a copy); Blankert 1978, p. 164, T 17 (with wrong Rosenberg reference); Giltay 50.*

The cluster of houses on the left side of the sketch appear in the center of Cat. no. 88. However, the shift in its relationship to St. Bavo and other buildings on Haarlem's skyline indicates that Ruisdael did not make the drawing at the same spot. Although the sketch cannot be related to a specific painting, the row of little houses recalls those seen near bleaching fields in many of Ruisdael's views of Haarlem.

Extensive Landscape with a View of Haarlem

90

The Hague, Museum Bredius (no. T96-1946)
Black chalk, gray wash, 10.7 x 15 cm.

PROVENANCE: *See Cat. no. 88.*

BIBLIOGRAPHY: *Ros Z23c; Simon 1930, pp. 68, 84 (rather later than 1663; the figures by another hand); Simon 1940, p. 210 (not by Ruisdael; a copy); Blankert 1978, p. 165, T 19; Giltay 51.*

Jakob Rosenberg (1928, p. 58) recognized similarities between this sketch and the *View of Haarlem*, formerly in the collection of Emil Georg Bürhle, Zurich (HdG 69; Ros 53, repr., identical with Ros 54; the painting is rubbed, especially in the dark areas of the lower third). In the present sketch and in the one at Amsterdam (Cat. no. 91) St. Bavo is seen from the west.

Extensive Landscape with a View of Haarlem

91

Amsterdam, Rijksmuseum, Rijksprenten-
kabinet (no. 1961:43)
Black chalk, gray wash, 8.9 x 14.8 cm.
Inscribed on the verso in black chalk:
J. v. d. Haagen.

PROVENANCE: Dealer van Wens;
acquired from him by the Rijksprenten-
kabinet, 1961.

BIBLIOGRAPHY: Slive 1973, p. 275,
repr.; Giltay 6 (perhaps the wash was
added by a later hand [Dalens?]).

Acquired by the museum as a work by Joris van der Haagen, but rightly attributed to Ruisdael by L.C.J. Frerichs of the Rijksprentenkabinet, this drawing is of a style and size that closely relate it to the three *Haarlempje* sketches at the Museum Bredius (Cat. nos. 88–90). Perhaps all of them belonged to the same sketchbook. Congruencies between the Amsterdam sheet and the *View of Haarlem* now in the collection of Sir Harold Samuel, Sussex (Fig. 84; HdG 58; Ros 41) indicate that it was used as a preliminary study for the painting. Significant alterations were introduced in the final work, where the silhouette of the upper edge of the dense woods has been made more regular, more of the plain beyond it is portrayed, and a rhythm of light and shadow has been set up which suppresses the lively detail that animates the drawing. The changes in the painting result in a gain in coherence and an increased effect of the vastness of the plain.

J. Giltay's suggestion (*op. cit.*) that the gray wash may have been added by another hand (Dalens?) is in accord with neither the fine gradations and transparency of the wash nor the suggestive way the giant cloud formation hovers over the earth.

Fig. 84. Jacob van Ruisdael, View of Haarlem. *Wych Cross Place, Sussex, Sir Harold Samuel.*

Fig. 84

A View of the Inner Court Behind the Handboogdoelen
on the Singel at Amsterdam

92

The inscription on the verso of the sheet, as well as an engraving made by Bathazar Florisz in 1625 that includes a bird's-eye view of the Handboogdoelen, its court, and neighboring buildings, and a map of the area made in 1642 (see Lugt 1920, Figs. 32B, 32C, respectively), confirm that the drawing shows a view of the inner court and an adjacent yard behind the headquarters of the crossbow (St. Sebastian) Civic Guard Company on the Singel in Amsterdam. B. Bakker (Amsterdam–Toronto 1977, *op. cit.*) mentions that Jacob made the drawing in a house in the Handboogstraat, a neighboring street.

The building with the tower served as the crossbowmen's headquarters (in Ruisdael's time it was used as an inn); left of it is the side façade of the Artilleriehuis (or Boshuis). Today these two restored buildings house part of the library of Amsterdam University. B. Haak noted that the gabled house that projects into the left corner of the court was built about 1670 (see Stubbe, *op. cit.*); his observation provides a *terminus post quem* for the drawing and one of the rare reference points for Ruisdael's late style as a draughtsman.

Ruisdael's drawing shares the informal character of most town views done from the window of a flat. His study is particularly intimate because it is devoted to rear views of buildings that flank a private court and yard, not to façades designed to be seen by one and all from the street or to a vista of anonymous rooftops. Artists have made similar studies at least since Dürer made his early watercolors of the *Courtyard of a Castle (Innsbruck?)*, but closer in spirit to Ruisdael's drawing is the group of sketches van Gogh did in the early 1880s of the modest yards he saw from the window of his attic studio in The Hague.

Hamburg, Kunsthalle (no. 22467)
Black chalk, gray wash, 22.6 x 21.6 cm.
Inscribed on the verso in a later hand:
de schuttersdoelen op de cingel.

PROVENANCE: *Sale, H. de Wacker*
van Zon, Amsterdam (de Leth), 26
October 1761, no. 44; possibly sale, M.
Oudaan, Rotterdam (de Bosch), 3
November 1766, no. Q.84; sale, C. Ploos
van Amstel, Amsterdam (van der
Schley), 3 March 1800, no. L.31; C.
Josi; bequeathed to the Kunsthalle by
E. Harzen in 1863.

EXHIBITIONS: *Hamburg 1920, no.*
138, repr.; Amsterdam–Toronto 1977,
p. 170, no. 79, repr.

BIBLIOGRAPHY: *W. Stubbe,* Hundert
Meisterzeichnungen aus der Hamburger Kunsthalle: 1500–1800,
Hamburg, 1967, p. 43, no. 86, repr.;
Das grosse Buch der Graphik, *1968,*
p. 282, repr.; Giltay 62.

A View of the Dam with the Weigh House at Amsterdam

The present drawing and Cat. no. 94 were formerly ascribed to J. Beerstraten (Nève, *op. cit.*). Frits Lugt attributed both sheets to Ruisdael in 1925 (note at the R.K.D.). J. Giltay (*op. cit.*) first published them as works by Jacob and correctly observed that they not only show unmistakable views of the Dam at Amsterdam but once formed a single sheet. In addition, Giltay noted that the very close correspondence of the joined drawings to Ruisdael's painting of *The Dam with the Weigh House at Amsterdam*, now at Berlin (Cat. no. 55), establishes that they served as a preliminary study for the painting. See Fig. 63 for a reconstruction of the drawings; the top and bottom edges no longer align but the left side of the present drawing makes almost a perfect fit with its mate.

The Berlin painting has been generally dated about 1670. However, as mentioned in the discussion of it (Cat. no. 55), its style suggests that it may have been painted toward the end of the decade. Similarities between the handling of the Brussels drawings and Jacob's sketch at Leipzig, which was most probably used as a study for his late panoramic views of the Amstel looking toward Amsterdam, tend to support this argument. The Leipzig drawing could hardly have been done before 1675, and it may have been made as late as 1681 (see Cat. no. 56 and Fig. 64). The Leipzig drawing, like the cut one at Brussels, is also comprised of two sheets of paper; whether its support was originally put together by the artist or was a single sheet that was cut, and later rejoined, is not known.

Jacob made changes when he transposed his drawing of the Dam into a painting. Notable is the shift in the direction of the light. In the preliminary study the façade of the blocky Weigh House is in shadow. When the artist turned to his canvas he decided to put it in full light and adjusted the light-dark effect accordingly. He also emphasized the massiveness of the Weigh House by reducing the height of the tower of the Oude Kerk and the building on the extreme left, a tavern and shopping center called *Het Huis onder't Zeil* (The House Under the Sail).

The figures in the drawing are surely by Ruisdael, while the more conspicuous ones in the paintings are by another hand, probably Gerard van Battem's (see Cat. no. 55). Virtually nothing is known regarding the instructions seventeenth-century Dutch painters gave to the artists they employed to embellish their pictures. However, in this case it is evident that Jacob's original conception included a group of figures similar to the one his staffage painter added to the finished work.

93

Brussels, Koninklijke Musea voor Schone
Kunsten, collection de Grez (no. 169)
Black chalk, gray wash, 9 x 15.1 cm.

PROVENANCE: Collection de Grez.

BIBLIOGRAPHY: Nève 1913, no. 169
(as J. Beerstraten, erroneously called
"Hôtel de Ville de . . . ,"); Giltay 32.

A View of the Dam and Old Church at Amsterdam

94

Brussels, Koninklijke Musea voor Schone Kunsten, collection de Grez (no. 168)
Black chalk, gray wash, 8.7 x 12.3 cm.

PROVENANCE: Collection de Grez.

BIBLIOGRAPHY: Nève 1913, no. 168 (as J. Beerstraten; erroneously called "La Grand'place à Harlem,"); Giltay 33.

See Cat. no. 93.

A Winding Road Along a Fence with a View of Trees and a Village in the Distance

95

K.E. Simon (*op. cit.*) rejects the drawing. J. Giltay (*op. cit.*) classifies it as an original that was worked up by Dirk Dalens (for another drawing he puts in the same category, see Cat. no. 70). Apart from the signature, which is not Ruisdael's, it is hard to see the work of two artists in the sheet. Jakob Rosenberg (1928, p. 66) rightly placed it with the wooded landscapes Jacob made during his last phase, when his tendency toward the pretty and small scale becomes notable. For Rosenberg these works were not without quality, but he found all of them somewhat weak. However, the present drawing as well as other wooded scenes Ruisdael did during these years can be defended as a vision of nature that stresses its gentle aspects rather than its heroic strength.

Berlin, Staatliche Museen, Kupferstich-kabinett (no. 3127)
Black chalk, gray wash, 15.1 x 19.4 cm.
Signed at the bottom center by a later hand: Ruisdael fec.

PROVENANCE: *Sale, D. Muilman, Amsterdam (de Bosch), 29 March 1773, no. B.88; collection W.A. Blenz; acquired for the museums in 1844.*

BIBLIOGRAPHY: *Ros Z12; Simon 1935, p. 192 (not authentic); Bock-Rosenberg 1930, I, p. 257, no. 3127; Giltay 19 (signed by Dalens?).*

Etchings

Since Jacob van Ruisdael's etchings are not nearly as well known as his paintings and drawings, it may be helpful to offer a few introductory remarks about them here.

It should be stressed straightaway that Ruisdael's corpus of etchings is very small and impressions of most of them are exceedingly scarce. Adam Bartsch, the indefatigable print cataloguer who published the first descriptive list of Ruisdael's prints in 1803, was able to cite only seven (Cat. nos. 96, 103–108). François Léandre Regnault-Delalande added three to Bartsch's initial list in the catalogue he published in 1817 of Comte Rigal's print collection (Cat. nos. 99, 100, 102). Georges Duplessis rediscovered two (Cat. nos. 97, 98), which he reproduced in the heliogravure edition of facsimiles of the etchings he edited in 1878 for Armand-Durand. C.H. Middelton spotted another unrecorded one in John Sheepshanks' album at the British Museum (Cat. no. 101). His discovery, published by E. Dutuit in 1885, was the last find. It brought the grand total of Ruisdael's existing prints to thirteen.

Bartsch can scarcely be faulted for failing to catalogue the six etchings he missed. Five of those he did not record are known only in unique impressions (Cat. nos. 97, 98, 100–102); there is no reason to believe he ever laid eyes on them. The sixth (Cat. no. 99) he knew, but he wrongly attributed it to Allart van Everdingen, an understandable error.

It is abundantly evident that Ruisdael decided to try his hand at etching at the start of his career. Two of his prints are dated 1646 (Cat. nos. 96, 97), the year he appears on the scene in Haarlem as a seventeen- or eighteen-year-old artist. Both are proudly signed: *JvRuisdael in.f.*. In 1649 he signed and dated another print the same way (Cat. no. 104). It is noteworthy that Rembrandt, who made more than 280 etchings and whose achievement in the medium was far greater than that of any of his contemporaries, inscribed on only two of his (*Flight into Egypt*, 1633 [Bartsch 52]; *The Good Samaritan*, 1633 [Bartsch 90]) that he was the author of the design (*in.* = *inventor*) as well as the maker of the print (*f.* = *fecit*).

Three tiny oval prints—they are about the size of calling cards—also are datable to Ruisdael's earliest years of activity in Haarlem (Cat. nos. 98–100). His rare etching of a heavily shaded thicket at the edge of a pond (Cat. no. 101) probably belongs with this early group, or was made soon afterward. Another three are signed and dated 1647, 1648, and 1649 (Cat. nos. 102, 103, 104, respectively).

Ruisdael's best-known etchings, the four landscapes that most likely were designed as a set (Cat. nos. 105–108), are datable to the first half of the 1650s. They mark the end of the artist's brief career as a printmaker. To our best knowledge he did not etch another plate from about 1655 until his death in 1682.

Apart from his existing etchings very little is known about Ruisdael's activity as a printmaker. For example, it is not known who taught him the technique or the elements of the graphic vocabulary of hatched lines, curlicues, hooks, and dots which he was able to employ with impressive competence by the time he made the two etchings dated 1646. To judge from their production as printmakers, neither Salomon van Ruysdael nor Cornelis Vroom, the artists who stimulated Ruisdael most in his youth, was his mentor. Not a single print by either artist is known. To judge from the high order of intelligence Ruisdael displays in his early works, it also seems safe to rule out the possibility that he was self-taught.

In view of his auspicious start and his ever-increasing mastery of the technique, Ruisdael's decision never again to touch an etcher's needle after about 1655 is puzzling. Knowledge that he moved from his native town to Amsterdam not long after he abandoned etching complicates the puzzle. Surely Amsterdam would have offered him a much larger market for his prints than Haarlem.

That Jacob responded to some of the demands of the art market of the largest and richest city of the United Provinces is shown not only by the way he adopted Everdingen's fashionable Scandinavian waterfalls soon after he settled in Amsterdam, but by the frequency with which he repeated the theme during the following decades. We have also seen that early in the 1660s he supplied topographical drawings of Amsterdam to help satisfy the new vogue for views of the city (Cat. nos. 83, 84). Abraham Blooteling, the prolific Amsterdam printmaker, made etchings after them. At least two separate editions of Blooteling's prints were

Fig. 85. The Cottage on a Hill, *Cat. no. 107, detail (enlarged).*

published: one by Justus Danckerts, the other by Hieronymus Sweerts. Ruisdael lived above Sweerts' book and print shop on the Dam in Amsterdam from about 1670 until his death in 1682 (see Cat. no. 55). In 1670 Blooteling also engraved copies of Ruisdael's two drawings of views of the Portuguese Jewish cemetery at Ouderkerk on the Amstel (see Cat. nos. 76, 77).

Ruisdael, like most creative printmakers of his day, was not the man to make literal transcriptions of relatively highly finished drawings into prints. He left the discipline demanded by that exacting process to the skilled craftsmen and women who specialized in producing prints done after designs by other artists.

But why did he cease using the print technique he had mastered? Why did he not make etchings for the large Amsterdam market?

Perhaps he decided soon after 1655 that the re-sults of the time and energy spent on polishing metal plates, sharpening needles, mixing grounds, preparing mordants needed to bite plates, messing with printer's ink, and finally struggling with the presses and other etcher's paraphernalia were simply not worth the effort involved. Moreover, consideration of what he had achieved in his paintings by the time he moved to Amsterdam suggests that he would have had to put much more effort into his plates than he had done in the past if he had attempted to transpose into his etchings fundamental aspects of what he had accomplished in his paintings.

Support for this hypothesis is found if we take a close look at a pair of his latest etchings: *The Cottage on the Hill* (Fig. 85) and *The Great Beech* (Fig. 86). In both prints we are impressed by the almost palpable presence of the verdant growth on the hills in the foreground and the gigantic trees that

232

Fig. 86. The Great Beech, *Cat. no.*
106, detail (enlarged).

dominate the landscapes. In these passages the etched lines are extremely dense and heavily worked. In contrast, Ruisdael used more widely spaced lines and the white of the paper for the few light accents in the foremost parts of the landscapes and for their subordinate distant views. The result is a clear distinction between the powerful forms in the foreground and the airy vistas beyond them; the division between the two is rather sharp.

Now, even before he had made these etchings Ruisdael had achieved far less abrupt shifts between the near and far views in his paintings, and in his subsequent work, the extent between the foreground and the distant view in his landscapes increased, while the transitions between the two became more subtle and gradual. To achieve similar effects in his etchings, Ruisdael most likely would have had to resort to repeated multiple bitings of his etched plates, a method used by the

printmakers of his time to obtain a wider range between the light and dark lines usually found in an etching.

A printmaker who desires to subject a metal plate to more than one biting normally etches his entire composition on a plate in the usual fashion. Then he covers his plate with transparent stopping-out varnish, which serves the same purpose as an opaque etcher's ground but permits him to see the parts he wants to rework with his needle. After the reworking has been finished, the plate is immersed in acid a second time. When done by a skilled etcher, the second biting introduces a greater range of gradations between the lightest and darkest etched areas of the print. The process can be repeated again and again until the desired effect is achieved.

Use of the multiple-biting process would have enabled Ruisdael to translate more of his pictorial

Fig. 87. Rembrandt van Rijn, The Three Trees, *1643. Etching.*

achievement into his etchings. But Ruisdael apparently never employed it. Indeed, he seems to have laid down his etcher's needle forever at the very time the process would have begun to serve him best. Perhaps he abandoned the technique because he decided that a single biting of a plate could not produce the effects he desired and never adopted the multiple-biting process because it had too many objectionable features for him. The process is slow and tedious; it also is risky. If the stopping-out varnish fails, all the etcher's previous effort has gone for naught. (For a print that shows evidence of accidental breaks in the etching ground occurring during the course of the first biting of its plate, see Cat. no. 106.) Third, fourth, or more bitings compound the difficulties and risk.

Ruisdael could have employed a different solution to the problem of obtaining a greater range of tones in his etchings if he had adopted the technique Rembrandt was evolving during the very years that span Ruisdael's brief activity as a printmaker. In the landscape etchings Rembrandt made from about 1645 until the early 1650s (when he,

too, ceased to depict landscapes in the medium, but unlike Ruisdael continued to use it for other subjects), he first used the conventional method of etching his design into his plate with a single biting. Then, instead of resorting to the multiple-biting process, he reworked his plate with a drypoint needle and occasionally with an engraver's burin. Drypoint was not unknown to Ruisdael—limited passages of it can be seen in a few of his prints, and Rembrandt himself, as well as other etchers, had combined both drypoint and engraved lines on etched plates earlier—but there was no precedent in the history of printmaking for the richly gradated scale of values Rembrandt achieved by his extensive use of drypoint in the landscape etchings he made from about 1645 to 1653. In addition, Rembrandt obtained new and unexpected tonal effects by the way he wiped ink from his plates. Instead of wiping one completely clean, he judiciously allowed ink to remain on its surface in some areas. In printing, the remaining film of ink was transferred to the paper, which established yet another range of tone between the lightest and

Fig. 88. Jacob van Ruisdael, Trees and Dunes, with a View of Dordrecht in the Distance, *1648. Springfield, Massachusetts, Museum of Fine Arts.*

darkest areas of the print (Christopher White, *Rembrandt as an Etcher,* I, London, 1969, pp. 203–25, provides the best discussion of Rembrandt's landscape etchings of this period).

Ruisdael did not follow Rembrandt's lead. He made no attempt to emulate the effects Rembrandt achieved in his peerless landscape etchings that make extensive use of drypoint and plate tone. In fact, the impact on Ruisdael of Rembrandt's total output as a landscapist is virtually nil. The younger artist went his own way. Jacob's late *Le Coup de Soleil* at the Louvre (Cat. no. 47) is the only painting I can cite that shows a trace of the influence of Rembrandt's dramatic paintings of imaginary views. He took nothing from Rembrandt's fresh drawings done from nature. As for the etchings, only a single print by Rembrandt seems to have inspired him: *The Three Trees,* 1643 (Fig. 87; Bartsch 212). The composition of Ruisdael's painting *Trees and Dunes, with a View of Dordrecht in the Distance* (Fig. 88; panel, 31.7 x 56.6 cm; Springfield, Massachusetts, Museum of Fine Arts), monogrammed and dated 1648, shows a debt to Rembrandt's most

romantic landscape print. Ruisdael's etching of *Three Oaks* (Cat. no. 104), dated 1649, likewise includes a paraphrase of the main motif, but its idyllic mood evokes nothing of the tumultuous drama of Rembrandt's etching. Apart from the striking chiaroscuro effect in his *Landscape with Trees and a Small Pond* (Cat. no. 101), which can be viewed as a youthful homage to the etchings Rembrandt did in his dark manner, the 1648 painting, the 1649 etching, and *Le Coup de Soleil* comprise the complete list of works by Ruisdael that reveal Rembrandt's influence—hardly an impressive number when we recall that Ruisdael produced more than 800 landscapes during the course of his career.

Few public or private print collections can offer their visitors the pleasure of seeing many fine original impressions of Ruisdael's etchings, and no print room has a full set of his thirteen prints. A passing remark in a letter that the passionate collector John Sheepshanks (1787–1863) sent in 1833 to Constable to thank the English artist for presenting him two of his own etchings informs us that they were already scarce in his day:

235

I can well imagine that these [etchings] will be sought for in another Century, as the rare Ruisdaels are now—What a pity, that dealers you will not live to see, must have all the pecuniary advantage, & that you have only the prospective reputation (Parris *et al.* 1975, p. 133).

We have previously noted that five of Ruisdael's etchings exist only in unique impressions: The British Museum has two (both were in Sheepshanks' collection); two are at the Albertina; one is at Amsterdam. We also have seen that his scarcest prints are datable to the early years of his activity as an independent artist. Ruisdael probably considered most of them trial essays that did not warrant publication in large editions.

Consideration of the number of impressions that the artist pulled from his plates, the prices they fetched, or the manner in which they were distributed for sale once again brings us to a frontier of knowledge. Nothing is known about these aspects of his activity. A publisher's credit line on later states of two of his prints, *Grain Field at the Edge of a Wood* (Cat. no. 103), 1648, and *The Three Oaks* (Cat. no. 104), 1649, informs us that they were printed by the Antwerp engraver and print publisher Frans van den Wyngaerde (1614–79), who had a knack for obtaining plates made by other artists (*e.g.*, Lievens, Vostermann, Hollar) and publishing editions of them. But how and when Ruisdael managed to make contact with his Antwerp publisher and what arrangements he made with him remain unanswered questions.

The prints that turn up most often are three etchings that belong to the set made about 1650–55: *The Little Bridge, The Great Beech*, and *The Cottage on a Hill* (Cat. nos. 105–107). Impressions of

first states of these outstanding prints, which show them before another hand added the skies and clumsy cumulus clouds that appear in their second states, are uncommon. Laurence Binyon first recognized these later additions in the brief essay he published on the artist (1895), and aptly described the added clouds as pudding-shaped, "with hard bulging edges (what a satire on this consummate master of clouds!)" and deplored "the presence of those inflated shapes inserted by a stupid publisher." (Not all Binyon's observations regarding Ruisdael's etched work are equally acceptable. He made a demonstrable muddle of their chronology and maintained that Ruisdael lacked Crome's masterful style—Binyon's book devoted to Crome and Cotman appeared two years after he published his essay on Ruisdael.) The cumulus clouds in the late state of the *Forest Marsh* (Cat. no. 108) also were added by another hand. For a view of Ruisdael's own sensitive and sometimes impetuous handling of skies and clouds we need only to turn to his other etchings that include them.

Late impressions of *The Little Bridge, The Great Beech*, and *The Cottage on a Hill* (Cat. nos. 105–107), made from reworked plates, also have been recorded. Rudolph Weigel mentions in 1843 that the printmaker, publisher, and author Pierre François Basan (1723–93) had the plates for these three etchings and pulled impressions from them. He added that in his time the plates for *The Great Beech* and *The Cottage on a Hill* were in England. In 1910, Alfred von Wurzbach wrote that the plate for *The Little Bridge* was still in existence but did not state where. The whereabouts of the three plates is unknown today; apparently no others have been preserved.

Cottages and a Clump of Trees near a Small River

96-A

96-B

Rudolph von Wurzbach (*op. cit.*) and K.E. Simon (*op. cit.*, 1930; *op. cit.*, *B.M.* 1935) evidently knew only the second state of this etching and erroneously read the date in the lower margin as 1645. Apparently, Wolfgang Stechow (*op. cit.*) followed their reading when he wrote that the print was begun in 1645 and finished in the following year because the date on it was changed from 1645 to 1646. In any event the date on the bottom margin of the etching is unmistakably 1646. To our best knowledge none of the artist's works is inscribed with an earlier date.

Widely spaced dots and irregular short lines help achieve the effect of sparkling sunlight in the print. Ruisdael used a similar pointillist-like technique in the early chalk drawings at Dresden that are datable about the time of the etching (see Cat. nos. 57–62).

An untraceable painting of the same site was listed as a Hobbema by Hofstede de Groot (HdG, Hobbema 280); Simon attributed it to Jacob's father, Isaack van Ruisdael (panel, 60 x 85 cm; see *B.M.* 1935, pp. 7–8, repr., Pl. I, C). Neither attribution is compelling. For Simon's tenuous attribution to Isaack of three other paintings that he relates to Jacob's early etchings, see Cat. nos. 98–100.

A unique impression of the third state of the etching is at the Bibliothèque Nationale, Paris. It has been given margins on all sides. A band 3 cm wide has been cut from the top; the crown of the large tree, the signature, and the date are in pen and ink. The darkened foreground has been burnished out; horizontal lines have been added to the right side of the cottage on the right, its chimney reworked, drypoint lines added in the sky and on the field on the right, and vertical lines added on the gable of the house on the left.

BIBLIOGRAPHY: Bartsch 1803, 7 (described from a cropped impression); Regnault-Delalande 1817, 7 (first notes that the print is signed and dated 1646 at the bottom and again at the top); Smith 1835, p. 104, no. 7; Weigel 1843, 7; Duplessis 1878, 8; Dutuit 1885, 7; Wurzbach 1910, 7 (dated 1645 in lower margin); Simon 1930, pp. 14, 68 (dated 1645 in lower margin); Simon B.M. 1935, p. 7 (dated 1645 in lower margin); Stechow 1968, pp. 250, 260, note 3 (apparently begun in 1645 and completed in 1646; the date was changed from 1645 to 1646); Keyes 1977, 1 (changes in the second state by another hand); Hollstein–de Hoop Scheffer 1978, 7; de Groot 1979, 221.

A. *First state, unique impression*
Paris, Fondation Custodia (coll. F. Lugt), Institut Néerlandais (no. 7253)
20.6 x 28.1 cm. Inscribed at the bottom left of the center: . . . n. f. 1646.

The bottom left margin of this unique impression of the print, which included the artist's signature, is missing. It can be deduced from impressions of the second state that, before the lower margin was damaged, the inscription on it read: JvRuisdael in. f. 1646.

B. *Second state*
Vienna, Albertina, Graphische Sammlung
20.3 x 27.3 cm. Signed and dated at the upper right: JvRuisdael f 1646.

The bottom margin is extensively darkened with hatching, which makes it difficult to read the first signature and date. Foliage has been added to the highest tree, additional hatching on the cottage to the right and the tree near it. A band 2.3 cm in width has been trimmed at the top. The only other existing impression of this state of the print is at the Rijksprentenkabinet, Amsterdam (20.4 x 28.1 cm).

Landscape with a Hut and a Shed

97

The print shows the sun breaking through a heavily overcast sky, a sharp contrast with Ruisdael's other etching dated 1646 (Cat. no. 96), which depicts a clear, sparkling day. The fusion of the modest buildings and trees in the distance with the leaden sky recalls the tonal paintings done by the landscapists of Salomon van Ruysdael and Jan van Goyen's generation, as well as a few of Jacob's own early black chalk sketches (see Cat. no. 61).

It is an effect that Ruisdael did not attempt again in his etchings. The bold, impetuous hatching in the sky, which obliterates some of the wispy clouds he initially drew, likewise is unique to this etching.

Georges Duplessis (*op. cit.*) and E. Dutuit (*op. cit.*) list a faithful copy by Johannes Arnoldus Boland (1838–1922).

BIBLIOGRAPHY: *Duplessis 1878, 9; Dutuit 1885, 11; Wurzbach 1910, 11; Keyes 1977, 2; Hollstein–de Hoop Scheffer 1978, 11; de Groot 1979, 216.*

Only state, unique impression
Amsterdam, Rijksmuseum, Rijksprenten-kabinet (no. OB 4867)
15.8 x 21.5 cm. Signed and dated on the bottom margin: JvRuisdael in. f. 1646.

Landscape with Two Willows

The close similarity of the handling of the trees in this little print to those on the left side of Ruisdael's *Landscape with a Hut and a Shed* (Cat. no. 97), dated 1646, supports a date of about the same time for the etching. There are also similarities in the artist's rudimentary attempt to give tone to the sky.

Format and style relate the work to Cat. nos. 99 and 100. These modest etchings are conceivably Jacob's first essays in the medium.

E. Dutuit (*op. cit.*) notes that C.H. Middelton called the print the *Water Mill*, and rightly adds that the mill is not well indicated. Neither the naked eye nor magnification shows a trace of it.

An etched copy (7.4 x 6.4 cm; Hollstein–de Hoop Scheffer, *op. cit.*, p. 182, repr.) was made by Benjamin Phelps Gibbon (1802–51) for John Sheepshanks. The impression of the copy in Rotterdam (no. BdH 20170); formerly collection Willink van Collen) is inscribed in Sheepshanks' hand: Copied by B.P. Gibbon/from the original Etching of/Ruysdael in the possession of JS/Aug:1st 1832/JS. For another etched copy inscribed by Sheepshanks, see Cat. no. 99.

K.E. Simon (*op. cit.*, pp. 8, 13, Pl. III, F) found a connection between the etching and a painting attributed to Hobbema at the Koninklijke Musea voor Schone Kunsten, Brussels (panel, 36.5 x 34 cm; Catalogue, 1949, p. 60, no. 400; Broulhiet 337). According to him the painting is by Isaack van Ruisdael and is akin to his son's print. There is, however, little resemblance between the two works; attribution of the painting to the nebulous Isaack is without foundation.

BIBLIOGRAPHY: *Duplessis 1878, 12; Dutuit 1885, 12; Wurzbach 1910, 12; Simon B.M. 1935, p. 8; Keyes 1977, 12 (youthful work); Hollstein–de Hoop Scheffer 1978, 12.*

Only state, unique impression
London, British Museum, Trustees of the British Museum
7.5 x 6.4 cm (oval). Signed at the bottom: JvRuisdael.

98

Landscape with a Brook and Willows

Made about 1646, the etching is more densely hatched than Cat. nos. 98 and 100, but nevertheless it is related to them. Adam Bartsch, who knew the print from a cropped impression that did not include the monogram, wrongly attributed it to Allart van Everdingen (1803, II, p. 162, no. 3); François Léandre Regnault-Delalande (*op. cit.*) corrected his error. George S. Keyes (*op. cit.*, p. 13) doubts the authenticity of the monogram. To be sure, it is rather awkwardly drawn and its prominent place in the sky is also unusual; however, its clumsy character and unusual position may be a consequence of young Ruisdael's inexperience as a printmaker.

Only four other impressions of the etching are known; they are in Copenhagen (a cropped impression; 5.7 x 7.3 cm), London, Paris (Rothschild Collection), and Vienna.

John Burnett (1784–1868) made a deceptive copy (7.4 x 8.4 cm, oval; Hollstein–de Hoop Scheffer, *op. cit.*, p. 179, repr.); impressions of it are in Hamburg, London, and Rotterdam. According to Rudolph Weigel (*op. cit.*), Burnett's copy was commissioned by John Sheepshanks for a catalogue that never was published. The verso of the impression of the copy in Rotterdam (no. BdH 20169; formerly collection Willink van Collen) is inscribed in Sheepshanks' hand: Copy by John Burnett/J.S. 1830.

K.E. Simon's claim (*op. cit.*, pp. 7, 13, Pl. III, D) that a painting which he attributes to Isaack van Ruisdael partially conforms to the etching is not convincing (formerly collection S.B. Goldschmidt, Frankfurt a.M.; sale, Goldschmidt, Vienna, 11 March 1907, no. 39, as Ruisdael; panel, 50 x 68 cm). Hofstede de Groot (HdG, IV, p. 363) attributed the untraceable Goldschmidt painting to Gerrit van Hees.

BIBLIOGRAPHY: *Regnault-Delalande 1817, 9; Weigel 1843, 9; Duplessis 1878, 11; Dutuit 1885, 9; Wurzbach 1910, 9; Simon B.M. 1935, pp. 7, 13; Keyes 1977, 11 (youthful work); Hollstein–de Hoop Scheffer 1978, 9.*

Only state
Berlin, Staatliche Museen, Kupferstich-kabinett (no. 257-11)
7.1 x 8.6 cm (oval). Monogrammed at the top, to the right: JvR.

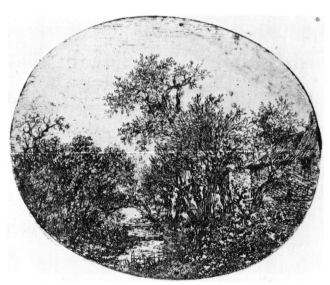

99

Little Hut near a Pond and a Bridge

Although the definition of forms in space is more clearly articulated and the foliage in the middle ground is airier in this print than in Ruisdael's two other small etchings done in an oval format (Cat. nos. 98, 99), it remains closely linked to them, and like them is datable about 1646.

Impressions of a deceptive copy are at Hamburg and London (6.2 x 7.2 cm, oval, on a rectangular plate; Hollstein–de Hoop Scheffer, *op. cit.*, p. 178, repr.).

A painting that appears to show the same site (in reverse) was with the dealer Duits, London (panel, 36.5 x 31.5 cm); it was exhibited Laren, Singer Museum, 1959, no. 69. Hofstede de Groot ascribed it to Gerrit van Hees (note at R.K.D.). K.E. Simon (*op. cit.*, Pl. III, C) stated the painting bears the litigated monogram IvR, and he attributed it to Isaack van Ruisdael. The dealer Duits read the monogram as Jacob van Ruisdael's own. To judge from a photograph, there is little reason to accept any of these attributions.

BIBLIOGRAPHY: Regnault-Delalande 1817, 8; Weigel 1843, 8; Duplessis 1878, 10; Dutuit 1885, 8; Wurzbach 1910, 8; Simon B.M. 1935, pp. 7ff.; Keyes 1977, 13 (youthful work); Hollstein–de Hoop Scheffer 1978, 8.

Only state, unique impression
Vienna, Albertina, Graphische Sammlung
6.3 x 7.4 cm (oval). Signed at the bottom: JvRuisdael f.

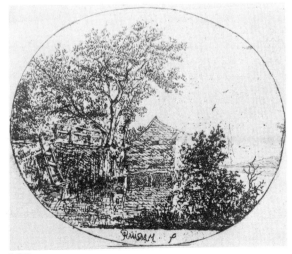

100

Landscape with Trees and a Small Pond

The attribution of the unsigned etching to Ruisdael was made by C.H. Middelton and published by E. Dutuit (*op. cit.*), with a slight reservation: "Il n'est pas impossible que l'auteur ne soit Ruisdael, mais cela est douteux."

Its style and technique are consistent with the artist's early etchings. The remarkable range of tonal values and control of the spatial relations of the dense shrubbery suggest that it may have been made slightly later than the small oval landscapes of about 1646 (Cat. nos. 98–100). Its compositional scheme bears some resemblance to Jacob's early painting of a close view of *A Pond* at Budapest (Cat. no. 4), but in the small print the sky has been darkened and the flickering light has become more intense.

BIBLIOGRAPHY: Dutuit 1885, 13; Keyes 1977, 10 (youthful work); Hollstein–de Hoop Scheffer 1978, 13.

Only state, unique impression
London, British Museum, Trustees of the British Museum
10.2 x 7.7 cm.

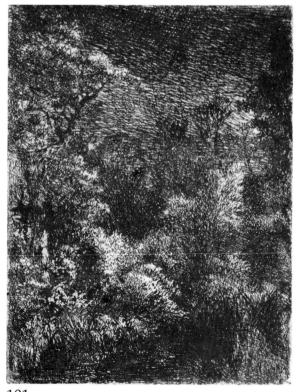

101

Landscape with Oaks and a Pond

The small hatched lines and dots used for passages of the light areas of the farmhouses and fields are similar to those Ruisdael employed a year earlier for his etching of cottages in a country setting (Cat. no. 96). However, the emphasis on the great oak, whose spiky crown virtually fills the sky, is a new note that anticipates the works of the early fifties in which a single tree becomes Jacob's principal protagonist.

The conspicuous scratches and burnish marks on the left and right of the trees may help explain why only a single impression of this splendid early etching is known. Perhaps Ruisdael abandoned the print when he discovered that burnishing failed to remove the scratches on the plate.

Rudolph Weigel (*op. cit.*) and E. Dutuit (*op. cit.*) list an impression at Amsterdam. There is no record of the existence of it at the Rijksprentenkabinet (kindly confirmed by D. de Hoop Scheffer). George S. Keyes (*op. cit.*) lists a second state without the burnishing on the left and the right of the trees and notes it is reproduced in the edition of facsimiles edited by Georges Duplessis (*op. cit.*). This facsimile is not a reproduction of a second state but was made from the unique Vienna impression and touched up for the publication. Jakob Rosenberg (1928, Pl. 18) reproduces the retouched facsimile, not the Albertina's unique impression.

According to Weigel (*op. cit.*) a copy of the print was etched by John Burnett for John Sheepshanks; the copy is untraceable. Weigel may have confused it with the copy he states Sheepshanks commissioned Burnett to make of Cat. no. 99.

BIBLIOGRAPHY: *Regnault-Delalande 1817, 10; Weigel 1843, 10; Duplessis 1878, 7; Dutuit 1885, 10; Wurzbach 1910, 10; Keyes 1977, 3; Hollstein–de Hoop Scheffer 1978, 10.*

Only state, unique impression
Vienna, Albertina, Graphische Sammlung
14.5 x 20 cm. Signed and dated, lower right: *JvRuisdael f 1647.*

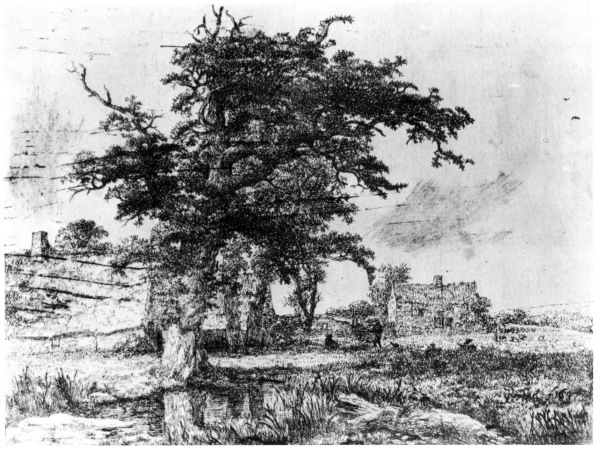

102

Grain Field at the Edge of a Wood

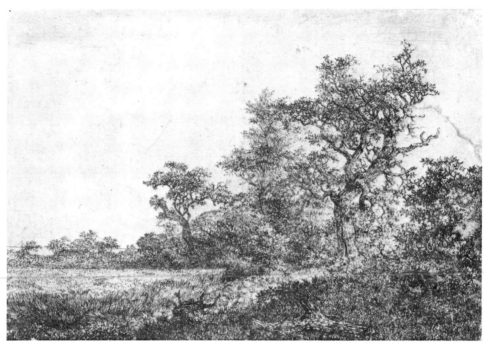

103-A

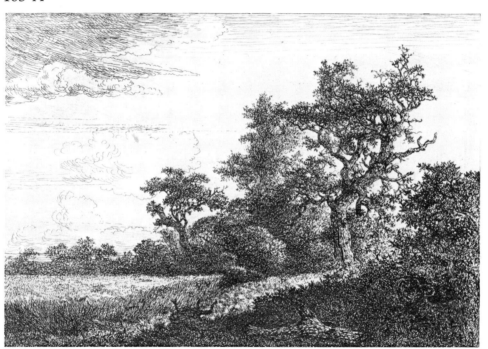

103-B

BIBLIOGRAPHY: Bartsch 1803, 5;
Regnault-Delalande 1817, 5; Smith
1835, p. 104, no. 5; Weigel 1843, 5;
Duplessis 1878, 5; Dutuit 1885, 5;
Wurzbach 1910, 5; Keyes 1977, 4; Holl-
stein–de Hoop Scheffer 1978, 5; de Groot
1979, 214.

9.9 x 14.8 cm. Signed and dated at the
lower right: JvRuisdael (f?) 1648.

A. First state, unique impression
London, British Museum, Trustees
of the British Museum.

*This impression was made before the
lines in the sky and clouds were added
with drypoint and before the fore-
ground and trees were reworked.*

B. Second state
Amsterdam, Rijksmuseum, Rijkspren-
tenkabinet (no. 1958:69).

*This state has the additions mentioned
above.*

Wolfgang Stechow's sharp eye discovered the original signature and date of 1648 on the etching (private communicaiton, 1968); it had been overlooked by all earlier cataloguers. The coherence of the composition and intricate filigree-like treatment of the foliage show the influence of Cornelis Vroom's idyllic landscapes on the young artist, which is also recognizable in other works he made about the same time (see Cat. nos. 8, 9).

The print served as the inspiration for an etching by the gifted Haarlem amateur Claes van Beresteyn (c. 1629–84) of a *Grain Field* (Fig. 90); H. Gerson, *Leven en werken van Claes v. Beresteyn*, The Hague, 1940 in E.A. van Beresteyn, *Genealogie van het Geslacht van Beresteyn*, vol. II, The Hague, 1941, p. 159, no. 5; Hollstein, I, p. 197, no. 5). Two of his etchings are dated 1650 (Gerson, *op. cit.*, p. 159, nos. 6, 8, repr.; Hollstein, I, pp. 198, 200, nos. 6, 8, repr.); judging from their style, his *Grain Field* was done about the same time. Beresteyn's pen drawing of a grain field, with a large clump of trees that look as if they would be more at home in a semi-tropical jungle than in the Dutch countryside (Fig. 91; Fondation Custodia, Paris, no. 1971-T. 17), is also related to Ruisdael's etching.

Third, fourth, and fifth states of the print are known which include reworking with a burin of contours and strengthening of hatching (see Hollstein–de Hoop Scheffer, *op. cit.*, p. 174). On the third and later states the signature *JvRuysdael fe* is engraved in the upper right, and *F.v.W. excud.* is engraved in the margin at the bottom right. These inscriptions were added by another hand. The initials are those of the Antwerp printmaker and publisher Frans van den Wyngaerde (1614–79); most likely he added the spurious "Ruysdael" signature that appears in these states. Wyngaerde also published impressions of Ruisdael's *Three Oaks* (Cat. no. 104), 1649.

François Léandre Regnault-Delalande (*op. cit.*) lists a slightly smaller copy (9.5 x 14.6 cm) of the etching in the same direction with the inscription

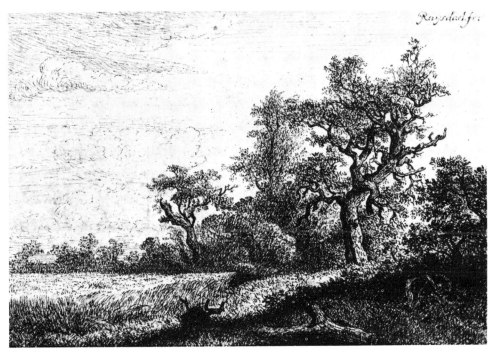

Fig. 89

Fig. 89. John Constable (after Ruisdael), Grain Field, 1818. London, Victoria and Albert Museum.

of J[v]Ruysdael fe and F.V.W. excud very lightly etched. Rudolph Weigel (op. cit.) notes that this copy was probably done by the Dresden landscapist and graphic artist Philipp Veith (c. 1768–1837); Veith also made a copy after the version of The Jewish Cemetery at Dresden (Cat. no. 21), as well as six preparatory drawings for the etchings that his pupil J.F. Bruder did after Ruisdael's paintings in Dresden. Alfred von Wurzbach (op. cit) cites a good but hardly deceptive copy signed: Berhault fecit. Dieuwke de Hoop Scheffer (op. cit.) lists a seventeenth-century copy (10.2 x 14.6 cm; Paris, Rothschild Collection) facing in the same direction, inscribed Ruysdael fe in the upper right corner and F.V.W. excud in the bottom margin to the right.

Constable's pen and ink copy of the etching (Fig. 89; 10.3 x 15.2 cm), which misses some of the delicacy of the original, includes the spurious signature and even the plate mark. His drawing, at the Victoria and Albert Museum (G. Reynolds, Catalogue of the Constable Collection, London, 1960, no. 169; London 1976–I, p. 107, no. 163), is monogrammed and dated on the verso: J.C. fe: 1818.

The compilers of the 1976 Constable exhibition catalogue (ibid., pp. 107–108, nos. 163, 164) have noted that Constable may very well have had his dearest friend Archdeacon Fisher in mind when he made his copy of the etching in 1818. In that year when Fisher sent a letter by hand to Constable's new abode at 1 Keppel Street in London, he addressed it to "Reysdale House," and a few days later he sent a note to the same address, slightly more correctly directed to "Ruysdale House" (Beckett 1952, pp. 38–39). Fisher, of course, knew of Constable's steadfast admiration for Ruisdael, and it was with the name of Ruisdael that he would link Constable's own when he was attempting to console or please the artist: "You are painting for a name to be remembered hereafter: for the time when men shall talk of Wilson & Vanderneer &

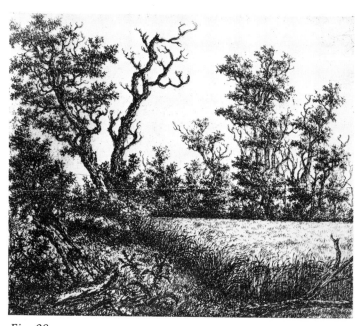

Fig. 90. Claes van Beresteyn, Grain Field. *Etching.*

Fig. 90

248

Ruisdale & Constable in the same breath," he wrote in 1822, after Constable had been overwhelmingly defeated in the election at the Academy by Richard Cook, a minor painter who married a rich wife and never exhibited again after 1819 (Beckett 1968, VI, p. 83).

Constable expressed a desire to copy Ruisdael's etchings as early as 1797, when he wrote on 16 January of that year to his early mentor John Thomas "Antiquity" Smith:

> I have a great mind to copy one of Rysdael's etchings, I have seen one at your house where there are two trees standing in the water [see Cat. no. 108], and there is one which your Father copied, either of these I should like very much, but as they are very scarce and dear, perhaps you would not like to [en]trust them [to me], if not any one which is not so (Beckett 1964, II, p. 9).

The mature master continued to find it worth expending time and energy in copying Ruisdael's works. In a letter sent to Leslie on 4 September 1832 less than a fortnight after Fisher's death he wrote:

> I cannot tell how singularly his death has affected me. I shall pass this week at Hampstead to copy the Winter—for which indeed my mind is in a fit state (Beckett 1968, VI, p. 265).

The winter piece to which he referred is Ruisdael's painting of a *Winter Landscape*, then in the collection of Sir Robert Peel and now at The John G. Johnson Collection, Philadelphia; for an additional note regarding his replica of Peel's painting, see Cat. no. 53. Constable's copy of the winter landscape along with three other of his Ruisdael copies as well as three originals by the Dutch artist were in his possession at the time of his death in 1837 (see C.J. Holmes, *Constable and His Influence on Landscape Painting*, Westminster, 1902, pp. 228–30).

Fig. 91. Claes van Beresteyn, Wooded Landscape with a Grain Field. *Paris, Institut Néerlandais, Fondation Custodia (Coll. F. Lugt).*

Fig. 91

The Three Oaks

Ruisdael's painting of *Trees and Dunes, with a View of Dordrecht in the Distance* (Fig. 88) shows that as early as 1648 he dramatized a group of large trees by setting them against a distant panoramic view and a vast expanse of sky, a scheme reminiscent of Rembrandt's etching of *Three Trees* of 1643 (Fig. 87). The present etching, dated 1649, of three towering oaks on a small hillock near a pond also recalls Rembrandt's *Three Trees*, but Ruisdael's virtual elimination of the effect of a distant view makes its concentration on the main motif more emphatic.

An untraceable drawing formerly in the A. Beurdeley Collection, which is monogrammed and also dated 1649 (Fig. 92; 18 x 14 cm; Ros Z67b; Giltay 106) and another sheet datable about the same time at the Musée Condé, Chantilly (Fig. 93; 14.6 x 19.7 cm; Ros Z16; Giltay 34) are variations on the theme of the present etching. Both drawings are on parchment and done in ink, gray wash, and watercolor. Similarities between the beautiful Chantilly drawing and the etching led Jakob Rosenberg (1928, p. 19) to conclude that it is a preparatory study for the print. Strictly speaking, it is not. Its unusual parchment support and high finish, not to mention differences in the composition, indicate that it was intended as an independent work. There is no reason to accept George S. Keyes' opinion (*op. cit.*, p. 14, note 27) that the Chantilly drawing is an eighteenth-century pastiche.

In the second state of the etching the borders were strengthened with the burin; parallel lines were added in the tree on the extreme right, on the shaded bank and in the willows at the foot of the bank; additional hatching is evident on the stone to the right. The second state is also inscribed by another hand in the margin, bottom left: F.V.W. ex.; the initials refer to Frans van den Wyngaerde (1614–79), who also published impressions of *The Grain Field at the Edge of a Wood*, 1648 (see Cat. no. 103).

Rudolph Weigel (*op. cit.*) cites a copy by Philipp Veith of Dresden as the best one done after the print (see Cat. no. 103 for Veith's other copies of Ruisdael's works). It is probably the one that is clearly inscribed: JvRuisdael iu; in the original, the *in* of the inscription can be misread as *iu*. E. Dutuit (*op. cit.*) notes that a vigorously executed copy is in the Cabinet des Estampes, Paris.

BIBLIOGRAPHY: *Bartsch 1803, 6; Regnault-Delalande 1817, 6; Smith 1835, p. 104, no. 6; Weigel 1843, 6; Duplessis 1878, 6; Dutuit 1885, 6; Wurzbach 1910, 6; Keyes 1977, 5; Hollstein–de Hoop Scheffer 1978, 6; de Groot 1979, 220.*

First state
Paris, Petit Palais, Dutuit Collection
12.8 x 14.5 cm. Signed and dated on the lower margin: .JvRuisdael.in.f. 1649.

Fig. 92. Jacob van Ruisdael, Oaks on a Hillock, 1649. *Formerly Paris, A. Beurdeley.*

Fig. 93. Jacob van Ruisdael, Two Oaks. *Chantilly, Musée Condé.*

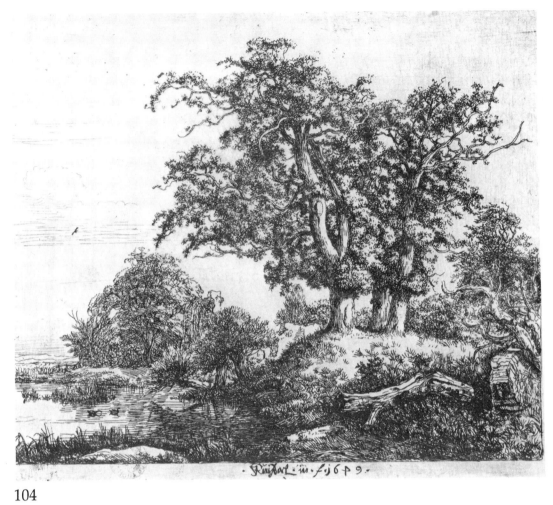

104

Fig. 92

Fig. 93

The Little Bridge

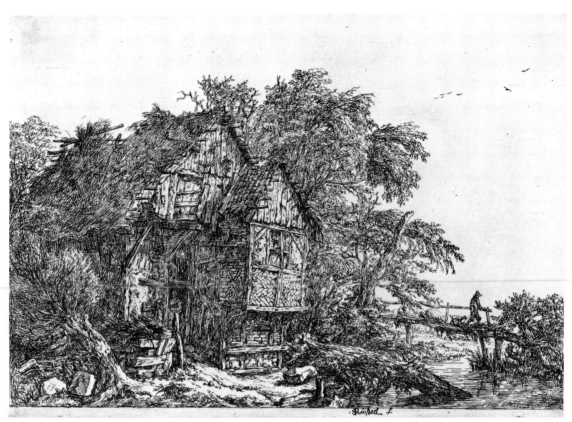

105-A

BIBLIOGRAPHY: Bartsch 1803, 1; Regnault-Delalande 1817, 1; Smith 1835, p. 104, no. 1; Weigel 1843, 1; Duplessis 1878, 1; Dutuit 1885, 1; Binyon 1895, pp. 48, 50; Wurzbach 1910, 1; Bradley 1917, p. 161; Simon 1930, p. 69; Keyes 1977, 8; Hollstein–de Hoop Scheffer 1978, 1; de Groot 1979, 215.

19.5 x 27.7 cm. Signed on the bottom margin: JvRuisdael f.

A. First state
Washington, D.C., National Gallery of Art, Rosenwald Collection, 1943 (no. B-9967).

Impressions of this state were pulled before the clouds and sky were etched in.

B. Second state
Rotterdam, Boymans–van Beuningen Museum (no. BdeH 12910).

The clouds and sky have been etched in and there are retouches of drypoint. The foliage behind the large fallen tree trunk on the right has been enlarged, and there is more hatching on the sprouting willow on the left. In late impressions the drypoint on the lower clouds is worn.

105-B

The similarity in size, style, and technique of this etching to *The Great Beech* (Cat. no. 106), *The Cottage on a Hill* (Cat. no. 107), and *The Forest Marsh* (Cat. no. 108) indicates that the four prints were conceived as a set, made not long after Ruisdael returned to Haarlem in the early 1650s from his journey to the border region between the United Provinces and Westphalia in Germany. The tie-beam construction and vertical planks of the gable of the half-timbered cottage that fills the left side of the present print are characteristic of the vernacular architecture of the region (see Schepers 1976, *passim*); half-timbered buildings of this type are not found in Holland. Ruisdael first began to incorporate them in paintings and drawings that are related to the trip he made to Bentheim about 1650 (see Cat. nos. 13, 70); he continued to employ them in works produced in the following decades.

Attempts have been made to establish a firm chronology for the four etchings. Kurt Erich Simon (*op. cit.*) dated *The Little Bridge* in the early fifties, assigned a date of about 1654 to *The Great Beech* (Cat. no. 106) and *The Cottage on a Hill* (Cat. no. 107), and placed *The Forest Marsh* (Cat. no. 108) in the late fifties. George S. Keyes (*op. cit.*, pp. 11–12) dates all four etchings 1650–55, and argues that *The Forest Marsh* is the earliest and *The Great Beech* is the latest of the group. In my view, a date of about 1650–55 is a reasonable one for all of these etchings; the limit of valid inference from the available visual evidence is strained by attempts to establish an uncontestable chronology for the four prints.

L. Binyon (*op. cit.*, pp. 48, 50) rightly observed that the sky and clouds in the second state of the present print as well as those in *The Great Beech* (Cat. no. 106) and *The Cottage on a Hill* (Cat. no. 107) were added by another hand. His opinion has been endorsed by W.A. Bradley (*op. cit.*) and Keyes (*op. cit.*, pp. 11–12).

Rudolph Weigel (*op. cit.*) mentions that Pierre François Basan (1723–93) had the plates for the present print and Cat. nos. 106 and 107, and pulled impressions from them, but he does not provide evidence to support this statement. However, Basan's brief entry on Ruisdael in his *Dictionnaire des Graveurs . . . avec une Notice des Principales Estampes qu'ils ont gravées seconde partie*, Paris, 1762, shows that he was familiar with Jacob's etchings; it is the earliest known printed reference to them. His succinct notice (with wrong dates) states:

> RUYSDAEL, (Jacob) habile Peintre Hollandois naquit à Harlem en 1640, & mourut à Amsterdam en 1681. On trouve dans ses Ouvrages une touche ferme, sçavante, & un coloris vigoureux. Il a gravé a l'eau-forte plusieurs Paysages de sa composition (*ibid.*, p. 428).

It is evident from Basan's entry that, if he had the three plates by the time he published his *Dictionnaire* in 1672, he did not think prints pulled from them were worthy of special mention as *principales estampes*.

Weigel (*op. cit.*) lists a third state with the clouds hardly visible, and notes that in Basan's time, or later, the plate was etched again; he adds that the modern impressions that often turn up in England are hard and common. Alfred von Wurzbach (*op. cit.*) also cites a third state, probably retouched by Basan; according to him the plate for *The Little Bridge* was still in existence in his time.

The Great Beech, with Two Men and a Dog

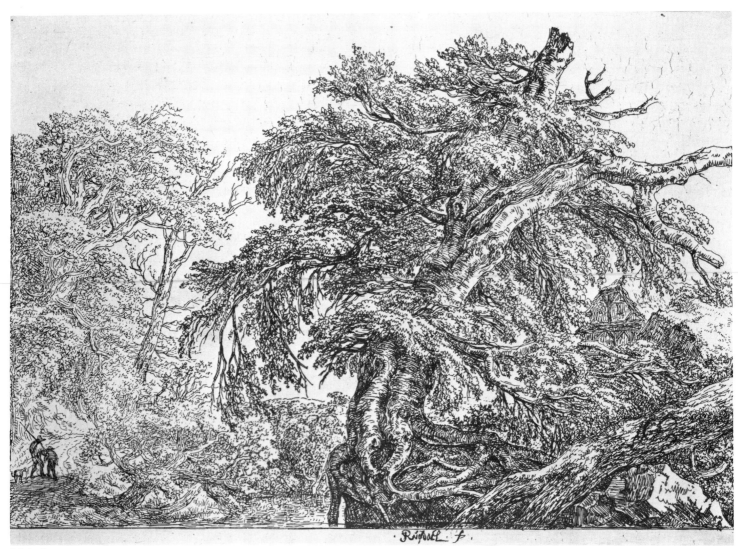

106-A

BIBLIOGRAPHY: *Bartsch 1803, 2;*
Regnault-Delalande 1817, 2; Smith 1835,
p. 104, no. 2; Weigel 1843, 2; Duplessis
1878, 2; Dutuit 1885, 2; Wurzbach
1910, 2; Simon 1930, p. 69; Keyes 1977,
9; Hollstein–de Hoop Scheffer 1978, 2;
de Groot 1979, 217.

19.1 x 27.6 cm. Signed on the bottom
margin: JvRuisdael f.

A. First state
Amsterdam, Rijksmuseum, Rijksprentenkabinet (no. OB 4860).

Impressions of this state were pulled
before the clouds and sky were etched
in. Irene de Groot (op. cit.) notes
that the craquelure *in the upper*
right corner is due to breaks in the
etching ground. Rembrandt had the
same kind of accident in the biting of
the plate for his etching of The Wind-
mill, *1641 (Bartsch 233).*

B. Second state
Rotterdam, Boymans–van Beuningen
Museum (no. BdeH 920).

The clouds and sky have been etched
in; there is additional hatching on the
large tree trunk at the lower right;
the area above and below it were
strengthened with hatching. There
also is additional hatching on passages
of the roots and tree trunk of the beech.

Ruisdael's particular emphasis on the growth of powerful natural forms is keenly felt in this etching of a gigantic beech, and in the predominant trees in his prints of *A Cottage on a Hill* (Cat. no. 107) and *The Forest Marsh* (Cat. no. 108). Here an ancient beech clings with its roots to the projection of a cliff; its broken top helps balance the weight of its heavily foliated branches. During the early 1650s Ruisdael showed a predilection in his paintings for variations on the theme of a monumental tree clawing into high ground or precariously balanced on a bank. Outstanding examples are seen in his *Landscape with a Footbridge*, dated 1652, at The Frick Collection (Fig. 94; no. 49.1.156; HdG 525, probably identical with HdG 719c; Ros 393 [wrongly dated 1654]) and *A Pond with Two Large Trees and Cottages*, which is datable about 1652, Indianapolis Museum of Art (Fig. 95; no.

62.247; HdG 576 [wrongly dated 1666]; Ros 441). *The Great Beech* was probably etched about the same time.

Ruisdael's prints must have been copied often by budding artists. Constable's interest at the start of his career in copying *The Marsh* (Cat. no. 108), or any other impression he could put his hands on, has already been mentioned (see Cat. no. 103); none of his early copies are known. The attrition of such works is high. One that has survived is a pen and brush drawing after the present etching by Adrian Ludwig Richter (1803–84), the Dresden artist who became one of the most popular book illustrators of his time. He made his copy, dated 1818, when he was fifteen (see *Mit Kreide und Tusche*, Catalogue, C.G. Boerner, Düsseldorf, 1977, no. 79, repr.). Richter describes the way he began as a boy to make copies of the Netherlandish

106-B

prints that were in his father's collection in his *Lebenserinnerung eines deutschen Maler*, Frankfurt a.M., 1885.

Rudolph Weigel (*op. cit.*) and E. Dutuit (*op. cit.*) cite a third state that was etched again and reworked; for instance, there is evidence of drypoint work on the beech tree and in the cloud on the left.

Alfred von Wurzbach (*op. cit.*) also lists a third, reworked state. According to Weigel the plate for the etching was in England in his day; see Cat. no. 105 for further references to the history of the plate and additional comments about the print.

There is an etched copy in reverse at Berlin (8.9 x 11.7 cm).

Fig. 94. Jacob van Ruisdael, Landscape with a Foot Bridge *(detail), 1652. New York, The Frick Collection.*

Fig. 95. Jacob van Ruisdael, A Pond with Two Large Trees and Cottages *(detail).*
Indianapolis, Indiana, Indianapolis Museum of Art, Gift of Mr. and Mrs. A.W.S. Herrington.

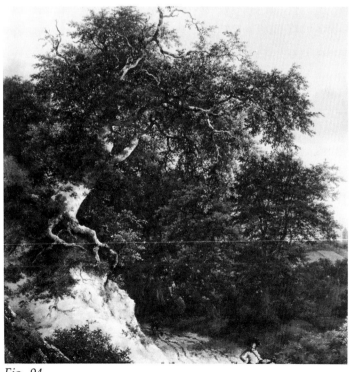

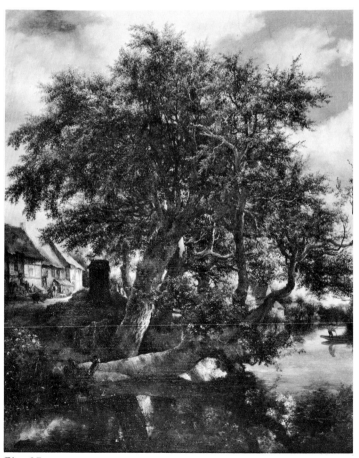

Fig. 94

Fig. 95

A Cottage on a Hill

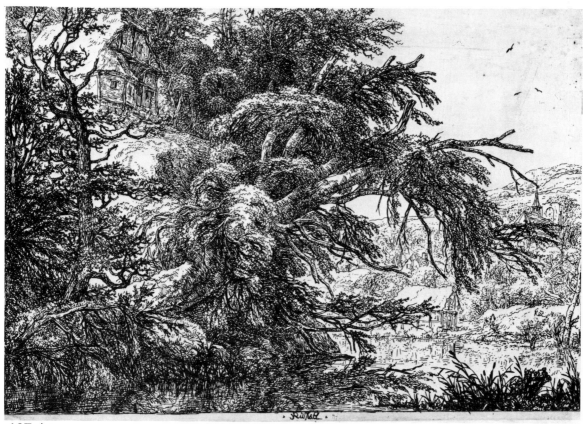

107-A

BIBLIOGRAPHY: Bartsch 1803, 3; Regnault-Delalande 1817, 3; Smith 1835, p. 104, no. 3; Weigel 1843, 3; Duplessis 1878, 3; Dutuit 1885, 3; Wurzbach 1910, 3; Simon 1930, p. 69; Keyes 1977, 7; Hollstein–de Hoop Scheffer 1978, 3; de Groot 1979, 218.

19.4 x 27.9 cm. Signed on the bottom margin: JvRuisdael.

A. First state
Paris, Bibliothèque Nationale
London, British Museum, Trustees of the British Museum.

Impressions of this state were pulled before the clouds and sky were etched in.

B. Second state
Rotterdam, Boymans–van Beuningen Museum (no. BdeH 689).

The clouds and sky have been etched in, and there are some touches of drypoint. Passages in the foliage at the top of the trees to the right of the cottage have been burnished out; there is some burnishing in the lower trees beside the cottage.

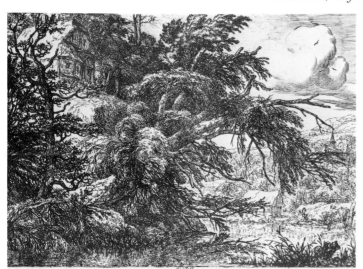

See Cat. nos. 105, 106 for comments on the print.

A third state, which shows evidence of retouchings in the shaded areas and in which the black spot in the lower margin has faded, has been described by Rudolph Weigel, Georges Duplessis, E. Dutuit, and Alfred von Wurzbach. Weigel (*op. cit.*) mentions that the plate was in England in his time; for additional references to the history of the plate, see Cat. no. 105.

Duplessis (*op. cit.*) lists an etched copy in reverse that is signed in the left bottom margin: D.L.sc. 1759.

107-B

A Forest Marsh with Travelers on a Bank

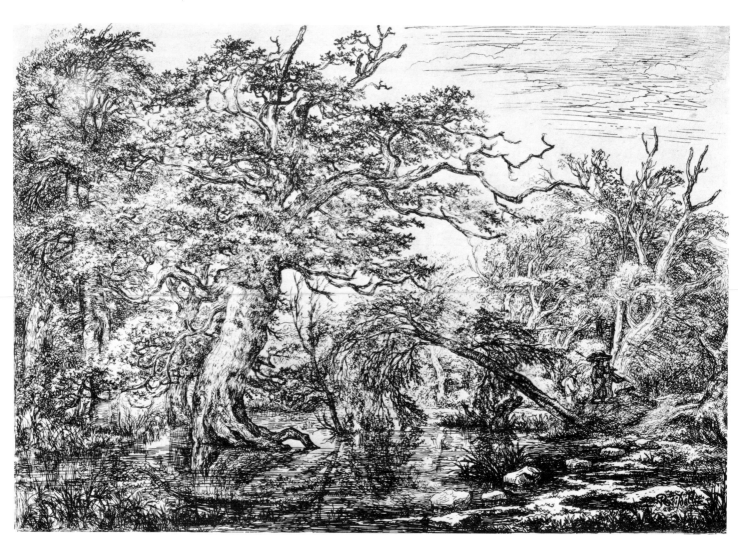

108-A

BIBLIOGRAPHY: *Bartsch 1803, 4; Regnault-Delalande 1817, 4; Smith 1835, p. 104, no. 4; Weigel 1843, 4; Duplessis 1878, 4; Dutuit 1885, 4; Wurzbach 1910, 4; Simon 1930, pp. 35, 60; Keyes 1977, 6 (erroneously stated as dated); Hollstein–de Hoop Scheffer 1978, 4; de Groot 1979, 219.*

19.5 x 28 cm. Signed at the lower right: JvRuisdael.

A. First state
 New York, The Metropolitan Museum of Art, Harris Brisbane Dick Fund, 1926 (no. 26.72.9).

Impressions of this state were pulled before the drypoint lines were inserted on the right in the sky and the small lines were added in the sky above the dead tree, before the hatching was added to the tree trunks and foliage to the left of the large oak, and the shadow of the large tree in the water was strengthened.

B. Third state
 Amsterdam, Rijksmuseum, Rijksprentenkabinet (no. OB 4863).

This state has all of the work mentioned above. George S. Keyes (op. cit., pp. 11, 17) recognized a unique impression of the second state of the print in the Rothschild Collection at the Louvre, which includes all of work cited above, apart from the drypoint in the sky.

C. Fourth state
 Rotterdam, Boymans–van Beuningen Museum (no. L 1958/48).

In this state clouds were added and changed, the trunk of the oak reworked and foliage added, alterations made to the left and right of the oak tree, and hatching added to the reflections in the water on the left. Keyes (ibid.) first ascribed all of the changes in this state to another hand.

108-B

108-C

In this outstanding etching of a forest scene a stout oak, which has clawed itself into the marshy ground, dominates the rich variety of growth reflected in the broad expanse of stagnant water. Comparison of the third state with the rare first one shows how Ruisdael's additional work on the plate heightened the massiveness and solidity of the oak and the high wall of trees beyond it without losing the lively play of light that permeates the landscape.

Hobbema painted two copies of the etching. Both were done in the early sixties, when he often imitated his teacher's work. One of them, signed and dated 1662, is at the National Gallery of Victoria, Melbourne (Fig. 96; no. 2252/4; HdG, Hobbema 132). The other also is signed and is datable about the same time; it is at the Thyssen-Bornemisza Collection, Lugano-Castagnola (HdG, Hobbema 264; Rosenberg 1927, pp. 142–43, repr.; Broulhiet 224, repr.). In both paintings Hobbema introduced modifications that make Ruisdael's composition more open in its spatial setting, changes that help account for the marked loss in mystery and intensity of the pupil's versions.

The fact that Hobbema's copy in Melbourne is dated 1662 and the Thyssen-Bornemisza variant is datable to about the same time may help explain why some authors have dated *The Forest Marsh* in the late 1650s (see Simon, *op. cit.*, pp. 35, 60; Thyssen-Bornemisza Collection, Catalogue, 1969, p. 151, no. 132). However, there is no reason to assume that Hobbema was inspired only by the works Ruisdael produced while he "served and learned with him for several years." Works Ruisdael had in stock also could have been used as models for his pupil.

Another painted variant after *The Forest Marsh* is at Dresden (Fig. 97; panel, 55 x 74 cm; Catalogue, 1908, no. 1493); Hofstede de Groot (455) wrongly ascribed it to Ruisdael. Jakob Rosenberg (1928, p. 117, note 4) attributed it to Jan van Kessel and recognized that remnants of his scratched-out signature still are visible under the false Ruisdael signature on the panel. The spurious signature was most likely added to the picture before 1743, when the landscape was acquired for the Dresden gallery as an authentic Ruisdael (kind communication from Dr. Anneliese Mayer-Meintschel). If this

was the case, it is the earliest known example of the transformation of a work done by a follower into one done by the master.

A black chalk drawing after the print by an anonymous hand is at Berlin (19 x 27.2 cm). It is erroneously published and reproduced by Friedrich Lippmann (1910, II, no. 310) and by W.A. Bradley (1917, p. 168) as an original; Rosenberg rightly catalogued it (Bock-Rosenberg 1930, p. 259,

no. 5302) as a copy after the print. According to Rudolph Weigel (*op. cit.*), a good unsigned copy (18.3 x 25.9 cm) was etched by the Frankfurt amateur L. Wagner. There is an impression of an unsigned etched copy in reverse at the British Museum (9.2 x 15.1 cm). For young Constable's request to borrow an impression in 1797 in order to copy it, see Cat. no. 103.

Fig. 96. Meindert Hobbema (after Ruisdael), The Forest Marsh, 1662. *Melbourne, National Gallery of Victoria.*

Fig. 97. Jan van Kessel, A Ford in a Wooded Landscape. *Dresden, Staatliche Kunstsammlungen.*

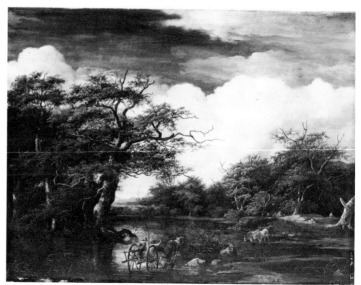

Fig. 96

Fig. 97

Exhibitions Cited in Abbreviated Form

Amsterdam 1925
Historische tentoonstelling der Stad Amsterdam, Rijks-museum–Stedelijk Museum, Amsterdam, 3 July–15 September 1925.

Amsterdam 1932–I
Kaarten, profielen en panorama's van Amsterdam, Amsterdam, 1932.

Amsterdam 1932–II
Klassieke Hollandsche teekenaars, Museum Fodor, Amsterdam, 1932.

Amsterdam 1935
Hollandsche Teekenkunst in de Gouden Eeuw, Rijksprentenkabinet, Amsterdam, 1935.

Amsterdam 1963
Fodor 100 jaar, Museum Fodor, Amsterdam, 12 July–30 September 1963.

Amsterdam 1971
Hollandse schilderijen uit Franse musea, Rijksmuseum, Amsterdam, 1971.

Amsterdam-Toronto 1977
Opkomst en bloei van het Noordnederlandse Stadsgezicht in de 17de eeuw. The Dutch Cityscape in the 17th Century and its Sources, Amsterdams Historisch Museum, Amsterdam, 17 June–28 August 1977–Art Gallery of Ontario, Toronto, 27 September–13 November 1977.

Baltimore 1968
From El Greco to Pollock, Early and Late Works by European and American Artists, The Baltimore Museum of Art, Baltimore, Maryland, 1968.

Basel 1945
Meisterwerke holländischer Malerei . . . Ausstellung aus Privatbesitz in der Schweiz, Kunstmuseum, Basel, 28 June–19 August 1945.

Berlin 1906
Ausstellung von Werken alter Kunst aus dem Privatbesitz der Mitglieder des Kaiser-Friedrich-Museums-Verein, Ehemalig Gräflich Redern'schen Palais, Berlin, 27 January–4 March 1906.

Berlin 1925
Gemälde alter Meister aus Berliner Besitz, Kaiser-Friedrich Museums Verein, Berlin, July–August 1925.

Berlin 1955–56
Gemälde der Dresdner Galerie, National-Galerie, Berlin, 1955–56.

Berlin 1974
Die holländische Landschaftszeichnung: 1600–1740, Berlin-Dahlem, Staatliche Museen, Preussischer Kulturbesitz, Berlin, April–June 1974.

Bristol 1937
Loan Exhibition of Art Treasures of the West Country, Bristol Museum and Art Gallery, Bristol, 25 May–26 June 1937.

Brooklyn 1945–46
Landscape: An Exhibition of Paintings, Brooklyn Museum, Brooklyn, 8 November 1945–1 January 1946.

Brussels 1935
Cinq Siècles d'art, vol. 1, Exposition Universelle et Internationale, 1935, Brussels, 24 May–13 October [1935].

Brussels 1937–38
De Jérôme Bosch à Rembrandt, dessins hollandais du XVIe au XVIIe siècle, Palais des Beaux-Arts, Brussels, November 1937–January 1938.

Brussels 1971
Rembrandt en zijn tijd, Palais des Beaux-Arts, Brussels, 23 September–21 November 1971.

Brussels-Antwerp 1946
De hollandsche schilderkunst van Jeroen Bosch tot Rembrandt, Paleis voor Schoone Kunsten, Brussels, 2 March–28 April 1946–Koninklijk Museum voor Schone Kunsten, Antwerp, May 1946.

Brussels-Hamburg 1961
Hollandse tekeningen uit de gouden eeuw, Bibliothèque Royale Albert 1er, Brussels, 22 April–24 June 1961–Kunsthalle, Hamburg, 8 September–15 October 1961.

Brussels-Rotterdam-Paris 1972-73
Dessins flamands et hollandais du dix-septième siècle, Collections de l'Ermitage Leningrad et du Musèe Pouchkine, Moscou, Bibliothèque Royale Albert 1er, Brussels, 21 October–25 November 1972–Boymans-van Beuningen Museum, Rotterdam, 1 December 1972–7 January 1973–Institut Néerlandais, Paris, 12 January–18 February 1973.

Brussels-Rotterdam-Paris-Berne 1968–69
Dessins de paysagistes hollandais du XVIIe siècle de la collection particulière conservée à l'Institut Néerlandais de Paris, Bibliothèque Royale Albert 1er, Brussels–Boymans-van Beuningen Museum, Rotterdam–Institut Néerlandais, Paris—Musée des Beaux-Arts, Berne, 1968–69.

Cambridge 1958
Drawings from the Collection of Curtis O. Baer, Fogg Art Museum, Cambridge, Massachusetts, 11 January–25 February 1958.

Caracas 1967
Grandes Maestros, Siglos XV-XVIII, Museo de Bellas Artes de Caracas, 5 November–17 December 1967.
Chapel Hill 1958
Inaugural Exhibition, The William Hayes Ashland Memorial Art Center, Chapel Hill, North Carolina, 1958.
Chicago 1942
Paintings by the Great Dutch Masters of the Seventeenth Century, The Art Institute of Chicago, Chicago, 18 November–16 December 1942.
Cologne 1954
Meisterwerke holländischer Landschaftsmalerei des 17. Jahrhunderts, Wallraf-Richartz-Museum, Cologne, May–June 1954.
Cologne 1955
Rembrandt und seine Zeitgenossen, Handzeichnungen aus dem Museum Fodor, Amsterdam, Wallraf-Richartz-Museum, Cologne, June–August 1955.
Cologne-Rotterdam 1970
Sammlung Herbert Girardet, holländische und flämische Meister, Wallraf-Richartz-Museum, Cologne–Boymans-van Beuningen Museum, Rotterdam, 1970.
Detroit 1929
Catalogue of a Loan Exhibition of Dutch Genre and Landscape Painting, The Detroit Institute of Arts, Detroit, 16 October–10 November 1929.
Dijon 1950
De Jérôme Bosch à Rembrandt, peintures et dessins du Musée Boymans de Rotterdam, Musée de Dijon, Dijon, 1950.
Düsseldorf 1929
Alte Malerei aus Privatbesitz, Düsseldorf, 1929.
Düsseldorf 1970–71
Die Sammlung Bentinck-Thyssen, Kunstmuseum, Düsseldorf, 23 October 1970–3 January 1971.
Eindhoven 1937
Collection of Dr. A.F. Philips, Eindhoven, 1937.
Eindhoven 1948
Nederlandse landschapskunst in de 17de eeuw, Stedelijk van Abbe Museum, Eindhoven, 1948.
Groningen 1931
Verzameling Dr. C. Hofstede de Groot, Groninger Museum, Groningen, March–April 1931.
Groningen 1952
Honderd tekeningen, Groninger Museum, Groningen, 1952.
The Hague 1930
Verzameling Dr. C. Hofstede de Groot, III, Gemeente Museum, The Hague, 16 August–16 September 1930.
The Hague-London 1970–71
"Shock of Recognition": The Landscape of English Romanticism and the Dutch Seventeenth-Century School, Mauritshuis, The Hague, 24 November 1970–10 January 1971–Tate Gallery, London, 22 January–28 February 1971.
Haifa 1959
Holland's Golden Age, Museum of Modern Art, Haifa, April 1959.
Hamburg 1920
Zeichnungen alter Meister, Kunsthalle, Hamburg, 1920.
Hartford 1950–51
Life in Seventeenth Century Holland; Views, Vistas, Pastimes, Pantomimes, Portraits, Peep Shows, Wadsworth Atheneum, Hartford, 21 November 1950–14 January 1951.
Jerusalem-Belgrade 1960
Master Drawings from the Fodor Collection–Crtezi majstora iz Kolekcije Fodor u Amsterdamu, Jerusalem–Belgrade, 1960.
Leeds 1868
National Exhibition of Works of Art at Leeds in 1868, Leeds, 1868.
Leiden 1916
Teekeningen van hollandsche meesters uit de verzameling van Dr. C. Hofstede de Groot, III, Stedelijk Museum "De Lakenhal," Leiden, 12 May–14 June 1916.
Leiden 1965
17de eeuwse meesters uit Nederlands particulier bezit, Stedelijk Museum "De Lakenhal," Leiden, 1965.
Leningrad 1926
Dessins des Maîtres Anciens (catalogue published in Leningrad, 1927), Hermitage, Leningrad, 1926.
Leningrad 1959
Western European Landscape from the XVI to the XX Century, Hermitage, Leningrad, 1959 (Russian text).
Leningrad 1976
Exhibition of Pictures from the United States of America, Hermitage, Leningrad, 11 February–24 March 1976 (shown at Moscow, Kiev and Minsk; Russian text).
London 1924
Lord Haig's Fund Exhibition, Thos. Agnew, London, 1924.

London 1929
Exhibition of Dutch Art, 1450–1900, Royal Academy of Arts, London, 4 January–9 March 1929.
London 1938
Exhibition of 17th-Century Art in Europe, Royal Academy of Arts, London, 3 January–12 March 1938.
London 1945
Dutch Painting of the 17th Century, Arts Council, London, 1945.
London 1946–47
Exhibition of the King's Pictures, Royal Academy of Arts, London, 1946–1947.
London 1947–48
Cleaned Pictures Exhibition, National Gallery, London, 1947–1948.
London 1949
Richard Wilson and his Circle (organized by the City Museums and Art Gallery, Birmingham), Tate Gallery, London, January 1949.
London 1952–53
Dutch Pictures: 1450–1750, Royal Academy of Arts, London, 1952–1953.
London 1961
From Van Eyck to Tiepolo: An Exhibition of Pictures from the Thyssen-Bornemisza Collection . . ., National Gallery, London, 2 March–20 April 1961.
London 1970
Drawings from the Teyler Museum, Haarlem, Victoria and Albert Museum, London, 1970.
London 1971–72
Dutch Pictures from the Royal Collection, The Queen's Gallery, Buckingham Palace, London, 1971–1972.
London 1975–76
Paintings and Drawings from the Royal Collection, The Queen's Gallery, Buckingham Palace, London, 1975–1976.
London 1976–I
Constable: Paintings, Watercolours and Drawings, Tate Gallery, London, 1976.
London 1976–II
Art in Seventeenth Century Holland, National Gallery, London, 30 September–12 December 1976.
London 1978
Dutch and Flemish Pictures from Scottish Collections. A Loan Exhibition in Aid of the National Trust for Scotland, Thos. Agnew & Sons, Ltd., London, 8 November–8 December 1978.
Manchester 1857
Art Treasures of the United Kingdom (catalogue published in London, 1857), Manchester, 1857.
Milan 1954
Mostra di pittura olandese del seicento, Palazzo Reale, Milan, 25 February–25 April 1954.
Munich 1930
Sammlung Schloss Rohoncz, Neue Pinakothek, Munich, 1930.
New York 1830
Richard Abraham Collection, American Academy of Fine Arts, New York, March 1830.
New York 1909
The Hudson-Fulton Celebration. Loan Exhibition of Paintings by Old Dutch Masters, The Metropolitan Museum of Art, New York, September–November 1909.
New York 1939
Catalogue of European Paintings and Sculpture from 1300–1800, Masterpieces of Art, New York World's Fair, New York, May–October 1939.
New York 1940
Catalogue of European and American Paintings: 1500–1900, Masterpieces of Art, New York World's Fair, New York, May–October 1940.
New York 1942
Paintings by the Great Dutch Masters . . . in Aid of the Queen Wilhelmina Fund, Duveen Galleries, New York, 8 October–7 November 1942.
New York 1974
Major Acquisitions of The Pierpont Morgan Library 1924–1974: Drawings, The Pierpont Morgan Library, New York, 1974.
New York-Toledo-Toronto 1954–55
Dutch Painting, The Golden Age, An Exhibition of Dutch Pictures of the Seventeenth Century, The Metropolitan Museum of Art, New York–The Toledo Museum of Art, Toledo–The Art Gallery of Toronto, Toronto, 1954–1955.
Oberlin 1963
Youthful Works by Great Artists in *Allen Memorial Art Museum Bulletin*, XX, no. 3, 1963, Oberlin College, Oberlin, Ohio.
Oslo 1959
Fra Rembrandt til Vermeer, National Gallery, Oslo, 9 October–6 December 1959.
Oxford 1975
Dutch Pictures in Oxford, Ashmolean Museum, Oxford, 10 May–27 July 1975.
Paris 1921
Exposition hollandaise: tableaux, aquarelles et dessins

anciens et modernes, Musée de l'Orangerie, Paris, April–May 1921.

Paris 1945
Exposition des chefs-d'oeuvre de la peinture, Musée du Louvre, Paris, 1945.

Paris 1950–51
Le Paysage hollandais au XVII^e siècle, Musée de l'Orangerie, Paris, 1950–51.

Paris 1970
Choix de la Collection Bentinck, Institut Néerlandais, Paris, 20 May–28 June 1970.

Paris 1970–71
Le siècle de Rembrandt: Tableaux hollandais des collections publiques françaises, Musée du Petit Palais, Paris, 17 November 1970–15 February 1971.

Paris 1974
Dessins flamands et hollandais du dix-septième siècle, Institut Néerlandais, Paris, 25 April–9 June 1974.

Paris-Antwerp-London-New York 1979–80
Le Siècle de Rubens et de Rembrandt. Dessins flamands et hollandais du XVII^e siècle de la Pierpont Morgan Library de New York, Institut Néerlandais, Paris–Koninklijk Museum voor Schone Kunsten, Antwerp–The British Museum, London–The Pierpont Morgan Library, New York, 1979–1980.

Philadelphia 1950–51
Diamond Jubilee Exhibition: Masterpieces of Painting, Philadelphia Museum of Art, Philadelphia, 4 November 1950–11 February 1951.

Portland 1967–68
Seventy-five Masterworks, The Portland Art Museum, Portland, Oregon, 12 December 1967–21 January 1968.

Poughkeepsie 1976
Seventeenth Century Dutch Landscape Drawings and Selected Prints from American Collections, Vassar College Art Gallery, Poughkeepsie, New York, 28 March–7 May 1976.

Prague 1966
Tri Stoleti Nizozemské Kresby (Three Centuries of Netherlandish Drawings), Palác Kinskych, Prague, 1966.

Providence 1938
Dutch Painting in the Seventeenth Century, Rhode Island School of Design, Providence, Rhode Island, 1938.

Rome 1928
Mostra di Capolavori della Pittura Olandese, Galleria Borghese, Rome, 1928.

Rome 1954
Mostra di Pittura Olandese del Seicento, Palazzo delle Esposizioni, Rome, 4 January–14 February 1954.

Rome 1956–57
Le XVII^e Siècle Européen, Palais des Expositions, Rome, December 1956–January 1957.

Rotterdam-Essen 1959–60
Collectie Thyssen-Bornemisza [Schloss Rohoncz], Boymans-van Beuningen Museum, Rotterdam, 14 November 1959–3 January 1960–Museum Folkwang, Essen, 1960.

St. Petersburg 1867
Collection des Dessins, Ermitage Impérial (Galerie No. XII), Hermitage, St. Petersburg, 1867.

San Francisco 1940
Art: Official Catalogue, Golden Gate International Exposition, Palace of Fine Arts, San Francisco, 1940.

San Francisco-Toledo-Boston 1966–67
The Age of Rembrandt. An Exhibition of Dutch Paintings of the Seventeenth Century, California Palace of the Legion of Honor, San Francisco–The Toledo Museum of Art, Toledo–Museum of Fine Arts, Boston, 1966–67.

Seattle 1962
Masterpieces of Art, Fine Arts Pavilion, World's Fair, 1962, Seattle, 21 April–4 September 1962.

Stockholm 1963
Mästarteckningar från Eremitaget Leningrad, Nationalmuseum, Stockholm, 1963.

Stockholm 1967
Holländska mästare i svensk ägo, Nationalmuseum, Stockholm, 3 March–30 April 1967.

Tel-Aviv 1959
Holland's Golden Age, Tel-Aviv, 1959.

Tokyo-Kyoto 1968–69
The Age of Rembrandt: Dutch Paintings and Drawings of the 17th Century, National Museum for Western Art, Tokyo, 19 October–22 December 1968–Municipal Museum, Kyoto, 11 January–2 March 1969.

Tokyo-Kyoto 1974–75
Meisterwerke der Europäischen Malerei aus der Gemäldegalerie alte Meister Dresden, National Museum for Western Art, Tokyo, 21 September–24 November 1974–National Museum, Kyoto, 3 December 1974–26 January 1975.

Utrecht 1953
Nederlandse Architectuurschilders, 1600–1900, Centraal Museum, Utrecht, 28 June–28 September 1953.

Vancouver 1958
The Changing Landscape of Holland, The Fine Arts Gallery, Vancouver, 23 July–29 August 1958.

Vienna 1936
Die holländsche Landschaften im Zeitalter Rembrandts, Albertina, Vienna, 1936.

Washington *et al.* **1958–59**
Dutch Drawings, Masterpieces of Five Centuries, National Gallery of Art, Washington, e.a., 1958–1959.

Washington *et al.* **1975–76**
Master Paintings from the Hermitage and the State Russian Museum, Leningrad, National Gallery of Art, Washington, e.a., 1975–76.

Washington-New York-San Francisco 1978–79
The Splendor of Dresden, National Gallery of Art, Washington–The Metropolitan Museum of Art, New York–California Palace of the Legion of Honor, San Francisco, 1978–1979.

Worcester 1951
Condition: Excellent. A Catalogue of a Special Exhibition of Paintings Notable for their State of Preservation, Worcester Art Museum, Worcester, 22 March–22 April 1951.

Zurich 1949–50
Gemälde der Ruzicka-Stiftung, Kunsthaus, Zurich, December 1949–March 1950.

Zurich 1971
Kunstschätze aus Dresden, Kunsthaus, Zurich, 28 May–18 September 1971.

Works Cited in Abbreviated Form

van der Aa 1839–51
Abraham Jacob van der Aa, *Aardrijkskundig woordenboek der Nederlanden*, 13 vols., Gorinchem, 1839–51.

Agafonova 1935
K. Agafonova, "Ruisdael's Drawings in the Hermitage," *Iskusstvo*, 1935, no. 3, pp. 177–84 (Russian text).

d'Ailly 1953
A.E. d'Ailly, *Repertorium van de profielen der stad Amsterdam en van de plattegronden der schutterswijken*, Amsterdam, 1953.

Ainé [n.d.]
Duchesne Ainé, *Musée Français. Recueil des plus beaux tableaux, statues, et bas-reliefs qui existaient au Louvre avant 1815 . . . École Allemande*, Paris, n.d.

A.Q.
The Art Quarterly

Bartsch
Adam Bartsch, *Catalogue raisonné de toutes les estampes qui forment l'oeuvre de Rembrandt . . .*, Vienna, 1797.

Bartsch 1803
Adam Bartsch, *Le Peintre-graveur*, vol. I, Vienna, 1803.

Beckett 1952
R.B. Beckett, *John Constable and the Fishers: The Record of a Friendship*, London, 1952.

Beckett 1962–68
R.B. Beckett, *John Constable's Correspondence*, 6 vols., London–Ipswich (Suffolk Records Society), 1962–68.

Benesch
O. Benesch, *The Drawings of Rembrandt, A Critical and Chronological Catalogue*, 6 vols., London, 1954–57.

Bernt 1957–58
Walther Bernt, *Die niederländischen Zeichner des 17. Jahrhunderts*, 2 vols., Munich, 1957–58.

Binyon 1895
L. Binyon, *Dutch Etchers of the Seventeenth Century*, London, 1895.

Blanc 1857–58
Charles Blanc, *Le Trésor de la curiosité*, 2 vols., Paris, 1857–58.

Blankert 1978
A. Blankert, *Museum Bredius, catalogus van de schilderijen en tekeningen, met een biographie van Abraham Bredius door Louise Barnouw-de Ranitz*, The Hague, 1978.

B.M.
The Burlington Magazine

Bock-Rosenberg 1930
Elfried Bock and Jakob Rosenberg, *Die Zeichnungen niederländischer Meister im Kupferstichkabinett zu Berlin*, 2 vols., Berlin, 1930.

Bode 1913
W. von Bode, *Catalogue of the collection of pictures and bronzes in the possession of Mr. Otto Beit*, London, 1913.

Bol 1973
Laurens J. Bol, *Die holländische Marinemalerei des 17. Jahrhunderts*, Braunschweig, 1973.

Bradley 1917
W.A. Bradley, "The Etchings of Jacob Ruysdael," *The Print Collector's Quarterly*, VII, 1917, pp. 153–74.

Bredius 1888
A. Bredius, "Het geboortejaar van Jacob van Ruisdael," *O.H.*, VI, 1888, pp. 21ff.

Bredius 1912
A. Bredius, "Iets over de copie van Gerrit Lundens naar Rembrandt's 'Nachtwacht,'" *O.H.*, XXX, 1912, pp. 197ff.

Bredius O.H. 1915
A. Bredius, "Twee testamenten van Jacob van Ruisdael," *O.H.*, XXXII, 1915, pp. 19ff.

Bredius 1915–22
A. Bredius, *Künstler-Inventare: Urkunden zur Geschichte der Holländischen Kunst des XVIten und XVIIIten Jahrhunderts*, 8 vols., The Hague, 1915–22.

Bredius
A. Bredius, *The Paintings of Rembrandt*, 3rd. ed. (revised by H. Gerson), London, 1969.

Broulhiet
Georges Broulhiet, *Meindert Hobbema*, Paris, 1938.

Bürger 1858–60
W. Bürger [E.J.T. Thoré], *Les Musées de Hollande*, 2 vols., Paris, 1858–60.

Bürger 1865
W. Bürger [E.J.T. Thoré], *Trésors d'Art en Angleterre*, 3rd ed., Paris, 1865.

Bürger 1869
W. Bürger [E.J.T. Thoré], "Nouvelles études sur la Galerie Suermondt, à Aix-la-Chapelle," *Gazette des Beaux-Arts*, Ser. 2, t. 1, 1869, pp. 5–37; 162–87.

Burke 1974
James D. Burke, "Ruisdael and his Haarlempjes," *M, A Quarterly Review of the Montreal Museum of Fine Arts*, VI, no. 1, Summer 1974, pp. 3ff.

Carus [1955]
C.G. Carus, *Neun Briefe über Landschaftsmalerei, Geschrieben in den Jahren 1815 bis 1824*, Dresden [1955].

Castro 1883
De Henriques de Castro, *Keur van Grafsteenen op de Nederl.-Portug.-Israël. Begraafplaats te Ouderkerk aan den Amstel*, Leiden, 1883.

Davies 1978
Alice I. Davies, *Allart van Everdingen*, New York and London, 1978.

Dobroklonsky 1961
M.V. Dobroklonsky, *Grafika*, Hermitage, Leningrad, 1961 (Russian text).

Dubiez 1967
F.J. Dubiez, "Beth Haim, Huis des Levens: de Portugees Israëlietische begraafplaats te Ouderkerk aan de Amstel," *Ons Amsterdam*, XIX, 1967, pp. 178–86; 205–12.

Duplessis 1878
Georges Duplessis, *Eaux-Fortes de J. Ruysdael*, Paris, 1878.

Dutuit 1885
E. Dutuit, *Manuel de l'amateur d'estampes*, vol. VI, Paris-London, 1885, pp. 275–84.

Filhol 1804–15
A.M. Filhol (pub.), *Galerie du Musée Napoleon*, 10 vols., Paris, 1804–15.

Frerichs 1963
L.D.J. Frerichs, *Keuze van Tekeningen bewaard in het Rijksprentenkabinet, Rijksmuseum, Amsterdam*, Amsterdam, 1963.

Fuchs 1973
R.H. Fuchs, "Over het landschap. Een verslag naar aanleiding van Jacob van Ruisdael, 'Het Korenveld'," *Tijdschrift voor Geschiedenis*, LXXXVI, 1973, pp. 281–92.

Gerson 1934
H. Gerson, "The Development of Ruisdael," *B.M.*, LXV, 1934, pp. 76ff.

Gerson 1936
Horst Gerson, *Philips Koninck*, Berlin, 1936.

Gerson 1952
H. Gerson, *De Nederlandse Schilderkunst, II, Het Tijdperk van Rembrandt en Vermeer*, Amsterdam, 1952.

Giltay
J. Giltay, "De tekeningen van Jacob van Ruisdael," *O.H.*, XCIV, 1980 (in the press).

Goethe 1790
Johann Wolfgang von Goethe [notes in a 1771 Dresden Gallery catalogue], 1790, in *Goethes Werke*, vol. XXXXVII, Weimar, 1896, pp. 368–87.

Goethe 1816
Johann Wolfgang von Goethe, *Ruysdael als Dichter*, 1816, in *Goethes Werke*, ed. E. Trunz, 7th ed., vol. XII, Munich, 1973, pp. 141–42; 611–13.

Götker 1964
H. Götker, "Beitrag zur Baugeschichte der Burg Bentheim," *Jahrbuch des Heimatvereins der Grafschaft Bentheim*, 1964, pp. 96–100.

Gool 1750–51
J. van Gool, *De Nieuwe Schouburgh der Nederlantsche Kunstschilders en Schilderessen*, 2 vols., The Hague, 1750–51.

de Groot 1979
Irene de Groot, *Landscape Etchings by the Dutch Masters of the Seventeenth Century*, Maarssen, 1979.

Hagels 1968
Herman Hagels, "Die Gemälde der niederländischen Maler Jacob van Ruisdael und Nicolaas Berchem vom Schloss Bentheim im Verhältnis zur Natur des Bentheimer Landes," *Jahrbuch des Heimatvereins der Grafschaft Bentheim*, 1968, pp. 41ff.

Haskell 1976
Francis Haskell, *Rediscoveries in Art*, Ithaca, N.Y., 1976.

Hind 1915–31
Arthur M. Hind, *Catalogue of Drawings by Dutch and Flemish Artists . . . in the British Museum*, 4 vols., London, 1915–31.

Hoet
Gerard Hoet, *Catalogus of naamlyst van schilderyen, met derzelver pryzen*, 2 vols., reprint of 1752 ed., Soest, 1976.

Hofstede de Groot 1893
C. Hofstede de Groot, "Hollandsche Kunst in Schotland," *O.H.*, XI, 1893, pp. 129ff. and 211ff.

HdG, I-X
C. Hofstede de Groot, *Beschreibendes und kritisches Verzeichnis der Werke der hervorragendsten holländischen Maler des XVII. Jahrhunderts*, 10 vols., Esslingen a. N., 1907–28. English trans. of vols. 1–8 by E.G. Hawke, London, 1908–27.

HdG; HdG Zus.; HdG, Hobbema
C. Hofstede de Groot, *Beschreibendes und kritisches Verzeichnis der Werke der hervorragendsten holländ-*

ischen Maler des XVII. Jahrhunderts, vol. IV, Esslingen a. N., 1911.

Hollstein
F.W.H. Hollstein, *Dutch and Flemish Etchings, Engravings and Woodcuts*, Amsterdam, 1947–

Hollstein-de Hoop Scheffer 1978
Dieuwke de Hoop Scheffer, *Hollstein's Dutch and Flemish Etchings, Engravings and Woodcuts*, vol. XX, Amsterdam, 1978.

de Hoop Scheffer 1978
See Hollstein-de Hoop Scheffer 1978.

Houbraken 1718–21
A. Houbraken, *De Groote Schouburgh der Nederlantsche Konstschilders en Schilderessen*, 3 vols., Amsterdam, 1718–21.

Huffel 1921
N.G. van Huffel, *Cornelis Ploos van Amstel Jacob Corneliszoon, en zijne medewerkers en tijdgenooten. Historische Schets van de techniek der Hollandsche Prentteekeningen gemaakt in de tweede helft der 18ᵉ eeuw*, Utrecht, 1921.

Jameson 1844
Mrs. A.B.M. Jameson, *Companion to the most celebrated Private Galleries of Art in London*, London, 1844.

Josi 1821
C. Josi, *Collection d'imitations de dessins d'après les principaux maîtres hollandais et flamands . . .* , 2 vols., London, 1821.

Keyes 1977
George (not Roger) S. Keyes, "Les Eaux-Fortes de Ruisdael," *Nouvelles de l'Estampe*, no. 36, November–December 1977, pp. 7ff.

Kleinmann [n.d.]
H. Kleinmann & Co., *Handzeichnungen alter meister der hollaendischen schule . . .* , 4 vols., Haarlem, n.d.

Kouznetsov 1973
Iouryi Kouznetsov, "Sur le symbolisme dans les paysages de Jacob van Ruisdael," *Bulletin du Musée National de Varsovie*, XIV, 1973, pp. 31ff.

Kronig 1914
J.O. Kronig, *A Catalogue of the Paintings at Doughty House, Richmond and Elsewhere in the Collection of Sir Frederick Cook, Bt.*, vol. II, *Dutch and Flemish Schools*, ed. Herbert Cook, London, 1914.

Kusnezow 1975
Juri Kusnezow, *Holländische und flämische Meisterzeichnungen*, trans. J. Rehork, Munich, 1975.

Lippmann 1910
Friedrich Lippmann, *Zeichnungen alter Meister im Kupferstichkabinett der K. Museen zu Berlin*, 2 vols., Berlin, 1910.

Lugt 1920
Frits Lugt, *Mit Rembrandt in Amsterdam*, Berlin, 1920.

Lugt 1950
Frits Lugt, *École nationale supérieure des Beaux-Arts, Paris, Inventaire générale des dessins des écoles du Nord*, Paris, 1950.

MacLaren 1960
Neil MacLaren, *National Gallery Catalogues. The Dutch School*, London, 1960.

Michel [1890]
Émile Michel, *Jacob van Ruisdael et les paysagistes de l'école de Haarlem*, Paris [1890].

Michel 1910
Émile Michel, *Great Masters of Landscape Painting*, London, 1910.

Nève 1913
Joseph Nève, *Inventaire des dessins et aquarelles . . . de Grez*, Brussels, 1913.

Oldewelt 1938
W.F.H. Oldewelt, "Ruisdael en zijn Dam-gezichten," *Algemeen Handelsblad*, 23 April 1938.

O.H.
Oud Holland

Parris *et al.* 1975
Leslie Parris, Conal Schields and Ian Fleming Williams, *John Constable: Further Documents and Correspondence*, Ipswich (Suffolk Records Society), 1975.

Puyvelde 1944
L. van Puyvelde, *The Dutch Drawings . . . at Windsor Castle*, London, 1944.

Regnault-Delalande 1817
François Léandre Regnault-Delalande, *Catalogue raisonné des estampes du Comte Rigal*, Paris, 1817.

van Regteren Altena [n.d.]
J.Q. van Regteren Altena, "Het Gelaat van de Stad," in *Zeven Eeuwen Amsterdam*, ed. A.E. d'Ailly, vol. III, Amsterdam, n.d.

Renaud 1940
J.G.N. Renaud, "De iconografie van het slot te Egmond," *Maandblad voor beeldende Kunsten*, XVII, 1940, pp. 338ff.

R.K.D.
Rijksbureau voor Kunsthistorische Documentatie, The Hague.

Roggeveen 1948
L.J. Roggeveen, "Een Gezicht op het Damrak van Jacob van Ruisdael," *Phoenix*, III, 1948, pp. 91–94.

Rosenau 1958
Helen Rosenau, "The Dates of Jacob van Ruisdael's 'Jewish Cemeteries'," *O.H.*, LXXII, 1958, pp. 241ff.

Ros; Rosenberg 1928
Jakob Rosenberg, *Jacob van Ruisdael*, Berlin, 1928.

Rosenberg 1933
Jakob Rosenberg, Review of M.F. Wijnman (*O.H.*, 1932) and Jacob Zwarts (*Oudheidig Jaarboek*, 1928), in *Zeitschrift für Kunstgeschichte*, II, 1933, pp. 237–38.

Schaar 1958
Eckhard Schaar, *Studien zu Nicolaes Berchem* (diss.), Cologne, 1958.

Scheltema 1872
P. Scheltema, "Jacob van Ruijsdael," *Aemstel's Oudheid*, IV, 1872, pp. 95ff.

Schepers 1976
Josef Schepers, *Haus und Hof westfälischer Bauern* [1960], 3rd ed., Münster, 1976.

Scheyer 1977
Ernst Scheyer, "The Iconography of Jacob van Ruisdael's *Cemetery*," *Bulletin of the Detroit Institute of Arts*, LV, 1977, pp. 133ff.

Scholten 1904
H.J. Scholten, *Catalogue raisonné des dessins . . . au Musée Teyler à Haarlem*, Haarlem, 1904.

Sedelmeyer 1898
C. Sedelmeyer, *Catalogue of 300 Paintings by Old Masters*, Paris, 1898.

Simon 1930
Kurt Erich Simon, *Jacob van Ruisdael* (diss.), Berlin, 1927; reprinted with additions and corrections, Berlin, 1930.

Simon 1935
K.E. Simon, "Isaack van Ruisdael," *Thieme-Becker, Allgemeines Lexikon der bildenden Künstler*, vol. 29, Leipzig, 1935, pp. 188–89; and "Jacob van Ruisdael," *ibid.*, pp. 190–93.

Simon 1935-I
K.E. Simon, "Wann hat Ruisdael die Bilder des Judenfriedhofs gemalt?," *Festschrift zum 70. Geburtstag von Adolph Goldschmidt*, Berlin, 1935, pp. 158–63.

Simon *B.M.* 1935
K.E. Simon, "Isaack van Ruisdael," *B.M.*, LXVII, 1935, pp. 7–23; and "'Doctor' Jacob van Ruisdael," *ibid.*, pp. 132–35.

Simon 1940
K.E. Simon, Review of G. Broulhiet, *Meindert Hobbema*, Paris, 1938, in *Zeitschrift für Kunstgeschichte*, IX, 1940, pp. 205 ff.

Slive 1973
Seymour Slive, "Notes on Three Drawings by Jacob van Ruisdael," in *Album Amicorum J.G. van Gelder*, The Hague, 1973, pp. 274–76.

Smith; Smith 1835; Smith Suppl.
John Smith, *A Catalogue Raisonné of the Works of the Most Eminent Dutch, Flemish and French Painters*, vol. VI, London, 1835. Supplement, vol. IX, London, 1842.

Stechow 1966
Wolfgang Stechow, *Dutch Landscape Painting of the Seventeenth Century*, London, 1966.

Stechow 1968
Wolfgang Stechow, "Ruisdael in the Cleveland Museum," *Bulletin of The Cleveland Museum of Art*, LV, no. 8, October 1968, pp. 250–61.

Stechow 1975
Wolfgang Stechow, *Salomon van Ruysdael, eine Einführung in seine Kunst*, revised 2nd ed., Berlin, 1975.

Taillasson 1807
[Jean-Joseph] Taillasson, *Observations sur quelques grand peintres*, Paris, 1807.

Terwesten
Pieter Terwesten, ed., *Catalogus of naamlyst van schilderyen, met derzelver pryzen . . . door Gerard Hoet*, vol. III, reprint of 1770 ed., Soest, 1976.

Trautscholdt 1954–55
Eduard Trautscholdt, "Altholländisches Lebengezeichnet," *Imprimatur*, XII, 1954–55, pp. 34–39.

Vega 1975
L. Alvares Vega, *Het Beth Haim van Ouderkerk: beelden van een Portugees-Joodse begraafplaats—The Beth Haim of Ouderkerk aan de Amstel: Images of a Portuguese Jewish cemetery in Holland*, Assen, 1975.

de Vries 1915
R.W.P. de Vries, *Cornelis Ploos van Amstel et ses élèves, essai d'une iconographie*, Amsterdam, 1915.

Waagen 1854
Gustav Friedrich Waagen, *Treasures of Art in Great Britain*, 3 vols., London, 1854.

Waagen 1857
Gustav Friedrich Waagen, *Galleries and Cabinets of Art in Great Britain*, London, 1857. Supplement (vol. IV) to Waagen 1854.

Weigel 1843
Rudolph Weigel, *Suppléments au Peintre-Graveur de Adam Bartsch . . .* , vol. I, Leipzig, 1843.

Wiegand 1971
Wilfried Wiegand, *Ruisdael-Studien: Ein Versuch zur Ikonologie der Landschaftsmalerei* (diss.), Hamburg, 1971.

Wijnman 1932
H. F. Wijnman, "Het Leven der Ruysdaels," *O.H.*, XLIX, 1932, pp. 49–60; 173–81; 258–75.

Woermann
Karl Woermann, *Handzeichnungen alter Meister im Königlichen Kupferstichkabinett zu Dresden*, 10 vols., Munich, 1896–98.

Wurzbach 1906–11
Alfred von Wurzbach, *Niederländisches Künstlerlexikon*, 3 vols., Vienna-Leipzig, 1906–11.

Zwarts 1928
J. Zwarts, "Het motief van Jacob van Ruisdael's Jodenkerkhof . . . ," *Oudheidkundig Jaarboek*, VIII, 1928, pp. 232–49.